Uncommitted Crimes

Published in Canada by
Inanna Publications and Education Inc.
210 Founders College, York University
4700 Keele Street, Toronto, Ontario M3J 1P3
Telephone: (416) 736-5356 Fax (416) 736-5765
Email: inanna.publications@inanna.ca Website: www.inanna.ca

 Canada

We gratefully acknowledge the support of the Canada Council for the Arts and the Ontario Arts Council for our publishing program. We also acknowledge the financial support of the Government of Canada.

Printed and Bound in Canada.

Front cover artwork: Kara Springer, Untitled, *Ana & Andre* series, 2015, 36 x 54 inches, archival pigment print. Artist website: www.karaspringer.ca.

Front cover design: Kara Springer

Library and Archives Canada Cataloguing in Publication

Atluri, Tara, 1979-, author
 Uncommitted crimes : the defiance of the artistic imagi/nation /
Tara Atluri.

Includes bibliographical references.
Issued in print and electronic formats.
ISBN 978-1-77133-393-1 (softcover).—ISBN 978-1-77133-394-8 (epub).—
ISBN 978-1-77133-395-5 (Kindle).—ISBN 978-1-77133-396-2 (pdf)

 1. Nationalism and art—Canada. 2. Art—Political aspects—Canada.
3. Politics in art—Canada. 4. Art and society—Canada. I. Title. II. Title:
Defiance of the artistic imagination.

N72.N38A85 2017 701'.030971 C2017-905461-9
 C2017-905462-7

MIX
Paper from
responsible sources
FSC® C004071
www.fsc.org

Uncommitted Crimes
The Defiance of
the Artistic Imagi/nation

TARA ATLURI

INANNA

F.A.R. Art Series

This book is dedicated to all of the remarkable artists whose work
I attempt to pay tribute to in this text:

Andil Gosine, Syrus Marcus Ware, Elisha Lim, Amita Zamaan,
Helen Lee, Shirin Fathi, Kara Springer, Rajni Perera, Farrah Miranda,
The Mass Arrival Collective, Joshua Vettivelu, Brendan Fernandes,
Kerry Potts and Rebecca Belmore.

Thank you for your inspiring work.
Your creative courage has produced this book,
and an enduring reverence for the artistic imagi/nation.

Table of Contents

The function of art is to do more than tell it like it is—
it is to imagine what is possible.

—bell hooks

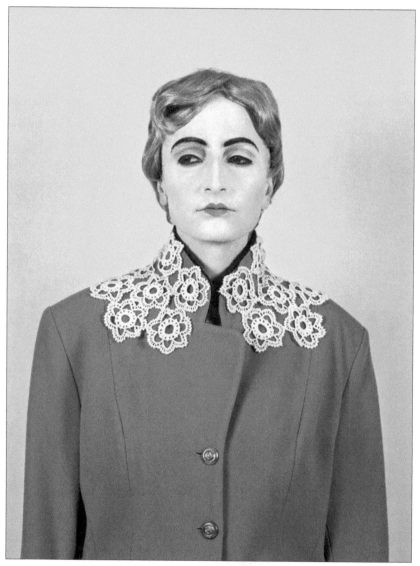

Figure 01.1: Shirin Fathi, Heart Throbs *Series.*

Artistic Imagi/nations and Opening Scenes

By Way of Introduction

BEAUTIFUL CRIMINALS: ARTISTIC DEFIANCE

THEODOR ADORNO ONCE REMARKED, "Every work of art is an uncommitted crime" (111). The idea of art as an act of defiance is deeply important in uneventful times of the political, which often inform cultures of consumer capitalism transnationally. The crimes of colonial history, racism, sexism, heterosexism, transphobia, and classism are but a few of the explicit and implicit forms of oppression that colour global capitalism and define everyday cruelties. While a "fair is fair" rhetoric of meritocracy informs systems of political governance and capitalist ideology such mythologies are haunted by history. In *Violence: Six Sideways Reflections*, Slavoj Žižek comments on the relationship between violence and language. Žižek rewrites Adorno's famous comment that after Auschwitz no poetry is possible. Rather, he suggests that after Auschwitz only poetry is possible. He asserts that violent events resist full, linear representation in language. The truth of trauma evades factual, rational narratives. It is in the language of the seemingly irrational, the poetic, and the affective that trauma is often cathartically expressed (63).

The pages of this book invite you into the worlds of artists whose resplendent visions of love and justice are beyond mere words. I attempt to offer a window into their rich and creative praxis. The imaginative prose of these visionary thinkers defies the "polite" bigotry and silently imbibed phobias of mainstream culture. While the glaring realities of skin colour, gendered embodiment, and markers of non-white, non-Christian aesthetics are often muzzled in a language of legalistic right and disembodied bureaucratic grammars of equality, these artists use

1

poetic grammar to comment on oppression and aesthetic genealogies that challenge racist and myopic understandings of the world.

Each artist and artistic work bears some reference to contemporary Turtle Island/white settler Canada in the artist's location, education, artistic praxis and reference points. These artists are at once called "Canadian" while also reflective of a generation that does not embody dominant mythologies of nationalism represented in images of whiteness, secularism, and conservative heteronormative sexual moralities. Colonizing cottage country mythologies of peaceful white settlers, grinning suburban cheerleaders glorifying sexism, "hockey night in Canada" jockishness and fair (is fair) missionary maidens in prairie bonnets are nowhere to be found in the aesthetics, sensibilities, and political defiance of the artists considered in this book. Similarly, a rhetoric of "Canadian multiculturalism" that involves a celebration of food and festivals as selling points in Canadian cities is also challenged by these artists who refuse the position of exotic Orientalist commodity or what Gayatri Chakravorty Spivak terms as the position of the "native informant" (*A Critique* 6). The native informant role is one in which racialized Others, migrants and other constructed minorities are often called upon to tell saleable narratives of exotic spectacle and violence in non-Western contexts and subaltern communities. Native informants tell titillating tales of the barbarism of "other" places and people that position white Western spectators as beyond implication and responsibility. As Usamah Ansari points out, the diasporic or migrant female from a supposedly "backward" place and particularly the Muslim, Arab, or brown diasporic subject within an ongoing global "war on terror" is often positioned as one who knows enough to speak on behalf of others in the Global South. The "native informant" is also constructed as knowing enough to act as an enlightened critic, who inevitably judges countries such as Canada to be safe havens of gendered freedoms. Against the figure of the conservative diasporic patriot, many emerging artists cultivate a political and visual imaginary that exists across national borders. This creative work is in itself a political gesture and a philosophical questioning that challenges the ahistorical silences of those Others who are at once here in North America, and invisible to nationalist imaginaries. A common thread that runs through the narratives of many of the artists considered in this book lies in their comingling of references to multiple nations,

cultures, and religious milieus. These fluctuating reference points as well as a multiplicity of grammatical and visual discourses inform the sensibilities of a transnational generation of creative workers who cannot be held in place.

Julia Kristeva argues that the figure of the foreigner is one whose strangeness allows us to question that which is unfamiliar and unsettled within psychic, social, and political constructions of the self. Kristeva considers the foreigner as one who is at once familiar as an unrecognized body within the nation state, while also estranged from dominant images of nationhood and constructions of the human. Kristeva writes, "Strangely, the foreigner lives within us: he [sic] is the hidden face of our identity, the space that wrecks our abode, the time in which understanding and affinity founder. By recognizing him within ourselves, we are spared detesting him in himself" (1). The Other within the self and the self within the Other appear visually in the work of many artists who are both situated within certain national milieus, while exiled from belonging because of their marginalized positions. Today's fearless creators use various artistic mediums to create a space of translation between racist invocations of dominant whiteness as the norm that represents Western ideals of citizenship and exotic multicultural spectacles that construct the supposedly foreign as existing in timeless places across borders. In constructing artistic images that belie antiquated ideas of nationalism, community, and culture, these artists allow one to see succinct ideas of home as foreign and fleeting. Subsequently, in the creative praxis of subaltern artists in a white settler nation, art is used to challenge the idea that aesthetics of whiteness, heteronormativity, secularism, and wealth connote an entitlement to belong on stolen land (see Spivak, "Can the Subaltern Speak?").

The "terror" on the faces of conservative white settlers who encounter Indigenous people, racialized migrants, transgender persons, and queers is perhaps in part born out of a fear of the Other in the self. As Kristeva further states, "The foreigner comes in when the consciousness of my difference arises, and he disappears when we all acknowledge ourselves as foreigners, unameable to the bonds of communities" (1). The artists whose works I consider in this book create spaces of dialogue in which spectators and audiences are forced to consider themselves as unfamiliar bodies whose presence continues

to be a strange affront to Indigenous peoples who existed long before the formation of the modern North American nation. In the works of these remarkable cultural provocateurs, art is a means of losing oneself in images in the best and most thought-provoking ways. The apparent foreignness of those whose skin does not correspond to the idealized biopolitics of citizenship is not challenged in a celebration of disaporic patriots and good immigrant families. Rather, many of these artists use provocative aesthetics and narratives to disrupt the familiar colonial metaphors of happy families that serve as a conservative microcosm for the nation. This is a new generation of artists whose boundless energies this book tries to capture and who refuse to be domesticated by quaint provincial scripts of trite apolitical love stories. These artists intrude on mythologies of happy homes with a creative fury that refuses to be held in place. The artist as "foreigner" is one who challenges those who are too sure of themselves and too settled in their ways. This generation of creative workers confronts one with the uncanny similitude between the fear of those marked as Others and the terrifying realization of one's own strangeness. Art is used as an eviscerating critique, causing viewers and audiences to question the ability to conceive of both happy homes and quaint colonies as spaces of "pre-political humanity" (Berlant and Warner 553).

ART IN UNEVENTFUL TIMES: THE POLITICS OF CREATIVITY AND THE CREATIVITY OF POLITICS

Alan Badiou sees politics as an event, one that is not predetermined by a rational plan or framed by a set of bureaucratic rules or laws. The true political event for Badiou is one that is formed in the moment, born out of a set of contingent circumstances that cannot be planned. The event of politics much like the artistic event is not often expressed in a clear language of demands or under a fixed nomenclature of a succinct movement. Politics are often espoused within contemporary Western secular capitalist cultures through a language of bureaucracy. The grammars of "identity politics" that structure discourses used in academic disciplines and non-governmental organizations construct "communities" that can be succinctly categorized. However, for Badiou the political is always an event that comes into being within a moment

beyond pre-given histories of bodies and movements. As Badiou writes, "[R]esistance, proceeding by logic, is not an opinion. Rather, it is a logical rupture with dominant and circulating opinions" (20). As Badiou further argues, "When all is said and done, all resistance is a rupture in thought, through the declaration of what the situation is ... and the foundation of a practical possibility opened up through this declaration" (20). Badiou argues that authentic political resistance is not an organized business of fully formed groups all bartering for separate claims from the state. He counters an identity politics rhetoric in which different factions of identity-based groups all demand certain forms of mainstream representation at the political level and in the language of the law. Rather, Badiou gestures to the dissolution of a class-consciousness that is concerned with universal moral questions. As he writes, "...the contemporary philosophical situation is one where, on the ruins of the doctrines of classes and class-consciousness, attempts are made from all sides to restore the primacy of morality" (20). The primacy of morality in the ruins of class conciousness is relevant to cultures of left wing politics throughout the world. Feminist and anti-racist groups comprised of those who can utilize the cultural capital of identity politics discourse engage in endless debates regarding the "right" English language terms to use, and demand to be included in mainstream media and legal categories. These bids for inclusion in the North American context often amount to wanting to participate in a hegemonic white settler ethos of North American colonialism. In this "business" of politics through cultures of social work, governmental agencies, and academic institutions, overarching moral questions regarding colonial history as well as the abhorrent crimes that curtail the movement of migrants and the treatment of exiles are made invisible.

In the works of the politically savvy artists discussed in this book, questions of morality and class-consciousness beyond state category and multicultural multinational capitalist pageantry are addressed (Žižek, "Multiculturalism"). In the public art installation *Mass Arrival*, the racist xenophobic hysteria that surrounded the arrival of the *MV Sun Sea* in British Columbia is commented upon, gesturing to how the fear that pervades Western nations is implicated in civil wars and genocides in postcolonial nations such as Sri Lanka. The *Mass Arrival* installation comments on the immorality of border security and how

questions of citizenship inform class-consciousness. The installation also comments on the hypocrisies of white settler moralities in which entitlements to belong to Canada are born out of colonial genocide, while new waves of racialized migrants seeking refuge from war are met with suspicion, hostility, and exclusion. As the artists behind this installation argue, Tamil migrants fleeing an ongoing civil war in Sri Lanka were termed diseased "smugglers," illegal immigrants, and criminals, beyond all claims to hospitality and humanity. The rhetoric of meritocracy and the North American dream was troubled in centring the bodies and lives of non-status migrants. While nations such as Canada are often famed for universal access to healthcare and for employment equity laws and policies, those without Canadian citizenship cannot access basic rights to life.

Artists Kerry Potts and Rebecca Belmore pose poignant questions regarding morality and class-consciousness. Potts's film *Love on the Streets* narrates interviews with homeless people regarding love. In this beautiful and striking short film, Potts recovers universal maxims of human love that reach beyond property. Rebecca Belmore's compelling installation *Vigil* involves a use of the techniques of performance art to offer an embodied commentary and critique regarding the thousands of "missing" and murdered Indigenous women in contemporary Canada. Again, questions regarding universal morality, the right to life, violence, and the glaring hypocrisies of Western grammars of legal equality are challenged. Canada and Canadians are often known for supposed kindness and for low rates of crime when compared to the United States. However, both Potts and Belmore offer a scathing artistic critique of the immoralities of ongoing colonial genocide, which often leave many urban Indigenous people homeless or "missing" from the nation. Indigenous women, Two Spirited, and Transgender people are particularly vulnerable to brutal forms of sexual violence and murder that are part of the ongoing rape culture of Turtle Island. Badiou's assertion that class consciousness is dissolving within contemporary politics at the same time that questions of morality are lost is also of relevance to the work of many avant-garde cultural workers and their politicized praxis.

While those attempting to access nations such as Canada without certain citizenship documents are often called "criminals," and are seen as immoral in their attempts to seek refuge, such a rhetoric removes

questions of ethics from hierarchies of power that not only determine who is forced to breach legal rules but also who is perceived to be ostensibly moral. The Tamil migrant is constructed as a smuggler, one whose supposed wrong is constructed against the "good," moral Canadian who is imagined through phantasms of white settler colonial discourse as being entitled to belong to the nation. Such a construction ignores histories of ongoing colonial genocide in which white Europeans were not invited with open arms by the Indigenous but rather became "Canadian" through violent means, including the forced seizure of Indigenous land, the spread of disease, murder, gender-based violence, and forms of missionary moralism in which Indigenous peoples were placed in residential schools and subject to horrific forms of molestation and abuse.

The language of supposed universal morality rather than espousing a class-consciousness and solidarity with the oppressed in Canada has historically been tied to Christian and Catholic colonial moralities that are deeply imbricated in ideologies of "race" and racism. The aesthetic association between "morality" and whiteness is one that exists beyond political declaration, one that exists in the skin and the psyche. A study by University of Toronto researchers, for example, found that female desirability is often determined by skin colour. Male participants in the study preferred images of white women as opposed to women of colour who were constructed as morally suspect, sexually promiscuous, and dangerous ("Study: Men Are More Attracted to Women with Lighter Skin"). If politics is a question of a return to universal conceptions of morality, consciousness regarding how aesthetics determine perceptions of morality is central to contemporary social life. Rather than espousing set political doctrines, many of the artists I have chosen to write about both politicize aesthetics and aestheticize politics beyond protest banners emblazoned with red and black fists. Rajni Perera's artistic works, for example, open up a different genealogy of art, religion, history, and, subsequently, morality. In drawing on artistic references from Sri Lankan cultural mythologies and South Asian history, coupled with sultry feminist sensibilities, Perera's paintings offer a political aesthetic that challenges sexless colonial missionary moralities. Perera's fierce visuals also provide a counter-discursive critique of the Christian- and Catholic-centred aesthetics of innocence often found in European artistic traditions in which images

7

of beauty and morality resonate with biblical imagery and European history. As Badiou further states, "No genuine political sequence is representable in the universe of numbers and statistics" (6). Beyond statistics and numbers, which celebrate Canada as a multicultural haven for immigrants, as a crime-free paradise, and as a place of supposed morality and peace, the artists discussed in *Uncommitted Crimes* offer a sincere political commentary on the untranslatable rage, indifference, and invisibility that structure the politics of literal and symbolic exclusion.

WORKING ON AND AGAINST THE MAINSTREAM: FEMINIST ART, MINIMALISM, AND AVANT-GARDE FILM THROUGH A NEW LENS

José Esteban Munoz writes of disidentification as a process through which minoritarian subjects work on and against the dominant culture in order to construct a liminal space, perhaps one that resonates with Homi Bhabha's understanding of the "third space" as one of cultural mixture and hybridity. Munoz suggests that many artists of colour, racialized feminists, and transgender and queer people of colour who are excluded from the mainstream often use the grammars of the majority to construct subcultural spaces and artistic texts that resist the logic of the dominant culture from within. Rather than wholly assimilating to the mainstream or wholly refusing to participate in cultural, social, and political life, those that disidentify with the dominant culture engage in what Pierre Bourdieu terms acts of "world making." Throughout this book, I draw on Munoz's writings regarding disidentification to address a new generation of transnational artists who all in some way embody a position that is historically, discursively, and politically constituted as marginal. Several of these artists exist in multiple margins of nationalist imaginaries, globally. Rather than assimilating to dominant ideology or rebelling against the mainstream to the point of invisibility and a refusal to engage in dialogue, Munoz writes of disidentification as a third strategy aimed at cultural production, translation, and an ingenious remaking of norms. He writes, "Disidentification is the third mode of dealing with dominant ideology, one that neither opts to assimilate within such a structure nor strictly opposes it; rather,

disidentification is a strategy that works on and against dominant ideology" (11).

Disidentification is a process through which queer people of colour work on and against dominant racist and homophobic culture. Munoz draws on the work of French theorist Michel Pecheux who writes of "good" and "bad" subjects who assimilate to or wholly refuse to participate in the dominant culture. Munoz writes,

> Disidentification is a strategy that works on and against dominant ideology. Instead of buckling under the pressure of dominant ideology (identification, assimilation) or attempting to break free of its inescapable sphere (counter identification, utopianism), this "working on and against" is a strategy that tries to transform a cultural logic from within, always laboring to enact permanent structural change while at the same time valuing the importance of the local or everyday struggles of resistance. (11)

The artwork of Shirin Fathi offers creative disidentifications with canons of photography. Fathi challenges Orientalist constructions of Iran and Iranian women by making reference to alternative genealogies of Iranian history and subculture. The artist also offers a disidentificatory commentary regarding the work of feminist artist Cindy Sherman. Fathi does not wholly refuse the canons of Western feminist art production. Rather, Fathi's work utilizes similar techniques as Sherman in constructing striking portraits of herself in different disguises that make reference to histories of radical aesthetics and gendered subversion in Iran. These rich genealogies of dissident subculture in Iran rarely appear in contemporary discourses regarding the Middle East within a time of a global "war on terror," in which the "Middle East" is essentialised and pathologised through neo-Orientalist ideology. Subversive representations of gender within Iranian and Middle Eastern history are also scarce within Eurocentric canons of feminist art.

Similarly, the films of Amita Zamaan and Helen Lee, whose works are also commented on in this book, offer a disidentification with the worlds of Canadian and North American film. While Canada is often celebrated for independent film and multicultural media

representations that are used to herald North America as an anti-racist success story, both Zamaan and Lee use the techniques of film to enter into an ongoing conversation regarding the meanings of exile and home for migrants and colonized people. The artwork of Shirin Fathi offers creative disidentifications with canons of photography. Fathi challenges Orientalist constructions of Iran and Iranian women by making reference to alternative genealogies of Iranian history and subculture. Rather than refusing to use the mediums of filmic and photographic representation, the artists I concentrate on employ the techniques of the visual to tell complicated, interesting, and fiercely political stories that unsettle the colonial foundations of contemporary Canada.

In Kara Springer's art works, the minimalist tradition, which is often celebrated as the iconoclastic greatness of a few great white men is disidentified with by this brilliant artist's subversion of the minimalist canon. Springer's *Ana & Andrea* is a deftly crafted minimalist installation that comments on Black female aesthetics, the invisible and yet startlingly white and male tradition of minimalist art in North America and Europe, and the haunting political questions concerning racialized aesthetics that continue to be marked by colonial history.

E-MOTIONS AND ARTISTIC AFFECT:
CREATIVE FEELING

We live in times of increased declarations of sentiment coupled with a paradoxical lack of feeling. Words like "love" and "hate," along with precious sentiments of elation and disgust, appear ad nauseam in advertising branding. Intense emotions are used to sell products through one-dimensional parades of billboards and the numb narcissism of (anti) social media while increasingly human connections are lost. One "loves" their friends and family through one Internet window while doing online banking through another. The exclamation mark on an event is often no longer proclaimed in the real time of the streets but in the banal clicks of computer screens (!).

In times of global economic precariousness and the dissolution of the social welfare state globally, people are often forced to compete for unstable contract labour, to brand themselves online, and to be

cautious of how they might appear within public space and cyberspace to the point that passionate outbursts and free speech are implicitly censored. Within contemporary biopolitical scripts in which those who cause disturbances through outbursts of emotion are constructed as disturbed, the place for sincere expressions of human feeling are often muzzled. Somewhere between happy faces on Internet screens and happy pills used to medicate a generation of anxious precarious workers, the space for feeling is as fleeting as an internet connection.[1]

The artistic realm may offer one of the remaining bastions of publicly articulated emotion. Affect resonates throughout the poignant installations of Andil Gosine, Syrus Marcus Ware, and Elisha Lim. Beyond colonial categorizations of bodies; these artists offer archives of feeling. Their works also offer handmade and heartfelt creations that comment on the relationship between the sacredness of art objects and human feeling. Gosine and Ware use letters to comment on political history, while Lim uses comic books, calendars, and the medium of the graphic novel to tell touching stories that move one beyond static narratives of white, heteronormative romance. Joshua Vettivelu's artwork is also a testament to the powers of emotion and affect that emerge through creative acts, through staged moments of feeling that emerge between the artist, the art object, and the spectator. Finally, the artistic work of Brendan Fernandes is one that moves the viewer beyond colonial narratives of settlement and outside of paradigms of multicultural fetishism of the ostensibly authentic. Several of Fernandes's remarkable artistic works are exemplary of the political, visual, philosophical, and affective importance that lies in the creative oeuvre of this gifted artist. Drawing on an interview with Fernandes, I argue that this artist's staging of public art in the context of a contemporary technologically driven moment is both unique and needed.

In times and places in which the artist-worker is both everywhere and nowhere, typing words, creating artistic works, self-branding through Internet mediums, the body of the transnational cultural provocateur can sometimes cross borders, if they hold the privileges required to travel. The artist who can travel carries a whole career in a laptop computer placed in airport security bins at security checkpoints, while metaphorically travelling to reach global audiences through technological tools. However, the time of e-motion can also give rise to

chilling forms of cybercrime, namely, the hatred of queers, transgender people, women, people of colour, and others who can be followed with hate speech at all times through the infinite language and imagery found in life worlds online. In what Alan Badiou terms the "worldless" spaces of global capitalism in which relationships, identities, and desires are often structured through technological means, the occupation of public space becomes an exceedingly important political and aesthetic gesture (Žižek, *Violence* 67). Fernandes's staging of queer desire in a gallery space involves the material and affective experience of artistic audiences being touched by an emotive and embodied performance. Whether it is through the transnational movement of migratory bodies, the movements of queer lovers, or the movement of spectators who feel something when bearing witness to the artistic event against the numbing lull of an internet era, Fernandes unsettles something profound in the viewer and in the world.

UNFAMILIAR FEELING
NOMADIC ETHICS, AFFECT, AND TRANSNATIONAL ART

The emotive character of transnational artistry resonates with Rosi Bradotti's writing regarding the ethics of the nomad. Braidotti's philosophy offers an important theoretical intervention within times of increased transnational migration in which bodies cross borders as much as ideas and images do through Internet wires and computer screens. Braidotti states that nomadic ethics involve a willingness and capacity to engage in affective relationships with those whom one encounters in shared spaces beyond the colonial countenance of skin and forms of familiarity in which the figure of the "stranger" is often understood through oppressive forms of biopolitics. Braidotti writes that "[b]eing an affective entity means essentially being interconnected with all that lives and thus to be engulfed in affects, emotions, and passions" (164). This form of affect does not divide emotional relations and responsibility to others based on a familiar image of an idealized biopolitical citizen as opposed to a feared "stranger." Nomadic ethics and emotional sensitivities to those that one encounters outside of categories of citizenship and skin are expressed, engaged with, and deeply felt in the artistic imaginings of the cutting-edge cultural workers I write about in this book.

All of these artists are in some way nomadic subjects, either through their physical movement across borders or through their use of artistic mediums to traverse buried genealogies of multiple temporalities and cartographies that are often not found in everyday discourses of Western secular capitalism. The capacity for an affective relation that transgresses borders is significant for a generation of artists whose creative works reach audiences globally online and through transnational artistic events. The talented, sensitive, and provocative iconic artists whose creativity I attempt to comment on in *Uncommitted Crimes* offer passions that are perhaps beyond literal translation. If the figure of the artist is often a deviant within a global capitalist context that produces banal conformities and fearful apolitical publics, then these artists are guilty of being truly criminal in their sublime creativity.

THE POSSIBILITIES OF THE IMAGI/NATION
A BADLY DRAWN MAP FOR THE READER

Chapter 1, "The Transient Aesthetic," is a love letter to Andil Gosine's installation *Khush: A Show of Love* held at the Canadian Lesbian and Gay Archives Gallery in Toronto, Canada, Syrus Marcus Ware's *Activist Love Letters*, and Elisha Lim's calendar "The Illustrated Gentleman" and graphic novel *100 Crushes*. The inspirational works of all three of these artists is nothing short of breathtaking. I ask the reader to consider the creative archives these artists offer in documenting histories, which are absent from official state archives. Narratives of love, feeling, and political passion among queer and transgender people of colour, migrants, and activists are documented through non-linear grammars of artistic expression.

Chapter 2, "A Shot in the Dark," focuses on the films of Amita Zamaan and Helen Lee. I write about Zamaan's film *Disconsolatus* and Helen Lee's film *Prey*. This chapter comments on techniques of avant-garde film production in the work of racialized feminist filmmakers who offer subtle and imaginative stories of political exile and colonization through the personal narratives of individual exile. Both these filmmakers employ interesting filmic techniques to offer a commentary regarding the loss, love, lust, and longing of racialized migrants and Indigenous peoples in North America. In the films of these provocative creative workers, narratives of personal desire cannot

be divorced from political histories. This chapter also comments on the labour that is often involved in producing short films in North America, particularly for women of colour artists who strive to make meaningful and interesting artistic works.

"Fashion Crimes," chapter 3, offers a glimpse into Shirin Fathi's photographic installations, which have been compared to the artwork of feminist art icon Cindy Sherman. In this chapter I make reference to Fathi in relation to Sherman and also in relation to the Qajar dynasty in Iran, a historical reference point and aesthetic that Fathi's portraits are connected to. Fathi's artistic works offer a critical aesthetic commentary on Orientalist history, the construction of the imagined "Eastern woman," and the global "war on terror."

Kara Springer's *Ana & Andrea* is the topic of chapter 4, "A Simple Strand?" Springer's installation is an affront to official histories of minimalist art, those in which celebrated minimalist artists are often white men whose art is not considered to be embodied or political. Springer challenges the viewer to see minimalist art, the reduction of Black female subjectivity to racialized skin and hair, and the politics of what is considered as "Black" and "feminist" art through new eyes.

Chapter 5, "And Their God's Were Blue-Eyed," considers the artistic oeuvre of Sri Lankan-Canadian painter Rajni Perera. In this chapter, I read Perera's work in relation to non-Western traditions of art and aesthetics that challenge normative representations of Christian ideology. Drawing on certain paintings such as those in Perera's *Yoginis* series, I invite the reader into this artist's clever oeuvre, one which uses artistic mediums to offer powerful visuals of embodiment that open up new worlds and words of historical, sacred, and aesthetic genealogies not contained within Western art history.

While purportedly political art is often quarantined to certain galleries and only reaches select audiences, "Smuggled Skin" (chapter 6) celebrates the *Mass Arrival* installation, staged in response to the case of the *MV Sun Sea* arriving in British Columbia. In addition to offering a meaningful and memorable response to the xenophobic hysteria that surrounded the arrival of Tamil migrants fleeing genocide, the Mass Arrival art collective, comprised of women of colour in white settler Canada, used public space as a stage for political art.

The Glory Holes, skipping stones, and *(un)washed hands* of Joshua Vettivelu are the subject of chapter 7, "Brown Skin, White Mirrors." Vettivelu offers an impressive and challenging body of work in which the artist employs multiple mediums to comment on "race," racism, desire, narcissism, and longing. I suggest that this artist's work broaches important psychoanalytic and philosophical questions that resonate with spectators both consciously and unconsciously, in compelling ways.

"Unsettled" is the title of chapter 8, which draws on an interview done with transnational artist Brendan Fernandes. Fernandes's artistic work and restless creativity is both prolific and noteworthy. This chapter comments on some of Fernandes's installations, the artist's questioning of static concepts of identity, his movement across borders, and his artistic work as an example of what Halberstam terms a "queer art of failure." In refusing to be held in place, to be contained by borders of skin, nation, and imagination, Fernandes unsettles the expectations of viewers and critics in remarkable ways.

Moving rapidly across competing histories of marginality, resistance, and a colourful cavalcade of images, I finish by returning the reader's gaze to the stolen land of Turtle Island. In chapter 9, I consider the artistic works created by two Indigenous feminist artists, Kerry Potts and Rebecca Belmore. I offer a close reading of Potts's film *Love on the Streets* and Belmore's performance art installation *Vigil.* Both of these artists and their creative praxis should be understood in the context of contemporary white settler Canada, the politics of "home," homelessness, and the obscene underbelly of colonial violence that haunts this thing called "Canada," better described as Turtle Island. There is no proper language in which to articulate the ongoing ghostly disappearances of Indigenous bodies, who are stolen from the streets, just as there is no language that can articulate the wretched traumas of colonial violence. However, the language of art offers a grammar of feeling(please remove s) that goes beyond the written word.

There is an unlikely optimism found in the works of all the artists who are included in the pages of *Uncommitted Crimes.* The optimism of dissident art is not a politically naïve feeling born out of empty platitudes, but rather a use of art to gesture to what might lie beyond the banalities and unremarked-upon cruelties we live with. As bell

hooks writes, "The function of art is to do more than tell it like it is—it is to imagine what is possible" (281).

ENDNOTES

[1]As Žižek writes, "Today, in the era of 'risk society,' the ruling ideology endeavours to sell us the very insecurity caused by the dismantling of the Welfare State as the opportunity for new freedoms. Do you have to change jobs every year, relying on short-term contracts instead of a long-term stable appointment? Why not see it as a liberation from the constraints of a fixed job, as the chance to reinvent yourself again and again, to become aware of and realize the hidden potentials of your personality? You can no longer rely on the standard health insurance and retirement plan, so that you have to opt for additional coverage for which you must pay? Why not perceive it as an additional opportunity to choose: either better life now or long-term security? And if this predicament causes you anxiety, the postmodern or 'second modernity' ideologist will immediately accuse you of being unable to assume full freedom, of the 'escape from freedom,' of the immature sticking to old stable forms.... Even better, when this is inscribed into the ideology of the subject as the psychological individual pregnant with natural abilities and tendencies, then I as it were automatically interpret all these changes as the result of my personality, not as the result of me being tossed around by market forces" ("The Prospects" 67).

WORKS CITED

Adorno, Theodor. *Minima Moralia: Reflections on a Damaged Life.* Frankfurt: Suhrkamp Verlang, 1951. Print.

Ansari, Usamah. "'Should I Go and Pull Her Burqa Off?': Feminist Compulsions, Insider Consent, and a Return to Kandahar." *Critical Studies in Media Communication* 25.1 (2008): 48-67. Print.

Badiou, Alain. Metapolitics. London: Verso, 2012. Print.

Berlant, Lauren, and Michael Warner. "Sex in Public." *Intimacy.* Spec. issue of *Critical Inquiry* 24.2 (1998): 547–566. Print.

Bhabha, Homi. *The Location of Culture.* New York: Routledge, 1994. Print.

Bourdieu, Pierre. "Social Spaces and Symbolic Power." *Sociological Theory* 7.1 (Spring 1989): 14-25. Print.

Braidotti, Rosi. *Transpositions: On Nomadic Ethics*. Cambridge: Polity Press, 2006. Print.

Emberley, Julia. *Defamiliarizing the Aboriginal: Cultural Practices and Decolonization in Canada*. Toronto: University of Toronto Press, 2008. Print.

Halberstam, Jack. *The Queer Art of Failure*. Durham: Duke University Press, 2011. Print.

hooks, bell. *Outlaw Culture: Resisting Representations*. New York: Routledge, 1994. Print.

Kristeva, Julia. *Strangers to Ourselves*. Trans. Leon S. Roudiez. New York: Columbia University Press, 2001. Print

Munoz, Jose. *Disidentifications: Queers of Colour and the Politics of Performance*. Minnesota: University of Minnesota Press, 1994. Print.

Spivak, Gayatri Chakravorty. *A Critique of Postcolonial Reason*. Boston: Presidents and Fellows of Harvard College, 1999. Print.

Spivak, Gayatri Chakravorty. "Can the Subaltern Speak?" *The Postcolonial Studies Reader*. Ed. Bill Ashcroft, Gareth Griffiths, and Helen Tiffen. London: Routledge, 1995. 24-29. Print.

"Study: Men Are More Attracted to Women with Lighter Skin." *Jezebel Magazine* 17 March 2008. Web. 27 Aug. 2015.

Žižek, Slavoj. "Multiculturalism or the Logic of Multinational Capitalism." *New Left Review* I/225 (1997): 28-51. Print.

Žižek, Slavoj. "The Prospects of Radical Politics Today." *Documenta11_platform1: Democracy Unrealized*. Ed. Antonio Negri, Lain Chambers, and Boris Groys. Berlin: Hatje Cantz Verlag, 2002. 67-85. Print.

Žižek Slavoj. *Violence: Six Sideways Reflections*. London: Picador, 2008. Print.

1.
The Transient Aesthetic

The Timeless Archives of Andil Gosine, Syrus Marcus Ware, and Elisha Lim

THROUGHOUT THIS CHAPTER I highlight the work of three inspirational queer and transgender artists and cultural workers who survive despite a racist, transphobic, and homophobic world. This chapter is informed by the writings of the late José Munoz who introduced the term "disidentification," which I discuss in the introductory chapter of this book, as a comment on the creative methods of survival used by racialized queer people. Munoz writes,

> Let me be clear about one thing: disidentification is about cultural, material, and psychic survival. It is a response to state and global power apparatuses that employ systems of racial, sexual, and national subjugation. These routinized protocols of subjugation are brutal and painful. Disidentification is about managing and negotiating historical trauma and systemic violence. I have gone to great lengths to explicate, render, and imagine complicated strategies and tactics that enact minoritarian subjectivity. (161)

The historical traumas of colonialism, slavery, and gendered violence are ones that some transgender and queer artists of colour survive, using art and avant-garde aesthetics to create a new archive of feeling and support underground subculture transnationally. Elisha Lim's illustrated calendar, "The Illustrated Gentleman," and graphic novel, *100 Crushes*, as well as other artistic projects, gesture to the possibility of artistic practice as an opening to new spaces of desire. Syrus Marcus Ware's exhibition *Activist Love Letters* offers a different set of archival practices of collecting and sharing historical memories of activists in

the City of Toronto and globally. Andil Gosine's *Khush: A Show of Love* that was held in Toronto, Canada, at the Canadian Lesbian and Gay Archives acts as another artistic example of all that might evade official collections of historical and anthropological archives. Jacques Derrida writes, "Survival in the conventional sense of the term means to continue to live, but also to live after death" (38). The artists live on, immortalized through the creative works they produce. This is especially important for minoritarian subjects whose lives are often threatened by oppressive violence.

KHUSH: A SHOW OF LOVE

Andil Gosine's artistic exhibition *Khush: A Show of Love* tells a different truth of temporality. *Khush* was staged at the Canadian Lesbian and Gay Archives (CLGA) from August to September 2011. Gosine is a professor of sociology at York University in Toronto and a multidisciplinary artist. Khush was formed in 1987 as a group comprised of queer South Asians. The group subsequently held several festivals and conferences such as Desh Pradesh, Salaam Toronto, and Discovery '93, an International South Asian Gay Men's Conference. Gosine charts the process through which the show also titled *Khush* was curated with the CLGA:

> I was approached by Robert Windrum, then executive director of the CLGA, to consider doing something with a pending contribution of materials from Khush founder Nelson Carvalho. I took it on because I saw it as an important moment to recognize Khush, and one component of queer activism in Toronto. (Gosine)

He reflects further on how the show came together:

> I called it *A Show of Love*, on the one hand to be transparent about the valorizing intent of the show. I had to do a show that was considerately appreciative of Nelson's contribution— to do otherwise would be inhumane—but also to gesture toward complication. Love isn't innocent, and *Khush* certainly wasn't. I hoped that the show would still reveal my own trouble

with identity politics and criticisms that have been made of Khush's gender and ethnic politics, even in the context of this consciously valorizing historicization of Khush. (Gosine)

Figure 1.1: Andil Gosine, Khush: A Show of Love, *2011. Installation. Photo: Andil Gosine.*

It is perhaps important to consider the transnational activist efforts of *Khush* in light of the 2013 decision by the Supreme Court of India to criminalize "unnatural" queer sex and queer people by upholding Section 377, India's colonial sodomy law. (Narrain; Atluri) Journalist Serafin LaRiviere writes about the significance of *Khush* in Toronto and its support of queer people in India:

> From 1987 to 1992, Khush was an integral force in uniting and supporting South Asian queers in Toronto. The organization provided a safe space for social interaction within the city and acted as a symbol of encouragement to South Asian gays and lesbians living outside of Canada.

LaRiviere further states:

> During its brief but important tenure, the group gave birth to the Alliance for South Asian AIDS Prevention, as well as Desh Pardesh, a cultural arts festival that showcased early works from seminal creators like *Touch of Pink* director Ian Rashid and author Michael Ondaatje.

Gosine reflects his artistic installation *Khush: A Show of Love* and its relationship to queer South Asian genealogies, through the formation of art-based archives. In the show, Gosine curates an exhibition comprised of handwritten letters that function as artistic works to be viewed by the public. He discusses the sharing of the handwritten letter and its relationship to very personal narratives of loss and longing that are definitive of sexual histories:

> Letter writers did not intend for their letters to be shared this way, of course, and I wondered about that—was it fair to share these very personal statements without the authors' permission? But since Khush had made them part of a public archive, they were already part of the public domain. What the letters provide is some possibility of alternative discourses—a recording of Khush that was not necessarily of its own making. I found this far more fascinating than what was shared in the minutes and other official documents, et cetera. I think in a general way, because of how handwritten or typed letters are created, they provide room for alternative renderings of history, ones that might push against the dominant frameworks of a community or state. (Gosine)

Gosine's installation disidentifies with the dominant homophobic public sphere and legal injunctions against queer desire in India. In the context of white settler Canada and an ethos of multinational capitalist multiculturalism, Gosine's installation also disidentifies with a desexualized model minority rhetoric that imagines South Asians as sexless labourers while constructing white aesthetics and desires as the norm (Žižek). In the deft praxis of artists such as Andil Gosine, subaltern South Asian queer and feminist communities are able to survive across borders, if only in spaces of imagi/nation in a world where the securitization of borders can determine who lives and who dies. What further survives in *Khush* is the disidentificatory work of the artist who does not deny the ongoing traumas of colonial histories, but works on and against them to produce "a show of love." When asked about whether the show resonated with a particular time period, Gosine states, "Khush was in effect trying very hard to find affirmation from a white queer community. That drive is probably as

strong today in many QPOC (queer people of colour) spaces spaces as it was 25 years ago when Khush was founded."

The object of the letter itself can be thought of spatially, as a blank page upon which one can make their mark. While entry into the art world is often a privilege of white upper-class cisgender men, the letter is a work of art that any individual who has access to a language can create. Gosine states,

> [O] ne of the reasons I turned to the letters was to bring more attention to women's experiences, since many letter writers were women—and I think the kind of letter too (intimate, personal) tends to be considered more "women's domain." But queer South Asian men were overrepresented in the Archives simply because they were also, by far, the dominant majority in Khush. And even among men, non-Indian men (e.g., Tamil men) and working-class men were given little space.

Gosine comments on the space created by the exhibition:

> I think my task was to create space for participants ... despite the historical truth that the group was organized primarily around gay cis male identities. In the sound element of the installation, I did not consider gender. Male-identified narrators read letters by cis women sometimes, et cetera. I also used just one photographic image of Khush members, which acknowledged the phallocentrism of the group, but hopefully did not serve to invisiblize women.

Lucas Cassidy Crawford cites Jay Prosser who discusses a metaphor used in narratives regarding trans identity where gender identification is constructed as a quest to be "at home in one's skin" (517). This metaphor of home and the entitlement to the body in spatial terms is perhaps reminiscent of white settler colonial ideologies of stasis as a final goal in settling lands and colonizing people. The survivalist rhetoric of "great" colonizing men from great white nations is challenged in the delicate object of the letter that is not held in place, just as the idea of national, racial, and communal belonging shifts

across time and space much like the art object of the letter. Gosine's installation also transgressed the fixity of gender through the fluidity of gendered acts of reading in live performances that accompanied the show, of love. It is perhaps in the refusal to be fully settled or held in place by both dominant nationalist mythologies and dominant white queer discourses that enable the imaginative survival of queer, racialized artists.

Khush: A Show of Love dared to deal with the ongoing struggles of those who are exiled into invisibility, turning the privatized longing of desire into a public moment of politically charged emotion. The sentimental and personal nature of the letters, displayed and read aloud in a public space, used artistic space as one of translation. This remarkable installation leaves the viewer with lasting questions regarding intimacy and spectacle, privacy and publicity, the exhibiting of emotions, and the secrecy that shrouds certain lives and certain longings. *Khush: A Show of Love*, like many of the artistic works discussed in this book, asks one to consider and question the possibility and idea of love itself.

ACTIVIST LOVE LETTERS

Syrus Marcus Ware, a Black transgender activist and artist in Toronto, also stages artistic and disidentificatory modes of survival that reimagine love and remap history. Ware's *Activist Love Letters* was staged at the Feminist Art Gallery (FAG) in Toronto in 2012, the Gladstone Hotel in Toronto in 2013, and as part of a larger installation of all of the letters with a corresponding performance at the University of Lethbridge Art Gallery in Lethbridge, Alberta, in 2014. Ware describes what inspired the show:

> I was and am inspired by my own activism and by the many organizers that I have had the privilege to work with and learn from. But I am also fascinated by the decision to become/get involved in activism, and this drove my curiosity. As a young child, my dad told us a story from his high school years during the lead up to Freedom Summer. My dad was approached by organizers of some sit-ins at the local Walgreens counters in Memphis and across the state border in Mississippi. They

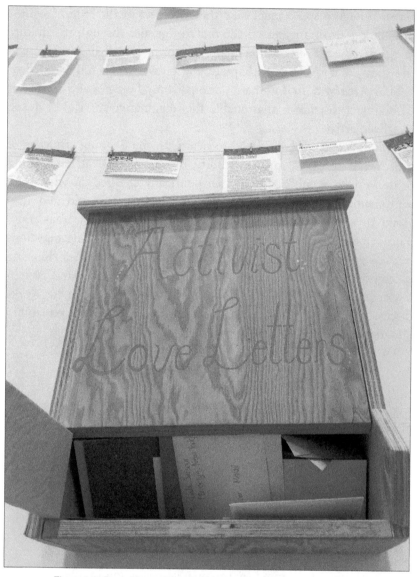

Figure 1.2: Syrus Marcus Ware, Activist Love Letters," 2012. Installation.
Photo: Syrus Marcus Ware.

were organizing a bunch of kids to go and sit down at the segregated lunch counter and quietly eat their lunch. No matter what happened to them, they were to stay seated, until being dragged off the seats by force by the police or [by] restaurant patrons. (Ware)

Ware further recounts his own father's struggles during the Civil Rights period in Mississippi:

> My dad chose not to go. His exact wording in the story was, "I told them, 'I can eat my lunch anywhere.'" I respect his choice to not go. It was a terrifying time, and the stakes were incredibly high. Those lunch counter sit-ins got very violent, and while some establishments like Woolworths ended up integrating, Walgreens closed down their lunch counters all together. I have always remembered this story, perhaps because I would like to think that I would have gone to the sit-in. It is a narrative that plays out in my head. But would I have gone, if in the same (high-risk) situation?

The violence that is definitive of the lives of racialized people produces lingering traumas that survive on and in the skin. It is striking that Ware is a transgender artist of colour as the embodied nature of racism is always gendered, making the lives of transgender people of colour deeply precarious and riddled with violence. Transgender people are subject to routine forms of murderous disciplinary power. Cassidy discusses Brandon Teena, a transgender person who was a victim of transphobic violence, who did not survive the normative levels of violence enacted against minoritarian bodies. Because of the gender segregation of the prison industrial complex, Teena was placed in a woman's prison. Rumours circulated in the small town in which Teena lived that Teena was female bodied. Two transphobic murderers then sexually assaulted Teena and were not were not charged for this act of sickening heteronormative cis gender male violence. Days later, they murdered Teena. Cassidy writes that

> the cellblocks' "authority," to inscribe "woman" upon Brandon relies on the subtle gendered norms of buildings that are consolidated through thousands of years' worth of architectural tradition and memory. (518)

Ware discusses writing letters to CeCe McDonald, a transwoman of colour, whose case made history when CeCe and their friends were attacked by a racist and transphobic hate criminal. CeCe was

subsequently wrongly imprisoned for defending their right to bodily integrity, with the case being demonstrative of the white supremacist, transphobic nature of state power. CeCe's subsequent imprisonment in a male correction facility also spoke to the sickeningly violent ways power is spatlialized. Ware states:

> Through the performance, I have written to CeCe McDonald, to the parents of Trayvon Martin, to my sisters, to my partner—people who are known and unknown—all doing big A and little a activism in their daily lives. If I were going to write one right now, I would likely write to my gender-independent six-year-old niece, just an envelope full of love and hope and possibility....

Those who survive to disidentify with the transphobic public sphere offer new hope and new inspiration for generations to come. And yet, those who do not survive, such as Brandon Teena and many others, still remain with us in ways that haunt the artistic and activist oeuvre. Historical trauma becomes a means of building new modes of disidentificatory subcultures. There is a haunting effect on white settler space that informs the everyday realities of embodying places that carry brutal histories of racist violence. Gordan states that

> ...haunting is an emergent state: the ghost arises, carrying the signs and portents of a repression in the past or the present that's no longer working. The ghost demands your attention. The present wavers. Something will happen. What will happen, of course, is not given in advance, but something must be done. (3)

While many oppressed people do not survive, their presence haunts city and national spaces, informing the praxis of feminist and queer activists and artists. Ware expresses the possibility of remapping space politically, creating new subaltern histories with the exhibition *Activist Love Letters*. Much like Andil Gosine's *Khush: A Show of Love*, the letters allow people the time and space to produce affective narratives that now live in a rare archive of political sentiment. Ware comments on how the installation came to fruition and on charting the historical

Figure 1.2: Syrus Marcus Ware, Activist Love Letters," 2012. Installation.
Photo: Syrus Marcus Ware.

memory of avante-garde queer art and activism in Toronto:

> In 2012, I was invited to host a film screening at the Feminist
> Art Gallery as part of a larger project entitled "All Hands on
> the Archives/An Audience of Enablers Cannot Fail." The
> project aimed to animate the Cinenova collection, a UK-
> based film and video archive featuring a large assortment of
> films by women and trans filmmakers. "All Hands on the
> Archives" was an initiative of the Feminist Art Gallery, the
> Power Plant, and the Art Gallery of York University, in
> conjunction with the retrospective exhibition *Will Munro:
> History, Glamour, Magic.*

Artist Will Munro created countless imaginative spaces of sexual
revelry in Toronto. Munro was a queer artist, DJ, entrepreneur, owner

of a queer café, and impassioned activist whose fierce creativity is remembered by many. Munro also remains in the haunting archive of loss and hope that defines these shows of love. Munro died of brain cancer in 2010, and his memory is a lasting remnant of the creative possibilities of a city and all those who live in it, defiantly. Ware further states,

> I screened two films [Parmar's *A Place of Rage* and Aguila's *Within These Cages*] that spoke of activism, hope, rage, and social change. Following the films I read aloud from activist-penned letters, specifically, (a) a letter that author James Baldwin sent to Angela Davis [in 1970] while she was in prison; (b) a letter that Leonard Peltier wrote from within prison [in 2007] to Mumia Abu-Jamal, also in prison, encouraging him to stay strong, to keep fighting; and (c) a letter that Toronto activist Tooker Gomberg wrote [in 2002] to all community mobilizers encouraging each of us to take care of each other and ourselves. I then invited the audience to write their own letters to someone active in our communities, as a kind of "activist love letter." (Ware)

Ware's installation opens up genealogies of radical dissent, while at the same time extending an invitation to the viewer to become part of new conceptions of history. Contemporary art practice offers an aesthetic imaginary through which one can dream of different conceptions of time and space. It is through artistic survival that one carves out spaces beyond heteronormative capitalist fictions that define who is thought to constitute a worthy object and subject of historical inquiry and whose aesthetics come to represent "civilization" itself.

The stasis of space and provincial colonial gender ideals in which bodies are "at home" in the skin to the extent that they can mimic heteronormative patriarchal scripts are what artists Gosine and Ware have created. The exhibitions of these creative visionaries chart the transience of artistic space in which art can and does happen everywhere. Similarly, the happenstance meeting of bodies through activist and artistic space gestures to relationships that exist outside of metaphors of succinct "communities," often divided

based on skin. The construction of racialized "communities" within dominant discourses of Canadian multiculturalism often fetishize heteronormative familial models, while dominant images of queer "communities" are white. Within Ware's installation, "home" is found in the inspirational narratives and histories of queer people of colour. As Ware states:

> I choose to create bios about mostly activists of colour—BI POC, queer, and trans people—folks working on sex-worker activism, trans rights, disability activism, HIV/AIDSs, indigenous sovereignty. In this way, I ended up shaping some of the "who"—who people wrote to—but also the "what"—some of the things that people wrote about. Some of the

Figure 1.5: Syrus Marcus Ware, Activist Love Letters," 2012. Installation. Photo: Syrus Marcus Ware.

beauty of the performance is that people have also written to people close to them—strangers, often to me—and I ended up developing a relationship through the process with new communities and other activists.

"THE ILLUSTRATED GENTLEMAN"

The artistic praxis of Elisha Lim documents the changing, emotive, sensual, and fun lives of queer, racialized, feminist, activist, and artistic communities. Lim's work, like that of Gosine and Ware, not only disidentifies with dominant ideals of whiteness and heteronormativity but also creates a lasting archive of queer and transgender subculture globally. Lim's art never bores the viewer or reader. Rather than tarry in tired colonial metaphors of settlement, Lim's work implicitly suggests that one is never truly "at home in their skin." Their wonderful art opens up the possibility of infinite change (see Cassidy). To survive, the minoritarian bodies that appear in Lim's artistic novels must constantly transform themselves, living across borders and dawning new names and new forms of embodiment. Lim's artistic work archives the power of creative transcendence from oppressive, heteronormative gender binaries. Lim's work and life triumphs the dignity of transgender and gender-queer lives:

> Elisha Lim takes great pleasure in creatively portraying the beauty, dignity, and power of being neither straight, nor white, nor cis-gendered. They also successfully advocated for Canadian gay media to adopt the gender neutral pronoun "they." (Artist's Statement)

Lim's graphic novels and their blog, "New Art Every Day," offer tremendous sources of inspiration, which a life of restless creativity can produce. Lim's artistic oeuvre includes "the *Bitch Magazine* acclaimed 'Sissy Calendar,'" "The Illustrated Gentleman," and most notably, *100 Butches*, a graphic novel of portraits and anecdotes about masculine queers, with an introduction by *New York Times* bestselling author Alison Bechdel (Lim, "Art and Storytelling").

100 Crushes is another of Elisha Lim's notable works. The book comprises five years of Lim's comics and graphic novel narratives. The

text offers illustrated stories regarding the desires, wanderings, and daily political and personal struggles of queer bodies often marked and read as "male" but that defy stable categorizations of race, gender, and sexuality. As Lim's blog reads,

> They have exhibited art and videos internationally, proudly including the debut solo of Toronto's notorious Feminist Art Gallery. They have been awarded grants by the Canada Arts Council, Ontario Arts Council and Quebec Arts Council, and have juried art grants in Canada and the States. They have lectured on race representation and gender neutral pronouns on panels, artist talks and United Nations conferences since 2009, and directed Montréal's first Racialized Pride Week in 2012, for which they curated the central exhibit "2-Qtpoc" at the gallery *articule*. Their current film circuit short *100 Butches #9: Ruby* was controversially censored in Singapore and debuted this year at the London BFI.

Interestingly, articles and links to *Butches #9: Ruby* are now used as part of teaching materials to educate Asian students about censorship, art, and sexuality. The lesson plan and larger digital archive were created by Tania De Rozario, an educator, artist, and digital archivist based in Singapore, and Zarina Muhammad, also an educator, curator, and digital archivist of activist art.

De Rozario, who curated the Singapore-based show, writes about a controversy that emerged regarding Lim's artistic work. The artist's short film depicting queer desire was banned, offering evidence of how censorship can mar the creative vision of dissident and provocative artists. Lim's clay animation film *Butches #9: Ruby* that recalls a teenage crush was banned in Singapore, owing to deeply conservative heteronormative ideologies that produce disturbing acts of censorship. De Rozario states,

> The 52-second animation contains no sex, no violence, no nudity, no foul language, no drug references and no elements of horror. In a New York film festival [MIX NYC: New York Queer Experimental Film/Video Festival], the artist submitted it under the children's category. (qtd. in Tan)

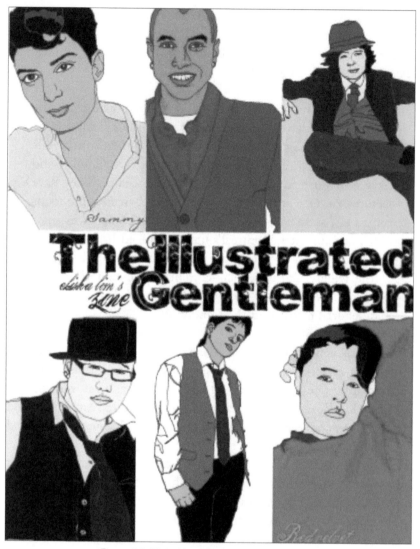

Figure 1.6: Elisha Lim, "The Illustrated Gentleman."

The reason behind the decision to ban Lim's film lay in the understanding of "homosexual acts" as criminal, seen as comparable to anti-state "terrorism" in Singapore. Jasbir Puar argues that within a global "war on terror" white, secular American queers are increasingly celebrated for supporting national branding, while Muslims and migrants become queer to the nation. In contemporary Singapore and throughout many parts of Asia, queer people continue to be

constructed as holy terrors, with non-reproductive sex and desire being seen to threaten nation-building and nationalist discourse. De Rozario states that, "while applying for the film to be classified, the form contained a section titled 'Declaration of Content Concerns,' which included the categories: sex, violence, language, nudity, drug use and themes. And under 'themes,' homosexuality is grouped together with child abuse and terrorism" (qtd. in Tan). In regards to the ban, Lim said: "I had no idea what a dangerous and repressive environment Singapore was. Of course I'm totally dismayed, disappointed, frustrated" (qtd. in Tan).

While the banning of art and activism is a threat to racialized queer subcultures, there are often archives of defiance such as the work of political artists like Lim, which survive as examples of creative courage and conviction. One can also consider efforts to ban the group Queers Against Israeli Apartheid from the Toronto Pride Parade. The massive "pink washing" done by the State of Israel and efforts to align global political power with lucrative productions of desire that brand a nation as temporally "liberated" and "at home" in a world of limitless wealth and war, demonstrates the relationship between queer politics and imagined "terror" (Houston). The alignment of homonormative gay subjects with state power is perhaps endemic of the biopolitical association of bodies with the "life of the nation" to the extent that they approximate colonial settler norms. As Puar astutely demonstrates, those who are truly queer to the nation often defy the logics of colonial occupation, both in white colonial settler states and in apartheid states such as Israel. As the global "war on terror" continues, and modes of homophobia, transphobia, and racism continue to produce violence in the lives of racialized queers globally, Lim's work is a testament to the survival of artists of colour who never fail to inspire in their refusal to cower under the pressure of state repression.

Lim's work is an act of queer defiance in its documentation of the unsettled and transient beauty of queer, racialized lives against the biopolitical reproductive anxieties of settler states. For example, "The Illustrated Gentleman" is a calendar that features beautiful and tender portraits of gender-queer butches who embody a constantly shifting and transient aesthetic. Lim's illustrated work makes reference to queer and transgender fashion and uses of clothing by racialized

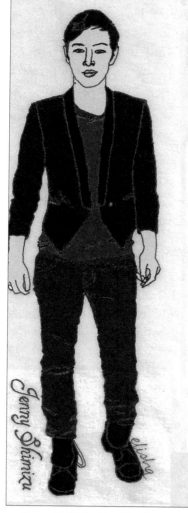

The Illustrated Gentleman

On Dress and Deportment, from "Idle Thoughts of an Idle Fellow," 1886 by Jerome K. Jerome.

Very young men think a good deal about clothes, but they don't talk about them to each other. They would not find much encouragement. A fop is not a favorite with his own sex. Indeed, he gets a good deal more abuse from them than is necessary. His is a harmless failing and it soon wears out. Besides, a man who has no foppery at twenty will be a slatternly, dirty-collar, unbrushed-coat man at forty. A little foppishness in a young man is good; it is human. I like to see a young cock ruffle his feathers, stretch his neck, and crow as if the whole world belonged to him. I don't like a modest, retiring man. Nobody does — not really, however much they may prate about modest worth and other things they do not understand.

Figure 1.7: Elisha Lim, "The Illustrated Gentleman: Jenny," 2009, Ink on paper, 5.5 x 8.5.

and queer people to signify the transience of identity and desire. Lim's work offers insight into the deep psychosocial connection between the exterior and the interior. Well-dressed gender queer butches of colour with radical politics, who work as activists, artists, community organizers, stylists, and everything in between are a

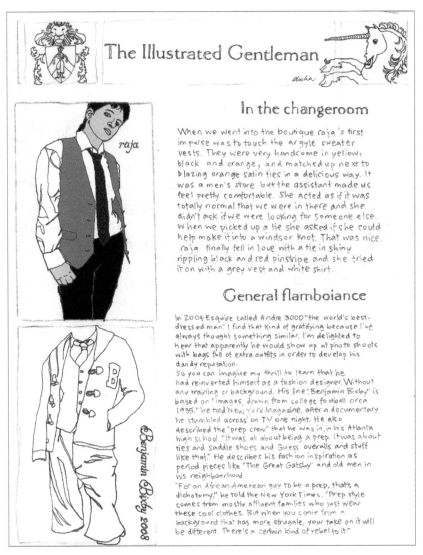

The Illustrated Gentleman

aloha

raja

©Benjamin Bixby 2008

In the changeroom

When we went into the boutique raja's first impulse was to touch the argyle sweater vests. They were very handsome in yellow, black and orange, and matched up next to blazing orange satin ties in a delicious way. It was a men's store but the assistant made us feel pretty comfortable. She acted as if it was totally normal that we were in there and she didn't ask if we were looking for someone else. When we picked up a tie she asked if she could help make it into a windsor knot. That was nice. raja finally fell in love with a tie in shiny rippling black and red pinstripe and she tried it on with a grey vest and white shirt.

General flamboiance

In 2004 Esquire called Andre 3000 "the world's best-dressed man." I find that kind of gratifying because I've always thought something similar. I'm delighted to hear that apparently he would show up at photo shoots with bags full of extra outfits in order to develop his dandy reputation.
So you can imagine my thrill to learn that he had reinvented himself as a fashion designer. Without any training or background. His line "Benjamin Bixby" is based on "images drawn from college football circa 1935," he told New York Magazine, after a documentary he stumbled across on TV one night. He also described the "prep crew" that he was in, in his Atlanta high school. "It was all about being a prep. It was about ties and saddle shoes and Guess overalls and stuff like that." He describes his fashion inspiration as period pieces like "The Great Gatsby" and old men in his neighbourhood.
"For an African-American guy to be a prep, that's a dichotomy," he told the New York Times. "Prep style comes from mostly affluent families who just wear these cool clothes. But when you come from a background that has more struggle, your take on it will be different. There's a certain kind of rebel to it."

Figure 1.8: Elisha Lim, "The Illustrated Gentleman: Raja," 2009, Ink on paper, 5.5 x 8.5.

far and fashionable strut away from the traumas of global capital, apartheid, and war often used to sell images of the (homo) normative white "body beautiful." Lim's artistic activism and those who are featured in the artist's graphic novels and calendars are as fierce as their fashion sense. Lim interviewed Michele for "The Illustrated Gentleman" and describes how Michele discusses their relationship with embodiment, fashion, and affect:

Michele tells me that it's been a really long time since they felt uncomfortable shopping in the men's section. Other people's reactions used to bother them when they were in mainstream spaces, Michele said, so they would make slight concessions to try to avoid the drama.

There is a conjoined bravery in the ways those whom Lim documents and honours in this text refashion mainstream gendered expectations through dress and subsequently refashion consumerist spaces. As Lim further writes of Michele, "Now they really don't care. They say they're much more comfortable in her body than they used to be, which has really changed the way that they shop" ("The Illustrated Gentlemen"). This may seem to be a small and inconsequential detail within the life narratives of transgender, feminist, gender queer, racialized, and diasporic people, but it expresses how changes in embodiment bring about changes in public spaces.

Transgender narratives of embodied resistance challenge the idea that anyone can ever be "at home in the skin," as we all shed skin, constantly transform our aesthetics, and unsettle one another in profound ways.

SURVIVAL: ONCE MORE, WITH FEELING

Andil Gosine, Syrus Marcus Ware, and Elisha Lim offer worlds of emotion that cannot be fully translated into mere words. Gosine's *Khush: A Show of Love* is a deeply affective exhibition that reflects the different temporalities and life worlds that many letter writers inhabit. The letters were not about official governmental policies or laws such as those old colonial sodomy laws upheld by the Supreme Court of India in 2013, criminalizing queer people. Instead, the letters in *Khush* expressed sensuous desires that are rarely found in colonial documents. Gosine states,

I was drawn to the letters for many reasons. The first is just that many of them were tenderly written, and exposed authors as vulnerable, human. That was more difficult to find in the other archived materials from Khush, which were recordings of various stagings, for different reasons.

The artist's acute sensitivity in staging this exhibition demonstrates the ability of emotions to survive across borders of nation and skin:

> I think Toronto, especially the arts community, is deeply mired in essentialist identity politics. The *Khush* show easily fits into this dominant paradigm that demands representational work from nonwhite artists. You are not permitted the space afforded to white artists to tell and explore the complexity of a personal story, instead there is pressure to tell individual experiences through a representational "community" voice. I wanted to explore my own feelings of alienation in Toronto, so I have to do it through a "community" project like *Khush*. I can't be valuable enough as myself, certainly not the way a white artist's personal story is valued. (Gosine)

Similarly, against the damning statistical and legal truth of ongoing systemic oppression and alienation, Ware discusses the tenacity of inspiration found in *Activist Love Letters*. Ware comments on how the opening up of art worlds to activists changes the affective dimensions of artistic space:

> The project has been wonderfully received—I have adapted it for each community that I do it in—having short bios about local organizers from that location for people to write to. Before mailing the letters, I include a little blurb about the project in the envelope and invite people to reply. The replies have inspired me to keep the project going. The majority of people who reply are stunned to have received a letter reaching out, sharing a story, or thanking them for their work.

Ware also comments on how the object of the letter carries an emotive and affective resonance that passes between bodies across borders of skin and name:

> It is significant to receive an outpouring of love from a complete stranger. People who have written letters during the performances have also told me that the process has made

them consider their own movement building/activism. *Activist Love Letters* is about connecting us all.

The making of an artistic community that produces transient spaces and objects of art challenges the will to fix people in airtight coffins of categorical closure, immortalizing acts of resistance and political sentiment. Similarly, Elisha Lim's calendar "The Illustrated Gentlemen" and most recent book *100 Crushes* also archives the changing feelings of many people, racialized and transgendered, gender queer and indifferent to and belying categorization. Writing in regards to Lim's work, Rob Kirby states,

> Toronto artist Elisha Lim exists in a special niche of the alt-comics realm. Lim's subjects are cultural outsiders and gender transgressors: masculine women (butches), and feminine men—some of them non cis-gendered and none of them Caucasian—whose very existence challenges the hetero-, racial-, gender-normative status quo.

The "alt comics" genre also belies easy categorization, particularly at a time in which political graphic novels such as Joe Sacco's *Palestine* offer an archive of the myriad of emotions that surround long-standing political conflicts. Kirby writes,

> In *100 Crushes*, a uniquely engaging book, Lim features and, more importantly, celebrates subjects generally invisible to the wider community and often left out of or downplayed in the queer community. And that certainly applies to the alt-comics community as well (yeah, don't get me started*). But times are slowly if steadily changing. Welcome to the future.

In the seemingly simple form of a comic, Lim's work is an archive that challenges the often-rigid categories of "butch" and "femme" and the well-pronounced categories of "race."

Kirby writes that Lim's ability to creatively archive queer history in Toronto with comics could be used to reflect on the humorous disidentification with mainstream North American popular culture icons:

100 Crushes is neatly divided into six sections: "100 Butches," a series of single-page, randomly numbered line-drawing portraits of butch women with accompanying biographical text; "Sweetest Taboo, Memoirs of a Queer Child in the Eighties," a single panel strip that ran for a couple of years in a Canadian gay newspaper, featuring different takes on such cultural icons as Corey Feldman, Inspector Gadget, and the great Pee-wee Herman.

The messy truths of embodiment and affective worlds of desire and skin are not reflected in the bureaucratic grammars of graphs, charts, or legal documents but in the sensitivity of the artist or writer's pen. As Kirby further writes,

> "The Illustrated Gentleman," pages from a butch fashion zine Lim once created for they and their friends ("our own illustrated book of subversive sartorial splendour"); "Sissy," the mirror opposite of "100 Butches," paying tribute to "the sissies and femmes that inspire us;" the autobiographical "The Sacred Heart" and "America" (more on this section below); "They," which details a queer collective experiment with the titular pronoun; and the deeply personal autobiography of "Jealousy."

Lim's work delves into the complex emotive worlds that define sexual politics. Emotion survives as does the sensitivity and empathy of the artist. It is the truth of these incalculable emotions, much like non-linear sketches from an artist's hand, which radically defy the logic of official history and tell of an artistic future, to come.

Claire Hemmings emphasizes the importance of affect theory, highlighting the importance of emotions that inform the relationship between self and world: "Affect broadly refers to states of being rather than to their manifestation or interpretation as emotions. Within discourses of psychoanalysis affects are the qualitative expression of our drives, energy and, variations. Affects are what enable drives to be satisfied and what ties us to the world" (551). Hemmings makes reference to how affect attaches itself to objects, rather than remaining bound in a stable archive of colonial knowledge. The author further

writes, "Unlike drives, affect can be transferred to a range of objects in order to be satisfied (love may have many objects for example,) which makes them adaptable in a way that drives are not" (551). Hemmings draws on the writing of influential psychologist Silvan Tomkins, who suggests that affects "have a singularity that creates its own circuitry" (551).

Making further reference to Tomkins writings, Hemmings states that affect may be

> autotelic (love may be its own reward), or insatiable (where jealousy or desire for revenge may last minutes or a lifetime).... Tomkins asks us to think of the contagious nature of a yawn, smile, or blush. It is transferred to others and doubles back, increasing its original intensity. (552)

Ware's inspiring installation, Gosine's touching exhibition, and Lim's sensuous sketches are beyond categorization. Objects of emotion are passed between artist and spectator. The tenderness, outrage, and lust written of in Ware's and Gosine's exhibited letters and in Lim's narratives and sketches bravely contaminate all those who are left with images and memories of artistic archives of fleeting loves and losses.

And yet Hemmings also makes clear that emotions are not politically innocent, particularly when they attach themselves to the oppressed. Drawing on the work of Frantz Fanon, Hemmings writes:

> ...following Frantz Fanon's insistence that social relations at both the macro and the micro level are based on unreasonable ties, critical race theorists argue that affect plays a role in both cementing sexed and raced relations of domination, and in providing the local investments necessary to counter those relations. (550)

Similarly, Judith Halberstam discusses how the transgender body often appears in artistic archives as a "tragic" figure. Writing about the 1992 movie *The Crying Game*, Halberstam discusses the tragedy that attaches itself to Dil, the transgender character in the film, and describes how crying,

…"the process of shedding tears (usually accompanied by sobs or other inarticulate sounds)"—speaks to the potential for tragedy in and around the transgender figure. The tragic transgender character weeps because happiness and satisfaction, according to transphobic narratives, are always just out of reach. (82)

Queer and transgender history is not fixed. Much like the transitory object and transgressive body, it moves just as feelings do. For example, Halberstam suggests, "the Brandon Teena archive," can also be read as an expanding archive of solidarity: "Ultimately, the Brandon archive is not simply the true story of a young queer misfit in rural North America. It is also a necessarily incomplete and ever expanding record of how we select our heroes as well as how we commemorate our dead" (25).

Dominant narratives that survive to immortalize great colonial battles through official histories often tell one who their heroes should be. One can ask how an affective archive born out of chance encounters with those that Lim sketches, and through the letters exhibited in the creative praxis of Ware and Gosine, speak to how our heroes can and sometimes do choose us. Gosine states:

Archives give you historical materials to investigate tensions, sensibilities, and questions. The thing is, artists and academics are productive in very different ways. The latter appear to only operate in the conscious—of course their subconscious is also in operation, but most academic methods demand and are led by conscious thought. Artists are generally much better at recognizing the value of allowing and inviting the subconscious to guide creation.

One can consider that many of the letters that Gosine received were written on delicate blue paper that travelled from India, across borders to Canada, and were translated from the cursive scriptures of Indian languages, to English. In the wake of the decision to criminalize queer desire in the Indian subcontinent using Section 377 of the Indian Penal Code, India's colonial sodomy law, perhaps informed by the violence of colonial haunting, puritanical patriarchal

ideology, and Hindu fundamentalism, Gosine's artistic work expressed the flow of emotion crossing borders. Human beings it is said, are made mostly of water. Like water, desire is transitory and transgresses expectations of stasis, surviving against succinct borders of time and place: "…when making *Khush*, it was a lot of just feeling—I thought it should be a very empty room and letters would be cool … the letters are mostly on blue paper, they kind of look like the sea" (Gosine).

WORKS CITED

A Place of Rage. Dir. Prathiba Parmar. Women Make Movies. 1991. Film.

Atluri, Tara. *Azadi: Sexual Politics and Postcolonial Worlds.* Toronto: Demeter Press, 2016. Print.

Baldwin, James. "An Open Letter to My Sister, Miss Angela Davis, 19 November 1970." *The New York Review of Books* 7 January 1971. Web. 20 May 2014.

Crawford, Lucas Cassidy. "Breaking Ground on a Theory of Transgender Architecture." *Seattle Journal for Social Justice* 8.2 (2010): 5. Print.

Derrida, Jacques. "I Am at War with Myself." Interview in *Le Monde,* 19 Aug. 2004. Web. 28 Feb. 2015.

Gomberg, Tooker. "Letter to an Activist, Earth Day, 2002." Web. May 2014.

Gordan, Avery. *Ghostly Matters: Haunting and the Sociological Imagination.* Minnesota: University of Minnesota Press, 2008. Print.

Gosine, Andil. Personal interview. 22 Oct. 2014.

Gupta, Alok, and Arvind Narrain, eds. *Law Like Love: Queer Perspectives on Law.* New Delhi: Yoda Press, 2011. Print.

Halberstam, Judith. *In a Queer Time and Place: Transgender Bodies, Subcultural Lives.* New York: New York University Press, 2005. Print.

Hemmings, Clare. "Invoking Affect: Cultural Theory and the Ontological Turn." *Cultural Studies* 19.5 (2005): 548-67. Print.

Houston, Andrea. "WorldPride Organizers Concerned about 'Pinkwashing.'" *Xtra Magazine* 27 June 2013. Web. 14 Oct. 2014.

Kirby, Rob. "Rob Kirby Reviews *100 Crushes* by Elisha Lim." *PanelPatter.com.* 8 May 2014. Web. 14 Oct. 2014.

LaRiveriere, Serafin. "*Khush: A Show of Love.*" *Xtra* 27 Jul. 2011. Web. Accessed: 22 Sept. 2017

Lim, Elisha. "Elisha Lim: Art and Storytelling." *Elisha.com*. Web. 14 Oct. 2014.

Lim, Elisha. "The Illustrated Gentlemen." *Nomorepotlucks.org*. 2011. Web. 14 Oct. 2014.

Lim, Elisha. "*New Art Every Day.*" Web. 14 Oct. 2014.

Lim, Elisha. Personal interview. 23 Oct. 2014.

Munoz, Jose. *Disidentifications: Queers of Colour and the Politics of Performance*. Minnesota: University of Minnesota Press, 1999. Print.

Narrain, Siddarth. "(En)Gendering a Rights Revolution." *Kafila* 16 April 2014. Web. 14 Oct. 2014.

Peltier, Leonard. "Leonard Peltier's Letter to Mumia Abu-Jamal." *Workers World: Workers and Oppressed People of the World Unite*, 23 May 2007. Web. 20 May 2014.

Puar, Jasbir. *Terrorist Assemblages: Homonationalism in Queer Times*. Durham: Duke University Press, 2007. Print.

Sacco, Joe. *Palestine*. Illus. Edward W. Said. Seattle: Fantagraphics, 2001. Print.

Tan, Syliva. "Rated NC-16, Short Film Dropped from LGBT-Themed Art Exhibition in Singapore." 16 Aug. 2012. Web. 14 Oct. 2014.

Ware, Syrus Marcus. Personal interview. 24 Oct. 2014.

Within These Cages. Dir. Melanya Liwanag Aguila. V-Tape. 2002. Film.

2.
A Shot in the Dark

Amita Zamaan and Helen Lee's Explosive Filmmaking

T O LABOUR INVOLVES NOT ONLY everyday performative productions of gendered bodies, and the reproductive labour of giving birth, but also entails the work of birthing nations and reproducing national narratives. Conversely, the labour of creative inspiration functions in what Jack Halberstam terms "queer time and space" (Halberstam 1), which I suggest is born out of a restless and transient desire and belies nationalist tropes. In this chapter, I discuss the do-it-yourself approach of racialized, queer/feminist filmmakers. The chapter focuses on the 2012 film *Disconsalatus*, made by South Asian Canadian filmmaker Amita Zamaan and the 1995 film *Prey*, made by Korean-Canadian filmmaker Helen Lee. These two short films are discussed in this chapter because they are representative of racialized women's labour in film production. Drawing on the previous discussions regarding Gosine, Ware, and Lim's artistic interventions, I argue that the creative praxis of these visionary thinkers involves disidentification from dominant heteronormative, white colonial narratives of belonging. The artistic techniques used by Zamaan and Lee produce discourses in which racialized, diasporic, queer/feminist bodies can find a "home" within the poetics created by the alienation of their bodies and desires on a white settler landscape.

I begin by offering a synopsis of the films and locating them in relation to Canadian and North American film history and production. *Disconsalatus* follows the story of Dana, a female Palestinian exile who is displaced in the City of Toronto. Dana's geographical, cultural, and political exile is tied to her psychic alienation. Dana comes to learn of an outbreak of a disease called "disconsolatus" in the city, which requires mandatory evacuations, medication, and quarantine for those

Figure 2.1: Amita Zamaan. Disconsolatus. 2015. Film. 22mins.
Photo: Petr Salaba.

who are infected with the mysterious illness. The disease produces symptoms, which mirror Dana's depressive state as a woman who is haunted by apartheid and loss. The film blurs the lines between fiction and reality through the point of view of this character whose mind is never at rest. Dana's dream world and daily reality in a city riddled with disease are blurred. The film represents an erasure of boundaries between succinct borders of reality and fiction, sickness and health, sanity and insanity. The waking dream state of the main character creates a film that is rich in poetics and one in which the lament of political exile cannot be divorced from mental and psychic trauma. The cast of the film includes Nilofar Dadikhuda as Dana; Tabitha Tao as Jenny; Glenn Reid as George; Matt Yantha as Siguror; Marcus Haccius as Le-ill D; Stacey Iseman as Paculla; Aeiron Munro as Antin; Aulfiqar Lena-Stewart as the young boy; Schlomo Benzion as Dr. Cerletti; Kyle Haccius as the White Coat; April Lee as the infected woman; and Damien Williams as the infected man.

Disconsolatus resonates with the films of Atom Egoyan, as Egoyan's films also address issues of exile and trauma, depicting psychic alienation and familial violence as a microcosm for larger forms of political crises that migrants carry with them across borders. The authors in the anthology *Image and Territory: Essays on Atom Egoyan* discuss Egoyan's use of the poetics of film to address the silencing of histories of the Armenian genocide and other traumas, which many of the characters in Egoyan's films live with. In "Telling a Horror Story Conscientiously: Representing the Armenian Genocide from Open

House to Ararat," Lisa Siraganian writes,

> Atom Egoyan's *Ararat* (2002) is the first widely released
> cinematic representation of the Armenian genocide. However,
> the film seeks not simply to document the genocide, but
> to reveal how a ninety-year-old event continues to have
> disruptive and even traumatic effects in a scattered Armenian
> population, now known as the Armenian diaspora. (133)

Siraganian further discuss Egoyan's *Ararat* and other films such as
Family Viewing, which also focuses on the after-effects of the Armenian
genocide through different generations of a family in relation to what
they term "the psychology and politics of denial" (133). The denial
of the genocide by Armenian migrants involves a will to forget what
has happened across borders in an effort to carve out a life within
the temporalities of North America. As migrants, the characters in
Egoyan's films often communicate using the English language and
the language of Western secular capitalism, with the painful histories
of war and persecution being unintelligible to the majority of North
Americans they encounter. And yet trauma and life histories, much
like ongoing political conflicts, do not disappear but remain buried in
the psyches of exiles, erupting in physical and mental sicknesses and
through familial tensions. Rather than depicting a genocide that no
longer exists in the material reality of Western secular time, Egoyan
depicts the after-effects of genocide as personal and familial trauma.
As Monique Tschofen and Jennifer Burwell write in their chapter,
"Through a careful consideration of the historical and political
allusions in a number of his short and feature length films ... Egoyan,
always conscious of his directorial role, seeks not to transmit trauma
to the viewer, but rather to represent catastrophe's aftermath" (126).

Similarly, in *Disconsolatus*, Zamaan does not represent the violence
of ongoing war and genocide in Palestine, but rather ruminates on
the traumas of war indirectly, through the psychic life of the exiled
Palestinan woman. The distanciation of conflict is similar to Egoyan's
filmic depictions of the Armenian genocide and the effects it has
within diasporas. As Tschofen and Burwell argue, "Genocide is an
absence implied rather than revealed" (127). In *Disconsolatus*, the
deep disturbances of the body politic become embodied and mental

disturbances that plague the Western city, at a distance from the actual site of conflict.

Figure 2.2: Amita Zamaan. Disconsolatus. *2015. Film. 22mins.*
Photo: Petr Salaba.

What also unites Zamaan's *Disconsolatus* with Egoyan's films is the use of the female body as one marked by political violence, one in which the body of the exiled and traumatized woman becomes a symbol for a raped, pillaged, and destroyed land. Egoyan's films *Open House, Diaspora,* and *Portrait of Arshile* all use artistic techniques to reflect on the buried traumas of exiles. Egoyan explores "the groundlessness of the exilic and diasporic experience by exploring the longings that haunt the disjuncture between image spaces and geographical spaces in Egoyan's short film, *Open House, Diaspora,* and *Portrait of Arshile*" (Tschofen and Burwell 3). Just as Zamaan's film uses a non-linear structure that offers the audience the perspective of the disjointed mental life of the Palestinian female exile, Egoyan also uses avant-garde film techniques to offer insight into the skewed temporalities and emotional lives of exiles.

Within Egoyan's films, a "'displacement effect is sometimes manifested formally in, for example, the non-linear structure of Egoyan's experimental short film 'Diaspora,' which 'exiles' the viewer from any stable referent" (Tschofen and Burwell 9). Without a stable referent and a linear narrative, the viewer is made to "experience time, space, and movement in a manner similar to the emotional cognitive experience of spatial and historical disorientation felt by diasporic and exilic subjects" (Tschofen and Burwell 9). Similarly, Zamaan's film

Figure 2.3: Amita Zamaan. Disconsolatus. 2015. Film. 22mins.
Photo: Petr Salaba.

can be thought of in relation to histories of Canadian films made by diasporic directors such as Egoyan, whose creative works offer insight into the incomprehensible lives of survivors of genocide exiled in North America.

Helen Lee's *Prey* is also a narrative that uses filmic and poetic techniques to reflect on migrant alienation and longing. The film revolves around the romance of two characters, Il Bae, the daughter of Korean immigrants who own a convenience store in downtown Toronto, and Noel, an Indigenous man who shoplifts from the store. The cast includes Sandra Oh as Il Bae; Adam Beach as Noel; Alan Gilimor as the TV narrator; In Sook Kim as Halmoni; Fred S. Muir as the pawnbroker; Ik Kejun Shin as the father; and Mung-Ling as the "dragon lady." A short film, *Prey* begins on the morning after a break in at the family convenience store. Il Bae a Korean Canadian woman in her twenties, works at her family's convenience store and catches Noel shoplifting, only to realize that they went to high school together. She does not chastise Noel for stealing, but finds herself drawn to his lawlessness as an escape from the conservative hard-working moralism of her immigrant family. Lee's film exists in a genealogy of representations of Asian femininity through Orientalist forms of cultural production, both reproduced and parodied within Canadian cinema. One of the most conciously and unconciously reproduced narratives involving Asian women in Western art and literature is the story of Madam Butterfly. Teresa de Lauretis charts the history of this figure, citing the narrative as an outgrowth of nineteenth-

century travel literature. She states that Madam Butterfly emerged in 1887 in a book titled *Madam Chrysantheme* by Julien Viaud, a French naval officer. The book detailed Viaud's travels in Japan and his temporary marriage to a young Nagasaki woman named O-kiku-san (Chrysanthemum) (de Lauretis 309-311). Viaud published the book under the pseudonym Pierre Loti. de Lauretis states that the book's popularity throughout Europe can be attributed to "the vogue for the exotic, the Oriental, and in particular the fascination that the West—Europe and the United States—had for Japanese culture, art, and design in the second wave of the nineteenth century, no doubt encouraged by Japan's opening of its ports to Western trade and travel around 1860" (310).

Gina Marchetti further argues that the most common depictions of Asian women in Hollywood cinema exist in "Madam Butterfly" type narratives: the "Butterfly tales ennoble female sacrifices of all sorts. They argue, in support of dominant male notions of the social order, that women can be morally "superior" to men by sacrificing themselves completely for the patriarchy" (79). Marchetti further states,

> The Butterfly character may be a fool, but she represents a spiritually transcendent folly that transforms her into a saint.... The Butterfly becomes a scapegoat for the excesses of men and for the abuses of the West. Thus, she both conjures up uneasy feelings of guilt and purges them through her self-sacrifice, presented as tragic but necessary. (79)

A rewrite of Madam Butterfly was created by Asian American playwright and activist David Hwang in 1988, called *M. Butterfly*, and was later turned into a film by Canadian filmmaker David Cronenberg who, like Helen Lee, challenges mainstream Orientalist representations of Asian femininity. *M. Butterfly* is a postcolonial queer parody of Puccini's classic narrative. As de Lauretis states, the script that was made into a film by Canadian director David Cronenberg attempts to "trouble, ironize, deconstruct, and ultimately reappropriate the dominant narrative" (312). In *M. Butterfly*, the Butterfly is a male body and a spy for the People's Republic of China; he is aware of the classic Madam Butterfly tale and seeks to self-exoticize in order to aid his career as a spy. In Hwang's rewrite, Song Liling, the modern

Butterfly, "is not guileless and not passive, not an object but indeed the subject—the conscious and wilful subject—of a fantasy that sustains the agency of his own desire" (de Lauretis 313). de Lauretis states that in Hwang's version of the tale, "the discontents of Western civilisation have come full circle and the aggression that it had displaced onto its colonised others now turns upon itself, upon the coloniser "(324). Whether they have seen Madam Butterfly or not, the images and implications of the narrative have been so widely reproduced in various cultural texts that Cronenberg argues, "technically you could take any man off the street in Western culture and he would believe all of these things. He doesn't have to ever have seen Madam Butterfly" (de Lauretis 316). As de Lauretis further argues, the Butterfly is a cliché, "a stereotype set in a threadbare orientalist narrative, which … like many other public fantasies, still has the power of something deeply felt and experienced" (216). The Madam Butterfly narrative is driven by a political history that make it a powerful story, a story that is always to some extent present in the representation of Asians in Western culture. It is a trope that has helped to both shape "the Orient" as feminized, to justify and glorify Western imperialism and European colonialism, and construct Asian women as passive, to justify patriarchal oppression. Helen Lee's *Prey* much like Cronenberg's filmic adaptation of Hwang's play is a contemporary challenge to Orientalist histories of artistic representations of Asian women and Orientalist discourse. Rather than reproducing a narrative of Asian female self-effacement and submission to white male authority, Lee's *Prey* uses the techniques of film noir to offer edgy, sexy, and politicized portrayals of Asian diasporic femininities.

Film noir allows the Asian feminine body, often made invisible within dominant white settler narratives of Canada and represented as sexually docile within Orientalist discourse, to embody the role of femme fatale. Karen Gygli discusses the role that race and gender play in film noir, and how these conventions are subverted by Asian Canadian writers and cultural producers. Gygli draws on the writing of Kaplan, who states,

> …the visual style of film noir refers to Western culture's unconscious linking of the darkness of the psyche (especially the female psyche) not only with the literal darkness of racial

others, but also with unconscious fear/attraction for the racial others that the "Imaginary" of dominant white culture represses both literally and symbolically. (1)

Lee employs film-noir techniques through allusions to both sexual and criminal deviance that gesture to the relationship between race and innocence. Within Lee's *Prey*, the Indigenous male character, Noel, played by Adam Beach, is scripted as a "dark" outlaw figure, while the Korean female lead, Il Bae, also exists in the shadows of mainstream white culture. As a racialized convenient store clerk in a white settler colony, Il Bae is constructed against fairy tale images of white femininity. Noel and Il Bae are not vilified for their darkness. Rather, they are seen to enjoy the pleasures of living on the edges of dominant white fantasies of elite professionalism and sexless moralism. Gygli discusses the usual narrative within film noir as one in which the femme fatale character's sexual freedom often does not last. She writes, "…the femme fatale is punished at the end and sexuality is returned to the realm of marriage and the home" (Gygli 1). Within Lee's *Prey*, the dominant racist and sexist ideologies of film noir are troubled, as Il Bae's sexual power is not harnessed to meet the biopolitical interests of the family or the nation state. Rather, her outlaw sexuality and deviance from idealized white colonial ideals of femininity and Orientalist ideals of feminine submission remain intact. Il Bae is neither the provincial colonial maternal figure of dominant white Canadian history nor is she the dutiful sexless immigrant daughter and thankless labourer. Helen Lee's *Prey* uses the techniques of film noir to reveal the idealized romantic scripts of "happy families" and "peace keeping" settlers, to be grandiose white lies born out of colonial genocide, buried under a veneer of customer service pleasantry.

One can consider specific mainstream film and television representations of Korean women within genealogies of war. Authors discuss representations of Korean "war brides" on television shows such as *M*A*S*H* and *AfterMASH*. Hamamoto states that while American popular culture is used to emphasize Asians as perpetual foreigners, it also circulates constant "success stories" that minimize the racism Asian Americans face while also justifying American imperialism. In the short-lived series *AfterMASH*, a spin-off of *M*A*S*H*, the trope of the "Asian war bride" is exploited. Soon-Lee is a Korean woman

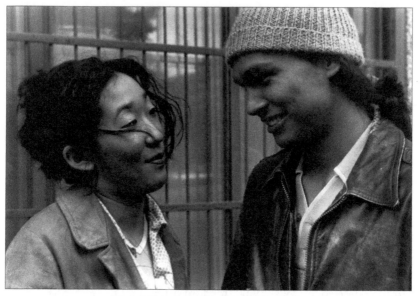

Fig. 2.4: Helen Lee, Prey, Film, 1995, 26 min.

who marries the American corporal Maxwell Klinger and relocates to America. Darrell Y. Hamamoto states that "*AfterMASH*, like its parent program *M*A*S*H*, exploits the historical experience of Asians ... caught in the vice of American militarism by implying that their lives actually have been bettered by the invasion, occupation, and destruction of their native countries" (27). The trope of the "Asian war bride" reinforces American imperialism through racist-sexist depictions of Asian culture as barbaric and Asian women as passive and helpless, needing to be saved by white American men to whom they will remain forever indebted. The trope not only reinforces ideas about Asian inferiority but also enforces racist-sexist ideas of Asian women as being naturally submissive, particularly to white male authority (Hamamoto 26). As Hamamoto states, "The Asian War Bride is the ideal companion or wife to white American males who prefer 'traditional' women untainted by such quaint notions as gender equality" (25). Hamamoto further argues that in recent years,

> ...perhaps in response to conservative male backlash against the advances of the women's movement over the past twenty years, there have been a number of "dating" and marriage services that promise to deliver compliant overseas Asian

women to men in search of alternatives to native-born Americans who might have been exposed to the virus of feminism. (26)

In *Prey*, Lee challenges this Orientalist rhetoric. The filmmaker depicts Il Bae as having sexual agency in her relationship with Noel, the male lead in the film. Il Bae is not controlled by the patriarchal rule of either her father or a husband; rather, she is seen to engage in a romantic and sexual relationship with an Indigenous man, challenging dominant racist and sexist expectations. Lee's film offers a necessary affront to long genealogies of filmic and media depictions of "Asian war brides" who are depicted as being desirable based on an assumed lack of feminist politics and of sexual agency.

In depicting the lives of racialized female migrants in Canada as those of psychic and physical distress, systemic racism, arduous work, and sexual desires that move outside of Orientalist narratives, both Zamaan and Lee challenge the myth of the "model minority." The myth of the "model minority" imagines Asians to be "hard workers" in comparison to other racialized people, such as African Canadians and Indigenous people. This myth masks the exploitation of Asian workers while also creating a divisive rhetoric that positions racialized people as adversaries. In *The Karma of Brown Folk*, Vijay Prashad writes,

> We are not simply a solution for black America but, most pointedly, a weapon deployed against it. The struggles of blacks are met with the derisive remark that Asians don't complain; they work hard—as if to say that blacks don't work hard. The implication is that blacks complain and ask for handouts. . .the myth of the model minority emerged in the wake of the Civil Rights movement to show up rebellious blacks for their attempts to redress power relations. The state provided the sop of welfare instead of genuine redistribution of power and resources, and even that was only given as reluctant charity. (qtd. in Samitha)

While Prashad makes specific reference to the use of Asians and South Asians to manage anti-racist dissent among African Americans, "model minorities" are also used to mask the ongoing colonial genocide

of Indigenous peoples in North America. *Prey* troubles this "model minority" rhetoric by offering a narrative that casts a Korean Canadian woman as one whose life intersects with an Indigenous man through romantic and sexual desire. *Prey* also refuses to reproduce narratives of Asian success and trite platitudes of multicultural bliss by depicting the realities of racism in urban Canada, such as Indigenous homelessness and the vulgar exploitation of Asian workers. The film is structured within the space of one day in which "Il Bae's family routine collides with her New World romance, catching her between loyalty to her father and her passion for a new lover with a checkered past" (*Women Make Movies*).

Zamaan's and Lee's film productions disidentify with fantasies of the "happy" reproductive labour of women, offering alternative economies of creation by racialized feminist/queer filmmakers who create ingenious films. What unites production values of contemporary racialized feminist/queer feminist films made on the streets of Toronto is a re-mapping of the nation through a tilted lens. If colonialism was and continues to be a capitalist venture, in which "happy homes" are reproduced by idealized white, bourgeois, heteronormative female subjects, the productive labour of feminist filmmaking challenges dominant familial scriptings of women's value. Zamaan uses her own artistic labour, and an innovative form of racialized queer diasporic film production ethics that involves support from communities of friends, lovers, allies, and artists. This alternative artistic economy disidentifies with dominant tropes of capitalist labour and heteronormative, white familial reproduction (Munoz). Just as Zamaan's film disidentifies with provincial tales of happy apolitical homes, Lee's film translates unspoken truths of haunting wars that displace migrants in urban centres and those of Canadian colonial genocide that displace urban Indigenous peoples. In discussing feminist/queer film production strategies, I use queer, anti-racist, film, and feminist theory to move away from narratives of pity, arduous struggle, and violence that often depict racialized, queer, and feminist lives and deaths on the margins of glorified nationalist narratives. Without discounting the difficulties facing queer, feminist, and racialized filmmakers, I suggest that their resilient will to create art offers a new economics of artistic production that can be understood as anti-colonial activism.

Dominant myths of family names and family money, passed down through lineages of white settler entitlements, are troubled by racialized female bodies that appear on screen to reproduce different mythologies of love and belonging. In both Zamaan's and Lee's films, the centrality of the female characters trouble the labour value of the immigrant woman's body as a servile worker or as the property of men. Drawing on narratives of labour that went into the making of *Disconsolatus*, and the film's relationship to the Toronto International Film Festival controversy surrounding Israeli apartheid, I discuss the relationship between land, settlement, and the ruptures presented by alternative communities of film production. I further comment on the production ethics of Helen Lee's *Prey* in her efforts to translate the schisms of language and loss that define migrant lives and the lives of urban Indigenous people. The body of the racialized, diasporic woman acts as a feminist translator in a similar way as feminist film translates and disidentifies with dominant myths of colonial patriarchy to create narratives of feminist/queer cinematic pleasure. I further discuss Lee's labour with reference to her choice of genre and the struggles of women who continue to make films despite systemic barriers of sexism and racism. If the "family" is a labour of patriarchal, colonial romantic scripts, the desire to tell stories that unsettle mythologies of white male authority are represented in the labour power of young, racialized, feminist/queer filmmakers. A challenge to white male authority is also presented by both Zamaan and Lee through the bodies they stage on screen, as figures of unapologetic sexual treason.

In an interview regarding *Prey*, Helen Lee discusses efforts to make an unsettling film regarding the truths of cultural alienation of second-generation migrants and their ambiguous relationship to Indigeneity. By staging a love story that begins in a convenience store, a common class-based reality that structures Korean immigrant lives, Lee's film labours to move away from simplistic narratives of white Canadian romances of "innocence" drowning in colonial denial. *Prey* also challenges narratives of happy immigrant families shrouded behind slave wage labour. The finality of settlement through migrant assimilation to dominant white colonial scripts is troubled by Lee, whose production ethics and writing style are demonstrative of the uneasy truths told by feminist film. As Lee says of the relationship between Sandra Oh and the character played by the male lead in

Prey, Adam Beach, "I think of their relationship as a completely contemporary one, a phenomenon of the late twentieth century that allows such encounters between Asian immigrants and Indigenous people to be possible" (Lee 21). As I discuss, both Zamaan and Lee labour to tell unsettling narratives of characters not at rest within dominant ideologies of nationalism.

SLAVE WAGE LABOUR AND "HAPPY HOUSEWIVES"

The labour power of the idealized Canadian female subject to reproduce the white settler state is challenged in Zamaan's portrayal of the female exile that lives in isolation. Zamaan's narrator is not a super-model minority who is "happy" to be home (Puar and Rai).[1] Similarly, Lee also tells the story of "Il Bae," known as Eileen in her Canadian public school, a bad English translation that frames the film as a story of the mistranslated lives of migrants and urban Indigenous people. As we learn in the film, "Il Bae" is a boy's name in Korean, a symbolic queering of heteronormativity through the racialized female body. The "mistranslation" of "Ill Bae" into the English "Eileen" turns this figure into a heteronormative cis-gendered woman through the act of naming. The colonial Queen's English is used to settle the gender and sexual identity of this figure, while her relationship to Korean diasporas and languages calls normative gendered names into question. In this way, the construction of non-Western spaces and dialects as sexist, heteronormative, and homophobic as compared to the assumed liberatory spaces and languages of Canada are challenged. The queer body does not need to escape to "Turtle Island" to be "properly" named, but perhaps needs to escape bad translations in a colonized English tongue.

The film begins with a scene shot in blue light. Oh's character appears as a femme fatale, shown lying in bed and awakened by the sound of the phone ringing. An exhausted Il Bae answers the phone, appearing sexy and disinterested both visually and in her deep, cool tone of voice: "What, again?" she says, slamming the phone down in frustration (*Prey*). Il Bae has been told of another security alarm that has started ringing in the middle of the night at the family convenience store, which is disturbing her frantic immigrant father. The camera captures a lasting image of Oh's frustrated face as Il Bae proclaims with

sardonic irony, "I could tell this was going to be my lucky day." The narrative of the "lucky" peace-loving immigrant from a destitute and oppressive place is troubled by Il Bae's refusal to feign joy in the face of banal, provincial, white settler Canada. The film moves to Adam Beach's character Noel, the mysterious and handsome Indigenous man who remains haunted throughout Lee's film by his own familial ghosts and the larger ghosts of white settler colonialism.

The audience hears Noel's internal dialogue, "Last night, I dreamt I came home and then I was there" (*Prey*). The dialogue is however not heard at "home" but on a moving bus. Beach's character is the working-class urban Indigenous man turned petty thief who must traverse the "fair is fair" secular capitalist ideologies of colonial meritocracy with a wink and a nudge to entitlements to Indigenous land born out of colonial theft. Il Bae and Noel's romance begins when he shoplifts food from her family's convenience store, and he remembers her from their Toronto high school. The narrative centres on their "outlaw" affair that encapsulates theft, the death of Noel's younger sister, and the wage-based capital of immigrant labour. What Slavoj Žižek terms "multicultural multinational capital," in which discourses of "multiculturalism" are facets of multinational capitalist globalization, are troubled through the character of Il Bae who is positioned between the discourses of denial espoused by "happy immigrants" forced into slave labour and Canadian colonialism (Žižek). Il Bae is positioned as a translator of discourses of denial, as one who is able to translate the unspeakable racism that exists in Canada and the silenced entitlements of first-generation immigrants, who are often constructed only as workers, with no sexual or personal desire. Similarly, the rhetoric of Canadian multicultural "diversity" in which race blindness functions as a denial of white privilege is challenged in Zamaan's *Disconsolatus*. Zamaan's narrator is not happy to be home on stolen land. One can compare the characters in Zamaan's *Disconsolatus* and Lee's *Prey* to mainstream representations of the happy immigrant settlers depicted in mainstream Canadian Broadcasting Corporation (CBC) programs such as *Little Mosque on the Prairie*. Within such visual economies of racialized representation, racialized immigrant bodies follow in the footsteps of white settlers. Muslim women are depicted as being "free" in Canada and immigrants represent a diasporic middle class that is a far cry from the working-class labourers depicted in Lee's *Prey* and the

exiled figures depicted in Zamaan's *Disconsolatus*.[2] Dana, the female lead in *Disconsolatus*, is a Palestinian exile who is not settled at "home," neither physically nor mentally; rather, she is a disturbed character who makes a mess of the clean pageantry of apolitical platitudes of "peace," conjuring up ghosts from wars of colonial settlement that Canada and its film industry are implicated in. In allowing the audience to enter the mind of Dana, and in telling a narrative of sickness and plague that besets the imagined cleanliness and peace of Canada, the wars that Canadian governments support are fought in the bodies and minds of white settlers and diasporic subjects. Dana's grief does not stand apart from the silent grief of war and occupation that fund and govern Canadian life, but is representative of a melancholia that besets Turtle Island, a place of polite racist denial.

In her text, *The Promise of Happiness*, Sara Ahmed critiques platitudes of nationalist bliss with histories of feminist complaint. Drawing on histories of feminist struggle that reference Friedan's *The Feminine Mystique*, Ahmed writes,

> The happy housewife is a fantasy figure that erases the signs of labour under the sign of happiness. The claim that women are happy and that this happiness is behind the work they do functions to justify gendered forms of labour, not as a product of nature, law, or duty, but as an expression of a collective wish or desire. How better to justify an unequal distribution of labour than to say that such labour makes people happy? How better to secure consent to unpaid or poorly paid labour than to describe such consent as the origin of good feeling? (1)

The fantasy of the consensual labour of the "happy housewife" is conjoined with the idea of multicultural narratives of happiness, in which racialized diasporic women are often imagined to escape to white settler nations to achieve better lives.

One can also consider Deepa Mehta's film *Bollywood/Hollywood* (2002), in which racialized migrants in Toronto are depicted as affluent settlers who achieve heteronormative bliss through narratives and film techniques of light hearted romantic comedy. While Mehta's *Fire* (1996) and *Water* (2005), both set in India, depict obscene spectacles of gendered violence, South Asian Canadians who are

represented in this film are settlers who achieve "happiness" through middle-class suburban capital and heteronormative romance. Gayatri Gopinath argues that the inability to imagine queer female desire within *Bollywood/Hollywood* may be connected to the violent Hindu nationalist opposition to queer sexuality that erupted after the release of Mehta's *Fire*, which depicts the lives of queer women in India. Gopinath writes,

> In early December 1998, movie theatres in Bombay, New Delhi, and other major Indian cities were stormed by dozens of activists from the Shiv Sena, the Hindu right-wing organization that formed the militant wing of the BJP-led Hindu nationalist government then in power. The activists were protesting the screening of *Fire*, the 1996 film by the Indian Canadian director Deepa Mehta which depicts a lesbian relationship between two sisters-in-law in a middle class, joint-family household in contemporary New Delhi. Screenings were forcibly stopped, film posters burnt, and property vandalized. The Shiv Sena justified its actions by claiming that the film's depiction of lesbians was an affront to Hinduism and "alien to Indian culture." (131)

However, the racist ways that caste, colour, and colonial settler ideologies are reproduced through heteronormative tales of diasporic marriage economies are left unexplored in films such as *Bollywood/Hollywood*. While the oppressive treatment of women and queers are the focus of Mehta's films set in India, there is no mention in her depictions of Canadian migrant life of racialized economies of slave wage labour or misogyny. *Bollywood/Hollywood* offers no feminist critique regarding the deeply sexist, classist, casteist familial relations that structure South Asian diasporas in Turtle Island. The well-moneyed immigrant classes that Mehta stages in Toronto reproduce racial and caste-based lineages while also remaining at a distance from urban Indigenous poverty and working-class labour. The plot turns around a conflict regarding the marital and familial expectations of families and their immigrant children, which are easily resolved through heteronormative race and caste-based marriages with the film's lead character eventually marrying another affluent South Asian

Canadian. The "happy housewife" economies that tie economic capital to familial wealth are secured, while the exiled bodies of migrants from war-torn countries, Indigenous people, and the immigrant working class are invisible. Conversely, Helen Lee and Amita Zamaan labour to offer complex fictions that challenge the cartoonish song and dance of both Bollywood and Hollywood spectacles of fantasy.

While *Bollywood/Hollywood* ignores both white settler colonialism and feminism in Canada, Zamaan and Lee offer films that subtly critique colonial capitalist ideology and heteronormative biopolitics. Julia Emberley discusses the relationship between Canadian colonialism, filmic reproduction, and biopolitical mythologies of white settler nations such as Canada/Turtle Island. Emberley discusses "Tarzan and Jane" films in reference to economies of bourgeois heteronormative reproduction and the body of the idealized woman within a white settler colony. Jane is the bourgeois feminine woman whose white, upper-class body tames the "wild" Indigenous man, Tarzan, and makes him useful in reproducing idealized children for the nation. Within these films, the body of the racialized Indigenous woman is absent. The colonial history of racist white settler mythologies appears in the absence of the Indigenous female body, a lingering political truth in the ongoing genocide of Indigenous people in Canada/Turtle Island and the growing number of "missing" Indigenous women that haunt the landscape (Emberley). While the "Tarzan and Jane" films discussed by Emberley are emblematic of mainstream enactments of racist reproductions of whiteness, the avant-garde films of racialized feminist filmmakers translate all of the polite denials of Canadian racism into images of defiant dark women thrown against a lily white landscape.

THE LABOUR OF TRANSLATION:
BROKEN TONGUES AND DIRTY PICTURES

The production process for both Zamaan's and Lee's films can be read as works of ongoing translation. Zamaan's film is inspired by the late Palestinian poet, Mahmoud Darwish. The director discusses the film as a creative translation of Darwish, a famed Palestinian writer whose poetry reflects the psychic, emotive, and physical traumas of colonial exile. Zamaan states,

Fig. 2.5: Helen Lee, Prey, *Film, 1995, 26 min.*

In my opinion, the late Mahmoud Darwish possessed unparalleled artistry. Many of his poems utilize surrealistic imagery that blends the personal and political with fantasy. So it is no surprise that many artists have interpreted his work into different mediums. I came across "I didn't apologize to the well" this summer and I read it over and over again. It moved me deeply and evoked some fantastic imagery: oracles, mystical wells, and gazelles. It inspired me creatively and I put on the hat of a surrealist writer and a couple of days later I had a screenplay in my hand. (qtd. in Cadre)

The work of translation beyond borders of language, nation, and faith shaped the writing and production of *Disconsolatus*. Similarly, Lee states that her film was also written as a work of translation in which the hybridity of lives haunted across and because of borders is told in several tongues and is expressive of multiple realities. Lee discusses her production of the script for *Prey*:

The script for *Prey* was originally written for Sandra Oh and my mother's sister, In Sook Kim.... I knew this would be an interesting process of not only pairing a highly trained actor like Oh with my aunt who'd never performed before, but also because Oh, like the character, didn't speak Korean,

and my aunt doesn't speak much English. (Lee, "A Peculiar Sensation" 151)

Just as Zamaan translated Mahmood Darwish's poems of exile into the form of film, Lee also engaged in a labour of translation to make *Prey*. As she discusses,

> Since I cannot really speak Korean either, a process of translation was integral to the project. At every stage from rehearsal to shooting to editing, the interpreter, Jane Huh stuck close and ready. I wasn't prepared for the cultural wrangling over specific attitudes and sayings that I thought were authentic or convincing but Jane insisted were off-mark. (Lee, "A Peculiar Sensation" 151)

In *Black Skin, White Masks,* Frantz Fanon wrote, "To speak means to be in a position to use certain syntax, to grasp the morphology of this or that language, but it means above all to assume a culture, to support the weight of a civilization" (17-18). Zamaan's film, in taking on the language of an exiled Palestinian poet, takes on the weight of the unsettling truth of migrant melancholia and the haunting violence of Palestinian genocide. *Disconsolatus* is an expression of the incomprehensible losses of Palestinians, which cannot be translated into trite English-language Valentine's Day cards. So, too, does Lee labour to tell a story of linguistic translation that is tied to the impossibility of cultural translation. In "The Politics of Translation," Gayatri Chakravorty Spivak states, "The task of the feminist translator is to see language as a working to the clues of gendered agency" (312). The ways that both Zamaan and Lee shift across national histories and borders through creative labour, gestures to the artistic tenacity of feminist filmmakers.

The filmic feminist articulations of Lee and Zamaan do not involve assimilating and perfecting the grammar/diction of the Queen's English. Rather, it is through the language of film, never fully translatable in the aesthetic imagery it offers and emotions it produces in viewers, that anti-colonial feminist/queer filmic agency is found. Zamaan's film exists as an ongoing conversation between her and the late poet Darwish, while Lee's film is an attempt at translation

between her and her aunt, a Korean-speaking migrant who attempted to interfere in the romantic plotline between Il Bae and Noel scripted in *Prey*. As Lee recalls, "True to form, my aunt herself, a prolific essayist and poet, refused to play the role of the grandmother (who was initially written as very accepting of Noel and Il Bae's liaison) and demanded changes" (Lee, "A Peculiar Sensation" 151). Lee further remarks, "My aunt wanted Noel out of Il Bae's apartment and out of her life. While I never thought I'd take identity for granted, especially in a film about cross-generational differences, here I was making my own cultural assumptions" (Lee, "A Peculiar Sensation" 151).

If language is deeply interwoven with "culture" as the embodiment of a people, the cultural truths of Palestinian alienation and exile, as well as those of Korean migrants, are perhaps never fully translatable. And yet, if feminist translation is expressive of gendered creativity, both Zamaan's and Lee's films express the capacity of feminist artists to use a language of aesthetics, and of creative and courageous narratives to translate haunted lives, beyond mere words. Just as Zamaan had to work on and with Darwish's language, translating the ethos of his text to image, so too did Lee work with her aunt, labouring to interpret the untranslatable desire that language and history carry. Lee further states, "Ultimately, developing Halmoni's character was a collaboration between my aunt and myself, a creation of the Korean and the kyopo imagination. I doubt the film would exist without her" (Lee, "A Peculiar Sensation" 152). Similarly, while Darwish is perhaps beyond translation, Zamaan's film would not exist as a testament to the survival of racialized feminist/queer films that go against the grain without the haunting overtures of his writing.

PRODUCING ANTI-COLONIAL FILM: THE REPRODUCTION FEMINIST/QUEER FILM AS ANTI-RACIST ACTIVISM

Both Lee's and Zamaan's filmmaking speak to avant-garde cultures of film production that defy logics of racism and patriarchy, which posit women's "productive" role as lying in the thankless service or "happy housewife" rhetoric of idealized heteronormativities. While the promise of racialized feminine bliss exists in the ostensibly happy, healthy body of the character Jess in Gurinder Chadha's film *Bend It Like Beckham* (2002), in Zamaan's rendering, the female exile embodies

the traumatic grievances of Palestinian exiles (McWhorter). Zamaan's film can further be considered in relation to films such as *Return to Kandhar*, made by Canadian Afghani filmmaker Nelofar Pazira. The films of diasporic Canadian filmmakers are often funded by national film organizations and are positioned as "native informants" who construct narratives of third world barbarism and Canadian feminist "liberation." As Usamah Ansari discusses, in Pazira's film there is a will to "liberate" women in Afghanistan on the part of the feminist filmmaker that violently forces secular Western ideals of feminism onto the bodies of Muslim women, implicitly supporting Islamophobia and the global "war on terror." The alienation of migrant life that Zamaan represents in *Disconsolatus* offers an internal critique of multicultural utopias in which Canada and other secular Western capitalist nations are constructed as spaces of refuge for racialized diasporic women.

Lee's film also stages a narrative that resonates outside of great North American histories of pioneers and invisible Indigenous peoples, telling a contemporary narrative of urban working class culture in Canada and all the unlikely, invisible fictions it produces. Lee's film can be juxtaposed to mainstream Hollywood films such as *Crash* (Haggis), which offers a Hollywood portrayal of racial antagonisms in which the Indigenous body is absent, while issues of racism are presented only in relation to Asian, Latino, and African American bodies. Conversely, Lee's film centres the lives of Indigenous people in the urban sphere and also focuses on politically and sexually charged relationships between Indigenous people and racialized migrants. The absence of Indigenous characters in films such as *Crash* and the invisibility of desire on the part of the stereotypical migrant labourers, is challenged in Lee's *Prey*. As opposed to other mainstream renditions of racialized lives and politics in North America, within Lee's film, Korean migrants have sexual desires and Indigenous people are living and breathing city dwellers. Lee states,

> Since Koreans emigrated in significant numbers only in the past two decades, it's historically unlikely that Il Bae and Noel's worlds have met until now. Native people, who suffer the same invisibility as Asians and other racial minorities in mainstream media, are practically unknown to the Korean American/Canadian community. (21)

There is an unacknowledged loss in *Prey* between multilingual conflicts and invisible histories of the Korean war scripted onto migrant bodies and the melancholia of urban Indigenous alienation. At one point in a moment of irony, Il Bae's Korean grandmother refers to Noel as a foreigner, gesturing to the making of multicultural immigrant patriots against displaced Indigenous people. As Lee states, "It was important to me to explore how a Native character could impact on a Korean family who may have never before acknowledged the Native presence in their adopted land" (Lee 21). The Indigenous body remains an unacknowledged presence in Zamaan's *Disconsolatus*, another haunting body produced by colonial occupation. Dana's trauma is a lingering political truth, which remains unspoken in a Canada that builds upon histories of colonial denial by supporting new imperial occupations.

Given the ongoing controversies surrounding Israeli apartheid and the Canadian activist group *Queers Against Israeli Apartheid*, mentioned in the previous chapter of this book, there is an imbrication of queer political defiance, anti-apartheid discourse, and disconcerting truths of alienation from home and nation that unite minoritarian struggle and artistic labour. In 2009, a controversy arose regarding the Toronto International Film Festival (TIFF) and its support of Israeli apartheid. David Archibald and Mitchell Miller discuss the controversy in reference to the contentious decision made by TIFF to feature Tel Aviv as a filmic paradise, effacing the brutal 2008 Gaza bombing. The "happy" pageantry of filmic branding produced outrage on the part of the artistic community, transnationally. The authors discuss the 2009 controversy regarding TIFF:

> The introduction of a new "Cities" sidebar focusing on Tel Aviv provoked a fierce, divisive and highly public controversy at the 2009 Toronto International Film Festival (TIFF). Sponsored by the Israeli Government's Brand Israel campaign, the sidebar featured ten films set in Israel's administrative capital and, while none of the films was, in itself, especially controversial, the premise that a major international film festival would accept money directly from an Israeli government eager to promote an alternative media image to the one associated with their nation's long

and controversial involvement in Palestine elicited an angry response from a number of public figures. (274)

The "Toronto Declaration" was signed by many opponents of TIFF's decision to highlight Tel Aviv's film industry throughout the world. The effort to house emotion, politics, and art within the happy homes of localized film festivals was unsettled by international industries of finance tied to the global "war on terror." This political melancholia was not endemic to Toronto, but arose from the 2006 Israel-Lebanese War. During the ongoing war being waged by the State of Israel, Palestinian filmmakers asked for support from the international community. As Archibald and Miller note, filmmakers both living in and exiled from the occupied territories of Palestine called upon the international community to support the boycott of Israeli branded artistic events and commodities. Miller and Archibald quote the 2006 declaration made by Palestinian artists:

> Join us in the boycott of Israeli film festivals, Israeli public venues, and Israeli institutions supported by the government, and to end all cooperation with these cultural and artistic institutions that to date have refused to take a stand against the Occupation, the root cause for this colonial conflict. (274)

There is a position of political outrage produced in those who stand outside "happy" fictions of "home," both as feminist/queer Others and as racialized migrants standing at odds with the productive capitalist interests of wealthy nations.

WHITE LIES AND ULTRA-LIGHT TOBACCO

Helen Lee states that making *Prey* involved labouring to produce a story that is as restless as the arduous spaces of labour that define Korean migrant existence: "A typical convenience store was the perfect stage to enact this drama, a place where so many Korean Americans have spent their lives" (21). As Michel Foucault once remarked in regards to the temporalities of capitalist modernity, "the anxiety of our era has to do fundamentally with space, no doubt a great deal more than with time. Time probably appears to us as one of the various

distributive operations that are possible for the elements that are spread out in space" (Foucault and Miskowiec 22).

The labour of migrants and survivors of colonial occupations from Turtle Island to Palestine stand outside spaces and temporalities of imagined "happy housewives" and settled white colonizers. The twenty-four hour temporal and spatial realities of the all-night convenience store, run by Korean migrants who labour in arduous isolation in Lee's *Prey*, were similar to the production process of *Disconsolatus*. As Zamaan states, making the film involved a production process of forty-eight hours of intensive film production and no sleep in the deserted streets of Toronto that were used to stage dystopian images. Outlining the artistic strategies that structure the making of feminist/queer, anti-racist, and political film, Zamaan discusses her do-it-yourself production process,

> We all volunteered our time and devoted funds from our personal savings, primarily toward equipment and location costs. We kept costs low by renting a single camera and some cool lenses, as well as minimal lighting equipment for one week at a four-day rate. We shot 24/7 so that we could complete all the scenes in the seven days. A lot of our scenes were shot between 3AM and 6AM, when we could use the empty streets of Toronto as our film set. (qtd. in Cadre)

As Zamaan further says of the film's central character, Dana, "With her family far away in occupied Palestine, the artist becomes increasingly isolated in her Toronto home" (qtd. in Cadre). Similarly in *Prey*, the family dramas of second-generation working-class Korean fathers and their daughters do not happen around Thanksgiving dinner tables, but over convenience-store counters where coffee and cigarettes are sold. We see Il Bae outside the convenience store, smoking and chugging coffee from a Styrofoam cup. "We have coffee here. Did you forget?" asks Il Bae's money- and work-obsessed father. "But ours is shit," she grumbles to herself (*Prey*), telling the truth of migrant families whose livelihoods are tethered to globalized fast-food, frugality, and convenience. The economy of tobacco is a remnant of colonialism that positions Il Bae between the wealthy bourgeois body and the urban Indigenous man who has no "peace

pipe" left. Rather, Noel is left to shoplift food from the convenience store.

The bio politics of "health" revolve around normative white settler economies of heteronormative reproduction in which rich women consume excessively and "happy housewives" frequent downtown yoga studios. The audience sees a bourgeois woman buying cigarettes from Il Bae, who is working behind the counter. Beach's character Noel bumps into her. "Walk much," she says in a haughty tone. "It's called hand-eye coordination. Jesus! And I just got this thing dry cleaned. Look at those lines," she says, looking at her own reflection in a cosmetic mirror. "Make those ultra-lights" (*Prey*). Drawing on a symbolic and poetic use of mirrors, we see Beach's character reflected in the security mirror, as the bourgeois female customer becomes a useful distraction to hide Noel's petty theft. She continues talking to herself, while Il Bae rings up her ultra-lights and catches a glimpse of Noel stealing food. "Of course, my weekend didn't help, total debauchery. We practically closed the club" (*Prey*). The affluent excess symbolized in the woman's ultra-light tobacco and the reflection of her post-party image in her cosmetic mirror are juxtaposed with those of Beach's image in the security mirror. Noel's image haunts dreams of diasporic wealth in which narratives of happy "multicultural" lives are shadowed by colonial genocide. So, too, is Zamaan's film an artistic truth that challenges biopolitical scriptings of "healthy" bodies at home in "healthy" nations with the ghostly exiles of Western-funded wars.

The legalized truths of addiction, figured in the ultra-light cigarettes of a wealthy woman who "enjoys" weekend parties in the context of what Slavoj Zizek terms the postmodern capitalist "injunction to enjoy," are juxtaposed with the image of the Indigenous male body. Noel is a moving "tobacco Indian" whose outlaw behaviour is not reflective of normative consumer excess, in which bourgeois addictions are legislated and taxed while Indigenous men steal food from a convenience store. Similarly, Dana, in *Disconsolatus*, is not a "healthy" white settler or super-model minority at home in a body that reproduces idealized middle-class white Christian or Catholic citizens. Just as the disease of Indigenous people and the excess of bourgeois cocktails, cosmetics, and ultra-light cigarettes fund industries in Canada, Dana's distress supports state industries of pill-popping therapeutics. As Zamaan says of Dana's addiction to pills,

"*Disconsolatus*" is a Medieval Latin term for someone incapable of consolation. It is relevant to the predicament of our lead character, but it also sounds like an infectious disease, doesn't it? I think the fictional disease that we portray in this film is something that all audiences can relate to, either directly or through someone close to them. Similarly, the film touches on the themes of the power of big pharma and the institution of psychiatry. (qtd. in Cadre)

Dana's addiction to pills expresses a dark side of the nation, productive of medicated lives that are hidden from nationalist fantasies of "healthy" representations of "good Canadian families."

Zamaan discusses the theme of disease, perhaps reflecting a disease of the main character Dana as a racialized, colonized, and feminine subject who is a sick haunting to a national imagery of great white men and their colonizing, survivalist embodiment.

Ahmed discusses the "feminist killjoy," "melancholic migrant," and "out-raged queer" that are represented as problems and obstacles to anti-intellectual and apolitical fantasies of white, middle-class heteronormative bourgeois families. These filmmakers present a bare truth in images of barren shelves looted by Indigenous pick-pockets and full medicine cabinets of Palestinian exiles. There is a great and lasting beauty to the poverty of "home" only found in the escapism of screen images in which invisible racialized migrant exiles finally find snippets of their own reflections.

DISIDENTIFICATORY DESIRES: WORKING ON AND AGAINST DOMINANT FILM AESTHETICS/PRODUCTION

José Munoz documents disidentificatory performances that "circulate in subcultural circuits and strive to envision and activate new social relations. These new social relations would be the blueprints for minoritarian counterpublic spheres" (5). Zamaan discusses her disidentificatory approach to filmmaking as well as the possibilities that technology offers to emerging, racialized feminist/queer filmmakers.

Technologically speaking, filmmaking has never been more

accessible—it's quite feasible these days to make high-quality, feature-length films on a micro-budget. This opens up the industry to stories and filmmakers like never before. A young director whose story doesn't fit the status quo and whose uncle isn't so-and-so in the biz might get a chance to sit in the director's chair. Said director might be a woman (four per cent of feature-film directors are women in Canada), or even a woman of colour. (qtd. in Cadre)

The worlds of racialized, feminist/queer filmmakers and their production ethics are not divorced from capital and from aspirations of artistic success. However, the production ethics of filmmakers such as Zamaan in making *Disconsolatus* and of Lee in making *Prey* act as minoritarian counterpublic spheres that work on and against mainstream film. In their production process, these artists create new social relations outside of family money tied to caste and class-based lineages, and nationally-funded films that often implicitly support white settler empires. Zamaan discusses her production process, involving a labour-intensive method and supported by feminist/queer, anti-racist activist, and artistic subcultures in Toronto. Writer and journalist Fathima Cadre asks Zamaan, "Rumour has it that you made the film in under a week with less than $10,000. How did you pull that off?" (Cadre). Zamaan responds,

It's true. People see the four-minute teaser we put online and don't believe that we shot this thing for next to nothing. It definitely wasn't easy. Once I had a screenplay, I was faced with the challenge of funding a Darwish-inspired poetic sci-fi with a Palestinian lead in Canada. After sharing a few laughs with myself, I decided to enlist some of the smartest people I knew, who were foolish enough to take on the task. (qtd. in Cadre)

There is creativity in Zamaan's production ethics, which is reflected in the story she narrates. *Disconsolatus* refuses to succumb to well-funded, trite mainstream narratives. She states, "Working with a microscopic film budget requires a whole other level of creativity. Our actors rehearsed for a month before shoot week. We planned and planned meticulously so that we could pull off this truly insane

challenge. We were all zombies by the end of it" (qtd. in Cadre).

The exile of Dana, the film's lead character, is mirrored in the zombie-making production described by Zamaan, which involves all night labour, working against the temporalities of the nine to five grind that structures normative capitalist industry in Toronto and transnationally. Disconsolatus offers an example of the D.I.Y processes of feminist/queer racialized filmmakers who labour to tell political stories in an industry of Israeli apartheid film. Similarly, Helen Lee also discusses the labour, production, and distribution process involved in making short films such as *Prey*, which is twenty-six minutes long, and discusses the difficulty of producing short film in North America:

> As for the short film format, I remember attending the Clermont France short film festival in France with *Prey* and realizing, hey, shorts are not marginal here in Europe at all; they make them in 35 mm and they're shown before features in theatres and bought for television. Canada and the U.S. have caught up somewhat but the status of the short filmmaker is still zip. (Lee 21)

Much like Zamaan's choice of sci-fi as the genre for *Disconsolatus*, the production of shorts disidentify with heteronormative stories of white, bourgeois, romantic feature films. Zamaan discusses science fiction in relation to the politically charged, unsettling narrative of a migrant female exile told beautifully in her film. She states,

> The only viable film genre that would satisfy this kind of storytelling was the sci-fi genre. So in *Disconsolatus*, we have a Palestinian artist who actually has Darwish's poetry and imagery pop up in her subconscious world. This is presented through sci-fi staples like telekinesis, telepathy, and interdimensional travel. The poem, as I read it, also deals with a personal awakening, one that I connected with on many levels. (qtd. in Cadre)

Working against the cartoonish, heteronormative, and colonial/orientalist Walt Disney imagery of *Aladdin* (1992), *Mulan* (1998), and

Pocahontas (1995), both Zamaan and Lee use a queer/feminist ethics of production to disidentify with the mainstream.

IT NEVER GETS BETTER: THE HAUNTING OF EXILE

Disconsolatus and *Prey* are, at the level of script writing, choice of genre, and production process, precarious labours of unsettled and restless desire. Lee states,

> In Europe you can be a short filmmaker forever, and not necessarily have to "graduate" to making feature films—it's a viable format.... I didn't start off making films with the ambition of making features. Shorts were very much my world having worked at DEC films in Toronto and Women Make Movies in New York, the arena of non-theatrical film and video for the educational market was/is many short films. To me they weren't marginal at all and, I made short films with that attitude. Every frame, every scene and every minute had importance. (21)

Zamaan also discusses the precarity that defines the making of non-traditional films, particularly those centering on Palestinian characters in a time of controversy and protest regarding the occupation of Palestine by the State of Israel. As discussed, protests arose during the 2009 Toronto International Film Festival in Toronto due to the focus on films and filmmakers from the city of Tel Aviv and the erasure of Palestinian artists. Israeli images occupied Toronto's film festival, perhaps offering an example of how the lucrative branding of certain artistic events in one city are imbricated in the branding of cities such as Tel Aviv, with art being used to conceal racism, occupation and war. Filmmaker John Greyson was among the most vocal opponents of the 2009 Toronto Film Festival's decision to focus on Israel, during a time of sickening violence against Palestinians ("Canadian director protests"). The director chose to withdraw his film *Covered* in protest of the callous disregard of the state of Israel's vulgar hate crimes against Palestinians. Greyson discusses the events that took place in the same year that TIFF decided to shine a celebratory spotlight on the city of Tel Aviv:

This past year has also seen: the devastating Gaza massacre of eight months ago, resulting in over 1,000 civilian deaths; the election of a Prime Minister accused of war crimes; the aggressive extension of illegal Israeli settlements on Palestinian lands; the accelerated destruction of Palestinian homes and orchards; the viral growth of the totalitarian security wall; and the further enshrining of the check-point system.... (qtd. in "Canadian director protests")

Greyson further stated, "This isn't the right year to celebrate Brand Israel, or to demonstrate an ostrich-like indifference to the realities (cinematic and otherwise) of the region, or to pointedly ignore the international economic boycott campaign against Israel" (qtd. in "Canadian director protests").

Perhaps the ongoing indifference to the occupation of Indigenous land in "Canada," and ongoing systemic racism and attempted genocide of Indigenous peoples normalizes racist forms of denial in order to support a worship of capitalist accumulation, setting the stage for diverse forms of white settler violence.

Zamaan discusses *Disconsolatus* as a film that was made in and defined by struggle, a common feature in the narratives of racialized feminist/queer filmmakers, and describes the guerrilla tactics involved in the making of the film:

Perhaps the only people pleased with the ridiculous summer construction that plagues Toronto every year are guerilla filmmakers. We might not have big studios, but we can be assured that a few major streets will be closed off to traffic year after year, waiting to be filmed. *Disconsolatus*'s plotline involves an empty city under quarantine so we really needed the streets to be completely abandoned. We also shot in some unusual places in the early morning hours. (qtd. in Cadre)

There is an outlaw desire to both *Disconsolatus* and *Prey*, with Zamaan's narrator embodying all of the passionate and queer outrage of Darwish in her chronic unrequited craving for an affective reckoning to colonial genocide. Dana is depicted as an artist whose desire to express herself appears in her creative productivity rather than her capacity to

reproduce idealized settler citizens. Just as Il Bae and Noel embody a lustful anti-colonial politic that is temporary, dirty, and fleeting, Dana embodies states of creative and mental distress outside of fictions of settlement.

Zamaan's filmic portrayal of migrant melancholia, specifically through the figure of a Palestinian female exile, resonates with Jasbir Puar's arguments regarding homonationalism, queerness, and "terror." While "happy" idealized gay, white, and male figures function as a form of homonationalist capital through a "pink dollar" marketing of gay family life that reproduces white settler mythology, Dana remains haunted. The "It gets better" rhetoric of homonationalist capitalist dreams is challenged in Zamaan's film. It does not "get better" for Palestine, and therefore the "health" of the white settler state that funds genocide is cancerous for the exiled female Palestinian. Rather than identifying with mythologies of settler states as "home" and with trite provincial tropes, *Disconsolatus* and *Prey* disidentify with mainstream nationalist discourse.

SHOOTING BLANKS:
COMPETING RACIALIZED (IM)MASCULINITIES

In *Prey*, we also see that the fiction of the universal patriarchal European family is troubled by narratives of racialized immigrant life. Il Bae's father, the owner of the convenience store where she works, plays an interesting role in the film. His dialogue is mainly spoken in Korean with English subtitles and smatterings of English-language phrases. Throughout the film, we never see him leave the convenience store. Instead, it is Il Bae who leaves the space of the store to do business for the family. The Korean immigrant father is continually emasculated by the labour force and his inability to communicate in a public sphere governed by the English language, which his Canadian-born daughter speaks fluently. The fiction of the heteronormative patriarch governing both the public sphere and the family is troubled by the Asian immigrant male's lack of capital in a white Western settler society. Similarly, in *Disconsolatus*, there are no husbands or fathers. There is only the lone female Palestinian artist in exile, who creatively labours against the alienation and loss produced by colonial occupation. The "comforting" heteronormative bourgeois

family romance is an absent truth in the life of the Palestinian female exile, just as Il Bae is not a Korean "comfort woman" but a person with her own desires, perhaps fulfilled in a lustful night with Noel. What both Zamaan and Lee labour to tell are edgy stories of desire. Against the banal denial of racism and the reality of wars that leave immigrants displaced in North American cities, Lee and Zamaan offer complex and difficult films to reflect great losses of love and nation. As Lee says, "I do think the immigration story is suffused by loss, and not only the gain of a next life in a new country. Somehow there's a conflation of mother and culture in my films; this yearning for cultural connection is symbolized by the lost mother" (Lee 21).

Just as Dana is left alone, with her family across borders in occupied Palestine, so too does *Prey* tell a story of familial grievance. Both Il Bae and Noel are at a loss, with her mother having passed away and his sister having passed away. Lee states,

> The relationship between Noel's loss of his sister and Il Bae's loss of her mother, tenuously linked in the story is also a lynch pin for their connection—not that they should be defined by negatives, however. They both know sadness in their lives, that much is shared. And how does one calculate loss, particularly a concrete one such as a family member? (21)

The incalculable loss of homeland and family also produces mental and emotional distress in Dana that is never fully settled. Similarly, loss also troubles Il Bae's widowed father, a haunted convenience store operator whose life revolves around arduous and thankless work. Lee's *Prey* also symbolizes grief and grievance in a doll that belonged to Noels' deceased sister, which he pawns to obtain money to survive in the context of a visciously individualistic white settler colony where capitalist entitlement often supercedes human empathy. Il Bae attempts to recover the lost doll, a metaphor for her will to make peace with the dead feminine, her own mother, and perhaps the lack of marriage and childbirth often expected from women and particularly the female children of Asian immigrants. And yet, within a life world of cash-based truths, she can only steal money from her grandmother's purse to buy the pawned doll. Within secular capitalism, incalculable loss melancholically replaces a deficit of life with money. Il Bae's buying

Fig. 2.6: Helen Lee, Prey, Film, 1995, 26 min.

of the pawned doll reflects the tenuous position of the racialized diasporic daughter in relation to both her emasculated and widowed father and Noel. She buys the doll as Noel looks down in shame, his posture connoting immasculation, perhaps born out of colonization. Throughout the film, Il Bae also labours to translate English to her immigrant father in an effort to soothe his deep anxiety in the face of the untranslatable loss of a migrant worker. Feminist film is an effort to translate spaces of loss, excess, retail therapies, and colonial denial into uncomfortable creative truths.

Zamaan discusses shooting *Disconsolatus* in downtown Toronto. The urban spaces of contemporary Toronto that appear on the surface to be clean and peaceful are re-signified as those that are haunted by the bloodiness of war and all the fraught exiles left to roam the streets, also mapped in the blood of colonial occupations. Zamaan states,

Trinity Square, outside Eaton's Center, has this beautiful historic well that is unbelievably cinematic, which we used as the mystical water-well from Darwish's poem. The graffiti

alleys on Queen Street West are like a labyrinth straight out of a graphic novel. For the scenes involving infected patients in the psychiatric complex, we used Toronto's infamous "hedonist" club, Wicked, which just happened to host a number of caged beds. I guess you could say that was memorable. (qtd. in Cadre)

There is a restaging of sexless missionary moralities that remap the landscape of the "great white North" in both Zamaan's and Lee's films.

A SHOT IN THE DARK: RISK AND RESILIENCE IN RACIALIZED QUEER/FEMINIST FILMMAKING

Prey offers insight into how Indigenous people and people of colour hold a tenuous position in nationalist narratives that are deeply intertwined with idealized notions of the white bourgeois family. While the film ends by suggesting the possibility of further romance between Noel and Il Bae, the last scene is a precarious shootout that offers an ironic feminist restaging of cowboy and Indian films, parodying colonial stories of Tontos and damsels in distress.[3] Il Bae reluctantly lends Noel the family car, which he crashes, causing property damage but emerging unscathed. He enters the family convenience store and tells Il Bae's confused father who barely speaks English that he has crashed their car. Noel offers him the gun, Il Bae's father tries to snatch the gun from his hands. Il Bae, much like Lee and Zamaan, embodies a feminist reversal of the heteronormative bio political gaze as a woman who can win in a shootout of competing racialized (im) masculinities. While Zamaan and Lee labour to shoot their films in a male-dominated industry, Il Bae shoots the gun, a phallic symbol of power. She wrestles the gun from her father, attempting to stop him from shooting Noel, and it goes off in a final, dramatic blow. The screen goes to black. With wonderful comic timing, the last scene depicts all three characters rising to their feet after the shootout, with the moment becoming an unlikely time for Il Bae to introduce her lover Noel to her father. "Dad, this is Noel. Noel, this is my Dad" (*Prey*). The charming film depicts ongoing struggles of love, lust, colonialism, and racism that continue just as Lee is resilient in her efforts to make film. Lee discusses the focus and inspiration required to survive as a

racialized feminist filmmaker, against all odds:

> I'm acutely aware of my filmmaking peers who are women, who after some promising short films had children or got married or moved on to other work. It's the men who remain, actually. Most, if not all of my filmmaking colleagues now are men. But the pressure is all mine, the pressure to produce, to make films that are good and that matter. (Lee 21)

Il Bae is driven by a passion beyond the rational in her final shooting of the gun. Similarly, feminist filmmakers survive outside of drives born only in economic reward or valorization by a patriarchal film industry in which women exist in film to be strangled and shot, and rarely do the shooting. Zamaan also discusses the struggle to find ways to distribute *Disconsolatus*:

> We want to continue the volunteer-based community feel by raising the money from the public to finally get *Disconsolatus* out to festivals and audiences around the globe. I encourage people who are interested in the film and this kind of filmmaking to contribute what they can to our Indiegogo campaign, even if it's just coffee change. (qtd. in Cadre)

Just as Lee continues to labour to receive funding and an audience within a filmic economy dominated by men, whiteness, and wealth, so too is *Disconsolatus* a film in which labour production ethics are born out of the realities of racial, gendered, and class politics. Il Bae and Helen Lee take a risky shot in the dark, just as Zamaan's films are precarious ventures. Zamaan describes the financial challenges of completing the film:

> I'm not going to shock anyone when I say that the film industry in North America isn't exactly gushing over a film inspired by Darwish with a Palestinian main character, so we are really relying on the support of individuals to help us bring *Disconsolatus* to the finish line. We can't accomplish this without you. Fans and contributors can get regular updates off Facebook and Twitter pages. (qtd. in Cadre)

UN-HAPPILY EVER AFTER:
COFFEE, CANNED BEANS, AND CREATIVE STRUGGLE

Throughout Lee's *Prey* we see food, coffee, and cigarettes as recurring motifs that frame the realities of migrant life. While Il Bae chugs coffee and smokes outside the convenience store, her grandmother brings her fruit. When Il Bae's grandmother Halmoni arrives at her apartment to find Noel there, and her conservative elderly moralities are rattled, she speaks of a long lost love in Korea who used to bring her bananas. She brings fruit, which the granddaughter and grandmother peel together, watching "wildlife" images light up the TV screen. Bananas are a signifier for colonization as they are not an indigenous fruit of Korea, but were imported and considered a luxury in Korea in the '50s and '60s. Il Bae's grandmother reminisces about the past in Korea, with the fruit serving as a metaphor regarding shared histories of imperialism across borders and temporalities. Halmoni sits between Il Bae and Noel, an old migrant woman's loss positioned between a post-coital and non-committal "outlaw" pair of unlikely lovers. There is no bearing of fruit on stolen land—only coffee, cigarettes, and sex.

The film however gestures to possible postcolonial futures. We see Il Bae hand Noel a mandarin orange. He takes a bite and the camera focuses on him planting the seeds in the ground. Il Bae and Noel's future together, and the future of postcolonial love in Turtle Island, is left to grow, like planted seeds on stolen land.

The truth of wage labour and productions of desire with no finality of familial reproduction also define the endless struggle of the racialized feminist/queer filmmaker to give birth to film. When asked what advice she would offer to emerging filmmakers, Zamaan is frank. She offers the hard-earned wisdom of the last women left standing, one who wins in a shootout born out of bursting fires of film, her camera used with as much passion as Il Bae's smoking gun. Zamaan's advice to emerging filmmakers represents the determination of politicized women and queers of colour making films, those who take a shot in the dark:

> Put it on paper and then film it. Even if it's with your iPhone. Even if your iPhone is 3G. Then make another one. And get used to eating canned beans, because some of your grocery

money is undoubtedly going to pay for your film. (qtd. in Cadre)

ENDNOTES

[1]Puar and Rai discuss *Bend it Like Beckham* in relation to the production of images of model minority "domestic patriots" within a time of a global "war on terror." The body of the peace-loving model minority represented in Gurinder Chadha's film is juxtaposed with the figure of the "terrorist." Zamaan's film disidentifies with the image of the model minority by centring the narrative of a displaced Palestinian female exile.

[2]For example, Al-wazedi's "Representing Diasporic Masculinities in Post-9/11 Era" discusses the emotive tragedies of "terror" scripted onto Muslim male bodies imagined to be "security threats" in a time of a global "war on terror," so too does the female exile in *Disconsolatus* represent a haunted figure of loss.

[3]See Kemper's "'Geronimo!' The Ideologies of Colonial and Indigenous Masculinities in Historical and Contemporary Representations about Apache Men." The author discusses representations of racialized Indigenous masculinity, as well as femininity in films such as *The Lone Ranger* in which the Indigenous man is depicted as a "Tonto" sidekick while the authoritative white man acts as the heroic cowboy.

WORKS CITED

Ahmed, Sara. *The Promise of Happiness*. Durham, NC: Duke University Press, 2010. Print.

Aladdin. Dir. Ron Clements and John Musker. Perf. Scott Weinger, Jonathan Freeman. Walt Disney Pictures, 1992. Film.

Al-wazedi, Umme. "Representing Diasporic Masculinities in Post-9/11 Era: The Tragedy Versus the Comedy." *South Asian History and Culture* 5.4 (2014): 534–50. Print.

Ansari, Usamah. "'Should I Go and Pull Her Burqa Off?': Feminist Compulsions, Insider Consent, and a Return to Kandahar." *Critical Studies in Media Communication* 25.1 (2008): 48–67. Print.

Anthias, Floria and Nira Yuval Davis, *Racialised Boundaries: Race, Nation, Gender, Colour and Class and the Anti-Racist Struggle*.

London: Routledge, 1992. Print.

Archibald, David, and Mitchell Miller. "From Rennes to Toronto: Anatomy of a Boycott." *Screen* 52.2 (2011): 274-79. Print.

Bend It Like Beckham. Dir. Gurinder Chadha. Perf. Parminder Nagra and Keira Knightly. Fox Searchlight Pictures, 2002. Film.

Bollywood/Hollywood. Dir. Deepa Mehta. Perf. Lisa Ray, Rahul Khanna, Moushumi Chatterjee. Different Tree, Same Wood, Telefilm Canada, 2002. Film.

Cadre, Fathima. "*Disconsolatus*: An Interview with Amita Zamaan." *Briarpatch Magazine* 9 Nov. 2012. Web. 31 Dec. 2014.

"Canadian director protests TIFF Tel Aviv spotlight." *CBC Arts* 29 August 2009. Web. Accessed: 5 June 2018.

Cheng, An Anlin. The Melancholy of Race. Oxford: Oxford University Press, 2000.

Crash. Dir. Paul Haggis. Perf. Sandra Bullock, Don Cheadle. Bob Yari Productions. 2005. Film.

de Lauretis, Teresa. "Popular Culture, Public and Private Fantasies: Femininity and Fetishism in David Cronenberg's *M. Butterfly*." *Signs* 24.2 (Winter 1999): 303-334. Print.

Disconsolatus. Dir. Amita Zamaan. Perf. Nilofar Dadikhuda, Tabitha Tao, Glen Reid. Vahana Films, 2012. Film.

Emberley, Julia. *Defamiliarising the Aboriginal: Cultural Practices and Decolonisation in Canada*. Toronto: University of Toronto Press, 2007. Print.

Eng, David. *Racial Castration: Managing Masculinity in Asian America*. Durham: Duke University Press, 2001. Print.

Fanon, Frantz. *Black Skin, White Masks*. Trans. Charles Lam Markmann. New York: Grove Press, 1967. Print.

Fire. Dir. Deepa Mehta. Perf. Nandita Das, Shabana Azmi. Kaleidoscope Entertainment, Trial By Fire Films. 1996. Film.

Foucault, Michel, and Jay Miskowiec. "Of Other Spaces." *diacritics* (1986): 22–27. Print.

Gopinath, Gayatri. *Impossible Desires: Queer Diasporas and South Asian Public Cultures*. Durham, NC: Duke University Press, 2005. Print.

Gygli, Karen. "Out of the Shadows: Three Asian-Canadian Playwrights Confront Film Noir." *The Projector; Bowling Green* 14.1 (Spring 2014): 74-96. Print.

Halberstam, Jack. *In a Queer Time and Place: Transgender Bodies,*

Subcultural Lives. New York: New York University Press, 2005. Print.

Hamamoto, Darrell Y. *Monitored Peril: Asian Americans and the Politics of TV Representation*. Minnesota: University of Minnesota Press, 1994. Print.

Kemper, Kevin R. "'Geronimo!' The Ideologies of Colonial and Indigenous Masculinities in Historical and Contemporary Representations about Apache Men." *Wicazo Sa Review* 29.2 (2014): 39-62. Print.

Lee, Helen. "A Peculiar Sensation: A Personal Genealogy of Korean American Women's Cinema." in *Screening Asian Americans*. New Jersey: Rutgers University Press, 2002. 133-159. Print.

Lee, Helen. "Helen Lee: Priceless." *Practical Dreamers: Conversations with Movie Artists*. Ed. Mike Hoolboom. Toronto: Coach House, 2008. 21-34. Print.

McWhorter, Ladelle. "Sex, Race, and Biopower: A Foucauldian Genealogy." *Hypatia* 19.3 (2004): 38-62. Print.

Munoz, José. *Disidentifications: Queers of Color and the Performance of Politics*. Minnesota: University of Minnesota Press, 1999. Print.

Pocahantas. Dir. Mike Gabriel and Eric Goldberg. Perf. Irene Bedard and Mel Gibson. Walt Disney Pictures, 1995. Film.

Prashad, Vijay. *The Karma of Brown Folk*. Minneapolis: University of Minnesota Press. 2000. Print.

Prey. Dir. Helen Lee. Perf. Adam Beach, Sandra Oh. Canadian Film Centre, 1995. Film. Web. 1 Nov. 2016.

Puar, Jasbir K. *Terrorist Assemblages: Homonationalism in Queer Times*. Duke University Press, 2007. Print.

Puar, Jasbir K. and Amit Rai. "The Remaking of a Model Minority: Perverse Projectiles under the Specter of (Counter) Terrorism." *Social Text* 22.3 (2004): 75-104. Print.

Rubin, Gayle. "The Traffic in Women: Notes of the Political Economy of Sex." *Towards an Anthropology of Women*. Ed. Reina Reiter. City: Publisher, 1975. 157-210. Print.

Said, Edward. *Orientalism*. London: Vintage Books, 1978. Print.

Samhita. "Nikki Haley and the Myth of Republic Diversity." 15 June 2010. *Feministing*. Web. 1 March 2015.

Siraganian, Lisa. "Telling a Horror Story Conscientiously: Representing the Armenian Genocide from Open House to Ararat." *Image and Territory: Essays on Atom Egoyan*. Ed. Monique Tschofen

and Jennifer Burwell. Waterloo: Wilfred Laurier Press, 2007. 133-157. Print.

Spivak, Gayatri Chakravorty. "The Politics of Translation." *The Translation Studies Reader*. Ed. Lawrence Venuti. New York: Routledge, 2000. 312-31. Print.

Treagus, Mandy. "Not Bent At All Bend It Like Beckham, Girls' Sport and the Spectre of the Lesbian." *M/C Journal: A Journal of Media and Culture* 5.6 (2002): 255-271. Print.

Tschofen, Monique, and Jennifer Burwell. *Image and Territory: Essays on Atom Egoyan*. Waterloo, ON: Wilfrid Laurier University Press, 2006. Print.

Water. Dir. Deepa Mehta. Perf. Lisa Ray, Seema Biswas, John Abraham. Mongrel Media, 2005. Film.

Yang, Suzanne. "A Question of Accent." *The Psychoanalysis of Race*. Ed Christopher Lane. New York: Columbia University Press, 1998.

Zamaan, Amita. Facebook page: *Disconsolatus*. Web. 1 Nov. 2016.

Žižek, Slavoj. "Multiculturalism, or, the Cultural Logic of Multinational Capitalism." *New Left Review* I/225 (1997): 28–51. Print.

3.
Fashion Crimes

Orientalism Frays in the Sartorial Worlds of Shirin Fathi

SMOKE AND MIRRORS:
SHIRIN FATHI'S AFFRONT TO ORIENTALISM

THE MIRRORS OF CAMERAS become cloudy, stained with the sultry smoke of an artist who challenges the objectification of the feminine form and images of the ostensible "Orient." In *Orientalism*, Edward Said discussed the construction of the colonial power dynamic between the constructed Orient and Occident as a gendered power relation. Said wrote of the relationship between Occident and Orient as one of forced submission stating, "The Orient was Orientalized not only because it was discovered to be 'Oriental' in all those ways considered commonplace by an average age nineteenth-century European but also because it could be—that is submitted to being—made Oriental" (6). The author discusses the relationship between French artist Gustave Flaubert and his muse, an Egyptian courtesan, Kuchuk Hanem. Said wrote of the epistemic and authorial violence of Flaubert, who represented the "Oriental woman" through a masculinist, white, European gaze that was expressive of and further solidified the power of the Occident to define and name the imagined Orient. Said wrote,

> There is very little consent to be found, for example, in the fact that Flaubert's encounter with an Egyptian courtesan produced a widely influential mode of the Oriental woman; she never spoke of herself, she never represented her emotions, presence, or history. He spoke for and represented her. He was foreign, comparatively wealthy, male, and these

84

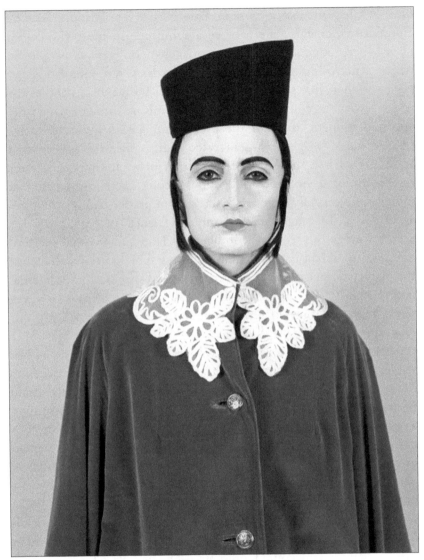

Figure 3.1: Shirin Fathi, Heart Throbs *Series.*

were historical facts of domination that allowed him not only to possess Kuchuk Hanem physically but to speak for her and tell his readers in what ways she was typically Oriental. (6)

The representation of the "typical" within colonial history was often made possible through mediums such as photography and

film. While Said discusses representations of the Middle East by European colonizers, one can see a similitude in the technologies of visual reproduction to produce images of Indigenous peoples in white settler colonies such as Canada. As discussed, Julia Emberley suggests that the staging of images of Indigenous peoples by white settlers in colonial Canada, was a means through which the apparent mimetic truth of the photo produced a highly selective range of racist images that denigrated Indigenous peoples. Far from apolitical artistry, these images were part of what Emberley terms representational violence. Indigenous people were constructed as morally and sexually degenerate, lacking in proper family structures and civility. This staged photographic "evidence" of degeneracy was used to justify the seizure of Indigenous land and colonial political governance. Shirin Fathi's striking photographic portraits challenge the history of racist uses of photography and specifically Occidental male authority. Fathi's artistic work also offers an affront to white settler representations of Other women that are used to solidify bids of white male power.

Flaubert also suggested that travel produced humility. The author wrote, "*Travel makes one modest*: one sees what a tiny place one occupies in the world" (181). And yet, Flaubert was not too modest to refrain from speaking on behalf of the imagined "Oriental woman," assuming a position of arrogance and claiming authority and the right to author narratives of women in the so-called East whom Flaubert represented in ways that solidify white masculinist power. One can consider how histories of entitlement inform who has the right to represent and speak on behalf of Others in both Orientalist representations and in white settler Canada. Europeans who traipsed across world maps in search of riches and land did not feign modesty when faced with those whom they arrogantly named and represented. The tiny place that whiteness and European history occupies in the world became the centre of the universe in shameless escapades of imperialism, in which artists played a crucial role in reproducing and creating racist discourse. Fathi's use of portraiture is representative of a new generation of transnational migrant artists, whose humility perhaps lies in occupying places on the margins of many nationalist, masculinist fantasies. As a female migrant artist whose work exists in a dialogue with Iranian history, Western feminist art history, and the "multicultural" mythologies of

a white settler nation, Fathi puts banal mainstream representations of "Oriental women" to shame.

As an Iranian artist who has studied in the United Kingdom and Canada, Fathi's work crosses borders just as the mediums that the artist employs are interdisciplinary. The artist's oeuvre bridges divisions between performance, photography, and fashion. Fathi's work has been compared to the artist Cindy Sherman, known for staging portraits of herself that offer images of the often static ways that American women are misrepresented in sexist popular and political culture. Fathi uses similar techniques to create images of herself that draw attention to how an artist's camera can manipulate ideas of authenticity. In the artist's series *Harem Babes, Me, and the Lover Boy*, Fathi appears dressed as a masculine figure with a long beard conjuring up images of the Qajar dynasty of Iran. Simultaneously, this series also includes images of Fathi dressed in feminine attire, again reminiscent of the portraiture photography of Iranian history. While Flaubert and other canonical male Orientalists used their artistic techniques to construct an imaginary Eastern feminine subject as inherently submissive, Fathi returns the gaze of Occidental history. The artist represents herself not as herself, but in ways that magnify the relationship between aesthetics, civilizational anxieties, and sexuality while also drawing attention to the staging of the "typical Oriental woman" as an ideologically driven artistic phantasm.

QAJARS, HAREMS, BABES, AND ARTISTIC TEMPORALITIES: FATHI'S PORTRAITS OF PROGRESSIVE DYNASTIES

Fathi's *Harem babes, me, and the loverboy* challenges the cartographical mapping of civilizational notions of culture, progress, and succinct borders of authenticity. As one reviewer states, Fathi's work, in representing the gendered ambiguities of nineteenth-century Iranian painting and portraiture, ruptures essentialist male/female binaries and simplistic divisions of "Eastern" and "Western" tradition. As one journalist states in discussing the installation,

This series looks at the representation of gender identity in relation to eighteenth-nineteenth century Iranian painting. The men and women in the images of this period have very

similar facial and bodily features; at times it is only the style of headgear that distinguishes male from female. Through photography and self-performance, this work explores the notion of gender ambiguity and draws a connection with the Western European painting of the same era. (Central Saint Martins)

In rupturing both the European colonial fantasies of a submissive "Eastern" woman to reveal the ambiguous gender-based and sexual aesthetics that are definitive of Iranian history, Fathi challenges ideas of Western secular feminist "progress." While neoliberal white Western feminism—particularly within a time of a global "war on terror"— often imagines women from or in the Middle East as oppressed by tradition, Fathi presents an alternative history of gender and sexual transgression that runs counter to myths of universal Western teleological progress. Orientalist ideas of time often depict totalizing images of "the East" as lagging behind "the West," particularly within universalist discourses of gender-based and sexual freedom. By presenting the Qajars as transgressive icons who subverted gendered norms well before English language feminist theory and branded forms of girl power, Fathi's camera shows us feminism through a different lens. Furthermore, in gesturing to not only the Qajar period but Western European artistic histories of representation, Fathi's novel artistic praxis also asks audiences and viewers to question how the geographical divides made between Orient and Occident are futile efforts to purify bodies and histories which have always commingled. Fathi's portraits echo Julia Kristeva's writings regarding the face of the foreigner as one who unsettles something in the viewer. In Fathi's portraits, the artistic rendering of the "Oriental" generates a psychic desire to look that cannot be divorced from the collective anxieties, aggressions, and desires of Orientalism and its lingering and new articulations within a global "war on terror." As Kristeva writes, "From heart pangs to fist jabs, the foreigners face forces us to display the secret manner in which we face the world, stare into all our faces, even in the most familial, the most tight knit communities" (4). One can consider that Fathi's staging of figures that represent the Middle East, Arabs, and Orientalist imagery arise at a time of global anxieties regarding the figure of the "home-grown terrorist," and a deep anxiety

towards brown bodies that besets how Brown people are imagined by the public, from every day encounters on city streets to major international borders. Fathi conjures up portraits that are tied to the Qajar dynasty, invoking the figure of the bearded Middle Eastern man and the image of the "Oriental" woman. The artist's rich and poignant work plays with libidinal desires and aggressions that have existed historically, in relation to outlaw images in Iran's ancient dynasties and in the contemporary Western world where the familiarity of who is "at home" compared to images of the supposed "foreigner" reveal how old Orientalist fables inform xenophobic paranoia toward "terror." Fathi's arresting artistic works boldly expose and challenge an age of (in) security.

Judith Butler argues that, "hegemonic notions of progress define themselves over and against a pre-modern form of temporality that they produce for the purposes of their own legitimation" (1). Butler makes reference to how ideas of "sexual radicalism" often imagine Europe and the West to be universal cites of liberation against images of a tyrannical and "backward" non-Western Other. Within an ongoing global "war on terror," this notion of regressive tradition is acutely expressed in Islamophobic discourses in which neo-Orientalist rhetoric constructs the so-called East as a space of submission. Western-led wars in the name of imperialist oil interests have been justified on the basis of liberating women in the Middle East from repressive patriarchies, with little attention given to specificities of histories of gender in the "Orient." Fathi's work resonates with the Iranian Qajar dynasty, opening up worlds that challenge Eurocentric genealogies of rebellion. Fathi's work moves against the strong currents of representational and epistemic violence which often ask the "native informant" and particularly migrant women to narrate a "back home" or culture of gender-based repression in which white Western nation states are scripted as sites of nouveau missionary salvation. Fathi conjures up an Iranian dynasty rich with defiance to puritanical sexual and gender-based moralities. As writer Joobin Bekhrad states,

Two of Shirin Fathi's series, *Heart Throbs*, and *Harem babes, me, and the loverboy*, see the photographer bedecked in typical (and at times, suggestive) Qajar attire, gazing languorously into the camera from behind kohl-rimmed eyes, in an exploration

of gender roles and sexual ambiguity during an age of "women with moustaches and men without beards," as scholar Afsaneh Najmabadi calls it.

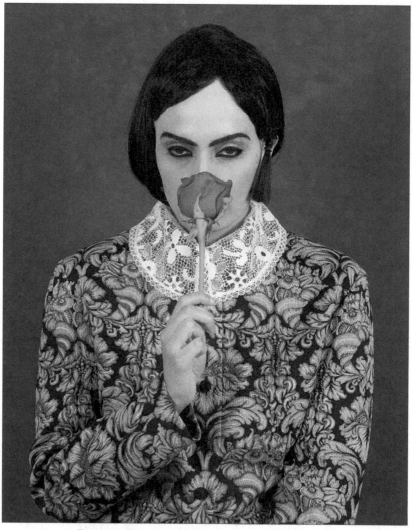

Figure 3.2: Shirin Fathi, Harem babes, me and the loverboy.

Against a banal mainstream rhetoric of white Western popular culture that would see the breaking of gendered norms as originating in the West, Fathi's performative worlds of photographic staging unearth buried mythologies of artistic history in Iran that cause one to question Occidentalist narratives of representation.

The Qajar dynasty is a fascinating example of the use of photography and performance-based aesthetics to capture transgressions that were made possible long before cultures of drag were appropriated and branded by major Western multinationals. Bekhrad further discusses their love of the images of the Qajars:

> My fascination with the Qajars as a teenager, one could argue, was purely superficial, as my knowledge of the depraved dynasty had been garnered from but the extravagant and iconic portraits of amorous wine-imbibing couples, dazzling concubines performing acrobatic feats on hennaed hands, and stern-faced, resolute monarchs, replete with monobrows, fulsome moustaches, and other sundry varieties of facial hair in vogue at the time. In other words, who could have blamed me for falling prey to all those swarthy locks and languid gazes?

The "in vogue" quality of the Qajar dynasty, so ingeniously invoked within Fathi's portraiture installations, also positions the artist and their praxis within the realm of fashion. One can consider the deep foreboding anxieties that exist toward the bodies of women in and from the Middle East within a contemporary global "war on terror." European and North American nations are increasingly banning Muslim religious signifiers, thus forcing Muslim women out of public space. Simultaneously, when Middle Eastern and Arab cultural signifiers are represented in Western media and political discourse, the Brown body is assumed to be Muslim, and Islam is pathologized through contemporary Orientalist discourse. The imagined "fashion crimes" of a traditional East are aesthetically and temporally challenged by Fathi's references to a dynasty in which the ancient and traditional cannot be separated from an edgy and sexy aesthetic that provides the foundations for contemporary subcultures of fashion, music, and art in Iran. Just as Occidentalist and colonial political history often constructed the "Orient" as following in the footsteps of European structures of governance and democracy, the history of creativity is by no means innocent.

The Orientalist imaginary continues to construct images of a tyrannical Middle East in order to support the corresponding narrative of "the West" as a space that can lay claim to the origins of an artistic

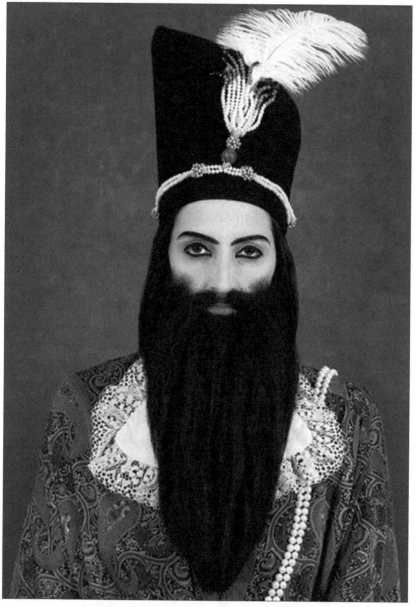

Figure 3.3: Shirin Fathi, Harem babes, me and the loverboy.

avant-garde. And yet, scholars note that histories of representation such as those of the Qajar dynasty point to an alternative mapping of global counter-culture. Bekhrad writes of the relationship between Qajar history and subculture:

The Qajars, by all accounts, were the genuine bad boys (and girls) of modern Iranian history bar none. Eons before David Bowie appeared haughty and epicene on the cover of *The Man Who Sold the World*, and later begot Ziggy and the scores of bastard glam rockers that would spring forth from his stardust seed, the Qajars were turning gender expectations and conventional appearances on their heads ... before ZZ Top and Sid Vicious, there were Fat'h Ali Shah and the all-out bad boy prince Zell-ol-Soltan, and before the likes of Johnny Thunders ever posed snarling with battered Les Pauls in their grimy hands, the Qajars were beating them at their game with *tars* and *setars* in their stead, and just as much—if not more—camp and swagger.

What is particularly striking in Fathi's recreation of the Qajar dynasty through the self-staging of portraits is the artist's use of their own feminine Iranian body as an artistic tool. In using her own body to perform a subaltern history of Iran, the artist challenges both the silent position of the subaltern woman within Occidentalist histories of European male authorship, and the image of a masculinist dynasty in which male figures were represented as rock stars with adoring female groupies.

Fathi takes centre stage in her artistic works, and thus decentres a cartographical, political, and aesthetic imaginary that comes to haunt masculinist and Eurocentric artistic worlds through an ongoing fetishistic gaze. Far from the silent, trapped women of *National Geographic* postures of Otherness, Fathi brings history to life, while also breathing life into long-standing histories of feminist uses of the photograph to challenge the phallic power of the camera.

MORE FACES THAN CINDY SHERMAN: A TRANSNATIONAL TAKE ON EARLY FEMINIST PORTRAITURE

As mentioned, Fathi's work has been compared to the work of artist Cindy Sherman, who began taking photos of herself in staged images reflective of the multiple ways that women are represented in popular culture. As one journalist writes, "In the school of Cindy Sherman, Fathi plays the wide range of characters in her own photographs, examining

the mundane, her own heritage, sexuality, repression and symbolism" (*Sixpillars*.org, Online, 2014). Sherman employs the techniques of photography to draw attention to the reproduction of certain tropes of the feminine within American popular culture and film. From femme fatale to victim to vixen, Sherman uses her body to perform tropes of femininity in ways that prove disconcerting to ideas of visual mimesis. The truth of the image is challenged in Fathi's shapeshifting poses, which draw attention to the ideological construction of the ostensible "real" behind the artifices of aesthetic performance. Fathi's work echoes the postmodern sensibilities of Cindy Sherman that scholars such as Laura Mulvey have commented on. Mulvey writes,

> Her art is certainly postmodern. Her works are photographs; she is not a photographer but an artist who uses photography. Each image is built around a photographic depiction of a woman. And each of the women is Sherman herself, simultaneously artist and model, transformed, chameleon-like, into a glossary of pose, gesture and facial expression. (137)

Fathi's portraits resonate with Sherman's ability to manipulate her own body to draw attention to the inherent performativity of gender. However, Fathi's skill as a transnational artist from Iran lies in her ability to create images that gesture to the chameleon-like postures of a racialized feminine body that crosses borders. As an artist from Tehran, who has studied in London, England, and Toronto, Canada and who lives and exhibits work on multiple continents, Fathi's performance-based photography demonstrates a deft skill in transforming her body to reflect multiple genealogies, routes, and roots. What is specifically striking in Fathi's portraits in relation to her time in Toronto lies in how her artwork troubles the fetishism of authenticity that often defines Canadian multiculturalism. Within official statist multicultural discourse, ideas of cultural and racial authenticity construct saleable images and products that are rooted in colonial and Orientalist understandings of the fixity of tradition, culture, and bodies.

Throughout *Uncommitted Crimes*, I draw on the writing of Slavoj Zizek, who suggests that multiculturalism functions as a form of

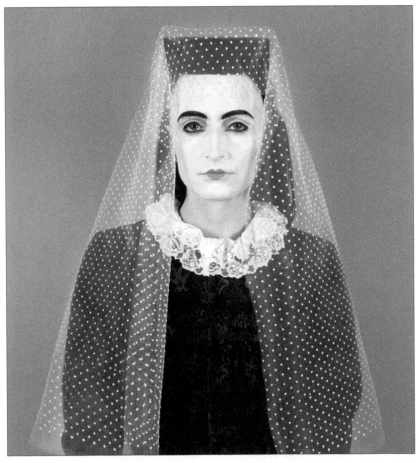

Figure 3.4: Shirin Fathi, Heart Throbs *Series.*

multinational capitalist colonialism. In the pageantry of Western multicultural branding the white consumer can occupy an empty universalist position from which to consume cultural Otherness, at a safe and sanitized distance. The irony of the fetishism of "authentic" cultural and racial alterity lies in how such seemingly "pure" cultures are made into capitalist goods. The ostensibly "authentic" is a highly stylized image of a palatable Otherness, branded as saleable to support state- and city-wide multicultural pageantry often in the form of official festivals and branded ethnic neighbourhoods used to support tourism. The body of the woman within official multicultural state pageantry is often stripped of all gendered and sexual agency, constructed as a passive object that represents static ideas of tradition.

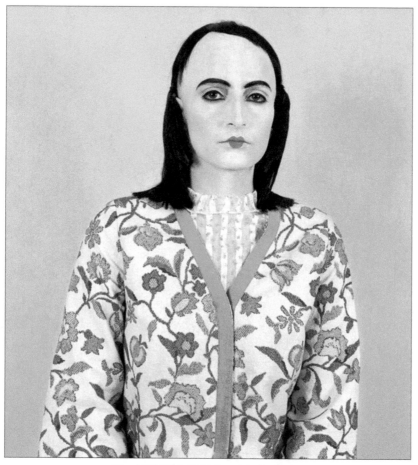

Figure 3.5: Shirin Fathi, Heart Throbs *Series.*

This gendered scripting of "culture" is caught within an enduring genealogy of Orientalist submission and passivity. Through her ability to embody Orientalist representations of both masculine and feminine images associated with "the East," Fathi draws attention to the often-ridiculous investments made in gendered, racial, and cultural ideas of the "authentic" and "pure." In discussing Fathi's *Harem babes, me and the loverboy* series, journalists comment on Fathi's reference to Persian histories that trouble a romanticizing of cultural tradition, and offer a sartorial set of photos that simultaneously mock the narration of nationalist histories of the nobility, and the phobic sentimentalizing of the sacredness of cultural Otherness definitive of the hegemonic Western multicultural gaze. As one author comments,

It was her Qajar series (pictured *Harem Babes, me and the loverboy*) that first caught our eye, with exaggerated, mostly disparaging portrayals of the dynasty that brought photography, amongst other things, to the Persian Empire (1785–1925), replacing the Zand dynasty, and re-asserting Persian sovereignty over much of the Caucasus. What are they often remembered for? Decadence, foreign relations, bankruptcy, resistance to a constitution. (*The Six Pillars*)

In using her body to display the decadent, the resistant, and the bankrupt, Fathi departs from the multicultural caricatures of the spiritually pure and submissive "East" and the "Eastern woman." Much like Sherman, Fathi often taps into libidinal anxieties regarding gender, profanity, and the psychosocial relationship between aesthetics and truth. It is striking that the *Harem babes, me and the loverboy* series also disrupts fixed ideas of race through the artist's staging of her body within this series. In one of the portraits, the viewers are faced with an image of the artist posing as part of the Qajar dynasty in white powdered make-up, with balding hair gesturing to age. The investment made between the truth of racial difference, age, and gender are ruptured through the capacity of the artist to manipulate her body. Much like Sherman's deft use of make-up, costume, and lighting to expose how judgments are made based on the assumed factuality of representation, Fathi challenges us as spectators to question how perception comes to be determined based on the illusion of appearances. There is an enigmatic appeal to Fathi's work, which much like Sherman's is often encoded with various signs and signifiers that leave viewers to unravel the multiple mythologies and reference points that exist within each image. As Mulvey writes of Sherman's work,

Sherman's work stays on the side of enigma, but as a critical challenge, not as insoluble mystery. Figuring out the enigma, deciphering its pictographic clues, applying the theoretical tools associated with feminist aesthetics, is—to use one of her favourite words—fun, and draws attention to the way that through feminist aesthetics, theory, decipherment, and the entertainment of riddle or puzzle solving may be connected. (138)

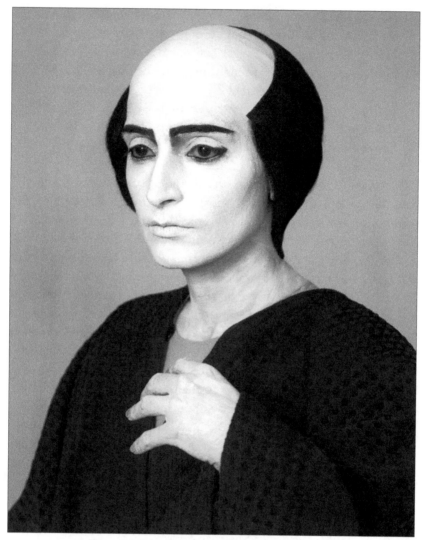

Figure 3.6: Shirin Fathi, The Heroes of Mountain of Love.

Are the figures represented in Fathi's works representative of the East or West? Is her body as a transnational artist from Iran who studies and resides in the West representative of one nation or cultural truth? The enigma of Fathi's work, much like Sherman's, might lie in the ambivalence of the aesthetic texts she offers. Fathi's artistry, like Sherman's and other iconic contemporary artists, fails to ever fully offer a fixed, static, and linear truth regarding identity, origin, and binary constructs of gender, race, and culture. Neither

femme nor butch, Eastern nor Western, representative of a sacred tradition nor of inherent secular trends, Fathi's portraits like several of the artists discussed in this book are neither here nor there, crossing infinite borders of the imagination. What is also remarkable in the work of Fathi is that like Sherman, Fathi's art points to the importance of the politics of the body. Sherman's work emerged in 1970s America, a time when second wave feminists were beginning to politicize the body. Mulvey argues that while body politics were popular among second wave feminists in politicizing reproductive rights, abortion, sexual violence, and sexual pleasure, Sherman's photography elucidated the importance of representations of the body to contemporary feminism. Mulvey suggests that Sherman's artistic works emerged within a climate in which political and scholarly debates arose regarding the representation of women's bodies in all facets of social and artistic life. Sherman's intervention into the climate of an emerging mainstream American feminist movement was an artistic one that utilized creative skill and style as a means of feminist pedagogy (Mulvey 139).

While Sherman is an artist whose politicization of the representations of bodies was reflective of second wave feminism in North America, Fathi's artworks offer insight into the importance of representations of Middle Eastern, Arab, and Brown bodies within our contemporary political climate. One can consider the banning of burqas, headscarves, hijabs, and veils throughout Europe and the over-representation of Brown feminine bodies that often define the ongoing global "war on terror": images of the burqa-clad woman as imagined victim of patriarchy and tradition appear over and over again within mainstream news media and popular culture. One can also consider the historical representations of the "Oriental" woman within European colonial travel narratives, painting, and photography: the harem was used to represent "the East" as a place of sexual depravity, lust, and sin. The irony of contemporary neo-Orientalist representations of Arab women lie in how colonial discourse once conceived of the Orient as a space of sexual depravity through images of the assumed licentiousness of the harem, while contemporary imperialist ideology conceives of the Middle East as a space of sexual repression. The body, within an ongoing genealogy of Orientalist image production born out of the politics of colonial

occupation, war, and global economic exploitation is one of shifting aesthetic meaning.

Debates concerning the global "war on terror" and meanings of sexual freedom, agency, and democracy are often structured in relation to a certain catalogue of images of Arab, Middle Eastern, Muslim, and Brown women. Just as the images of sexually-provocative Harem women of the East were used to promote colonial travels to the Middle East, contemporary images of Arab women as being in need of nouveau missionary salvation inform the politics of international development and war. Mulvey discusses Sherman's ability to utilize her artistic practice to neither wholly celebrate female bodies and aesthetics nor to wholly reject feminine performance. Mulvey argues that Sherman's iconic art practice lies in making mainstream representations of female bodies seem strange. Sherman began to gain critical acclaim at a time when the feminist movement in America was often concerned with critiquing and analyzing the caricatured and sexist representations of women in popular culture (Mulvey 139). Feminist artists often wholly reject the cartoonish ways women appeared in advertising and film, but Sherman's artistic oeuvre involved a refusal to turn away from dominant images of women. Rather than wholly standing at a distance from the derogatory and reductive portrayals of white American women in mainstream media, Sherman plays with these static roles as a form of hyperbolic theatre. In Sherman's photography, sexist and trite images of women in popular culture that are normalized through a barrage of television programming and Hollywood blockbuster films are troubled. Sherman over-performs the postures of white American femininity to the point that they seem bizarre and unreal. Similarly, in referencing the Qajar dynasty and other notable figures and images in ancient Iranian history, Fathi makes the representation of the "Orient" and the imagined "Oriental" woman strange. There is a curious questioning that takes place by the viewers of Fathi's work when one is asked to consider the relationship between the poverty of images of Brown, Arab, and Middle Eastern bodies and the poverty of history in contemporary popular, political, and artistic culture. What is further made strange are the static and cartoonish representations of the Middle East as a space of fixed temporalities and static ideas of gender, sexuality, and race. One is also left to question the idea of succinct ethnic religious "communities" fetishized within a discourse

of Canadian multiculturalism that relies on aesthetics as a marker of imagined "culture." Orientalism is made strange in the work of Fathi through the ways that the artist's references to the Qajar dynasty and the impurity of artistic lineages rupture the imagined binaries between East and West, between what is familiar and strange. Mulvey further discusses the spatial and temporal dimensions of Sherman's work.

> The journey through time, through the work's chronological development, is also a journey into space. Sherman dissects the phantasmagoric space conjured up by the female body, from its exteriority to its interiority. The visitor, who reaches the final images and then returns, reversing the order, finds that with the hindsight of what was to come, the early images are transformed. (139)

By using artistic space to trouble ideas of temporally fixed representations of gender and romantic images of the past, Sherman's artistic work refuses nostalgia. Images of supposedly "classic" femininities within Hollywood film and advertising are revealed to be highly fictionalized renderings of gendered subjectivities. Sherman's restaging of archetypal images of white American femininities also point to the 1970s and 1980s as times when there was a paradoxical rise in feminist consciousness, while women were simultaneously faced with tremendous pressure to conform aesthetically from sexist advertising and mainstream media. As Mulvey states, "The accoutrements of the feminine struggle to conform to a facade of desirability haunt Sherman's iconography" (141). Sherman's work reflects the ironies of North American feminist movement history and histories of capital. Feminist movements rose to public prominence in conjunction with increased popular culture and advertising representations of misogyny as beauty. These artistic works point to the relationship between female images of success, beauty, and wealth that continue to inform neo-liberal feminist careerism and the ironies of individualist ideas of achievement that often divide middle-class feminists from those engaged in grassroots political struggle. Fathi's portraits also trouble nostalgia, particularly popular among exiled migrants in the West. In restaging the Qajar dynasty, Fathi's installations do not romanticize Iranian history, but question the relationship between history, mimetic

truth, and artistic performance. Were the Qajars a dynasty that truly reflected their popular visual representations, or like the staged colonial portraits of the Indigenous and images of women captured by the phallic imaginaries of the male gaze, were these merely uses of the artistic to tell a selective historical narrative?

Mulvey argues that Sherman's performances of staged femininities offer insight into the relationship between surface and depth. Within many of Sherman's most famous works, there is an affective element to the image. Their photos point to an emotive longing, desire, and feeling that lies beneath the image. Sherman's blurring of the boundaries between theatre and photography involve a usage of facial gestures and poses that connote emotion. The characters Sherman plays convey vulnerability and an uneasiness that creates a moving experience for viewers. Similarly, the stoic poses that Fathi strikes give personality to the one-dimensional images that often structure Orientalist representations of "the East," particularly in a time of a global "war on terror" where racist representations flatten out the complexity of human lives.

One can consider this in relation to Fathi's use of religious iconography, which is visualized onto the body. Within an ongoing global "war on terror" the representation of Muslim and Middle Eastern women's bodies often involves the interpretation of religious signifiers—and particularly clothing—as emblems of gender-based repression and nationalism. However, these surface readings of bodies do an injustice to the complex genealogies of signification embedded in these signs. Mulvey further writes of the affective dimensions of Sherman's work:

> These photographs concentrate on the sphere of feminine emotion, longing and reverie and are set in private spaces that reduplicate the privacy of emotion. But, once again, an exact sensation is impossible to pin down.... They exude vulnerability and sexual availability like lovesick heroine/ victims in a romantic melodrama. (142)

Fathi's portraits are also deeply affective, resonating with emotions that are perhaps beyond translation. Fathi's works like Sherman's pose questions about the relationship between gender and emotion.

In Fathi's works however, a specific philosophical questioning occurs regarding the relationship between race, nationalism, exile, and affect. Can the Western spectator who is not familiar with the Middle East truly empathize or enter into the emotions conveyed by the artist's portraits? In what ways are white Western audiences able to emotionally connect to and understand the longing of the racialized migrant woman and man from the Middle East? One should recall how mainstream media often stages vulnerable images of Middle Eastern, Muslim, and Brown women within the ongoing "global war on terror" to justify missionary types of salvation that mask imperialist oil interests. By using techniques of performance, Fathi challenges notions of mimetic representations of the body, gesturing to the highly constructed and staged nature of identity. Fathi's work troubles the gaze of pity that is often lauded onto the bodies of Middle Eastern and Brown women by pointing to the ability for aesthetics to be manipulated by photographers and artists in order to generate emotion.

There is a voyeuristic element that perhaps comes with looking at images of artists such as Sherman and Fathi performing feminine tropes. By portraying women in often intimate and domestic scenes, in moments of trauma and vulnerability that are turned into public spectacle, Mulvey suggests that Sherman's works rupture divisions between the public and private lives of gendered bodies. One can consider the nature of gendered and sexual voyeurism within North American mainstream popular culture, in which celebrity culture, talk shows, and tabloid news often turn the private lives and desires of women into public forms of spectacle and scrutiny. Mulvey discusses Sherman's play upon voyeurism, one that offers a chance to consider the staging of private lives before public cameras, challenging the credibility and truth of highly constructed identities within times of mass brandings of the self. At a time when personality is publicized over social media to support one's financial aims, career, and image, Sherman's artwork offers both a chance for voyeurism and a chance to reflect on the gendered nature of an invasive gaze (Mulvey 142). The idea of voyeurism is also deeply relevant to the barrage of visual signifiers of torture, terror, and racialized Middle Eastern bodies that define representations of the global "war on terror." Voyeuristic impulses also pertain to the fetishism of moments of political spectacle such as the

Arab Spring. The bodies of Arabs have become symbols of fascination, titillation, fear, anxiety, and desire for white Western audiences. Fathi's portraits much like Sherman's point to the discomforts of a voyeuristic gaze lauded onto the body marked as "Oriental Other within a time of "terror." Much like Sherman's work, Fathi's portraits also offer an affective feeling of curiosity and ambivalent emotions regarding the artist's staging of images that rupture the public and private divide, offering the viewer the ability to peer into the domestic and bodily lives of female characters that the artist stages. In one of the artist's earlier series of works, Fathi is depicted in a domestic environment cutting vegetables. She wears make-up and her hair is done in a feminine style reflective of images of North American prom queens and debutants. This series is very much reminiscent of Sherman's works in which the seemingly mundane images of female domesticity are made into public spectacle. Like Sherman's invocation of the voyeuristic gaze of the public toward the female body as an object of both reproductive labour and sexual desire, Fathi's series captures the domestic drudgery and paradoxical sexualization of women in private space. In a bathrobe, positioned behind vegetables, the viewer is left with depictions of women at home that are demonstrative of the ambivalence of images of female domesticity as maternal and reproductive, that which is associated with unpaid labour, and simultaneously with sexuality. The peering eye of the viewer that casts its gaze onto the woman in private is left with all of the confounding impossibilities of constructions of the feminine within patriarchal culture. The woman at home must be at the same time a mother, a sexual vixen, an unpaid worker, and a body of leisure reflecting class-based ideas of the "kept women" of affluent men. Through the image, Fathi—like Sherman—offers us a mirror image of the haunting political questions that produce and structure supposed aesthetic truths.

SUPERMODEL MINORITIES:
FASHION, (RE)PRESENTATION, AND THE PUBLIC SPHERE

Fashion crimes cut across borders and bodies. There are those of authoritarian regimes of governance dictating dress, those of major multinational corporations branding bodies as sales, and those of artists who defy category and offer the viewer the chance

to consider the relationship between the artistic act and the always intangible jouissance of the emotive and bodily "real." Fashion within contemporary Tehran, as scholars discuss, is highly political in regards to what can be seen within the contemporary public sphere. Alec H. Balasescu discusses the male-dominated images that often define representations of fashion within the public sphere in Tehran. The author focuses on fashion brands such as E-cut that depict men in advertising found on public billboards, while images of women remain absent. Balasescu writes,

> Driving or walking through Tehran, one cannot but notice the advertisements for "E-cut.... E-cut, a ready-to-wear fashion brand for men, uses "stars" to advertise its products. Mohammad Reza Golzar, the lead singer in the band Aryan, appears on the banners in two different poses: at the seashore, barefoot, dressed in an e-cut three-piece suit, petting a horse (only the head of the horse is visible, along with Mr Golzar from the chest up). The same model can also be seen shooting an arrow with a defiant attitude. In contrast with this, in and around Tehran there are no banners advertising women's fashion. Likewise ... there are no representations of women at all on Tehran's streets, parks or public spaces. At the moment, e-cut is the only brand that advertises fashion products on public boardings. (737)

One can consider that in addition to her artistic uses of photography to create iconic works within series-based installations such as *"Harem babes, me and the loverboy,"* Fathi also has an active photographic practice within the fashion industry.

As an Iranian female artist who appears both behind and in front of the camera, Fathi ruptures divisions between subject/object that often structure the patriarchal phallic gaze. Fathi refashions representations of Iranian female artists, through manipulating their body as a performer and through the use of their skills to create interesting images of transnational fashion. Fathi's fashion photography departs from mainstream images found in conventional branding, and involves edgy, avant-garde images of street style globally. The body of the Iranian woman who is missing in action within mainstream advertising

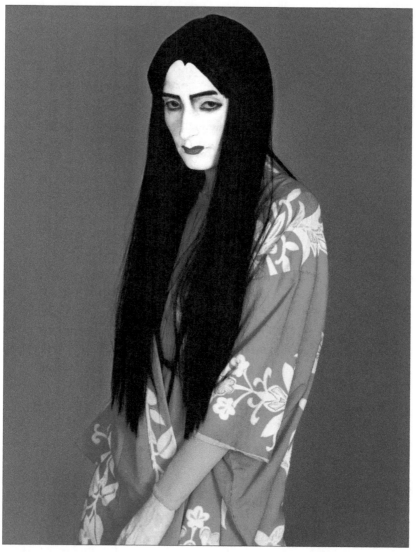

Figure 3.7: Shirin Fathi, The Heroes of Mountain of Love.

images in the public sphere in Iran is much like the bodies of many unconventional gendered and racialized bodies within mainstream Western fashion. However, the implicit censorship of sartorial gestures connoting secularism and sexual agency in the public sphere in Iran might produce novel forms of subculture. Writing in *Tank Magazine*, Fathi and Kourosh document the use of fashion salons to support local designers. As the authors state,

Salons and pre-season viewings, exclusive by choice as much as necessity, are organized by text message and phone calls on the day of the event. The fashion scene has evolved by word of mouth, and by people watching: those in the know can spot certain designers' work worn by people in the streets.

Much like the world of avant-garde art, Tehran's underground fashion salons offer a striking example of how creativity can and does flourish despite censorship from state authorities. In the absence of major multinational corporate branding of women's fashion through billboard advertising, Iranian fashion salons create spaces that defy the erasure of feminine pleasure. This culture of underground artistry also challenges an Occidentalist lens that celebrates the globalization of conformist aesthetics of white middle class beauty. Far from mall chic whiteness and the erasure of embodied feminine enjoyment, avant garde fashion spaces unfurl in city streets, turning style into a political act. While the "freedom" to express oneself through dress is often touted as a sign of liberty within life worlds of Western secular capitalism, this is coupled with the rise of major multinational chain stores and a uniformity of products, styles, and aesthetics often selling images of youth, whiteness, and suburban collegiate lifestyles as universally desirable (McBride). The supposed freedoms of Western consumer culture often leads many to the same old racks of sweatshop-made clothing under fluorescent mall lighting. Conversely, through a culture of salons, fashion in Tehran offers a different economy of clothing and an interesting sensory and social experience for the act of purchasing clothes. Fathi and Kourosh describe the experience of shopping in Tehran as one that resonates with the space of artistic exhibition and performance. As the authors state,

Tehran's fashion salons, in private houses across the city, hide in plain sight. The door might lead you to a bright showroom dotted with colourful racks of clothing. At the centre of the room stands a live mannequin, a tall, commanding presence in a carefully curated look. As she strides around, through clusters of shoppers, her overdramatic poses coupled with her sheer boldness bring a sense of the uncanny to the showroom.

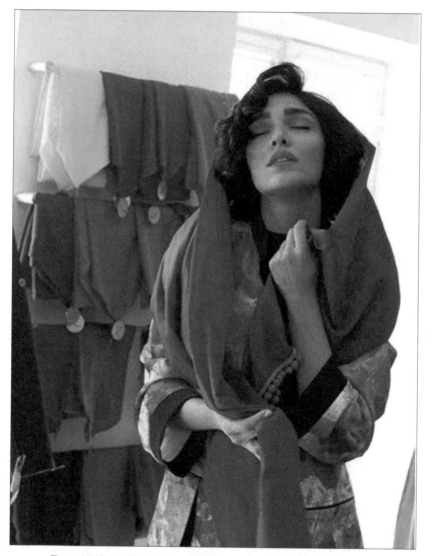

Figure 3.8: Shirin, Fathi, Mode a La Maison: Tehran's elusive fashion salons.

Everyone's attention is fixed on her and the clothes she wears always sell best, and fastest. The women in the salon are a range of ages—young women bring their mothers, who in turn come with grandmothers—but they are united by wealth. Women in ripped jeans and obscure hand-painted scarves, carrying Prada bags, swan about among the racks. The buzzer rings over and over again. (n.p.)

Fathi's writings and photography of underground street fashion and fashion salons in Tehran gesture to the artist's ability to cross disciplinary boundaries and tap into a global subculture. Fathi's photography, through the use of her own body as a gender transgressor, and through her keen eye for subversive style challenges the mainstream aesthetics of a banal public sphere of aesthetic similitude and conformity across borders. The quirky vintage muses of hip side streets in Western cities meet the beautifully bizarre restaging of vintage portraits of Iran's forgotten rebel dynasties, all definitive of Fathi's interdisciplinary and inspirational fashion crimes (Bergman; Fathi and Kourosh). In documenting street style across borders, Fathi's fashion photography challenges the erasure of women's bodies from the public sphere while also troubling mainstream beauty and fashion cultures in which women's appearance is often branded to value an archetypal white, middle-class bio-political feminine subject. Fathi's photographic work in global fashion along with their stylized portraits capturing the gender transgressions of Iranian history are a far cry from provincial colonial mothers in "Little House on the Prairie" bonnets, and the "Little Mosque on the Prairie" aesthetics that turn white settler narratives Brown. Fathi refashions the catalogue of representations of Iranian women and Brown diasporic bodies that are often made both hyper visible through neo-Orientalist frames, and simultaneously invisible in terms of individual sartorial and political sensibilities.

(IN)VISIBLE BODIES: THE FALSITY OF IMAGES: AND THE UNATTAINABLE JOUISSANCE OF THE REAL

Alec Balasescu discusses the politics of photographic representation within the public sphere in Iran, troubling Western understandings of visibility as being connected to political participation, particularly in regards to women's mobility and lives within Tehran.

Photography is a matter of concern in any public space, be it Muslim or not. Representing an object (the body) through photography means not only invoking the spectre of that object but also recreating its material presence, albeit a two-dimensional one. Approaching the practices of fashion

photography and clothing display in Tehran's urban spaces, [I] propose a divorce from liberal Western notions of a visible subject for understanding the construction of civil society in a Muslim context. [I] show how the relationship between women's mobility and body visibility is multi-layered and thus demands rethinking the concept of meaningful participation in the public sphere. (Balasescu 737–39)

One can consider the relationship between gender-based mobility for women, photography, and the fashioning and refashioning of the transnational female migrant's body depicted in Fathi's photography. While images of Iranian women's bodies within fashion photography are often absent from the public sphere in Tehran, contemporary Islamophobia and racism often makes the Brown woman's body an invisible presence in white Western settler nations. Fathi's photography troubles the modernist and Orientalist invisibility of the Iranian woman's body in the public sphere in both Iran and in Western multicultural discourses, in which "respect" for antiquated and conservative ideas of essentialist culture, tradition, and religion often remove the image of the Iranian woman from the public sphere. The visibility of the sexually transgressive, creative, and fashionable body of the Iranian diasporic migrant artist is one that in many ways ruptures Orientalist ideology. The colonial constructions of modernist citizenship that imagine the ideal citizen to be a warring Western male body is an Occidentalist conception of the figure of the citizen. Rather than being reflective of Iranian history, this understanding of the polis is reflective of a very Western idea of who counts as a member of society (Isin and Turner). Similarly, Canadian multiculturalism, which often fetishizes conservative gendered, sexual, political, and artistic images of "communities," also reifies gendered and spatial binaries, which are not foundational to Iranian history as evinced by the Qajar dynasty.

The relationship between cartography and history is often expressed through the appearance of certain gendered images in the public sphere. The modernist anxieties of time and space haunt the practices of fashion photography within contemporary Iran, and the politics of gendered visibility of the photographic images within the public sphere of Tehran. As Balasescu states,

Photographic practices in Tehran's fashion world reveal a certain mode of imagining and representing (women's) bodies in relation to modern repertoires (like fashion) in the spatial regime of ideal public and private separation along the lines of gender. At a second degree of reading, this finely traced line, based on visual regimes and on modes of representations (and presence) of women's bodies in public, also constitutes a discursive separation between a modern West and a non-modern Iran. Nonetheless, this (imaged) separation is continuously rearranged, explored and renegotiated through practices of fashion photography. (739)

Fathi's work is an ingenious artistic critique, which troubles these succinct divisions between Western fashion and Eastern tradition. In her portraits, there is a renegotiation of history itself, one that bears witness to an ancient past of fashionable and defiant dynasties that are not the product of supposed Westernization.

POLITICAL VOYEURISM AND PRIVATE SALES: SHIRIN FATHI'S DEFT CRITIQUE

Cindy Sherman's work offers a voyeuristic lens that ruptures divisions between the public and private spheres in women's lives and in the world of feminist art. Similarly, Shirin Fathi's artistic praxis bridges divisions between the ostensibly familiar body and the phantasmagoric representations of "foreign" women. The artist demonstrates that public politics regarding nationalism, belonging, and exile are interwoven into the personal aesthetic markers of racialized migrant women. Fathi stages gendered bodies in ways that trouble succinct ideas of what is familiar and strange, Eastern and Western. Balasescu discusses the relationship between dichotomies of the public and private stating that,

In general, much of the critique of modernity has been concerned with the nature of the public sphere. Theoretical analyses of the dichotomy of the public and the private have come to emphasize the gendered social construction of spatiality that juxtaposes public and private with masculinity

and femininity respectively. Many scholars of colonialism have explored the political significance of this dichotomy, as well as its Eurocentric character. This in turn has contributed to the broadening debate on multiple modernities. (739)

The author goes on to trouble the understanding of that which is deemed "public" within a politics of visibility.

> ...an implicit argument that traverses these approaches tends to associate "public" with visibility. The legitimate public (and political) subjects are thus visible subjects. This kind of public sphere, privileging unmarked male subjects, is the basis of Western modernity. The significant absence of women (and other minorities) in public is central in the critique of the Habermasian concept of the public sphere. More to our point, photographic representations of women in various contexts reveal the same discursive strategy of minimizing the role of women or eliminating women's bodies altogether from the public sphere. (739)

Challenging the Western/Eastern binary, Balasescu notes that within European advertising history, women and racialized bodies are also often invisible or denigrated through processes of public representation and visibility. Far from being endemic to the "Orient," forms of epistemic and representational violence haunt the public spheres of many nations. Balasescu continues,

> Thus, in the history of advertising in Europe and United States, women usually appear in subordinated roles, especially if they are non-white. In medical representations of the body women were, until recently, altogether absent unless the reproductive system was in question. This underlines the naturalized inferior position in which women have been represented in Western modern public spheres and the social reproductive role they are assigned in public discourse (where images are discursive practices). (739–41)

Fathi's artistic oeuvre offers a critical opening through which

one can consider the possibilities and tensions that arise regarding representations of women in the public sphere in Iran and globally.

FROM THE GALLERY WALL, SHE DOES NOT RETURN YOUR GAZE: THE POWER OF DISAPPEARANCE IN FATHI'S ARTISTIC PRAXIS

One can consider that while the West often purports itself to be a bastion of "women's rights" and "human rights," mainstream fashion advertising often celebrates images of white, heteronormative, secular fashion models who epitomize unattainable ideals of supposed beauty. Simultaneously, Muslim women, women of colour, and all others who depart from conventional aesthetic norms are often invisible within a public sphere oversaturated with billboard models.

Princess Hijab is a Parisian graffiti artist who draws cartoonish burqas on French fashion models on billboards in Paris. Artists such as Princess Hijab provide an ironic commentary regarding the equation of veiling with sexism within a European public sphere in which airbrushed models are often worshipped as goddesses. Princess Hijab offers what might be seen as a visual opposition to France's burqa ban, but also offers a critique of the corporatization and misogyny that passes as "sexual freedom" within Western secular capitalist worlds. The equation of Islam with sexism and specifically with the burqa as a source of women's oppression is turned on its head. In the artistic praxis of Princess Hijab, one can see a critique of the hypocrisy of a state that argues for banning Muslim women's dress at the same time it actively supports the misogyny of advertising and the equation of "female liberation" with capitalist freedom and white, bourgeois beauty standards. As Princess Hijab says of their artwork:

> I'd been working on veils, making Spandex outfits that enveloped bodies, more classic art than fashion. And I'd been drawing veiled women on skateboards and other graphic pieces, when I felt I wanted to confront the outside world. I'd read Naomi Klein's *No Logo* and it inspired me to risk intervening in public places, targeting advertising. (Chrisafis)

However, Princess Hijab argues that they are not explicitly defending the rights of any group, and no one needs the Princess as a spokesperson. As the artist states, "If veiled women want to make a point, they'd do it themselves. If feminists want to do something, they're capable of doing it on their own" (Chrisafis). She further comments:

> The veil has many hidden meanings, it can be as profane as it is sacred, consumerist and sanctimonious. From Arabic Gothicism to the condition of man. The interpretations are numerous and of course it carries great symbolism on race, sexuality and real and imagined geography. (Chrisafis)

Fathi also challenges a Eurocentric genealogy of art by referencing artistic traditions that are part of Iranian history. Just as Princess Hijab's artistic works make reference to the Arab Gothic period to subvert the assumed feminist imagery of Western secular space, Fathi's Qajars offer an alternative history of defiant images. Similarly, in making the Qajars and other figures from Iranian history into fashionable, interesting, and iconic works of art reminiscent of Sherman, Fathi's work calls into question the removal of certain gendered and racialized bodies from the public sphere globally.

The idea of political subjectivity and acts of "citizenship," which are counted as recognizable forms of participation in polis, are bound to Occidentalist ideas of the visible. As Balasescu states,

> In Eurocentric definitions of the public sphere, politically meaningful presence is therefore tied up with the question of visibility, an invisible body being automatically considered absent or politically meaningless. Speech, visibility and mobility are not only linked but also interchangeable. Research on the Muslim public sphere and Islamic modernities, however, calls into question the universality of this frame of analysis, pointing out both the importance of women's presence in the public sphere and the complicated relationship between visibility, mobility and political engagement. (741)

As the author further notes,

The presence of Muslim women in national and transnational public spheres is accompanied by, or follows the rules of, "choreographies of ambivalence" that seem contradictory to Eurocentric modernity. The dead end reached by the veil dispute in France (and the law against wearing the headscarf promulgated in 2003 is a dead end) is the expression of this incapacity to conceive of the modern political subject in terms other than those of Western liberalism. (741)

One can consider the relationship between imagined political power and visual representation in relation to mainstream images of fashion such as fashion billboards, in which the public visibility of women far from connoting political power is used to brand anti-feminist images as normative ideals to sell mainstream brands and oppressive notions of beauty. In Fathi's portraits, the artist is very visible, as she uses her own body to stage different portraits, while also being invisible, since Fathi does not represent her "authentic" self. In using the medium of photography, the ideas of presence and absence are themselves troubled. Similarly, artists such as Princess Hijab discuss the relationship between absence and presence in aesthetic signifiers such as the veil that trace the appearance and disappearance of the bodies of Muslim women in the Western secular public sphere. In a time of "terror," many women are caught within a racist gaze that makes the symbol of the veil both hyper visible and invisible due to legal bans. Princess Hijab discusses the visual imagery of the niqab and its relationship to public spaces within Europe:

> What is interesting about the Niqab is that it isolates the person wearing it, while at the same time, here in the Western world, especially in France, it puts you in the spotlight. That is the contradiction; by wishing to disappear from the public sphere, you are far more visible, you take possession of the public space. It is an empowering piece of clothing, but it can also be frightening. (Chrisafis)

In utilizing the image of the veil to subvert advertising, Princess Hijab offers a nuanced visual critique regarding the imbrication of capitalism and the global "war on terror." The relationship between

a global "war on terrorism" and global capitalism is also subtly commented on by iconic artists who play with Orientalist symbols. After the bombing of the World Trade Center, which marked a key moment in an era of security measures and Islamophobic rhetoric, George W. Bush instructed the American public to go back to shopping. Toni Morrison suggests that this offers evidence of how Americans were "not to be called on as citizens, only as consumers" ("Toni Morrison and Cornel West"). Princess Hijab's reference to Klein's *No Logo* is suggestive of the use of art to challenge a Western secular capitalist public sphere in which loyalty to national culture often amounts to brand loyalty to major corporations. As Annelies Moors remarks, "The message of Princess Hijab is not sartorial liberalism, but a critique of the visual terrorism of market liberalism" (134). While Islamophobic rhetoric pathologizes Islam as sexist, in using the aesthetics of the niqab, the hjiab, and the veil to attack high fashion advertising, Princess Hijab turns a deft and critical gaze back to mainstream secular culture. This artist offers an eviscerating visual commentary on the relationship between sexism, Western secular capitalist aesthetics, and saleable images of idealized beauty. There is perhaps a similarity between Fathi's stylization and theatricalization of identity and Princess Hijab's use of disguise to "culture jam" advertising. What unites both these artists' work is a challenge to ideas that are often popular within contemporary Western secular discourses of feminism, identity politics, and art that equate visible representation with power. One can question how the will to represent "authentic" multicultural subjects and promote the public visibility of feminism is bound to neo-liberal capitalist discourse. One is "free" to brand themselves as a saleable body in similar ways that major multinationals brand the bodies of models. Increasingly, those whose images and aesthetics are not saleable are purged from the public sphere. This literal and symbolic exclusion can be seen in forcing veiled women out of public space, the removal of graffiti and avant garde art from the public sphere, and the absence of unconventional images of beauty and style in popular culture. Defiant aesthetics that do not offer quaint provincial multicultural images to support national branding, or conform to neoliberal capitalist aesthetics found in mainstream advertising campaigns, are increasingly invisible in the urban public sphere transnationally.

Racist associations between blackness and dirt that can be traced back to colonial discourses of white supremacy also pathologize certain sartorial and artistic gestures. The black of the niqab becomes "matter out of place" while graffiti is associated with a supposedly unclean neighborhood to justify the classist policing of aesthetics. Stuart Hall writes of the spatialization of racism and the anxieties that arise when racialized bodies enter zones that are assumed to belong to white people. Hall states,

> ...every culture has a kind of order of classification built into it and this seems to stabilize the culture. You know exactly where you are, you know who are the inferiors and who the superiors are and how each has a rank, etc. What disturbs you is what she calls "matter out of place" ... you don't worry about dirt in the garden because it belongs in the garden but the moment you see dirt in the bedroom you have to do something about it because it doesn't symbolically belong there. (*Race the Floating Signifier,* 1997)

The racist cleansing of Muslim women's veiled bodies from the European public sphere produces an imagined order that returns the European polis to its purportedly pure origins. Similarly, the removal of graffiti from a Western public sphere littered with billboards imagines art as that which only belongs in a gallery to be bought and sold. The disruption brought about by those who do not "know their place" is therefore an inspiring gesture on the part of avant-garde artists. Fathi counters the usual place of the Iranian body in Islamophobic Western popular culture as a supposed "terrorist" or conservative apolitical model minority by creating complex artistic images. Similarly, Princess Hjab "terrorizes" the war on creative expression that defines conformist aesthetics of urban spheres governed by capitalism.

BEYOND THE NORTHERN REFLECTIONS OF A WHITE SETTLER STATE: SHIRIN FATHI CLOTHED IN CREATIVITY

While ideas of "representation" are often celebrated as connoting political power, the photograph does not involve a presentation of the real jouissance of the embodied subject, but rather involves a highly

theatrical staging. What strangely unites the mainstream fashion and advertising industries, statist multiculturalism, Western secular feminist movements, and other leftist "identity" political struggles is a fetishization of the idea of positive representation and visibility. The branding of supermodel minorities is often used to connote progressive change. However, the politics of (dis) appearance and originality often remain unquestioned, with static images of women or "multicultural" Others being used to celebrate diversity in similar ways that corporations use banal images to celebrate sales. In refusing to play the role of the "authentic" Other by enacting many roles in her artistic photography, Fathi offers a wonderful means through which viewers can consider the politics of visibility. While the supermodel minority body within the branding of multicultural Western nations and Western secular liberal feminism is made visible through images of "diversity" used to brand nation states and cities as tolerant and anti-racist, the medium of photography makes these bodies into spectacles in which the camera conceals as much as it reveals. Those who appear in Sherman's and Fathi's artistic work are much like female characters who appear in film and television. The gendered characters the artists embody and document derive meaning from ongoing genealogies of representation staged in theatres of political, nationalist, and gendered narratives. Such forms of discursive representation, particularly of femininity and women's bodies, are often presented as mimetic truth. By pointedly playing different characters, and using the techniques of fashion, make-up, lighting, and photographic skill, much like Sherman, Fathi leaves one to consider the relationship between the Orientalist phantasms of succinct identities and the inability for image or word to ever fully contain the jouissance of the bodily and emotive "real."

From her use of costumes to conjure up images of defiant dynasties to her use of highly polished and remarkable photographic skills and a keen eye for cutting-edge aesthetics, Fathi's photography gestures to the importance of iconoclastic art and (and as) fashion. Rather than conforming to implicit injunctions that demand `acts of aesthetic assimiliation dictated by state or market authority, Fathi breathtakingly breaks the rules with boundless creativity and timeless style. As Balesascu states in regards to clothing and fashion within the history of Tehran, "Clothing matters, as Emma Tarlo has shown

Figure 3.9: Shirin Fathi, The Heroes of Mountain of Love.

in detail. During the period of colonialism it became the instrument of modernization policies, as well as a form of anti-colonial struggle and the affirmation of national identity. Iran, although not directly colonized, was no exception" (741). The author discusses the ambivalences, erasures, and paradoxes of Iranian history that find implicit expression through the visualization of bodies in the public sphere. The anxieties, aggressions, and desires of colonial history appear and disappear through the absent/present image of the Iranian body and its various disguises. Balesascu continues:

It is difficult to write about Iran without waking the ghosts of a variety of "isms," from Orientalism to Modernism, passing through and obsessively lingering on Islamism. The popular perspective on Iran is that after its period of modernisation under the Reza dynasty, the Islamic Revolution gave way to a regime that attempted to crush its previous social "achievements." This new regime marked its coming to power through laws derived from shari'a, many of them targeting women and women's attire: wearing the headscarf and/ or chador in public spaces became compulsory. For many Western eyes this meant blocking their own vision, blinding them to the social dynamics and transformations taking place beyond this visible obstacle. (742)

Along with iconoclasts such as Princess Hjab and Cindy Sherman, Shirin Fathi uses highly stylized artistic disguises to question the relationship between women's clothing and religious and political ideology. The reliance on the visual as a means of gaging "authentic" feminism, repression, and a stable historical referent is questioned through the use of fashion as artistic masquerade. While gendered bodies and dress are regulated by the Iranian nation state, ideas of community-based authenticity, religious sensitivity, and the privileging of antiquated and uniform ideas of tradition and culture are often fetishized within Western multicultural discourse. Through their artistic work, Shirin Fathi subverts images of racialized diasporic feminine bodies as authentic aesthetic representatives of uniform communities. Like the disguises used by Sherman and Princess Hjab, the body is adorned and aestheticized as an imaginative gesture that cannot be separated from the production of creative work. A far cry from a dutiful nationalist daughter, supermodel minority, or a diasporic Western patriot used to brand a saleable ethnic community, Fathi's fashion crimes are those of creative vision. The absent "real" of the artist haunts gallery walls with invisible histories beyond an Orientalist and masculinist gaze.

CRIMINALLY CLEVER: ARTISTS WHO PREVAIL

In a time of borders, surveillance, and securitization, an Iranian

female migrant artist who travels from Iran to Europe to Canada and back again can be captured and cursed by the hostile gaze of the state. This century is beset with banal images of plastic airport security bins containing the cameras of avant-garde artists who take inspiration from ancient images and names now often pathologized as "holy terrors." Crass border security guards mispronounce names born out of aesthetic splendor beyond translation. Much of the North American mainstream learns of Iran through new forms of nonsensical Orientalist racism, constructing Middle Eastern and Brown female bodies as both hapless victims and/or security threats. And yet, much like the defiant genealogies of all those rock 'n' roll Qajars who came before, Fathi continues to produce art that defies the logic, temporalities, and aesthetics of Orientalism. If, as Theodor Adorno once remarked, "Every work of art is an uncommitted crime" (111). Shirin Fathi is guilty of stunning fashion crimes.

WORKS CITED

Adorno, Theodor. *Minima Moralia: Reflections on a Damaged Life.* Verso: English, 2006. 111.

Balasescu, Alec H. "Faces and Bodies: Gendered Modernity and Fashion Photography in Tehran." *Gender & History* 17.3 (Nov. 2005): 737-68. Print.

Bekhrad, Joobin. "Sex, Drugs, and Gol-o-Bolbol." *Reorient Magazine.* 10 Nov. 2014. Web. 3 Aug. 2015.

Bergman, Randi. "Streetsyle Photos from London Fashion Week." *Fashion Magazine.* 9 February 2013. Web. 3 Aug. 2015.

Butler, Judith. "Sexual Politics, Torture, and Secular Time." *The British Journal of Sociology* 59.1 (2008): 1-23. Print.

Central Saint Martins, Photographic Review, Graduate Photography Online, 2013. Web.

Chrisafis, Angelique. "Cornered—Princess Hjab, Paris's Elusive Street Artist." *The Guardian* 11 Nov. 2010. Web. 9 June 2015.

Emberly, Julia. *Defamiliarizing the Aboriginal: Cultural Practices and Decolonization in Canada.* Toronto: University of Toronto Press, 2007.

Fathi, Shirin and Kourosh. "Mode à la Maison: Tehran's Elusive Fashion Salons." *Tank Magazine* 61 (2014): n. pag. Web. 3 Aug. 2015.

Flaubert, Gustave. *The Letters of Gustave Flaubert: 1830-1857.* Ed. Francis Steegmuller. Boston: Harvard University Press, 1980. Print.

Hall, Stuart. *Race: The Floating Signifier.* Directed by Sut Jhally. Produced by: Media Education Foundation. London, 1997.

Isin, Engin F. and Bryan S. Turner. *Handbook of Citizenship Studies.* London: Sage, 2003. Print.

Kristeva, Julia. *Strangers to Ourselves.* Trans. Leon S. Roudiez. New York: Columbia University Press, 2001. Print.

McBride, Dwight. *Why I Hate Abercombie & Fitch: Essays on Race and Sexuality.* New York: New York University Press, 2005. Print.

Moors, Annelies. "NiqaBitch and Princess Hijab: Niqab Activism, Satire and Street Art." *Feminist Review* 98 (2011): 134. Print.

Mulvey, Laura. "A Phantasmagoria of the Female Body: The Work of Cindy Sherman." *New Left Review* I/188 (July–Aug. 1991): 137-50. Web. 3 Aug. 2015.

Said, Edward. *Orientalism.* Ed. Bill Ashcroft and Pal Ahluwalia. London: Routledge, 2001. Critical Thinkers. E-book.

Six Pillars. "This Week's Six Pillars Show – Bizarre Qajar." *Six Pillars.* 27 February 2014. Web. 3 Aug. 2015.

"Toni Morrison and Cornel West: A Historic Discussion on the State of the World, the 50th anniversary of the Brown Decision and Condoleezza Rice." *OpenDemocracy.* 28 May 2004. Online video. 9 June 2015.

Žižek, Slavoj. "Multiculturalism, or, the Cultural Logic of Multinational Capital." *New Left Review* I/225 (Sept.-Oct. 1997): 28-51. Print.

4.

A Simple Strand

Kara Springer's Resplendant Minimalism

IN THE GALLERY SPACE are two white canvases. As haunting in their cold and austere emptiness as sheets of snow that line a white settler landscape. As pristine in their clean and hollow aesthetic as freshly starched bed sheets in provincial homes. One must, however, take a closer look. On the expansive canvas are the smallest of lines. Squiggly imprints that curve across the large white surface with the subtlest gestures, like the curve of a dancer's back, like the unremarked-upon etchings of shadows on the hard white concrete of a city. Kara Springer's *Ana & Andre* series was exhibited at the Nia Centre for the Arts in Toronto, Canada, as part of *Skin Deep: (Re) Imaging the Portrait* exhibition. Springer's installation is a beautiful example of minimalist art that breaks from canonical art histories of "apolitical," "unmarked" white male bodies selling dots and lines on pages for millions of dollars, their assumed brilliance divorced from and yet a product of their skin and all the colonial power it carries.

Springer's lines are pieces of her hair, branded on a white surface in archival pigment print. *Ana & Andre* is a large photo-diptych of strands of the artist's hair on a stark white canvas. The installation's name makes reference to Cuban American artist Ana Mendieta, who died tragically under mysterious circumstances, and her partner, Carl Andre, a famed minimalist artist who was accused of murdering Mendieta. Springer uses photos of strands of her hair, blowing up these images of the infinitesimal aspects of human embodiment to the point that they appear on the gallery wall as dark unidentifiable lines on a large white canvas. The strands of the artist's fallen hair took on personal significance resonating with her father's alopecia totalis, an autoimmune condition brought about by stress that caused

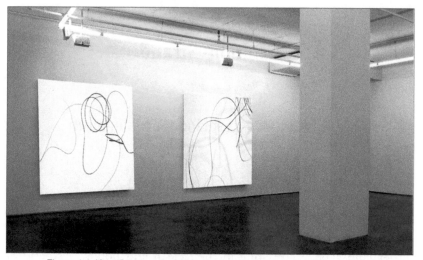

Figure 4.1: Kara Springer, Ana & Andre *Series, 2014, archival pigment print. Courtesy of the Artist. Photo: Kara Springer.*

him to lose his hair during her adolescence. Springer describes the artistic process that went into making this installation as an organic one that began when she noticed the imprint that strands of her hair made on the bathroom counter. After noticing the aesthetics of this everyday image, she began to consider what it would mean to shift its scale, turning the ubiquitous strand of hair into an ambiguous image of abstract expressionist art. In order to change the scale of this image from the very intimate to an abstract image for public view, Springer needed to capture high-resolution images of her hair. Springer began saving strands of her hair and then taking them to her studio, where *Ana & Andre* was created. In the space of her studio, Springer used intense light and high-resolution photography techniques to magnify strands of her hair, turning them into lines on a canvas (Springer). Springer interweaves everyday imprints of embodiment into a deft critique of canons of artistic history in which the bodies of artists carve out different impressions in artistic archives. Within discourses of Western meritocracy that bleed into the art world, the quality of one's artwork should ostensibly be judged outside of its embodiment. In Springer's work, the body becomes art and the art world becomes embodied.

Springer states that *Ana & Andre* exemplifies her grappling with minimalist artistic traditions and the place of her body as a Black

woman within an artistic canon that often cites cisgender white men as its most formidable icons. Springer uses this installation to comment on the relationship between her own body and the death of Mendieta. The artist's embodiment as a Black woman aesthetically disappears, while the body of racialized Cuban-American Mendieta has literally vanished through a death shrouded in suspicious circumstances and unspeakable violence (Springer). When the artistic work appears before an audience, they are left with the visual image of two lines dancing on a large white backdrop, a minimalist image that bears no apparent visual reference to the body or the histories in which it is constructed. This use of minimalism is expressive of Springer's magnanimous artistic skill. Author Pamela Edwards reviews Springer's installation that appeared publicly in Toronto as part of an exhibition, which reimagined portraiture and displayed the work of several prominent Black artists. Edwards writes, "Dark wisps of the artist's fallen strands of hair lie magnified against a boundless white background, their meandering lines rendering the body as an elusive trace" (10). The author further comments on the overarching political significance of the work: "Named for famed American minimalist sculptor Carl Andre and his wife, Cuban-born feminist body artist Ana Mendieta (who dies tragically under mysterious circumstances), these evocative works also function as haunting anti-portraits (of the artist couple and Kara herself) probing the tensions between realism and abstraction" (10).

In the seemingly simple image of two lines on a blank canvas, Springer gestures to the fraught politics of Black women's hair and embodiment within the Americas and globally. The artist uses this non-didactic image of Black femininity in a time when the burden of representation often evokes obvious positive representations of Black femininities to counter mainstream racism. Springer enters into the minimalist canon to offer an artistic work that ingeniously uses the techniques of minimalism in political ways. The artist, born in Barbados and raised in Canada, uses her own body and the minimalist art tradition to archive the marked bodies of racialized femininities. *Ana & Andre* exists within an artistic tradition often associated with those whose art-based praxis is often divorced from their identity— namely, white men. Springer's brilliance lies in a disidentification with minimalism. Writing in regards to the series, Edwards states,

"Springer's large scale photo-diptych, *Ana & Andre* are conceptually charged works that restage the subjective and unsettle identifications, refuting the spectacular function of the photography as neutral manifestations of the truth of appearances" (9). The medium of the photo is often assumed to offer a mimetic form of representation capturing the ostensible truth of the body. Along with other artists discussed in *Uncommitted Crimes*, the truth of the authentic image is troubled in Springer's deft use of this medium to produce minimalist artworks that challenge the voyeuristic gaze of the camera.

As discussed in relation to Shirin Fathi's artistic work (see chapter 3), one can consider the relationship between photography and colonial history in which the photo was often used to denigrate the bodies of the colonized. While photography has been and continues to be used to reinforce anti-Black racism and the sexualized spectacle of the Black female body, the photograph was also used as a form of epistemic violence against Indigenous peoples by European colonizers in the making of modern Canada. As Julia Emberley states, "...technologies of representation, including film, photography, and print culture, disseminated images that contributed, whether knowingly or not, to the imposition of the bourgeois patriarchal family on Indigenous societies" (3). Emberley argues that the family portrait was used to stage photographic images of Indigenous kinship structures as pathological, with matrifocal cultures of Indigeneity being denigrated against the image of the "good" white bourgeois colonial family. As discussed throughout this book, photographic images depicting Indigenous people as culturally and morally lacking were used to justify the seizure of Indigenous lands. Representations of the ostensibly dysfunctional Indigenous family served as a microcosm for state power and the imagined incapacity of Indigenous peoples to govern themselves. The image of the "wild squaw" and wayward Indigenous man as bad parents subsequently constructed such figures as being unable to hold power over motherlands and father countries. In troubling the innocence of the photograph as telling an apparent truth, Springer's works offer an anti-colonial rendering of the minimalist aesthetic.

Springer's work gestures to the work of minimalist artists such as Carl Andre and the absent body of the racialized female artist— that of Ana Mendieta whom Andre was accused of murdering.

While Andre was not found guilty of murdering Mendieta, there was a great deal of controversy surrounding her death; particularly in the feminist art community. In troubling the imagined real of the camera's gaze, the works also remain haunted by the ghost of European colonial representations of masculinist governance and patriarchal power figured in the absent bodies of Indigenous women stripped of political authority. Finally, in refusing to offer a spectacle of the Black female body often represented as a mimetic truth through cameras and screens, Springer's work is a rich philosophical text of multiple meanings.

In this chapter, I suggest that the *Ana & Andre* series poses philosophical questions regarding the ethics of interpretation and canon formation within art history. One could read the work as a challenge to the disembodied worlds of white masculinist art, an artistic praxis that poses questions regarding race, gender, and embodiment through uses of Black female hair within minimalist artistic traditions. However, once could also ask why the art of racialized people and women is rarely considered apart from or outside of their skin? Any individual creativity and iconic genius is often stripped of subaltern artists whose art is read through personal biography, familial histories, and assumed community membership.

Ana & Andre conjures up the ghost of Ana Mendieta, who died after falling thirty-four floors out of the window of the New York apartment she shared with Carl Andre. Andre was accused of pushing his wife out of the window and subsequently acquitted after a three-year trial. Andre's lawyers argued that Mendieta's death was a suicide. In naming this work *Ana & Andrea*, Springer gestures to the violence the body carries and to the gendered body as an archive that cannot be fully spoken. It is also deeply interesting that the artist uses Ana Mendieta's first name and Carl Andre's last name. The authorial masculinist power of the white male artist is expressed, while the use of Mendieta's first name personalizes them. This personalization is also reflective of the embodied connection that Springer and Mendieta share as racialized women whose artistic work, lives, and deaths cannot be separated from the ways history marks their skin. Andre, as a famed white male artist, is invoked as a public figure of authorial, professional, and artistic power by using his last name. This act of naming becomes a subtle critique of how

white men are often named in ways that allow them to be respected outside of their personal lives, bodies, and relationships with women. This is particularly striking in relation to Andre's life and career and the accusation that he murdered his wife Mendieta.

Figure 4.2: Kara Springer, Ana & Andre Series, 2014, archival pigment print. Courtesy of the Artist. Photo: Kara Springer.

The naming of the work deftly places Springer's body of artwork between the celebrated minimalism of canonical artist's such as Andre and the body of Mendieta, that of a racialized woman whose death raises questions pertaining to life and death, celebrity, trauma, and to many histories marked with the blood of women. Rather than offering succinct and finite answers to the many poignant questions that *Ana & Andre* evokes, Springer's sharp minimalist aesthetics are well-styled philosophical texts that do what philosophy is often meant to do— leave one with interesting questions.

HAIR: POLICED IMPRESSIONS

Art history can be contextualized and thought of in relation to political history. Anna Chave discusses the relationship between the minimalist art tradition and the biography of artists who are considered to be part of this canon. The author situates minimalist art within the

political history of 1960s America, which produced multiple social movements such as the anti-war, feminist, and radical Black Power movements. Chave discusses the relationship between philosophies of depersonalization that informed minimalist art history and Marxist philosophy. As Chave writes,

> In the radicalized 1960s, neo Marxists including partisans of Louis Althusser, elevated the categories of the material and the social over those of the individual or the subjective. For Marxists generally—as indeed for capitalism also— the personal and expressive values have historically been derogatory as secondary and tacitly or otherwise, as feminine since, women have ordinarily been acculturated to assume these areas as their proper domain. (149)

Chave goes on to discuss feminist art critics and artists whose creative practices were often tied to personal biography and a politicization of the social realm. Where minimalism attempted to divorce the body of the artist from the artwork, feminism politicized bodies and saw the personal lives of artists as being inseparable from their creative labour. One can further consider the radical Black activist movements that emerged within this time period, those that politicized Black bodies with slogans such as "Black is beautiful." The aesthetic productions of visual cultures in these movements were tied to political histories of racism and slavery. The personal bodies of Black people and specifically Black female radicals such as Angela Davis, known for their iconic Afro, were historical texts that countered white racist narratives of American nationalism. One can therefore question the refusal to consider biography within minimalist art histories that glorify the material productions of white men in relation to other histories of personalized politics and aesthetics that emerged in this period, namely those of racialized and female artists.

Within minimalist art history and criticism, the individual artwork and disembodied genius of the artist was valued outside of any larger political consideration. As Chave states, "The unseating of the author or artist as transcendent, self-present subject and authentic locus of meaning held, from this vantage point above all liberatory prospects"

(150). Whereas Black Power constructed an aesthetic that strove for a political, visual, cultural, and communal liberation of Black bodies from white supremacy, minimalist art saw the artwork and artist as insular and as standing apart from larger political goals. Black Panther, political revolutionary, and scholar Angela Davis's iconic hair was not only a visual challenge to white, racist conceptions of beauty and femininity but was also associated with a larger political struggle and anti-racist vision. Far from being a fashion trend or creative whim, Davis's hair, like the hair of Black women during this period and to this day, became an archive of political violence. One can consider that the police and FBI often stopped many Black women in this period who had Afros, owing to the routine harassment and assault of the Black Panthers by the state. Davis was even known to wear a straightened wig to evade police harassment (Davis).

The aesthetics of Black femininity have rarely been conceived of or discussed seriously in canonical histories of the Americas. The violent policing of Black femininities is part of ongoing genealogies of slavery, racism, and the biopolitical valorization of white middle-class lives against the scripted deaths of Black people and particularly the Black working class. In using strands of her own hair to construct artistic installations that can be situated within the minimalist tradition, Springer's work complicates both the assumed apolitical tradition of minimalist art and the essentialist politics often associated with Black diasporic aesthetics, specifically the visual productions and performances of Black women. The use of Springer's hair challenges the refusal within mainstream, larger white male art worlds to consider biographies and bodies within minimalist art history. Simultaneously, Springer's minimalist aesthetics also trouble dominant readings of "Black art" as being part of histories of African diasporic communities that stand apart from mainstream art history. Is the Black female minimal artist an iconoclast whose individual artistic genius should be judged outside of history, as so often happens with white men who produce minimalist art? Or should the stroke on Springer's canvas be read as part of feminist and Black political histories that challenge the capacity for the personal to be considered apart from the political and the relationship that both play to aesthetics? *Ana & Andre* does not answer lingering questions regarding the sexism and racism of mainstream white masculinist

art, feminist, and Black power movements with empty platitudes. Rather, Springer's thought-provoking work is a post-structuralist aesthetic of Black diasporic creativity that unsettles these mainstream histories with a "simple" line on a page.

Chave discusses the relationship between Marxist and post-structuralist criticism, both of which divorce the body of the artist from the artwork and inform dominant approaches to minimalist art. Chave states, "Marxist informed criticism has largely persisted in depreciating the biographical in so doing finding common cause at once with much post-structuralist art criticism as well as with the deindividualising impetus underlying key Minimalist initiatives" (149). Chave discusses the costs incurred by female artists who aligned themselves with the feminist movement as opposed to the depersonalization of minimalist and Marxist traditions. She writes that within this period, minimalist art criticism attempted to judge a piece of artwork only in relation to itself and the individual flamboyance of the artist. Feminist artists who politicized and aestheticized the personal risked being left out of the action of a largely white male art world. As she states, "For a woman to resist the example of Pop and Minimalism by overtly personalizing her art was to risk branding her work as retrogressive and by the same stroke to resist reinforcing that tacitly individuous division of labour that presupposes that women will assume 'expressive roles and orientations' while men assume 'instrumental ones'" (51).

One can consider Springer's series in relation to the history of minimalist art that sought to divorce the instrumental from the expressive, the emotional from the rational, and the body from the mind. While Chave offers a gender-centric reading of feminism and feminist art history, Springer's work further complicates the disembodied white masculinist ethos of minimalism by utilizing Black female hair as a minimalist artistic gesture. The idea of "expressiveness" is not only imagined within sexist discourse to be a trait associated with the assumed irrationality of women but also structures racist representations of colonized people. One can consider that it was in the 1960s that Negritude movements emerged, through which qualities such as free expression and emotion, used to denigrate Black bodies as anti-intellectual, were elevated to a higher status than essentialist instrumental qualities associated with whiteness. And yet, while early feminist, Black Power, and Negritude movements attempted to

celebrate feminine qualities of personality, emotion, and aesthetics, they did not challenge binary divides of masculine/feminine or white/ black, but merely elevated the assumed sentimentality of oppressed peoples to a privileged position. Negritude involved the promotion of jazz cultures and expressive arts traditions that bound Black art to African and African diasporic histories, while Black power celebrated essentialist Black aesthetics that were created in sharp contrast to all that was associated with whiteness.

Springer's work troubles both the essentializing production of "feminine" and "Black" art through her use of minimalist techniques. And yet, Springer's work also challenges the disembodied history of minimalist art and criticism by utilizing her own body as that of a Black female artist. Springer makes a minimal imprint on a canvas that opens up an archive of political history much greater and richer than what appears on a stark, white surface.

SKIN DEEP: SEEING *ANA & ANDRE*

In the gallery space, I see the lines on a white canvas. Like other artistic events, there is a relationship between the art as object and the performative work of seeing that makes exhibitions into performances. This performance-based dimension of an exhibition is especially acute in the staging of artistic works by racialized artists within exhibitions such as *Skin Deep*, a pointedly political art exhibition that displayed the under-represented works of Black artists in a white settler colony. The minimalist tradition within canonical writings pertaining to mainstream art history is often discussed as the antithesis of embodied performance. However, in this gallery space, seeing *Ana & Andre* at *Skin Deep* and seeing it be seen by spectators, there was perhaps an element of performance that entered into the frame of racialized and gendered representation.

Peggy Phelan discusses the increased turn to the techniques of performance and performance-based theory by artists and art critics working in diverse mediums of painting and photography. Phelan discusses the art of Sophie Calle, who photographed several paintings that were stolen from the Isabella Stewart Gardner Museum in Boston. Calle recorded descriptions of the paintings by those who had seen the works before they were stolen. Phelan suggests that the myriad

of descriptions of the paintings, all of which construct a different memory of the work function as a form of performance, resonating with the performative nature of viewing art. Phelan writes that Calle's artistic installation

> ...suggests that the descriptions and memories of the painting constitute their continuing "presence," despite the absence of the paintings themselves....The fact that these descriptions vary considerably—even at times wildly—only lends credence to the fact that the interaction between the art object and the spectator is, essentially, performative and therefore resistant to the claims of validity and accuracy endemic to the discourse of reproduction. (147)

At first glance, I understood *Ana & Andre* to be a form of minimalist art, seeing only the small lines that moved across a canvas, almost invisible to the eye. It was only after speaking with Springer and learning that these were imprints of the artist's hair that I saw the work in relation to histories and ongoing political struggles of racism and feminism. It was through the body of the artist, a Black feminine diasporic subject within a white settler colony, that the art took on a new and complex meaning. As Phelan writes, "The description itself does not reproduce the object, it rather helps us to restage and restate the effort to remember what is lost" (147). Read in context, staged alongside a collection of other African-Canadian, Caribbean-Canadian, and Black artists, one could see traces of Calle's and Phelan's emphasis on the performative nature of the staging of an exhibition as an event, one that cannot be reproduced in words and images alone. In the gallery, Springer stated that *Ana & Andre* is not simply a project about Black hair. I wondered, as she said this to me, of the multiple times that audience members seeing these minimalist constructions in the context of a "Black art" exhibition might discuss the works in relation to the politics of "Black hair." The hair and skin of Black women is often endlessly debated within North American popular culture in relation to beauty, self-esteem, and essentialist ideas of authenticity, pride, and communal loyalty. These public interrogations of Black femininities often make little reference to the complex roles that Black female bodies occupy in Black Power movements, racialized

sexism, and heterosexism within Black communities and the racist policing of Black women's bodies by the state.

While Springer's work obviously gestures to histories of racism and sexism that denigrate Black aesthetics, the impetus to read this art in relation to North American popular culture's obsession with Black women's hair perhaps does a disservice to the complex histories of minimalism that are inscribed in the work. And yet, the context in which the work is seen cannot be forgotten, as it also speaks to how one often sees the artistic production of racialized feminine artists through a priori markings of race and gender on the skin of the artist. While the work of canonical minimalist artists, largely white and male, are often read only in relation to themselves, seeing Springer's artwork at *Skin Deep* brought one back (perhaps reluctantly and perhaps politically) to her body. The performative nature of this exhibition questioned whose body is imagined to be present in their art and whose identity is assumed as normative to the point that they disappear into the canvas.

Springer's hair as the hair of a Black woman became part of the spectacle of the artistic event. Comparably, at other stagings of minimalist artworks made by white men, the bodies of white male artists disappear into the unmarked and unquestioned whiteness of the canvas with only their art being discussed. The burden of representation that is often lauded onto Black and female artists, the burden to create "political" art that speaks to and acknowledges all marginalized cultural workers, is not often one that white male artists face. While the celebration of Black hair that informed 1960s Black Power movements was seen as counter to racist representation, the overemphasis on the bodies of Black women bind racialized artists to colonial binaries and a reduction of their creativity to histories of skin, hair, embodiment, and biography. However, the brilliance of Springer's *Ana & Andre* lies not in a refusal to be embodied, but in the use of a supposedly disembodied, unmarked tradition of minimalism associated with white men to expose the performative nature of all acts of seeing.

In only seeing the lines and circles on the pages of "great white men" while seeing the Black hair of a racialized female artist, we are made to face our own underlying racism that divides a "true artist" from a "Black female artist." One can consider Albert Memmi's writings

regarding "the mark of the plural," which haunts colonized peoples who are made to not only represent themselves, but all people of their imagined race and nation. While canonical white male artists who use minimalist art techniques are only asked to represent themselves, colonized people's work is judged in relation to an entire imagined community. *Ana & Andre* does not ignore the question of racialized feminine representation, but rather asks one to consider how and why white male artists' bodies disappear from the performative staging of white art as an invisible, innocent, and unmarked norm. There can be power in representations of racialized bodies otherwise invisible in public culture. However, one of the questions Springer's minimalism poses is how power might lie in the disappearance of the body as evinced in the unmarked aesthetics of whiteness and masculinity, often seen as normal and unremarkable. Phelan discusses the relationship between the viewer and the art object as transforming the material of the artwork without altering its form. Phelan writes,

Just as quantum physics discovered that macro-instruments cannot measure microscopic particles without transforming those particles, so too must performative critics realize that the labor to write about performance (and thus to "preserve" it) is also a labor that fundamentally alters the event. (148)

In seeing and unseeing *Ana & Andre* as an artistic installation that is part of the minimalist tradition with no reference to the artist's embodiment; in seeing and unseeing *Ana & Andre* as a work about Black hair; in seeing and unseeing *Ana & Andre* in relation to necessary representations of Black artists in a white settler colony, I was left wondering about acts of preservation done in the service of "representation." In attempting to counter a racist, sexist, and colonial gaze with "Black" and "feminist" art, do we not unwittingly preserve and reify "race" and all the colonial and biopolitical baggage it carries? Does the performative act of writing about *Ana &Andre* and considering the artist's racialized feminine body alter the work, by inscribing histories of race and gender born out of colonial categorizations onto the canvas? Is a performative act of writing that remembers the staging of the event in the context of *Skin Deep*, an exhibition preserving histories of Black artistic production and

curation, challenge a white art world? And more importantly, is a performative act of writing that defines the minimalist canon of art history—one that refuses to see whiteness and masculinity—an act of writing that preserves the power of the white male body? Where was and is Carl Andre's hair and skin, as a white North American settler building bricks on stolen lands, one that disappears in white mortar to preserve the authority of white men, who are never seen as white men but as "artistic geniuses"?

Phelan discusses performance as existing within a metonymic rather than a metaphoric structure. She use the term "the kettle is boiling" to discuss the making of the body through performative artistic events and performance art. Phelan writes, "'The kettle is boiling' is a sentence which assumes that water is contiguous with the kettle. The point is not that the kettle is like water (as in the metaphorical love is like a rose), but rather that the kettle is boiling because the water inside the kettle is" (150). Within performance-based art and performative stagings of art exhibitions, which I would argue frame all public art events, the performer and artist's body is not metaphorically like the performance, but rather it is through the event that the body of the performer is materialized. Taken out of context, *Ana & Andre* is not "Black art" nor is Springer a diasporic Afro-Caribbean-Canadian female artist. Rather, it was through the event of *Skin Deep* that the artist's installation and body materialized through histories of race, gender, and the representational politics of aesthetics. Phelan discusses the irony of performance that makes the body seem hyper-visible, when in fact, the body disappears. Phelan writes that "in the plenitude of its apparent visibility and availability, the performer actually disappears and represents something else— dance, movement, sound, character, 'art'" (150). Phelan goes on to discuss the work of performance and performative stagings of art as posing a question regarding the inability to ever fully "represent" the body, as it is only through the signification of the work of performance that the body appears. Phelan states,

> *Performance* uses the performer's body to pose a question about the inability to secure the relation between subjectivity and the body per se; performance uses the body to frame the lack of Being promised by and through the body—that

which cannot appear without a supplement. In employing the body metonymically, performance is capable of resisting the reproduction of metaphor. (150–51)

The body of the racialized female artist is not "like" a minimalist representation of their hair, shown as part of a Black art exhibition in a white settler colony. Similarly, the bodies of white male artists celebrated for their individual creative works within the minimalist tradition are not like white canvases, white pages of canonical art history, and ivory towers into which their bodies disappear. The inability to see the staging of all artwork as performative allows for a metaphoric reading of great white male artists as being "like" all the other iconoclast white men who came before them, while racialized, female, queer, and other "marked" bodies are always made to perform. Springer's hair is not really there. Rather, it appears as a lost object that can only be found within a performative staging. This performative staging is marked by the historical and political context of Black hair and minimalist art history's simultaneous aversion to embodiment and obsession with the assumed disembodiment of white men.

The kettle is boiling. The body is racialized. The hair is black hair. The aesthetic is minimal. The "Hottentot" bodies of Black women are ghosts in an Irigrayan machine that haunt a white landscape, just as the cool, austere aesthetics of white men disappear into a background that makes their singular names and imprint stand out as works of the mind, not of the body. If the bodies of Black women are hot water in colonial kettles, it is the unmarked bodies of minimally threatening white men who pour the tea, made of stolen spices that chart the disappearances of the wealth of colonized nations. Like the stolen paintings that Calle writes of, there is no imprint of a white man's hand left on the jewels of former colonies now left as exotic trophies of colonial theft in museums. Like Black hair and Black bodies branded with hot irons as "Black" and "Slave," there is no trace of the hand of a white man, as invisible as the embodiment of canonical white male artists whose names garner fame, prestige, and capital. To see Springer's *Ana & Andrea* as a performative event of race that disrupts the racism and sexism of minimalist art history is to see the apparent apolitical work of white men as a kettle boiling.

ART AS ARCHIVE:
ARCHIVAL PIGMENT PRINTS AND HISTORIES OF BODIES

Springer's *Ana & Andre* archives a history that has no history. While artistic and architectural works are often used to commemorate official wars and mark moments in time, Springer's work is timeless in its strategic use of Black aesthetics to document the ongoing histories of race and racism that have no beginning or end. Anti-Black racism is not often contained within national borders or fixed temporalities, but lives in and on the body, with Black bodies being marked as targets of violence transnationally. Springer's minimalist aesthetics and their relationship to histories of anti-racist and feminist politics and political movements are often archived and remembered through key historical events. Springer's work both resonates with these archival practices and disidentifies with mainstream approaches to archiving histories of social movements. Springer offers a necessary intervention into the use of artistic techniques to comment on histories of "race" and racism as embodied experiences. I consider *Ana & Andre* in relation to the minimalist monuments of Maya Lin, whose use of subtle and austere structures were used to commemorate the Vietnam War, Civil Rights, and Feminist movements of the 1960s. Lin's monuments—the Vietnam Veterans Memorial in Washington, DC, the Civil Rights Memorial in Montgomery, Alabama, and the Women's Table that commemorates co-education at Yale University in 1993—all utilized minimalist techniques. Daniel Abramson argues that Lin's works are minimalist not necessarily in the materials the artist worked with, but in her use of simple timelines to chart great political struggles and impassioned battles regarding social justice that continue to this day.

Both Springer and Lin chart "official histories" of war that can be catalogued and dated through numerical orderings of sequential time. Jacqui Alexander uses the concept of the palimpsest to discuss how contemporary violence is underwritten by colonial histories and those of war. Alexander writes,

> The central idea is that of the palimpsest—a parchment that has been inscribed two or three times, the previous text having been imperfectly erased and remaining therefore still

partly visible.... The idea of the "new" structured through
the "old" scrambled, palimpsestic character of time, both
jettisons the truncated distance of linear time and dislodges
the impulse for incommensurability, which the ideology of
distance creates. (190)

While dates and timelines are used in Lin's monuments to honour
those who died in war and participated in social movements, her
minimalism also exists within a palimpsest of war and the embodied
oppressions that define North American history. The imperialist
palimpsest is both literal and metaphoric with the artistic inscriptions
being carved on the stolen land of Indigenous people and over the
unmarked burial grounds of slaves. Lin's minimalist use of architecture
also challenges linear narratives of history in which wars often
begin and end, as contemporary racial, gendered, and sexual politics
remain within a palimpsest of time with previous anti-war and civil
rights movements and colonial histories. Abramson states that Lin's
monuments "can be seen together as a suite of work representing
three defining social phenomena of the 1960s: the Vietnam War, the
civil rights movement, and the women's movement" (681). Abramson
discusses Lin's use of minimalist aesthetics in her construction of
large monuments that were made with simple aesthetic gestures and
emphasized a use of timelines to chart key events in 1960s social
movements. Abramson continues, "Lin's work popularized and
mutated the formal vocabulary and ideology of 1960s minimalism,
how it potentiates a new mode of critical monumentality, and how its
graphical experimentation may redeem the monument in the age of
information" (681).

Anderson states that Lin used materials that are meant to coexist
with the natural environment. The artist created structures that the
public could interact with and sit upon, allowing people to be part of
the monuments. The author further argues that Lin utilizes minimalist
forms as a mode of healing, particularly in relation to the traumas
of war and the oppressions that informed civil rights and feminist
movements. While canonical works of minimalist art by white male
artists are often imagined to be apolitical, Lin's work makes reference
to feminist, civil rights, and anti-war movements aesthetically through
the use of certain materials and the creation of spaces for populist

gathering, using art as a commons. Anderson writes, "In effect, Lin's monuments do to 1960s minimalism what they did to the decade's social struggles. They repackage the difficult, the divisive, and the controversial into loci of popular satisfaction and consideration" (705). Springer's work resonates with Lin's work in their use of minimalist forms to broach issues of the personal and the political. Abramson emphasizes the importance of time and social movement history that defines Lin's works, which were very much aligned with narratives of mainstream American history and politics. Conversely, Springer's work is a radical archive that marks the ongoing racialization of Black women's bodies despite official temporal closures of time that imagine race to be invisible after the formal ending of slavery in the Americas. If Lin's work utilizes set boundaries of time and space to document social movements in which the personal was said to be political, Springer's work documents the personal histories of racism and sexism that haunt the bodies of Black diasporic subjects in their everyday embodied movements.

While Lin uses time and built architectural forms that exist within the landscape of America, Springer uses the landscape of a Black female body that remains marked by ongoing histories of violence that cannot be quantified or timed. Unlike key dates of civil rights and feminist protests, there is no date or time at which Black hair and specifically the hair of Black women ever ceases to be both deeply personal and political, haunted by the residue of empire. While *Ana & Andre,* as an archive of bodily marking and violence that is beyond temporality differs from Lin's official monuments, both artists use minimalist forms in ways that challenge the imagined timeless and disembodied traditions of canonical white male minimalists. Though Lin is written of in relation to a pointedly political tradition and Springer's series was staged as part of a Black art exhibition, one can compare both artists and their artistic works to Andre's white bricks, an iconic work within the minimalist tradition. Springer's hair used as part of a minimalist art installation gestures to economies of race and racialized aesthetics, while Lin's monuments chart political histories of anti-racist, anti-war, and feminist history. The invisibility of violence and trauma that the racialized and gendered body carries is intelligently commented upon in a delicate piece of hair archived on a canvas in pigment print by Springer. Springer's

striking work is reminiscent of all that Lin's deftly political uses of minimalism simultaneously conceal and reveal. The simple timeline uses the subtle beauty of minimalism to catalogue the passions of a generation, to reflect upon one of the most turbulent decades of political unrest and social change in North America. And yet, while Springer's and Lin's works do not mask their politics, the artistic work made by white male minimalist artists such as Andre is rarely considered in relation to the deeply political movements of colonizing white male bodies across world maps. Andre's famed minimalist installations of ostensibly apolitical white bricks can be considered in relation to histories of racist violence and colonial history. When seen through an anti-racist feminist lens, Andre's white bricks and the seemingly apolitical minimalist works of "great white men" are haunted by Black slaves forced across continents to stack white bricks on Indigenous land.

"NICE" BLACK LADIES AND MINIMALIST ARTISTS: SPRINGER'S REPRESENTATIONAL AMBIVALENCE

The spectacle of the Black female body exists within ongoing genealogies of slavery and colonialism. Within contemporary popular culture, a litany of attention is lauded upon Black women's bodies as sex objects, maternal figures, ethereal griots, and pathologized working-class figures who represent the antithesis of the white feminine bourgeois subject. Many cultural producers, activists, and artists often counter the negative representations of Black femininity as morally suspect, ugly, and monstrous by producing simplistic "positive" images of Black women. The grandiose pageantry of "video hos" and "welfare mamas" exists alongside opposing, and yet often equally reductive caricatures of strong black women, earth mothers, and successful "Black ladies" who approximate idealized middle-class white femininity. Michelle Obama and Oprah Winfrey are viewed as "healthy" role models in a mainstream secular Western capitalist public sphere in which "health" can be branded and sold using anti-intellectual images of class mobility, imbricated into the biopolitical vitality of the nation. "Good" black women will make "good" mothers who will produce docile bodies of future middle-class citizens who will serve as "good" apolitical workers and consumers.

Stuart Hall discusses three dominant strategies of cultural representation that attempt to challenge the ghostly presence of colonial and slave histories that shadow images of Blackness. The first is what Hall terms "reversing the stereotypes." This strategy attempts to reverse the negative attributes that have been associated with racialized people through integrationist methods. In reference particularly to Blackness, Hall cites the work of post-civil rights filmmakers who often made films in which Black characters were seen to be heroes. Hall problematizes this representational strategy, stating that, "To reverse the stereotype is not necessarily to overturn or subvert it. Escaping the grip of one stereotypical extreme ... may simply mean being trapped in its stereotypical 'other'" (272).

The second strategy that Hall puts forward substitutes a range of "positive" images of Black people for the "negative" imagery that dominates popular representations. This strategy inverts the binary opposition, privileging the subordinate term. Hall cites the 1960s Black Panther slogan "Black is Beautiful," stating that this "expands the range of racial representations and the complexity of what it means to 'be black,' thus challeng[ing] the reductionism of earlier stereotypes" (273). Hall continues,

> [T]he problem with the positive/negative strategy is that adding positive images to the largely negative repertoire of the dominant regime of representation increases the diversity of ways in which "being black" is represented, but does not necessarily displace the negative. Since the binaries remain in place, meaning continues to be framed by them.... The strategy challenges the binaries—but it does not undermine them. (274).

While "positive" representations of Blackness add new forms of racial signification to the paucity of images of racialized lives within the mainstream imaginary, the binaries that structure racist and colonial ideology are upheld. For every Michelle Obama and Oprah Winfrey there is a shadow figure of an overly sexualized, socially, and criminally deviant Black female image within mainstream popular and political culture. Furthermore, the frameworks of the "positive" and the "healthy" continue to be defined through classist, heteronormative

disciplinary powers in which "Black ladies" are those that best approximate provincial white colonial mother figures.

The final strategy Hall discusses does not attempt to adjust binaries, but rather troubles them. The author states that this third strategy "locates itself *within* the complexities and ambivalences of representation itself, and tries to *contest it from within*. It is more concerned with the *forms* of racial representation than with introducing a new *content*" (274, emphases in original).

In utilizing the aesthetics of minimalism, Springer's *Ana & Andre* does not offer the usual image of "natural" Black women's hair as a revolutionary symbol and community property. Nor does Springer produce a trite representation of Black female beauty that approximates European traditions of portraiture that galvanize Hellenistic ideals of beauty. Black aesthetics are not romanticized or idealized, but rather they are minimalized. The often obscene spectacles of Black female bodies that are paraded across American television screens as music video vixens and ridiculed sitcom characters are nowhere to be found in the disappearance of the Black female body in the fascinating installation *Ana & Andre*. In using her own hair as artistic material, Springer's art poses questions regarding the materiality of the body itself. "Black hair" is neither celebrated nor is it straightened; rather it is simply a tool in the artist's palette. The obsession with Black women's bodies in North American popular and political culture is evaded by Springer's minimalist aesthetics. The lines on the page contest the ambivalences of racialized representations from within. As Hall writes of the third strategy of representation, new content is introduced in *Ana & Andrea* within both a minimalist canon of disembodied white male artistry and a history of excessive spectacles of Black female bodies.

SELF-REFERENTIAL WITHIN A RACIST GAZE: THE COMPLEX QUESTIONS THAT LINGER, THE SHADOWS THAT HAUNT

There is a resonance between Springer's minimalism and that of the artist Adrian Piper, who also used conceptual and minimalist art techniques to address the complexities of racialized feminine aesthetics. In *Adrian Piper: Race, Gender, and Embodiment*, John Bowles discusses Piper's use of minimalist art practices and the influence that canonical

white male minimalists of the 1960s and 1970s in America had on Piper's artistic production. The artist's early work used minimalism to escape from questions of racism and sexism that ironically bind racialized and female artists to creating identity-based work—what Memmi terms the "mark of the plural," as previously discussed. However, Piper's later work disidentified with minimalist art's white masculinist history by using these techniques to question racism and sexism. As Bowles writes,

> The Minimalism of Donald Judd and Robert Morris and the Conceptualism of Sol LeWitt would eventually provide Piper with tools for investigating the perpetual conditions of racism and sexism in America, but according to the artist, they first provided her with the means for avoiding them, something she says she only became aware of afterward. (34)

Bowles discusses Piper's use of art to pose philosophical questions to viewers regarding racism and sexism. The author suggests that the artist poses moral questions regarding one's responsibility to others. As Piper created much of her minimalist and situationist work in the 1960s and 1970s, a time when civil rights and feminist movements were at their height in the Americas, Piper's work speaks to the relationship between art and political consciousness. Bowles states, "Piper places her artwork within a history that begins with Minimalism's obdurate and self-referential objects and develops into situational artworks that provoke viewers to investigate specific issues of race, gender, sexuality, and class" (36). Bowles goes on to discuss how Piper used minimalism to position the viewer as the one whose reading of race and gender became central, rather than the intention of the artist. Within the context of the 1960s "Black is beautiful" imagery, and the often policed aesthetics and vocabulary of feminist discourse, Piper used minimalism to create provocative artistic works. Rather than dictating Black to be "beautiful" or repeating slogans of female empowerment, the ambiguities of minimalism and its focus on the spectator's reading of the work were used to expose the libidinal desires and aggressions that exist towards the racialized female body.

Similarly, Springer's minimalism is also complex and does not offer viewers a definitive answer or affect regarding the ethical questions

posed by race, gender, and power. If one reads *Ana & Andre* as lines on a page, the work is placed within a lineage of canonical white male minimalists such as Andre whose artistic celebrity was divorced from his embodiment as a white man and his fraught and tragic relationship with Ana Mendieta. However, if one reads the project as solely about Black hair, referencing the violence of white male artists and the violence of European masculinist power, there is a burden of representation placed on the racialized female artist to represent a community or certain political stance.

Springer, like Piper, creates minimalist artwork that poses important philosophical questions regarding race and gender that are situated within the political climate of the time period. While Piper's work was created in the 1960s and 1970s when civil rights movements were prominent, Springer created *Ana & Andrea* in a time of common-sense secular capitalism. The 1960s image of the Afro, once associated with political radicalism, is now often a branding tool used to sell products. In certain instances, the Black hair of previous generations' social movements is this generation's fashionable magazine layout. Political histories of African diasporas are sold through wholly superficial marketing campaigns, and over-the-counter Blackness can be bought in store through "hip hop" and "island" aesthetics, emptied of all meaning. *Ana & Andre* poses thoughtful questions regarding aesthetics and the branding of both the racialized female body and artist. Bowles sites Annette Michelson who writes that "the premise of Minimalism is that the artwork stands on its own, to be assessed by the viewer on its own terms. The Minimalist artist does not make a statement with his or her artwork, but establishes the conditions for the viewer's experience" (qtd. in Bowles 36).

In titling the piece *Ana & Andre*, in reference to the violent relationship between Andre and Mendieta that ended in her violent death, Springer leaves one to question whether the artistic work of those who are racialized and gendered as minimal citizens within North America can ever be known outside of their skin. The use of Springer's hair as a tool to create minimalist artwork makes reference to divergent histories that overlap in the artist's deft installation. The history of minimalism—in which art is imagined to stand on its own, outside of the body of the artist—is referenced aesthetically, and yet the political spectacle of racialized feminine aesthetics of Black

diasporic subjects used to sell capitalist consumers "sexy" images and products is also referenced. Like Piper's artistic minimalism, Springer's *Ana & Andrea* leaves one with moral and ethical questions regarding the relationship between artistic creation, celebrity, and histories of violence. The series is haunted by the canonical minimalism of Andre, and the absent Ana, whose name also exists in an archive of art and in haunting questions left behind by corpses of women "falling" out of windows.

The conditions of experience that inform my understanding of *Ana & Andre* are framed by a deeply important Black art exhibition, challenging the commonplace erasure of Black artists in an art world structured by systemic racism in a white settler colony. What the series left me to question are the possibilities of artistic genius to be respected outside of skin, hair, and bone. I was also left to consider how artistic iconoclasts emerge through processes of embodiment. *Ana & Andrea* causes one to consider unspeakable and untranslatable Black bodies haunted by slave histories. One is left with lingering questions regarding collective responsibility to formerly colonized and enslaved people. Black people whose lives are marked by the unspeakable violence of the transatlantic slave trade are not offered any political and economic reparations for the ongoing damage of white supremacy, and are also left to "repair" aesthetics deemed to be out of place within a racist imaginary. The self-referential ambivalence of Springer's memorable installation is a challenge to the framing of art history and the body through obscene ideals of whiteness and masculinity, as unremarkable in their violence as white bricks and open windows.

WORKS CITED

Abramson, Daniel. "Maya Lin and the 1960s: Monuments, Time Lines, and Minimalism." *Critical Inquiry* 22.4 (Summer 1996): 679-709. Print.

Alexander, Jacqui. *Pedagogies of Crossing.* Durham: Duke University Press, 2006. Print.

Bowles, John P. *Adrian Piper: Race, Gender, and Embodiment.* Durham: Duke University Press, 2011. Print.

Chave, Anna C. "Minimalism and Biography." *The Art Bulletin* 82.1

(March 2000): 149-63. Print.

Davis, Angela Y. "Afro Images: Politics, Fashion, and Nostalgia." *Critical Inquiry* 21.1 (Autumn 1994): 37-39. Print.

Edwards, Pamela. "Introduction." *Exposed 2015. Skin Deep: (Re) Imaging The Portrait.* Curated by Pamela Edmonds. Nia Centre for the Arts. Exhibition catalogue. Toronto: Project Gallery, 2015. Print.

Emberley, Julia. *Defamiliarizing the Aboriginal: Cultural Practices and Decolonization in Canada.* Toronto: University of Toronto Press, 2009. Print.

Hall, Stuart. *Representation: Cultural Representations and Signifying Practices.* London: Open University, 1997. Print.

Memmi, Albert. *The Colonizer and the Colonized.* London: Earthscan, 2010. Print.

Phelan, Peggy. *Unmarked: The Politics of Performance.* London: Routledge, 1993. Print.

Springer, Kara. Personal interview. 24 May 2016.

5.

And Their Gods Were Blue-Eyed

Rajni Perera (Re)Colours the World

IN A PUBLIC LECTURE given in January 2014 in Mumbai titled "Treading Water: Reflections on an Intemperate Medium," Homi K. Bhabha discussed the swimming lessons he was made to take as a middle-class Parsi school boy in Mumbai. Bhabha spoke of the body of the postcolonial man, often figured as effeminate through colonial and nationalist discourse. The young Bhabha was unable to achieve an idealized athletic prowess to correspond to the image of the well-built heteronormative nationalist man. The image of the idealized nationalist subject in India was haunted by the ghosts of colonial soldiers—those heroic, fertile, and warring men planting their flags, seeds, and semen across world maps in the rape script of history. Ziya Us Salam writes that Bhabha "spoke of how water is used in art, literature and culture" (Salam). Bhabha, however, also spoke of the sea as a metaphor for the traffic of ideas that flows between continents and countries: "To me, the sea is about the courage of exploration; and attempt to move towards a larger horizon. At the same time, the sea is a great experience of anxiety. The sea is symbolically linked to morality, ethics and creativity" (cited in Salam).

In the paintings of Sri Lankan-Canadian artist Rajni Perera, multiple references and intertexts flow like water, belying an authenticity fenced in by national borders and multicultural spectacles of exoticism. Perera's dazzling art challenges the fixity of imagined ethnic "communities" that are so often used to brand diversity as sales, while also offering reductive images of Brown female subjectivity. Perera's work is expressive of the creative courage of those who swim against the currents of mainstream diasporic multicultural images of racialized femininity and mainstream

nationalist narratives celebrating white settler colonialism. Much like Bhabha's lecture recalling swimming lessons and discussing the sea, in Perera's paintings, the body and its relationship to reductive and oppressive nationalisms, parochial ideas of culture and authenticity, and the natural world are explored.

Bhabha writes of Lord McCauley's treatise in which McCauley suggested British colonizers should aim to create an Indian that was an Englishman in mannerisms and customs (Bhabha, *Location of Culture*). Nationalists responded to McCauley's treatise by attempting to create partially British subjects, those mimic men who, as Bhabha suggests, would through processes of sly civility approximate the norms of the British through work ethic and civility while retaining their homes as havens of caste-based and cultural purity. The new nationalist man would in the public sphere be a warring figure and an industrious worker, while his good Hindu wife would maintain the home as a site of spiritual and cultural purity. As Partha Chatterjee has written, Indian nationalists attempted to retain an essential notion of "Indianness" within the home, constructing the middle-class Hindu woman as a wife whose role lay in preserving Indian culture through the maintenance of Hindu religious and cultural traditions that she would impart to children (Chatterjee).

Hiding under the folds of the sari fabric of "Mother India," the colonized body emerges as a site of ongoing conflict regarding competing notions of cultural and nationalist superiority, gendered norms, and the materialization of race, class, and caste on the skin. Was the young Parsi boy meant to cultivate a colonial and nationalist athleticism that mimicked great European and Indian officers of armies? Or was Bhabha to follow in the footsteps of an effeminate Gandhi? Would the boy sink or swim in the ongoing synchronized pageantry of colonial nations and their colonized shadow figures?

Nonetheless, Bhabha in essence sank: as a young and budding intellectual with high-minded ideas and effeminate gestures, he could not compete in the pageantry of hyper-masculinity. Like many colonial schoolboys he excelled in study but could not mimic the brute anti-intellectualism often forced upon young men through ideologies of archetypal masculinity, and through an embodied sexism that cultivates the bodies of men as those made to violently dominate capitalist industries and the bodies of women and children. Years later,

the jockishness of idealized colonial whiteness now finds expression in neocolonial expeditions.

As Slavoj Žižek has suggested, the torture of prisoners at the Abu Ghraib prison in Iraq should not be seen as an aberration to American culture, but rather an expression of its obscene underbelly. Arab men were tortured by American soldiers at Abu Ghraib, placed in feminized and submissive sexual positions, and photographs were subsequently circulated to document the torture and trophies of violence reminiscent of the locker-room sexism of North American athletes. Rather than being incidental or singular, the sexual and physical torture of Arab men at Abu Ghraib by both white male and female soldiers is part of the ongoing racist ritualistic nature of North American hate crime. Žižek suggests that these tortures, enacted as part of an ongoing "war on terror," were reminiscent of university hazing rituals (Žižek qtd. in Atluri "Is Torture" 242). Such compulsive wills to shame the bodies of others resonate with colonial history and nationalist wills to also shame lower castes, women, and religious, sexual, and racial minorities in India.

At the centre of history lies the body: sometimes buried under the earth, in rotting wooden coffins, with worms and dirt replacing once familiar faces; sometimes scattered as ashes across rivers like the Ganges, a polluted archive of caste-based oppression of the sickeningly "clean" and mundanely despised "untouchable." Sometimes bodies go missing, dead to the world in wonder: lost at sea, like greedy pirates frothing at the mouth for riches like spoiled hungry children; lost at sea, like hapless bored boys with bad directions calling themselves explorers, settlers, and great men of imagination; lost at sea, like the visas of Brown people whose skin was once measured by the scales of European progress and sized up against the images of a blue-eyed Christ, and the sturdy white kings and queens emblazoned on Western currency. The dark and poor always come up too short, in the red, or as haunting shadows in a phantasm of whiteness that resonates across time and space in images of angels turned billboard models, or invasive colonial missionary workers turned social workers and Girl Scout leaders. These skins are now categorized in biometric schemes, with religious symbols removed at governmental checkpoints, pieces of holy religious headdress thrown in plastic airport security bins, left to spin like Buddhist prayer wheels in an ongoing parade of racism

turned routine procedure. Lost, like transnational business elites looking quizzically into Google maps on iPhone screens, following in the tripping footsteps of "great leaders" and "heroes" of empires whose names are forever remembered in the almost comically bad lies of something called "history."

Bhabha's body however, flailing and sputtering in the seas of Mumbai, is also history. A body whose nervous twitches, near drowning with slow pace and shame is beyond record or apprehension. A history beyond countenance also exists in the bodies of all the "Mother Indias" of aunties, *ayas*, washerwomen, cooks, *didis*, and *ammas* that made neat stacks of English school books and vegetable curries out of the paradoxical injunctions of nationalism to both retain culture and produce capital.

The bodies of the colonized and supposed postcolonials are sites of violent battles that occur in the minute workings of the every day. Walter Benjamin once remarked that the pedagogy of the oppressed teaches us that the state of emergency is in the every day (qtd. in Osbourne 159). It is in the everyday rituals, decorum, production, spectacle, and representation of bodies that one can see ongoing wars being waged. Perhaps it is in the language of the unspeakable, in the language of affect, in creative mediums that carry emotion and joy beyond translation that one can find an anti-colonial body politic.

The image of Europe as the benchmark of civilization finds its visual representation in the idealized white, Western, bourgeois body. However, anti-colonial artistic traditions defy the valorization of European aesthetics. Sugato Ray discusses the relationship between idealized bodies and anti-colonial art traditions within the Indian subcontinent:

> Anti-colonial art history … appropriated colonizing discourses of the effeminate native body to epistemologically challenge the hegemonic hyper-masculinity advocated by both the regulatory mechanisms of the British Empire and a larger nationalist body culture in colonial India. The ingenious invention of a discursive intimacy between yoga and an aesthetics of demasculinization led to the strategic resignification of the male body in early Indian sculpture as both a sign and the site of an imagined national life. (Ray)

Similarly, one can consider the role that aesthetics played in the Sataygraha movements in which the making of homespun Khadi (cloth) was integral to boycotting British colonial rule. If, as scholars suggest, aesthetics and craft have always been central to colonial discourse and the global celebration of whiteness, aesthetic interventions also have a key role to play in decolonization.

Perera offers an anti-colonial aesthetic that utilizes images of racialized feminine bodies in interesting ways, offering an aesthetic hybrid that does not reproduce fetishistic ideals of cultural "authenticity" that are often tied to antiquated and oppressive nationalist ideologies. By offering a visual depiction of Brown feminine forms that use the aesthetics of the religious and of postmodern pastiche, the artist counters reductive representations of racialized women who are often presented within the West and specifically in "multicultural" Canada as the property of succinct ethnic and religious "communities," or as assimilated to the imagined benevolence of white settler colonial capitalist worlds. In their series of paintings *Yoginis*, Perera challenges racist and sexist representations of Brown and Black women's bodies by drawing on anti-colonial traditions. Perera utilizes aesthetics of Hindu iconography in which deities are depicted as animals and in colours that do not correspond with human skin, thereby challenging Eurocentric Judaeo-Christian aesthetics. Perera also gestures to and refashions Orientalism as a contemporary sexual politic by using imagery from tantric paintings and wall drawings found in Sri Lanka, India, and Pakistan. As discussed previously in this book, Jacqui Alexander discusses the "palimpsest of imperialism," using the metaphor of a parchment to refer to how contemporary culture is underwritten by previous histories of colonial violence (Alexander). Liz Phillipose draws on Alexander's writings, stating that "[i]mperialism is a palimpsest in the sense that the hegemonic practices of a hyper-militarized U.S. state are engaged in conflict with those whose histories are shaped by Euro-colonization and its modern racisms" (69).

If the parchments of everyday racism are underwritten by colonial history, perhaps racialized artists also exist in a palimpsest of anti-colonial resistance. Perera challenges reductive scripting of racialized femininities in European art and rape-scripts that often depict women in Sri Lanka as consummate victims of male patriarchy and civil war.

Perera's carefully crafted goddesses and yoginis explode with a colorful defiance that resonates with the delicate hands of anti-colonial homespun craft to create a sacred sensuality. In discussing anti-colonial art, this book suggests that far from being innocent, aesthetics continue to be passionately political.

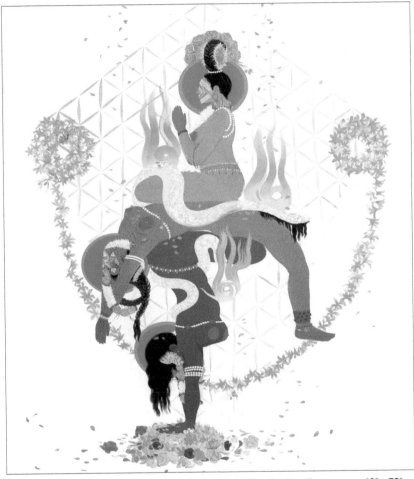

Figure 5.1: Rajni Perera, Stacked, Yoginis Series, 2013, mixed media on paper, 48" x 72".

YOGINIS RECOVERING ANTI-COLONIAL TRADITION
IN CONTEMPORARY ART PRAXIS

Rajni Perera's *Yogini* series offers three works, *Stacked*, *Natarajasana*, and *Garland Guts*. All of these works utilize mixed media on paper to

create striking, colourful, provocative images of Brown and Black bodies in yogic poses. It is worth noting that "yoga" cannot be separated from contemporary Hindu nationalist discourse, in which the ostensible purity of the body is supportive of casteist, racist ideologies of religious nationalism. Thus, Perera's figuration of Black and Brown bodies in yogic bodies is an affront to both the white neoliberal Western appropriation of yoga, and to puritanical casteist discourse. Discussing the complex history of yoga, Joseph Alter suggests, "Emerging out of South Asia, Yoga is a complex and comprehensive philosophy of transcendental consciousness that crystallized into a school of thought sometimes between 150 and 500 C.E." (4). Alter goes on to discuss the philosophy behind many schools of yogic practice, which suggest that beyond Western secular capitalist rationalities, the world is not self-evident. As the author states,

> The practice of Yoga is designed to transform illusion into reality by transcending ignorance and training the embodied mind to experience Truth. The experience of Truth is *samādhi*, which can be translated as a transcendent condition of ecstatic union of subject and object. Significantly, *samādhi* is both the technique for realizing this condition and the condition itself. (4)

Within Perera's *Yoginis* series, the Western mind/body dualism, which often structures ideas of the rational, is challenged. Similar to the emphasis on embodied knowledge within the philosophy of yoga, these works, by pointedly using images of racialized feminine subjects, also challenge a disembodied "race blind" (i.e., racist) ideology. This ideology imagines that all subjects experience secular capitalist Western life in the same way, through a "fair is fair" rhetoric of normative unmarked whiteness. The striking visual images of Brown and Black feminine bodies in yogic postures invite spectators to consider how knowledge is formed through and in relation to the aesthetic meanings that bodies carry, both through processes of embodied traditions such as yoga and through the embodied histories of colonialism and Orientalism that live on and in the skin. Alter further discusses the notion of *samādhi* within yogic philosophy, stating, "The transcendental Self is *samādhi* as a condition of Ultimate Truth that is beyond time

and space" (4). In creating works of art that are representative of a cultural hybridity that crosses borders to capture variant cultural, historical, and artistic intertexts, Perera's *Yoginis* are transcendental meditations on a world beyond the succinct borders of nationalisms. Perera's rich body of work offers gendered and racialized figures whose images defy the reductive, trite, and cartoonish mainstream images of Brown women as community property or perpetual foreigners. Furthermore, in utilizing images of ancient traditions such as yogic practice alongside postmodern and pop aesthetics, fixed ideas of time and temporality are evaded. Within Perera's timelessly beautiful works, the imagined "Orient" and the bodies of Brown women are not associated with cultural or temporal backwardness. Similarly, a Western secular rhetoric of disembodied rationality is not celebrated as progressive; as such an erasure of the truth of the skin hides the phenomenological experiences of sexualized racisms and the wisdoms of embodied epistemologies.

It is perhaps important to place Perera's use of yogic aesthetics in relation to colonial history and the denigration of sacred traditions through Orientalism. As Edward Said discussed in *Orientalism*, the Occident conceived of itself as a masculinist authority against the image of the feminized "Orient," which was associated with irrational forms of spirituality. Sturdy white men with golden calculators claimed authority over whole continents while Brown colonized women were assumed within deeply racist discourse to be tied to backward and nonsensical cultural and religious traditions. The austere aesthetics of colonial magistrates wearing white wigs and stiff-corseted fair-haired imperialist maidens are challenged by Perera's wonderful use of colour and radical rescripting of racialized bodies.

Perera's pointed use of Brown and Black feminine bodies in yogic poses and their striking use of bold colour offer an affront to the lululemon-branding of contemporary yoga culture, often sold as an appendage to support biopolitical fantasies of reproducing a white middle class. Sarah Banet-Weiser discusses the relationship between hegemonic whiteness and yoga branding within North America. The author draws on Prashad who argues that "the wide cultural adoption of South Asian symbols and practices into white hegemonic US culture does not in turn indicate a lessening of racist practices toward South Asians, or more 'tolerance' toward communities of color" (196).

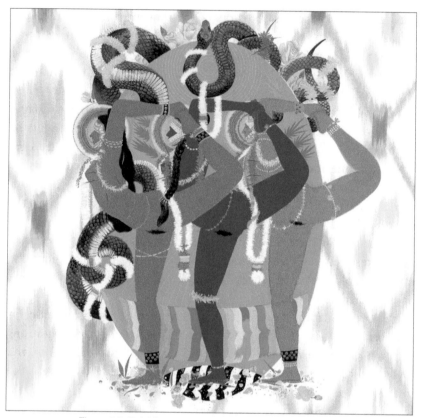

Figure 5.2: Rajni Perera, Natarajasana, Yoginis Series, 2013,
mixed media on paper, 48" x 48".

Perera's use of Brown and Black feminine bodies is a far cry from the white billboard models often appearing within consumer capitalist yoga branding schemes. As Banet-Weiser observes, the racist erasures of South Asians within mainstream cultures of yogic branding idealize the white consumer as a narcissistic shopper of other cultures. Žižek supports this, suggesting that the white consumer is propelled by a lingering colonial ideology in which white bodies are positioned as the explorers and consumers of racial and religious otherness. Just as white settlers travelled across world maps to pillage and loot entire countries and continents, contemporary white middle-class consumers can now pick and choose which aspects of otherness to consume while also participating in racism (Žižek). The branded Orientalism of "authentic" exotic South Asian cultures ironically emptied of all religious and philosophical meaning is a preferred commodity for

white yuppies, while Brown bodies are ignored, maligned, and subject to racism. As Banet-Weiser further writes, "The branding of Eastern spirituality is not about South Asians as a set of communities … but about a group of individual consumers who have pledged loyalty and affinity to brand culture" (196). While mainstream white North American shoppers of "brand yoga" pledge loyalty to images of the "mystical east," South Asian communities often exist on the periphery of nationalist imaginaries in North America, where Brown bodies are often invisible, depicted as terrorists within an ongoing global "war on terror," or constructed as perpetually foreign and associated with other times and places. Furthermore, cartoonish spectacles of South Asian labourers (such as Apu from *The Simpsons*, a racist comedic portrayal of the labour exploitation of South Asian migrants who serve as exploited workers) is reflective of the ability for white middle classes to romanticize the "mystical East" while simultaneously mocking Brown people (Vij).

Banet-Weiser discusses the sale of yoga through images of white celebrities, part of a "body-beautiful" branding scheme in which the spiritual ethos of yoga and the bodies of racialized South Asians are made invisible. As the author states, "Asian spirituality is positioned, through media representation and individual practice alike, through celebrities showing off their henna tattoos or through yoga as a means for all of us to find ourselves, as an aid for dominant white Americans to gain spiritual insight and an individual sense of morality" (197). While affluent white people in the Americas use yoga to aid their neocolonial souls, connecting to a ridiculous ethos of "moral shopping" for store-bought spirituality, there is little moral recourse in addressing the everyday violence of systemic racism. Perera's *Yoginis*, in depicting Brown and Black figures in sensual and warrior-like poses challenges an economy of yoga that has become disturbingly tied to white middle-class pretensions. Similarly, Perera's use of naked Brown and Black feminine forms is also an affront to religious nationalist depictions of the sacred, in which female sexuality is often repressed and aesthetically censored. Banet-Weiser quotes Jane Iwamura's insights on the relationship between white authorial forms of patriarchy and yogic branding:

The particular way in which Americans write themselves

> into the story is not a benign, non-ideological act, but rather constructs a modernized cultural patriarchy in which Anglo-Americans re-imagine themselves as the protectors, innovators, and guardians of Asian religions and culture and wrest the authority to define these traditions from others. (qtd. in Banet-Weiser 197)

The authority and entitlement of white capitalist patriarchs who conjure "authentic" images of saleable exotica through yoga, and simultaneously construct hegemonic images of a white upper class "body-beautiful" image has particular implications for the representation and racialization of femininities. Within dominant sexist narratives of diasporic communities it is often male elites who act as community authorities, constructing ideas of timeless culture that script racialized women into the reductive roles of women, wives, and daughters subject to patriarchal violence under the guise of "culture." In fetishizing ideas of Asian spirituality, the Brown woman's body as a passionate sexual and political agent is also invisible in the white capitalist imaginary. Perera's paintings fiercely defy depictions of docile, submissive Brown women owned as property of imagined communities and made invisible in a panorama of white yogic branding. Perera's aesthetics conjure up images of ancient depictions of dark-skinned women as goddesses found in early representations of the Hindu Goddess Kali, a Black figure who is often represented as an embodiment of Shakti, female power.

The aesthetics of the "Indian," the "South Asian," and the "Hindu" are ambiguously played with in Perera's series, as yogic imagery and other South Asian spiritual iconography is used while the figures in the artist's paintings are racially and culturally ambiguous. In the painting *Natarajasana*, the braids of the Brown and Black women depicted as flexible and vital warriors and goddesses conjure up images of the long braided hair of women in South Asia, and of Indigenous women. One can consider that many Indigenous children who were forcibly removed from their homes and placed in missionary-run residential schools were often forced to cut off their braids. Colonialism is not only a bid for land and political governance, but invades the bodies and minds of those who are subject to its brutal force. Similarly, the "Orient" is often constructed as a feminized Other, with the aesthetics

of the feminine, the sacred, and the spiritual being denigrated by European imperialists. While "yoga" is sold through Western yuppie marketing schemes as a sanitized version of Otherness, one can consider the obscene violence experienced by racialized women both through processes of European colonization of countries in the Global South and through the colonization of white settler colonies such as Canada. Julia Emberley discusses the figure of the "wild woman" within discourses of Canadian colonial ideology. Emberly draws on the work of Ann Laura Stoler who states that "colonial power relations can be accounted for and explained as a sublimated expression of repressed desires in the West, of desires that resurface in moralizing missions, myths of the 'wild woman'" (Stoler qtd. in Emberley 39). The repressed sexual desires of white colonizers were projected onto the bodies of racialized women whose aesthetics were associated with an unruly sexuality that required missionary moralizing and violent forms of repressive governance.

The use of Black and Brown female nudes by Perera and the long dark braids of the yoginis in the artist's imaginative paintings signify a resistance to desexualized images of yoga and a colonized "East." The ironies of consumer capitalist branding of yoga for white consumers lies in how such cultures of spiritual tourism and shopping reassert a mind/body binary. The white body is once again positioned as a rational secular capitalist consumer who can participate in the "fair is fair" rhetoric Western secular capitalist economies, in which rich white capitalists can buy anything and everything, with little implication in racism and colonial genocide. Within the *Yoginis* series, the racialized woman is not a sexless community martyr nor is she waving a flag for the whiteness of a colonial nation. Rather, their body rests within a postmodern space of liminality, between lingering traditions of an embodied spiritual and cultural practice and a cosmopolitan hybrid culture of multiple intertexts.

Just as the colonies were imagined to be playgrounds for white colonizers to engage in racist fantasies, Brown women's bodies often exist within a white phantasm of Orientalist tourist economies, appearing only as exotic commodities to soothe the souls of dazed white people. One can consider the relationship between Orientalism, sexism, and racism in the American film *The Darjeeling Limited*, as discussed by Jonah Weiner. In the film, a group of white men travel to

India as part of a spiritual sojourn. The love affair between one of the men and an Indian woman is part of his New Age therapeutic journey, with both the Indian subcontinent and the body of the Brown woman being used to fulfill apolitical Orientalist fantasies and heal the souls of white men. The enlightened yuppie can tour South Asia and engage in a temporary romantic relationship with a Brown woman as a form of yogic sex tourism, in which South Asia and the body of the South Asian woman are new hearts of darkness that exist for the amusement of dazed white men.

The white Western body within store-bought yoga cultures is at once everywhere and nowhere, just as the white body of colonial history was the absent and invisible norm that came to mark racialized Others as spectacles of deviance. The ironies of Western shoppers using "Eastern spirituality" to construct themselves as moral and self-righteous lies in how such a position makes colonial history and the bodies of racialized people disappear. While celebrities, "yummy mummies," and New Age yuppies construct their bodies as temples by worshipping at the shrines of appendages to neocolonial wealth, the ongoing violence done to colonized women is often an unspeakable truth that haunts the "fair is fair" mythologies of Western nations. The body of the rich white woman armed with a million dollar yoga mat becomes a figure of "enlightened" pursuits against the bodies of Brown women whose bodily desires are invisible within the mainstream white Western popular culture imaginary. The labour exploitation of South Asian convenient store operators is mocked through figures such as Apu, while Orientalist ideas of South Asia are used to create opulent industries of expensive asceticism. As commented on throughout *Uncommitted Crimes*, Emberley discusses how white Canadian colonizers often constituted Indigenous peoples as "diseased" in order to pathologize Indigenous ways of life and justify the seizure of land and political governance. Similarly, one can consider that migrant women from South Asian countries such as Sri Lanka and India are also often imagined to be from countries of disease. The sickening irony of white fantasies of the New Age and exotic forms of spirituality lies in how consumers can use products associated with racial and religious Others as appendages of middle class health, while racialized bodies are marked as figures of contagion.

Aesthetically, the forms that Perera uses move away from classical European paintings and Eurocentric art histories. While Perera studied European canons of art and art history, the artist states that she was first influenced by oil paintings as a child in Sri Lanka. When asked of her first memory pertaining to art she states,

> My first memory would probably be doing these oil pastel drawings when I was young in Sri Lanka. The first memory I have of my art creating a response in other people would be when I won a local TV station's children's art competition. My mother was working there and I entered a little landscape I had drawn and it got on TV. That could have been my first taste of artistic confidence. (Perera)

While dominant racist colonial ideologies often associate the Global South with "nature" and Europe and North America with "culture," Perera challenges this teleological narrative of Western temporal progress (Butler, 2008). Perera makes reference to the inspiration she garners from South Asian artistic canons, stating:

> I look at a lot of old art that comes from Southeast Asia. Rajput and Mughal Miniaturism, Buddhist and Tantric art, the visuals are very beautiful and intricate. I was taught quite a bit about European art in school which was either biblical or landscapes or abstraction, but in Ancient Southeast art I found all the sex, death and blood anyone could ever wish for. I also love looking back in time to paintings of deities and seeing the folklore and religious icons associated with them, the mythology and the spiritual and terrible sides to these gods and demi-gods. (Perera)

While the New Age branding of sexless cultures of puritanical yoga sales often empty images of the imagined East of all sensual and sexual desire and deviance, Perera takes inspiration from the traditions of embodiment represented within South Asian art. Within European canons of painting, bodies are often immortalized in ways that solidify images of the white feminine form as an idealized nationalist figure. White European women are represented as queens and princesses of

dynasties, serving to aestheticize their value to nations in biopolitical class-based terms. Similarly, within representations of the sacred, certain artistic techniques are used to create passive, precious, and sanitized images of religion, often associated with puritanical and sexless aesthetics. Perera's *Yoginis* offers kitschy, sultry images of naked racialized figures. Their clever creative works do not immortalize the body of the woman associated with the sacred in ways that place her on a pedestal or within timeless traditions divorced from the contemporary world of popular culture. Rather, the artist's yoginis are postmodern figures, reflective of a contemporary artistic sphere that is wholly infused with worlds of media, fashion, and counter culture. Perera's yoginis come to life in the artist's remarkable paintings. They are not dead or dying images of forgotten spiritual traditions; murdered or missing dark women lost to colonial violence or lost to border security jails. Rather, these figures erupt from the canvas of the artist, with their naked bodies in ambidextrous poses. Perera's shape-shifting postcolonial heroines are perhaps reflective of an anti-racist feminist artistic praxis that is as alive as the piercing colour that explodes from the canvas against the banalities of a white settler landscape.

As a Sri Lankan-Canadian artist, Perera's hybridity defies banal categorizations of East versus West. This centring and triumph of diasporic impurities resonates with other transnational artists such as UK-based singer M.I.A. M.I.A. has gained a great deal of popularity for her use of kitsch to comment upon politics in Sri Lanka and throughout the Global South. What both artists share is their refusal to succumb to reductive representations of cultural "authenticity." Anamik Saha discusses M.I.A.'s iconic artistic practice as a refusal to play into white fantasies of the East. Saha offers a reading of the relationship between hyperbolic performances of Orientalist femininity as an exaggerated play upon fetishistic ideas of Asian culture and a disruption of the neocolonial gaze through mimicry. As the author states, "The Orientalist signifiers are purposefully exaggerated and over-determined, and in this way disrupt a neocolonial discourse precisely through its mimicry, transforming the dominant culture's construction of exotic difference into uncertainty" (Saha qtd. in Atluri, "Like PLO" 189).

The certainty and fixity of racial, religious, and cultural identity is disrupted through artistic imagi/nation. Similarly, in Perera's playful

and powerful poetics, exaggeration of aesthetic symbols such as braids and the construction of naked women of colour's bodies, overexposed for the viewer, also offer a hyperbolic staging of racialized femininities. M.I.A.'s artistic praxis resonates with Perera's, as both artists refuse to succumb to the censorship implicitly enforced by discourses of identity politics in which artists are often made to fear using images and signs taken from other racialized communities. In offering images that resonate with Indigenous aesthetics and in using images of yoga, often historically connected to India, Perera refuses the usual forms of cultural show-and-tell in which symbols associated with certain nations and religions become the authentic property of racialized artists. Perera discusses the multiple influences that inform her artwork outside of colonial ideas of cultural ethnography. The artist state that their influences are comprised of "an endless list":

> Paleontology, astronomy, ethnography are a few. Ethnography is this crazy thing where colonizers of "new worlds" would go out and categorize its peoples pictorially in catalogues and things like that. Paleontology is my nerdy love of prehistoric life that never went away. I also saw Jurassic Park when I was about seven years old and that stuck with me in a big way. Ever since I was young I've needed to rediscover these antique worlds and find a relationship with the new. Astronomy to me means hope, in a childish kind of way. My paintings don't look too grown up, I suppose, because of these young nods to the fantasy, science fiction and comic book genres. (Perera)

Saha discusses how Orientalist discourse often constructs Asian artists in reference to a colonial understanding of essentialist ideals of Asian culture as timeless and pastoral (Atluri, "Like PLO"). The author suggests that M.I.A., in collaborating with artists from throughout the Global South, makes reference to political struggles transnationally and uses samples from diverse musical genres, thereby evading the dominant Orientalist gaze. This construction of a political identity as opposed to a multicultural ideal of ethnic and cultural uniformity is of particular importance for articulations of anti-racist feminism in creative industries. Saha states that M.I.A.'s "particular self-representation has managed to evade the dominant

Orientalist discourse that exoticizes and reifies Asian artists" (Saha qtd. in Atluri "Like PLO" 189). Similarly, Perera's *Yoginis* series offers edgy contemporary aesthetics exploding with colour, sexual innuendo, and a cultural hybridity that belies categorization and reflects a flexible position. The yogini of Perera's canvas is at once a sultry vixen, a spiritual figure, and a survivor of ongoing forms of white settler colonialism.

FROM MISSIONARY POSITIONS TO DOWNWARD DOGS: RACE, SEX, AND THE BODY

Beyond the colonial, provincial white settler images of white wigs and sturdy prairie women in bonnets, Perera offers a delicate anti-colonial prose in her construction of racialized women's bodies as sites of survival. The topic of sex within the scholarly and creative production of racialized women of colour is often met with trepidation. As Black feminists have written of, in an attempt to distance themselves from overly sexualized images of commodified Blackness used to justify the rape of enslaved African women, Black women are sometimes reluctant to write and create erotically charged images and narratives (Hill-Collins).

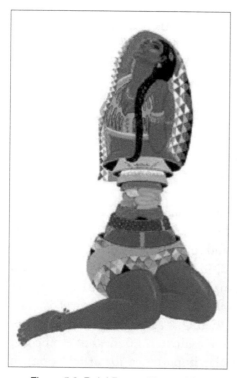

Figure 5.3: Rajni Perera, Matroyshka, 2011, mixed media on paper, 22 x 35 inches.

Similarly, as a Sri Lankan artist, Perera's genealogy can be read as being informed by ongoing histories of sexual and political violence. The bodies of Sri Lankan women, both Tamil and Sinhalese, are routinely subject to rape and sexualized torture as part of the ongoing Sri Lankan civil war. Rape and sexual torture are tools of masculinist na-

tionalist wars, ideologically steeped in rape culture. The body of the woman becomes synonymous with the seizure of land and the conquering of ethnic communities. Perera refuses to play it safe in her expressive depictions of race, sex, and exotica. Rather, the artist employs images of Blaxploitation in her work; those of sexualized Black femininities that offer the chance to consider the lust, anxieties, and aggressions towards Black female bodies that often simmer beneath the rhetoric of polite cultures of political correctness and moralism. Perera discusses her series *Afrika Galaktika*, one that plays with images of Blackness, representations of Africa, and Afrofuturism. In discussing this series she states,

> I'm having a lot of fun making this series; I want to talk about exoticism in a new way that is new and sort of glamorous with a scifi edge. When I start a piece I have a very specific vision of what I want and my work process is very singular and focused. I'm going into blaxploitation and afrofuturism with AFRIKA and I find new inspiration all the time through things like street style, high fashion, anime, comics, the internet... I have a lot of friends who design clothing and jewelry, and being surrounded by that type of atmosphere is great. They're full of creative sparks and it's entirely infectious.

The centrality of play and pleasure in the making of *Afrika Galaktika* offers a counter to the sexless moralisms that often inform mainstream statist forms of anti-racist multicultural production. As discussed in the previous chapter of this book, desexualized images of Blackness, and quaint images of apolitical cultural "authenticity" depict an other stripped of its libidinal jouissance. The anxious will on the part of critics and commentators to judge a work of art based on the origins of the artist are troubled in Perera's play upon histories of Black representation. When asked if she worries about cultural appropriation in representing Indigenous, South Asian, African, and ambiguous bodies in her work, Perera points out that while she is not concerned or censored by succinct borders of cultural ownership, she does consider the politics of representation. Specifically pointing to mainstream corporate uses of racialized bodies and romanticized images of static cultural and religious otherness she states,

> Cultural appropriation is something that happens over time in any case, but it becomes problematic, in terms of visual culture, when corporations or people disrespectfully co-opt stylistic elements, motifs or pieces of other cultures in order to make money or take something on that otherwise has sinuous connections to them, with no foundation of respect, no research done, no real inspiration tying it to anything substantial.

The artist further suggests that her work departs from this commodification of apolitical otherness by centring the racialized feminine body as a figure of power, and as one that is used to reflect upon the complexities of race, sexuality, and agency. She suggests that her work is a far cry from the appropriations of the mainstream, as it "poses questions of respect, agency, power and body politics." Perera also identifies as "an immigrant who navigates the space between cultures. So in terms of exploring the power of the colored female body in the white male world, I think I'm okay." Canadian multicultural narratives often construct airtight categories of religious and racial communities in which one is often only invited to represent succinct and saleable forms of diasporic nationalism. However, Perera discusses race and gender as being central in her experiences in the art world, seeing her vivid representations of dark-skinned female bodies whose vivid depiction is an affront to the celebration of white masculinities.

Stuart Hall argues that anti-racist cultural producers often remain trapped within binary frames of representation. Rather than constructing images of racial and cultural authenticity, moral missionary women, or harmlessly sexualized Black women, Perera's work offers a comical parody of ideas of the exotic. In her painting *Heels/Ethnic Accessories*, Perera depicts a nude Black female figure on her knees, with a fountain of shoes in tribal prints emanating from her body. Rather than celebrating a saleable "authentic" image of Black women's bodies or ignoring ongoing histories of exoticism as multiculturalism, Perera offers a playful commentary on the relationship between race, sex, and visual spectacle. One can also consider that Perera's paintings evade succinct borders of time and space. In *Afrika Galaktika*, Perera uses Blaxploitation images popularized in 1970s American film alongside

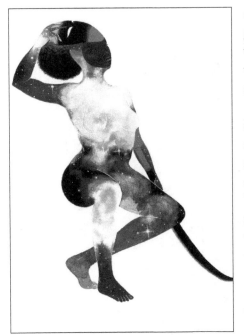

Figure 5.4: Rajni Perera, Spy, 2014, mixed media on paper, 15 x 24 inches.

astronomical aesthetics of galaxies, and images of warrior women of ambiguous origins who appear in several of the artist's works.

Discourses of European colonialism were acts of spatializing the world and narrating universal realities according to calendars of Western secular mythologies in which histories were written after colonial contact. Conversely, in Perera's artistic non-place are images of other galaxies mingling with those of popular culture and what could be conceived of as mythical female tribes. The worlds created in the imagination of Perera and her striking artistic creations offer a home for those who straddle the borders of different worlds. Perera discusses her use of multiple artistic referents, a wonderful pastiche used to create something new and novel: "I love looking at immigrant culture here and in other cities that have diasporic peoples. I'm inspired by the way that immigrant artists re-appropriate certain symbols of antiquity in a completely different context, giving them different looks and making something new with these old images" (Perera). In the deft hands of artist Rajni Perera, yoginis become sexy warrior women, "ethnic" multicultural products become provocative parody, and Blaxploitation images leave Hollywood en route to other galaxies.

FAIR AND LOVELY, DARK AND DANGEROUS: THE NEW ETHNOGRAPHY

The economies of secular Western capital are inculcated into the ongoing palimpsest of colonial aesthetics. The explicit and implicit racism of colonial desire meets the sale of "Fair and Lovely" lightening

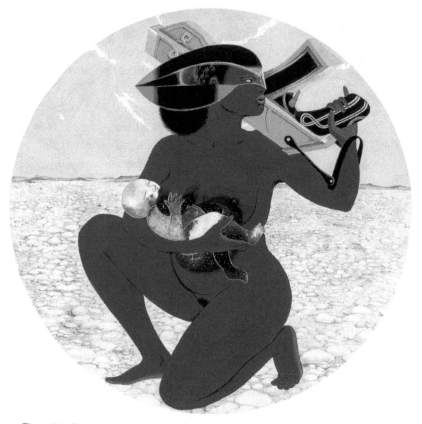

Figure 5.5: Rajni Perera, Mother with Gun, *2014, mixed media on paper, 36 x 36 inches.*

creams made to brand a "body-beautiful" image of whiteness. Margaret Hunter discusses the imbrication of colonial ideology and contemporary cultures of neoliberal beauty branding: "The merging of new technologies with old colonial ideologies has created a context where consumers can purchase 'racial capital' through skin-bleaching creams or cosmetic surgeries" (142). The racial capital of whiteness aligns ideas of capitalist and neo-liberal "betterment" and success with those of light skin. Hunter discusses how within the framework of secular capitalist rationalities, the body is often viewed as a work in progress. Whitening one's skin becomes tied to efforts to acquire employment, as light skin is associated with sophistication and wealth. As Hunter notes, "Light skin tone can be transformed into social capital (social networks), symbolic capital (esteem or status) or even economic capital (high-paying job or promotion)" (145).

Perera's artistic oeuvre challenges normative images of the body as a tool of social and economic capital. The artist's installations draw on images of religious mythology to challenge the idea that secular capitalist "post-feminist" consumerism is liberatory. Perera's artistic works pose ontological questions regarding the impoverishment of dark goddesses in a time when skin bleach is used to attain material wealth. In Perera's art, the meritocratic lies of North American dreams meet the images of multi-colored and hybrid religious feminine figures whose skin carries both anti-racist and anti-colonial resonance. The artist uses a patchwork of brightly cultured tapestries that make reference to the South Asian subcontinent and its textiles, which played a central role in anti-colonial movements. By drawing attention to the skin of the colonized woman and challenging an aesthetic of idealized whiteness, Perera challenges disembodied ideas of liberal equality, which refuses to acknowledge the role that racialized embodiment plays in maintaining hierarchies of power. The "fair is fair" rhetoric of Western governance and discourses of civility is deeply imbued with the disembodied, rational truths of celebrated whiteness. While the dark skin of colonized people was once used to connote savagery thereby justifying political domination, skin is used today to bar one's access from positions of economic power.

While Western secular capitalism is often imagined as a form of undisputed progress that racialized women from the Global South escape to, Perera's *The New Ethnography* series troubles this clear cartographical and temporal map of supposed freedom. In paintings from this series such as *Coloured* and *Amma*, Perera uses colour and iconic imagery to create religious and cultural deities with skin that is the piercing blue colour of oceans. In this series, as with many of the artist's works, imagi/nation becomes a deft way of challenging the aesthetic and ideological superiority of European colonizers. In the skilled hands of the artist, the racialized feminine form is reconfigured as a hybrid that draws strength from ancient religious traditions and mythologies in which the colour of skin is not categorized through hierarchical colonial ideas of beauty or a secular capitalist beauty industry. *Coloured* offers the striking visual of a brown-skinned woman who is bare breasted, challenging desexualized images of puritanical model minorities. What is remarkable about *Coloured* is the artist's use of fantastical colour, shape, and form that troubles mimetic

Figure 5.6: Rajni Perera, Sentinel North, *2015, polymer clay finished with leather, metal, acryl-gouache and varnish, approx. 12" x 12" x 4"*

depictions of the feminine body. The face of the woman's body is multicoloured, marked with tribal patterns that disidentify with a world of lightening cream and the pasted-on smiles of global beauty queens.

Geoffrey Jones documents the widespread sale of "Fair and Lovely" skin lightening cream, which is marketed internationally by the multinational corporation Unilever. Jones states that the skin bleach "was launched in Sri Lanka in 1992, and then rolled out to nearly 40 countries in Asia, Africa, the Caribbean, and the Middle East by 2008" (313). The author further discusses how the product is now increasingly sold in the West. Jones states, "More broadly, the skin-lightening products developed for these markets began to find their way to markets in Western countries, reinvented as anti-aging products to inhibit skin pigmentation" (313). While neo-liberal feminism purports that women gain freedom through free market capitalist economies, the aging woman's body and the dark woman's body are abjected from biopolitical ideas of beauty in which women's desirability is often coupled with youth, white images of innocence, and an ability to reproduce new generations of "fair and lovely" racists.

In *Amma"*—a word meaning "mother" in Malayalam, Tamil, Kannada, and Telegu—Perera offers a painting of mixed media on paper that depicts a blue-skinned female deity flying on the back of an unidentifiable animal. The painting conjures up ancient traditions of polytheistic religions in which gods and goddesses are often

Figure 5.7: Rajni Perera, Amma, 2011, mixed media on paper, 18 x 24 inches.

represented in animal form and in fantastical colours and shapes not corresponding to the human form. Here, the figure of the mother does not mimic the colonial mother image of white, bourgeois femininity. *Amma* is also not a provincial puritanical model minority mother raising the next generation of white and diasporic colonial settlers in the desexualized image of a white Virgin Mary. Rather, *Amma* is a proactive and wild figure whose tongue hangs from its mouth and whose eyes are alight with an otherworldly rage and spirit. One of *Amma*'s hands is a claw, representative of postcolonial mythologies referenced in several of the artist's works in which

sacred figures often bridge the divide between human and animal. The idea of age and tradition, often denigrated and bleached out in market-based ideals, meets the wisdom of a mother who is not a bonnet-laden prairie woman or a "yummy mummy" buying Botox. Rather, Perera's paintings recuperate aesthetic genealogies often violently disparaged by Occidental colonial powers. Rajni Perera uses breathtaking skill and a creative archive resplendent with inspiring postcolonial iconography to visualize a hybrid feminist pedagogy of colour, fuelled by remarkable artistic fury.

It is poignant that *Amma* appears in *The New Ethnography* series, as ethnography was used with a Eurocentric and racist gaze by colonial researchers and explorers to categorize non-white, non-Christian bodies in the Global South. The beauty of Perera's "new" ethnography lies in her use of pop art and illustrative techniques within a diasporic context to breathe life into ancient traditions, remaking them as postcolonial feminist fantasies of a future beyond the violent hierarchies marked on the skin.

The painting *Legs2* also from *The New Ethnography* series gestures to traditions of polytheistic religion found throughout South Asia and South East Asia, a recurring motif in Perera's praxis. *Legs2* depicts a headless and bodiless wheel of female legs, with pubic hair erupting in the centre of the wheel. The painting resonates with images of deities of Hinduism and Buddhism in which gods such as Vishnu are often represented as having multiple arms. Vishnu is often represented as having four arms and hands, each of which is a symbol of something that this god is responsible for. One can consider the many legs of Perera's Brown-skinned feminine goddess as being representative of the multiple journeys, routes, and embodiments of home that racialized feminine diasporic subjects from the Global South traverse.

The many legs of a woman who moves from Sri Lanka to Canada, who perhaps moves from being perceived as a nationalist, communal symbol to being a diasporic woman of colour creating inspiring iconic art, reflects the resonance of tradition and sacred mixing with the aesthetics and practices of postmodern creative labour. What is especially interesting in regards to Perera's visualization of images that resonates with surrealist traditions of painting lies in how her use of illustrative techniques construct comic book type images that are neither sentimental nor heavy handed. Rather, her works are playfully

political, inviting the viewer to be reincarnated in their gaze, seeing the paintings in a different light with every look.

The image of a whirling circle of brown feminine legs—each fastened with anklets often worn by South Asian women, crisscrossed with neon stripes, and all united in patches of pubic hair—are neither tame nor overly didactic. Rather, they are kitschy paintings that allow for multiple readings. The many lives of a racialized migrant woman meet the many lives of the surrealist and pop art tradition, always finding new expression in different generations of spirited artists.

BROKE LAKSHMI: COMIC AFFRONTS
TO MULTICULTURAL MULTINATIONAL CAPITAL

From caste-based weddings in the suburbs of Toronto to a global capitalist marketplace that valorizes images of South Asians as Bollywood princesses dripping in gold, the worship of wealth is often woven seamlessly into multicultural branding. The glorification of South Asian `"princesses"' and images of Bollywood opulence obscures the reality of many South Asian and specifically Sri Lankan migrant women who occupy low wage economic positions. Neo-Orientalist images of glitter and gold also efface the economic capital of whiteness. As mentioned, light skin is often used to access social networks of whiteness that lead to economic capital and wealth. The ironies of multiculturalism within white settler colonies such as Canada lie in the sale of items such as food, fashion, and film which celebrate "culture" as an over-the-counter form of authenticity that can be bought and sold by dazed white consumers, while women with dark skin often serve as slave-wage labourers. The "third eye" of a bindi, often used to represent an eye that sees beyond the physical, becomes a fashion accessory for affluent Western celebrities. Perera comments on the lure of self-exotification on the part of racialized migrant artists:

> POC (People of Colour) artists do have to be more careful about things like self-exotification without anything in particular to say, without any substance. It's an easy way in but watch that you're not making work just to repackage and sell your culture to a western market. You'll fall into a web of

lies (lol). There's lots to talk about outside of painting cute pictures of girls wearing bindis. (Perera qtd. in Shraya)

While Bollywood regalia sells itself as a glamorous trend for Western shoppers, the reality of poverty that is often experienced by those in and from the Global South is unremarked upon, and certainly not celebrated in citywide festivals or community parades. Perera's painting *Broke Lakshmi* offers a funny and yet poignant commentary regarding the relationship between diaspora, wealth, faith, and multicultural multinational capitalism (Žižek). While curry, samosas, and store-bought spirituality are all the rage, the bodies of Brown women are often maligned, deported, unemployed, and made invisible within a capitalist marketplace where rich white yuppies can enjoy Indian products while avoiding personal intimacies with Brown people. In *Broke Lakshmi*, the Hindu goddess of wealth Lakshmi is depicted as she often is within traditions of South Asian painting. However, Perera's Lakshmi is also seen using two of her many hands to reveal empty pockets. The artist is humorously and frankly commenting upon the reality of racialized feminine migrant artists who are not Bollywood princess or ethereal goddesses, but women of colour who must struggle to earn a living wage within competitive white male art worlds.

As I discuss through *Uncommitted Crimes*, multiculturalism often functions as a form of neocolonial capitalism, with the Western consumer being positioned as a "shop till you drop" colonial explorer. While Western cities and nations are overflowing with multicultural economies, the patronizing distance towards Other cultures can justify the invisibility of racialized migrants as complex subjects who do not correspond to Orientalist tropes. Such a distancing can allow for the brilliant and interesting work of migrant artists of colour, and specifically women of colour, to be overlooked or quarantined to the spaces of succinct ethnic "communities." Perera's paintings, generous in colour and philosophical and artistic references, challenge the poverty of imagination that often constructs the Brown woman within North America in cartoonish ways, as a representative of another nation, a wise spiritual savior of soulless white Western consumers, or as a victim of barbaric traditions waiting to be rescued by newfangled missionaries.

While white male artists often grace the pages of national and city-based magazines as representatives of celebrated contemporary art,

Figure 5.9: Rajni Perera, Broke Lakshmi, 2014, mixed media on paper, 12 x 12 inches. (Commissioned by Vivek Shraya for album cover.)

the work of racialized female artists in cities such as Toronto remains marginal. Žižek argues that "multiculturalism is a disavowed, inverted, self-referential form of racism, a 'racism with a distance'—it 'respects' the other's identity, conceiving the Other as a self-enclosed 'authentic' community toward which he, the multiculturalist maintains a distance rendered possible by his privileged universal position" (Zizek 171). Similarly, white male artists often occupy positions of power in which their artistic work is conceived of as universally appealing. As discussed in a previous chapter of this book in relation to Kara Springer's deft use of minimalism, the art of white male painters is rarely written of as representative of whiteness and masculinity, but simply as art. The art of idealized white men is judged based on aesthetics rather than the colonial histories of violence that come to mark some bodies as "multi-cultural" and other bodies as "cultured," due to the unspoken

cultural capital of whiteness. *Broke Lakshmi* is reflective of the ironies of an economy of multicultural corporate branding in a world where racialized people from and in the Global South, and Indigenous peoples globally, are subject to ongoing forms of colonial theft that have impoverished whole continents and attempted to break the spirit of the colonized. *Broke Lakshmi* offers what much of Perera's rich artwork offers, a painting that is lighthearted while subtly exposing harsh political and economic realities with trickster finesse. *Broke Lakshmi* is a goddess made with all of the hybrid influences, artistic prowess, and hard-earned wisdom of a racialized artist navigating a white man's world. Much like the many other finely crafted gems that encompass this prolific artist's body of work, *Broke Lakshmi* is a priceless wealth of colour and comic wit. Rajni Perera leaves one with lasting images of triumphant racialized feminine goddesses who are left to have the last laugh, their darkly comic brilliance lightening the heavy truths of history.

WORKS CITED

Alexander, Jacqui. *Pedagogies of Crossing.* Durham: Duke University Press, 2006.

Alter, Joseph. *Yoga in Modern India: The Body Between Science and Philosophy.* New Jersey: Princeton University Press, 2005.

Atluri, Tara. "Is Torture Part of Your Social Network?" *The Žižek Media Studies Reader.* Ed. Matthew Flisfeder and Louis Paul Willis. New York: Palgrave Macmillan, 2014. 241–57. Print.

Atluri, Tara. "Like PLO I Don't Surrender: Genealogies of Feminine 'Terror' and the Evils of Orientalist Desire." *Evil Women and Mean Girls.* Ed. Lynne Fallwell and Keira Williams. New York: Routledge, 2016. 177-97. Print.

Bhabha, Homi K. "Treading Water: Reflections on an Intemperate Medium." Vasant J. Sheth Memorial Lecture. Chhatrapati Shivaji Maharaj Vastu Sangrahalaya. Mumbai. 16 January 2014. Lecture.

Bhabha, Homi K. *Location of Culture.* New York: Routledge, 1994. Print.

Banet-Weiser, Sarah. *Authentic: The Politics of Ambivalence in a Brand Culture.* New York: New York University Press, 2012. Print.

Butler, Judith. "Torture, Sexual Politics and Secular Time." *The British*

Journal of Sociology 59.1 (March 2008): 1-23. Print.

Chatterjee, Partha. "Women, Colonialism, and the Nationalist Question?"*American Ethnologist* 16.4 (Nov. 1989): 622-633. Print.

Emberley, Julia. *Defamiliarising the Aboriginal: Cultural Practices and Decolonisation in Canada.* Toronto: University of Toronto Press, 2007. Print.

Hall, Stuart. *Representation: Cultural Representations and Signifying Practices.* London: Open University, 1997. Print.

Hill-Collins, Patricia. *Black Feminist Thought: Knowledge, Consciousness, and the Politics of Empowerment.* 2nd ed. New York: Routledge, 2000. Print.

Hunter, Margaret L. "Buying Racial Capital: Skin-Bleaching and Cosmetic Surgery in a Globalized World." *The Journal of Pan African Studies* 4.4 (June 2011): 142-164. Print.

Jones, Geoffrey. *Beauty Imagined: A History of the Global Beauty Industry.* Oxford: Oxford University Press, 2010. Print.

Osbourne, Peter. *Walter Benjamin: Critical Evaluations in Cultural Theory.* New York: Routledge, 2005. Print.

Phillipose, Liz. "Healing the Wounds of Imperialism." *Works and Days 57/58: Invisible Battlegrounds: Feminist Resistance in the Global Age of War and Imperialism* 29.1,2 (Spring/Fall 2011): 65-78. Print.

Perera, Rajni. "Rajni Perera, Artist." Hermann & Audrey Gallery Website. 4 Dec. 2013. Web. 19 July 2015.

Saha, Anamik. "Locating M.I.A.: 'Race,' Commodification and the Politics of Production." *European Journal of Cultural Studies* 15.6 (2012): 736-52. Print.

Said, Edward. *Orientalism.* New York: Random House, 1979.

Salam, Ziya Us. "We Need Lofty Principles, Not Lofty Statues." *The Hindu* 19 Jan. 2014. Web. 19 January 2015.

Shreya, Vivek. "Maharani Rajni." Heartbeats.ca. 26 Jan. 2015. Web. 17 July 2016.

Vij, Manish. "The Apu Travesty." *The Guardian* 16 July 2007. Web. 30 Oct. 2016.

Weiner, Jonah. "Unbearable Whiteness." *Slate Magazine* 27 Sept. 2007.Web. 30 October 2016.

Žižek, Slavoj. "Multiculturalism or the Cultural Logic of Multinational Capital." *New Left Review* I/225 (Sept.-Oct. 1997): 30-50. Print.

6.
Smuggled Skin

Mass Arrival Finds Refuge in the Creative

HE MASS, THE MULTITUDE, THE RABBLE, the people; they gather, they rise, they dialogue, they dissent, they become spectacles of fascination and fear. Within times of common-sense individualism in which Slavoj Žižek suggests that the most ultimate freedom lies in the freedom not to be harassed, what can be learned from divergent understandings of collective assembly? (Žižek, "The Prospects"). While the mass spectacle can provoke titillation in the form of media-driven spectacle, mass sales, and cultures of fandom, the mass is also associated with the perpetually excluded, with the swarm or smuggled cargo of migrant bodies constructed through racist discourse as bodies infesting the nation. Finally, the widespread disillusion of communal forms of life in favour of cultures of neo-liberal betterment can also give rise to oppositional new forms of collective political action and artistic collaboration.

Mass Arrival was an art installation by five artists staged at Whippersnapper Gallery in Toronto, Canada, in September 2013. It offered a breathtaking spectacle of ironic and impassioned artistic revelry, reflective of the spirit of the collective to take a stand against the policing of "swarms" of migrants who are pushed beyond borders of human hospitality. The installation offered a commentary on ongoing transnational racist, xenophobic, and money-driven policies of migration and border security. *Mass Arrival* was a visual spectacle used to reflect on the xenophobic and racist hysteria that surrounded the case of the *MV Sun Sea*, a ship carrying Tamil migrants seeking refuge from unspeakable brutalities of war and genocide. Those who sought refuge from genocidal persecution brought about by ongoing civil war between the Tamils and Sinhalese in Sri Lanka faced

detention, deportation, and rage on the part of mainstream conservative politicians, writers, and right-wing members of the public. The figure of the "swarm" or racialized mass overtaking white settler nations provoked fear and anxiety in the minds of many (Cader).

In an exhibition held in the Surrey Art Gallery in British Columbia titled *Disfiguring Canada*, Farrah Miranda, a curator of the collective art piece, reflects on how the idea for *Mass Arrival* arose as a response to the hysteria that surrounded the arrival of the *MV Sun Sea*, and the passing of Bill C-4 by conservative politicians. Miranda writes,

> Amidst the manufactured media frenzy of 2009 and 2010, Canada's Conservative Party introduced and later passed, Bill C-4 (formerly Bill C-49), which included a series of legal provisions to criminalize asylum seekers. Under these new laws, any two or more people suspected of being part of "smuggling incident" (for which there is no clear definition) face: mandatory incarceration for one year. They are denied access to healthcare, monthly detention reviews, and the right to appeal a negative decision on their refugee claim; and are prohibited from leaving Canada for five years after obtaining refugee status; preventing them from seeing family and loved ones.

Miranda further discusses how the anger and frustration that came from bearing witness to the criminalization of migrants inspired the production of collective political art. She writes, "Discussing these looming laws with friends, I blurted out in sheer exasperation that we should, 'get a boat, fill it with white people, and stick in an intersection.' We chuckled at the idea, but left it at that."

The public spectacle of the political and the artistic coalesced in *Mass Arrival*, producing a commendable collective artistic work. Through the *Mass Arrival* collective and project, this outrageous example of racism and xenophobia generated a moment of collective action in the form of artistic collaboration. In this chapter, I discuss feminist, anti-racist, migrant art collectives in relation to the image of the masses as migrant rabble—those who are often not figured as people with individual desires, but "swarms" and "boatloads" who are dehumanized in a rhetoric that associates them with nameless and faceless refuge.

Figure 6.1: The Mass Arrival Collective, Mass Arrival, 2013.
Photo: Tings Chak per: Mass Arrival Collective.

The figure of the migrant on the *MV Sun Sea* was often given no name, face, or individual intelligibility in the mainstream media. Rather, the racialized, impoverished Tamil migrant was simply another "boat person," part of objectified cargo, and associated with a rabble that lies beyond the human.

Those on the *MV Sun Sea* were what Žižek terms the perpetually excluded; people whose inability to find incorporation within universals of secular, liberal governance gesture to the failures of this order to function as truly universal (*The Parallax View* 35). If the rabble or the excluded mass were to gain entry into the polis and be assimilated, the competitive spirit of capital would perhaps not function to produce the affluent white settler subject whose individual success occurs against the objectified Other. In this regard, those on the *MV Sun Sea* were constructed through colonial ideology as people whom, as discussed in previous chapters of *Uncommitted Crimes*, bear the "mark of the plural" (Memmi). The racialized migrant is constructed as belonging to a community in which its lack of individuation stands against the assumed intelligence, creativity, and authority of the white colonial settler. *Mass Arrival*, however, demonstrated the powers of collective creativity and political engagement to challenge the white settler ideologies that inform this thinking, and a common-sense ethos of

liberal individualism that assumes the collective cannot act as a vital intellectual force.

In boats, they came. Masses and waves of migrants that have for centuries bound together to share in the hopes of survival. In boats, they came. Masses of artists, activists, and voluntary performers who participated in this wonderful installation in a show of solidarity, to share in the hopes of survival and an enduring belief in the perhaps intangible and untranslatable idea of something called justice.

Figure 6.2: The Mass Arrival Collective, Mass Arrival, 2013. Photo: Tings Chak per: Mass Arrival Collective.

MASSES AND MIGRATION: COLLECTIVE RACIAL EMBODIMENTS AND WHITE SETTLER IDEOLOGY

In considering the idea of the "mass," one can also consider colonial history. Julia Emberley discusses the relationship between leftist

political theory, socialism, and the ideology of the Iroquois. The author suggests that much of the thinking of early leftist theorists came from the Iroquois confederation. The idea of the tribal, the communal, and the collective was perhaps tied to traditions that defied common-sense understandings of the ownership of land, women, children, and individual property.

Ann McClintock discusses the fiction of the white imperial family man as the ultimate figure of liberal bourgeois individualism. This white masculinist figure owned the racialized rabble associated in colonial discourse with metaphors of dirt, impurity, and with the land itself. Writing in regards to Squire William Maybohm Haggard, a writer born in 1856 in British Colonial India, McClintock discusses how the politics of creativity became deeply imbricated in the workings of colonial ideology, reflective of deeper understandings of white male bourgeois subjectivity. The bodies of the colonized were considered to be undecipherable masses to labour, and to serve the sexual fantasies of white overlords, often through rape. McClintock writes,

> The poetics of male authorship is not just a poetics of creativity, but also a poetics of possession and control over the issue of posterity. It involves the production of an order and a hierarchy of power. In Haggard's case, the constellation of images of paternity, succession and hierarchy that informs the idea of authorship was particularly troubled and suggestive. (235)

McClintock notes that Haggard succeeded in perpetuating the family name "not, however, through the medium of land or the succession of male offspring, but through authorship" (235). The author goes on to discuss Haggard's ambiguous relationship to female authority found in the figure of his mother and racialized, working class, and enslaved servants. His grudging respect and simultaneous disdain reflect a deeper psychic anxiety that often plagued white colonial subjects. McClintock suggests that Haggard for example occupied an ambiguous masculinist positions of being both dependent on the labour of the colonized, while constructing himself as the master of the feminine and racialized. One can consider that *Mass Arrival* was

conceived by artist Farrah Miranda, a prominent and well-respected migrant justice activist in Toronto. Preferring to work collectively, Miranda formed the Mass Arrival Collective: Farrah Miranda (artist) Graciela Flores-Mendez (legal worker), Tings Chak (artist-architect), Vino Shanmuganathan (law student), Nadia Saad (social worker).

The marking of whiteness as strange and foreign to the landscape troubled dominant fictions of colonial settler ideology. The racialized feminine and collective authorship of this installation also gestures to the powers of radical art as an anti-colonial body politic.

In their writings regarding A/r/tography, Barbara Bickel et al. discuss the concept of relational aesthetics with reference to their ongoing collective work as artists, researchers, and writers working with migrant communities in Richgate, British Columbia. While the Collective focuses their work on relationally situated art practice with Chinese-Canadian migrants, they gesture to overarching possibilities of collectives engaged in A/r/tographic practice. They write,

> As a multilayered collaborative undertaking, involving a complex combination of new and established immigrants, universities, and art institutes along with artist-educators who are individually exhibiting artists, this project engages multiple identities/roles/situations that require stepping out of comfort zones and familiar ideologies, theoretically breaching established discourses to include "radical possibilities for a revision of the relation between imagination, cultural activity, and artistic institutions. (Bickel et al. 89)

The authors further write, "A/r/tographers readily admit that transforming perception into an experience and experience into perceptions complicates the process. A/r/tography is limited to the impossible only if one is trying to achieve some form of completion or mastery" (Bickel et al. 89). Rather than being focused on "mastering" narratives of migrants or completing the task of communal art practice, the authors state that, "A/r/tography is not about mastering a method but rather requires an ongoing, rigorous, messy, and radical multiplicity of relationships" (Bickel et al. 90). The artistic transformation of "whiteness" into a swarm, a mass arrival of white-bodied people taking over the streets of Toronto in a boat, parodied the perception of white

as the norm. *Mass Arrival* involved the staging of an installation in which the public could experience whiteness as strange and out of place, a spectacle of skin often only made out of racialized people's bodies. *Mass Arrival* can be read as an A/r/tography that challenges white settler mythologies of entitlement, racial privilege, and claims of authorial ownership of space (Bickel et al.).

SYMPTOMS AND SETTLERS:
GLOBAL CAPITALISM, WHITE SETTLER IDEOLOGY
AND THE BODY OF THE MIGRANT

Within times of common-sense neo-liberal consumerism, a security state brought about by the global "war on terror," and political conservatism, the migrant becomes an example of contemporary rabble. Žižek discusses the presence of the radically excluded within discourses of supposed universality that often structure secular Western democracies. The excluded are those who remain out of the bounds of structures of meritocratic capital to the point that their rights to life are suspended. Informed by Hegelian writings regarding the dialectics of universalism and the symptom, Žižek writes,

> ...the inherent structural dynamic of civil society necessarily gives rise to a class which is excluded from its benefits (work, personal dignity, etc.)—a class deprived of elementary human rights, and therefore also exempt from duties towards society, an element within civil society which negates its universal principle, a kind of "non-Reason inherent in Reason itself"—in short, its symptom. (*The Plague of Fantasies* 127)

Žižek draws on Hegel to discuss points of exclusion that are not an exception but integral to the functioning of a capitalist order. Žižek subsequently writes,

> Do we not witness the same phenomenon in today's growth of an underclass which is excluded, sometimes even for generations, from the benefits of liberal-democratic affluent society? Today's "exceptions" (the homeless, the ghettoized, and the permanent unemployed) are the symptom of the late-

capitalist universal system, the permanent reminder of how the immanent logic of late capitalism works. (*The Plague of Fantasies* 128)

The arrival of the *MV Sun Sea* on Canadian shores spoke to the presence of the often-unspeakable symptom of "polite" white settler societies. In restaging the mass arrival of migrants, the installation cleverly visualized the ironies of white panic regarding swarms of Brown bodies on Turtle Island, once only populated by brown-skinned people. Journalist Desmond Cole discusses the staging of the installation and space of dialogue it created. Cole considers the genealogy being staged in the artistic work of the Mass Arrival Collective regarding the relationship between the normalization of whiteness and entitlement of white settlers to land: In stark contrast to the occupants of the *MV Sun Sea*, which landed on Canadian shores exactly three years ago carrying nearly 500 Tamil refugee claimants, all the inhabitants of the Mass Arrival ship were white. Their brief street intervention was a challenge to the apparent normalcy of Canadian whiteness, and fear of racialized migrants like those aboard the *Sun Sea*.

Those who bore witness to and took part in the installation used the space created by *Mass Arrival* to publically discuss racism in Canada. Cole continues their report by drawing on interviews:

"This action made me think about the process of colonialism and genocide," said volunteer Meagan Gohnston. She believes the legacy of European settlement and the brutal treatment of Native people at the hands of colonialists still shapes Canadians' views on immigration. "How come one group is seen to have a legitimate claim to this land, but others don't?"

The ostensibly "illegitimate" claims of Tamil migrants, often referred to in the conservative press as "terrorists" and vilified by spectators as "invaders" exemplifies Žižek's reading of the symptom. The apparently legitimate claims to humanity that can be made in a capitalist secular order are empty universals that only function through the perpetual symptom that is not a contingency but a lingering truth hanging

on the mythology of Western liberal governance. From the colonial genocide of the Indigenous, to slavery, to the contemporary "war on terror," and increased production of stateless populations who occupy liminal spaces of humanity, fair has never been fair. Miranda discusses the racism that reared its ugly head upon the arrival of the *MV Sun Sea* and the worsening problems of xenophobia in Canada. Interviewed by Cole, Miranda states, "The racist discourse around the arrival of the Tamil ship was captured through images.... The government and media made references to people as cargo, as terrorists, as smugglers, as carriers of diseases ... as everything but human beings seeking safety" (Cole n.p.). Cole further comments, "Miranda believes Canada's federal immigration policy is only getting worse. 'The cuts to the Federal Interim Refugee Health program, the human smuggling laws that actually punish potential refugees ... it is all part of a revolving-door immigration policy,' she said."

It is perhaps interesting to think of the notion of the "revolving door immigration policy" in relation to Žižek's symptom, as a continually recurring feature of phantasmatic universalism that keeps mythologies of white secular capital in place. There is a perpetual ghost that haunts the colonial landscape; a recurring haunting that appears like a monster in the mirror, revealing the racist rage lurking beneath the apparent image of peace and order. Like many of the artistic works and artists discussed in this text, the arrival of Sri Lankan migrants to Turtle Island and the racist hysteria that ensued exist within a palimpsest of colonial temporalities (Alexander). The wretched violence of colonial genocide that constructs ideologies of white entitlement to Indigenous land set the stage for the exclusion of Brown bodies in a colonial nation of common-sense whiteness and white authority. Early acts of colonial genocide that caused the Indigenous to be a perpetual symptom demonstrate the failures of universalist multicultural mythology in which "diversity" is celebrated as sales. As discussed throughout *Uncommitted Crimes*, this "multicultural" marketing scheme happens as growing numbers of Indigenous women go missing and are subject to brutal forms of sexual violence and lingering racism. However, what is inspirational about *Mass Arrival* as an artistic intervention lies in how it visually carves out new markings on the landscape, in the cultural imaginary, and onto the parchment that defines the imperialist palimpsest of colonial time and space.

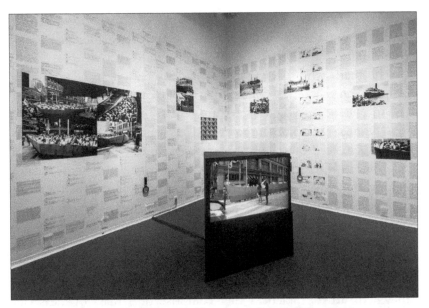

Figure 6.3: The Mass Arrival Collective, Mass Arrival, *Solo Exhibition at Whippersnapper Gallery. 2013. Photo: Mohammad Rezaei and Whippersnapper Gallery.*

ART AS PUBLIC PEDAGOGY:
CHALLENGING THE ANTI-INTELLECTUALISM OF
CONTEMPORARY NEO-LIBERAL CULTURE

During a time when public articulations of intellectual culture are increasingly disappearing, how might artistic practice function as a form of pedagogy? The imaginative installation *Mass Arrival* and collective of artists, activists, and volunteers who participated in this political event used art to create a space for public dialogue and critique. Taking place during the height of the student strikes in the United Kingdom, Žižek suggests that within a neo-liberal educational economy, intellectuals are being called upon to use what Immanuel Kant termed "private reason" in the service of individual corporately-funded universities, publishing, and paid consultancies for private businesses (Žižek, *Violence*). Instead of this privatization of the intellect, Žižek called upon intellectuals to use "public reason" to participate in political struggle. Using the skills of "public reason," a panel discussion in Toronto was organized by *No One Is Illegal* featuring intellectuals such as Kamala Kempadoo who discussed "smuggling" in relation

to the Underground Railroad and histories of slavery in which the supposed "contraband" of Black bodies were often smuggled across borders to flee the slave trade in the Americas.

Intellectuals who participate in public culture can provide a historical and theoretical context that complicates the surface reading of political issues in a high-speed, image-driven culture of viral media, often funded by major corporate advertisers and leaning towards conservatism to protect business interests. Irit Rogoff suggests that curatorial and artistic practice can offer interesting inroads into thinking through some of the most pressing political issues of our time, such as "citizenship." Rogoff writes, "The term 'smuggling' here extends far beyond a series of adventurous gambits. It reflects the search for a practice that goes beyond conjunctures such as those that bring together 'art *and* politics,' or 'theory *and* practice,' or 'analysis *and* action'" (1). Rogoff also offers a poignant questioning of how "smuggled" artistic practices that comprise of a mass of ideas can lead to forms of "embodied criticality": "The notion of an 'embodied criticality' has much to do with my understanding of our shift away from critique and towards criticality, a shift that I would argue is essential for the actualization of contemporary cultural practices" (1). Embodied criticality stresses a lived relationality to politics and to those whose identities shift across borders. For example, the critique of the global "war against terror" made at a distance cannot account for the affective ways "terror" comes to attach itself to racialized Tamil migrants in Canada. Tamil migrants are among those who are fleeing genocide, associated with terrorism, and subject to racist histories of persecution that haunt the landscape.

One can ask how cases such as the disgusting and irrational murder of Reena Virk, daughter of South Asian migrants in British Columbia, and the violent racialization of Brown bodies is shadowed by persistent violence against Indigenous people. Warren Glowatski, the man who was held responsible for Virk's murder, had a history of violently attacking Indigenous people, offering evidence of a continuum of white settler violence. The aesthetic policing of racialized feminine bodies could be seen as being part of a long genealogy of violence against racialized Indigenous women that defines the colonial encounter, and continues to be common today (Bhatacharya and Rajiva). Rogoff discusses critique as a means through which problems are often

diagnosed rather than solved. She suggests that "criticality" involves embodying a problem, not as an informed expert who feigns authority that allows them to stand at a distance but as a subject that lives within a problem. Rogoff writes that "[w]hile being able to exercise critical judgment is clearly important, it operates by providing a series of sign posts and warnings but does not actualise people's inherent and often intuitive notions of how to produce criticality through inhabiting a problem rather than by analysing it" (1). The ways that the artists who produced *Mass Arrival* inhabited problems of racist paranoia was reflective of the complex subject position of politicized artists, activists, and feminists of colour in Canada. As discussed in previous chapters of this text, Peggy Phelan argues that much like water in a kettle, the relationship between the body of the performer and that of the performative gesture does not exist in a metaphoric relationship but in a metonymic one. The performer does not exist outside the performative gesture, but comes into being as a staged subject through the work of performance. The white bodies that participated in the *Mass Arrival* installation were in the kettle of ongoing white settler colonial history.

The lived pain of the non-status migrant presents itself in the public sphere through acts of performance and performative utterance. In a 2014 protest in Australia, Iranian asylum seekers staged a hunger strike in which they sewed their mouths shut to protest their status as what Georgio Agamben terms "homo sacers," those who exist in a liminal space between life and death. It was reported that "[a]bout 75 asylum seekers reached day six of the strike on Sunday and have been joined by some 300 others, seven of who have stitched together their lips, the Refugee Action Coalition said" (*Australian Associated Press* qtd. in *The Guardian*). The article goes on to report that one detainee told the Refugee Action Coalition, "They are always warning we will be sent to Manus Island or Nauru. We need freedom." This cry for "freedom" is expressed in acts of political defiance that reach the mainstream press due to public, performative, and staged creative acts. The stitching of one's lips together is a painful and extreme spectacle that forces the general public to take notice of the "state of emergency" that is definitive of the condition of the oppressed (Benjamin). The *Mass Arrival* installation offered a moment in which anxieties of racism that haunt a white settler nation such as Turtle Island were

brought to public light. The palimpsest of imperial time in which the contemporary genocide of "the foreigner" is scratched onto histories of a landscape marred by traumas of white settler colonialism became a collective spectacle; an ironic commentary on how whiteness conceals and reveals itself as an unspeakable truth (Alexander). Finally, the installation can be read as a philosophical questioning regarding one's ethical responsibility to racialized migrants and our collective responsibility to confront racism.

If there is a collective responsibility to question the coordinates of our political moment, the collective unconscious of Canadian identity, and its relationship to whiteness, in what languages can intellectuals stage interventions? Cornel West, a brilliant philosopher and theorist has successfully bridged borders between art, the Ivy League, and grassroots spaces of activism. West's philosophical writing and ongoing investment in African-American spiritual life are coupled with their fervent love for music that has involved releasing hip-hop tracks and albums. Similarly, *Mass Arrival* offered an artistic moment in which passersby enter a space of embodied criticality in relation to the contemporary political moment, which is accessible and innovative in its pedagogy.

We live in and with politics, as much as we live in and with our bodies, emotions, and historical memory. This affective truth resonates with the artistic as a space of reckoning. Audie Cornish writes of West's album as a vehicle through which to communicate messages of political liberation and philosophical truth: "A prominent professor of African-American studies and philosophy at Harvard, West recently released his first album, 'Sketches of My Culture,' a mixture of rap and spoken word. He sees it as a way to deliver a message of pride in oneself and black history to people who may not get into Harvard or pick up his books." Cornish states that West is not a rapper by trade, but sees himself as being honoured to be part of the Black musical tradition. As Paul Gilroy remarks, Black musical traditions come out of histories of music and call-and-response traditions in Black churches, as well as slave spirituals used to communicate messages of rebellion to guide slaves to the Underground Railroad, thus to be counted as part of Black music is to be counted as part of anti-colonial resistance. Hip hop scratches beats and paints graffiti across the palimpsest of imperial time. The violence of flags raping stolen land and the scars

left across enslaved backs are expressed in the poet lament of slave spirituals resurrected as street culture. Like the use of music as anti-racist politics, creative interventions such as *Mass Arrival* provide a poesis of dissent, offering a waking dream that another world is possible.

Figure 6.4: The Mass Arrival Collective, Mass Arrival, *Solo Exhibition at Whippersnapper Gallery. 2013. Photo: Mohammad Rezaei and Whippersnapper Gallery.*

MASS HYSTERIA AND HYSTERICAL LAUGHTER: THE PARODY OF WHITENESS

There is an implicit relationship between the staging of mass spectacles of whiteness, the revisiting of colonial histories of settlement, and contemporary political spectacles. The 2010 G20/G8 protests in Toronto caused a mass spectacle due to the huge police presence; exorbitant money spent holding the G20/G8 summits in the city, and rampant human rights abuses, including the largest mass arrest in Canadian history. A spotlight shone on Toronto in ways that perhaps never had before, and spoke to the relationship between collective audiences of global spectators who watch history unfold through

screens and those who fight in the streets (Orpana and Mauro). The affective dimensions of the political cannot be experienced without participating in politics not only through text, but also through an occupation of public spaces that cause one to be moved by the crowd.

When one considers the visceral resilience of anti-austerity activists in Europe, protestors in ongoing Chilean student strikes, and those who participated in Quebec anti-tuition demonstrations, there is a moving emotion to political movements that is beyond translation (Juris). Similarly, the racist vitriol that erupted when the *MV Sun Sea* arrived carrying Tamil migrants was an affective and haunted rage that attaches itself to images of Brown-skinned people in ways that resonate with colonial history. The wonderful *Mass Arrival* installation spoke to how the staging of collective whiteness as the truth of dominant Canadian settler identity is also an affective image, one that generates anxiety regarding the unmarked and unremarked upon spectacle of white skin on stolen land. The inspirational pull of the mass to join political movements—or the fearful turning away from the crowd—are not rational decisions but resonate with the emotional life of spectacles of the political (Cooley). Similarly, the images that surrounded the arrival of the *MV Sun Sea* also generated an irrational and anxious rage that cannot be quarantined to the present but is part of an ongoing genealogy of colonial violence (Granados).

In the artistic and political event of staging masses of bodies that mark themselves as white, white people become publically suspect and culpable of historic crimes. These masses of white people moving through the downtown core in a makeshift boat mimic images of dark bodies that often cause a racist panic, by cleverly parodying the moment of colonial encounter (Granados). The white-skinned people who came and settled Turtle Island must have appeared more out of place than Brown Tamil migrants on the stolen land of racialized Indigenous people.

The reactions to this artistic event and desire to participate in it can be thought of as being beyond the rational order, in which people's psychic truth cannot be divorced from those of the collective. The hidden traumas of Canadian colonialism and histories of impoverishment, alcoholism, childhood sexual abuse, and the violence it has engendered among Indigenous people remains a hidden historical site of national Canadian denial that erupts in ways that cannot be conceived of as

wholly rational (Emberley). Emotion, unlike archival categories and the countenance of bodies through plastic ID cards is messy. It is the truth of these incalculable emotions—much like non-linear sketches of the artist's hand—that offer texts defying the logic of official archives that tells of an artistic future to come. As discussed in a previous chapter of this book, Clare Hemmings emphasizes the importance of affect theory, highlighting the importance of the emotive as informing one's relationship between self and world. And yet, as previously discussed, emotions are not politically innocent, particularly when they attach themselves to the oppressed. As we celebrate the artistic and emotive work of racialized cultural producers, we should also be critical of the violent histories that construct colonized people and feminized Others as being purely emotive, and incapable of intellectual and rational thinking (Hemmings 550).

Lisa Blackman discusses the relationship between affect, embodiment, and the cultivation of selves with particular reference to affect theory. Blackman suggests that for those interested in the political nature of emotion, what defines human existence is not rational masculinist individualism, but relationality. The author argues that subjects are permeable, and subject to the influence of others through the ways in which emotions circulate between people (30). Blackman writes, "This feminized space of relationality provided a way of thinking about social influence, which did not instate the figure of the clearly bounded individual exerting their will and exercising rationality as the means to set them apart from others" (35). One can ask how this space of the feminine and relational relates to the construction of the colonized as those who are inherently emotional, against the construction of the rational person that defines enlightened subjectivity. In this regard, the increased collective mobilization of political movements that often begin with the spontaneous eruption of collective protest and emotive movement of bodies through the crowd speaks to the affective dimensions of the political that move against the spirit of neo-liberal individualism. Neo-liberal and colonial ideology associates individual betterment with wealth, and a disassociation from the political truths and the collective artistic and political movements staged in installations such as *Mass Arrival.*

To say that we are changed by the histories we inherit not necessarily through lineages of birth but historical memories of land and nation is

to suggest that we are affective beings who are moved by genealogies that are beyond our control. The G20/G8 demonstrations generated a mass spectacle regarding the G20 Global Summits that were staged in Canada and bore witness to the staging of a political event. This staging involved spending a great deal of money and public resources to invite "world leaders" to the city, building a "fake lake" and a host of other fixtures of pageantry that define the making of a global spectacle. Miranda points out that years of work were put into organizing with grassroots migrant justice organizations such as *No One Is Illegal,* one of the many activist groups that participated in protests against the G20/G8 summit. She recounts the toll that surveillance had not only on the political organizing of activist organizations but also on the emotional well being of organizers. Miranda states,

> In 2010, *No One Is Illegal* had been targeted as part of a security and surveillance crack down against activist groups. Our organizers were followed and harassed by undercover officers, and detained and beaten, and the most prominent man in the group was targeted with harsh trumped up criminal charges and threats of deportation. These attacks put an immense strain on the resources of the organization, and on the emotional and mental well being of our organizers.

Miranda discusses the will to create art as a refuge and creative salvation:

> My departure from the organization left me with a sense of loneliness and isolation, but also one of relief. It's always been in moments of deep feeling that creativity has the chance to emerge; mine certainly did. It was at this time that the idea to "get a boat, fill it with white people and leave it in an intersection" resurfaced in my imagination. And this time it refused to leave. Not belonging to a political organization at the time, I didn't have access to much in the way of resources for this project. It was while thinking about how to fund and execute the project that it dawned on me: calling it art might do the trick. The "art" angle provides a defensive measure, an

added buffer of safety if you will from police, infiltrators and security forces.

Guy Debord suggests that in a world turned on its head, the truth can only be told in fiction. The truth of the feelings of isolation and frustration that arises on the part of social justice activists can be told in the realm of the artistic. Art might also offer a way to generate publicity and create positive senses of spectacle, while also connecting the affective spirit of the artist to the collective unconscious of the nation.

Frantz Fanon discusses the terrifying images of male savagery that historically defined racialized image production. Ann Pellegrini states:

> Fanon's particular examples are Tarzan stories, Mickey Mouse and other cartoons and comic books, and folktales from the American south, such as the story of Uncle Remus and Br'er Rabbit. These stories discharge collective aggressions, Fanon argues, by displacing fears, anxieties, and hostilities onto objectified types: "(T)he Wolf, the Devil, the Evil Spirit, the Bad Man, the Savage are always symbolized by Negroes or Indians. (111)

Writing these words in Tkaranto (Toronto) on "Thanksgiving Day," it is perhaps particularly important to discuss these images in relation to spectacles of arrival that haunt our collective unconscious in Canada. As Pellegrini further states, "If the colonizer assuages his/her guilt by feasting on the myth of the 'bad Injun' or the 'wicked Negroes,' the colonized internalizes his/her symbolization as evil and 'quite as easily' as the white subject, identifies with 'the victor'" (111). In restaging the moment of arrival through performance-based art, in which a boat of white-identified people marched passed The Hudson's Bay Company, there was a resignification of whiteness as the norm and as victorious. The mass of white bodies came to look as strange as they may have looked to Indigenous people at the point of colonial contact. Pellegrini suggests "[a]ttending to the world of representation is one way to attend also to the unconscious, even if the potential re-significations of the symbolic cannot be predicted in advance nor even be completely revealed to the unconscious after the fact. What form

or forms this attending will take also remains, quite literally to be seen" (112). The "to be seen" in addressing the unconscious fantasies of racism can happen in the collective mobilization of artists, activists, and participants in staging performance art installations such as *Mass Arrival*. The curation of this work by Miranda, a woman of colour, artist, and activist in Canada and by the Mass Arrival Art Collective comprised of women of colour serves to also construct the racialized woman not as an object to be traded or sold as a biopolitical commodity to breed races of men but as the producer of new images that re-signify dominant nationalist mythologies.

As discussed in previous chapters of *Uncommitted Crimes*, the myth of the "wild woman" and the "savage" Indigenous man perhaps lies buried in the subconscious minds of those who are inculcated into and imbibe mainstream nationalist fictions. Emberley discusses how image production and spectatorship cannot be divorced from political strategies of governmentality. The author suggests that image production is central to the production of colonial myth, and can function as a mode of "representation violence" that normalizes ongoing forms of violence against Indigenous people. Emberley states that representational violence "bound and reduced the complexity of Indigenous lived experiences to a fixed set of images, a panoramic phantasmania of aboriginality whose ghostly presence would haunt the apparent immortalizing technologies of re-production" (Emberley qtd. in Reder 410). The "ghostly presence" of the Indigenous functions very much like an Irigrarian "ghost in the machine" that structures not only conscious policies of governance but the subconscious mind (Emberley). Cynthia Sugars and Gerry Turcotte state:

> The "spectral" legacies of imperialism and globalization (that appear) in the form of unresolved memory traces and occluded histories resulting from the experience of colonial oppression, diasporic migration, or national consolidation, is readily figured in form of ghosts or monsters that "haunt" the nation/subject from without and within. (qtd. in Reder 411)

It is interesting to consider how the overrepresentation of white bodies that define the spectral image of *Mass Arrival* relates to images of the "vanishing Indian" that also figure within mainstream Canadian

aesthetics. Emberley discusses the example of the murals used on the British Columbia legislature walls to signify myths of Canada's origins. The murals depicted bare-breasted Indigenous women working, while white male overseers were constructed as figures of authority. Indigenous males in these murals were depicted as bowing their heads and signing over treaties to land, with the figure of governmental authority being represented as a white imperial bourgeois man. Indigenous peoples in these hegemonic aesthetic images of triumphant white settler racism were often reduced to one-dimensional caricatures of themselves and images of bonded labourers. The bare-breasted Indigenous woman is simultaneously depicted as a thankless workhorse and an object of sexual licentious. After protests from Indigenous feminist organizations and activists in British Columbia, the murals were finally painted over (Emberley).

The beauty of *Mass Arrival* lay not in offering a final commentary on racism and the workings of whiteness in the national unconscious, but in the parody of images of "arrival" and the "mass." The smuggled hordes of Brown bodies that crossed the border fleeing forms of persecution and threats to life that are beyond many people's comprehension were replaced with the banal and unspoken truths of how many white settlers crossed the border to plant flags in stolen land. Pellegrini discusses Louis Althusser's writings regarding how subjects are hailed into being: "There seems no way to opt out of ideology without losing claim to 'being' at all. Althusser: 'Ideology has always-already interpolated individuals as subjects.' Thus the paradox of subjection: the ideology that constrains the subject also launches him or her into being" (178). Pellegrini goes on to discuss the concept of misrecognition and the possibility of resisting authorial forms of interpellation:

> The famous scene of interpellation—"Hey, you there!"—with its stress on the subject called out, called into being, by language, recalls Freud after Lacan. If Althusser ultimately leaves these psychoanalytic points of contact "on one side," yet he provides a suggestive account of "the subject" as itself of contact, a go-between of sorts, forged at the juncture of prohibition and production, individual and state, the psychic and the social. (178)

Pellegrini writes that the domain of performance might offer a site through which relations between the psychic and social are not only restaged but also remade. She asks, "Might performance offer a potential site of rejoinder, helping not just to illumine relations between the psychic and the social but, perhaps, even to remake them?" (178). Pellegrini suggests that it is in a theoretical, theatrical domain that one perhaps encounters the possibility of resisting interpellation. She further suggests,

> It is here, in this "little theoretical theatre," that we encounter the possibility of resisting interpellations. However, this brief glimmer of resistance, admitted in the *sotto voce* of the parenthetical—"One individual (nine times out of ten it is the right one) turns round"—closes down in the next breath. Althusser writes, "Experience shows that the practical telecommunication of hailings is such that they *hardly ever* miss their mark: verbal call or whistle, the one hailed *always* recognizes that it is really him who is being hailed. (178)

It is in the theoretical slippage within Althusserian thought that turns around the "always" that offers the possibility of theatricality and misrecognition, as a means through which the subject can resist interpellation. Pellegrini asks, "Which is it: hailing "hardly ever' misses, or hailing "always" hits its mark? The fate of the tenth individual—the one who either did not turn when he should have or turned round when she was not the one being called—hangs on this difference" (79).

The interpellation of the racialized subject, the one who arrives to the scene of the white settler colony, is perhaps a theatrical arrival, haunted by the constant traffic of colonialism, migration, xenophobia, and deportation that defines Canadian political history. And yet, the restaging of this interpellation through the misrecognition of whiteness as foreign, as a mass of undifferentiated rabble, illustrates the possibilities of performance-based art in making what familiar seem strange. The unhomeliness of whiteness on the landscape is seen as a comical parody of both the racist panic that surrounded the *MV Sun Sea* and also a parody of the first moment of colonial contact. Whiteness—marked, named, and amassed through the installation of

large numbers of white bodies in a boat—comes to be spectacular in its humorous banality.

As discussed previously in this book, psychoanalytic theorists argue that jokes are never innocent. The structure of the joke and related discourses of the comedic offer insight into the unconscious aggressions and anxieties that produce laughter. If for Freud a cigar is never just a cigar, then for *Mass Arrival* an arrival is never simply an arrival and a white man is never simply a white man. The white man, figured within the dominant socio-symbolic imaginary as a representative of the phallic order of white male colonial power is seen to be foreign and out of place in this artistic intervention. The unhomeliness of the Tamil migrant, depicted in mainstream media representations and conservative public outcry as unwelcome, is juxtaposed with images of the white settler who was perhaps also not welcomed with open arms by the Indigenous.

Pellegrini draws on Sigmund Freud's writing about the relationship between the tendentious joke and instinctual satisfaction: "'Tendentious' jokes make possible the satisfaction of an instinct (whether lustful or hostile in the face of an obstacle that stands in the way. They circumvent this obstacle and in that way draw pleasure from a source which the obstacle had made inaccessible" (Freud 180). Freud further writes that "the joke will evade restrictions and open sources of pleasure that have become inaccessible" (Freud qtd. in Pellegrini 180). The pleasures of laughing at the strangeness of white bodies was made possible by *Mass Arrival*, perhaps leaving spectators with a collective laugh and sigh at the continuous obstacle of racism that undercuts political discourse regarding migration.

Activists turned artists refused to be hailed into being through violence by state authority during the protests against the G20/G8 summit in Turtle Island, which signaled a refusal to be named and to name oneself as a creator of colonizing culture rather than a threat to the nation. As Pellegrini writes of feminist performance artist Holly Hughes, "In the space of her embodied performance, laughter re-turns us to the fresh work of renewing and remaking a social world" (189). When considering the often affective rage, pain, and fear that define the life histories of activists and migrants fleeing genocide, the work of parody and unmasking of the banal truths of racism might be undercut by the resilient refusal to play the victim, and to laugh in the face of

great odds. Migrant bodies often appear within mainstream culture as objects of sacrifice for Western-funded wars. These images of pitiable Brown bodies in the Global South are coupled with a litany of images in the mainstream news media that associate Brown bodies with martyrdom and suicide bombing. *Mass Arrival* entails an artistic refusal to participate in racist aesthetic spectacles. In refusing to turn around to face state power as a "wild woman" or suspect, and in amassing a collective of white-identified people who refusal to be counted as anything but "smuggled" goods, Miranda's artistic installation was a tribute to the powers of collective solidarity in conservative and indifferent times.

Australian Indigenous comic Kevin Kropineyeri uses humour to educate and entertain audiences, while also offering a wry commentary regarding the ongoing impoverishment and genocide of the Indigenous, transnationally. Kropineyeri states, "We have had to learn to look at our situation. We never had much on the mission. My nana would spend three-month periods in gaol [prison] for being off the mission without papers. Laughter is healing and is a way of coping with life.... The flip side of tragedy is comedy" (Kropineyeri qtd. in Behrendt). Welcome home?!

WORKS CITED

Agamben, Georgio. *Homo Sacer: Sovereign Power and Bare Life.* Stanford: Stanford University Press, 1998.

Alexander, M. Jacqui. *Pedagogies of Crossing: Meditations on Feminism, Sexual Politics, Memory, and the Sacred.* Durham: Duke University Press, 2005. Print.

Behrendt, Larissa. "Aboriginal Humour: 'The Flip Side of Tragedy is Comedy.'" *The Guardian* 19 June 2013. Web. 14 Oct. 2014.

Benjamin, Walter. *On the Concept of History.* New York: Classic Books America, 2009. Print.

Bhatacharya, Sheila and Mythili Rajiva, eds. *Reena Virk: Critical Perspectives on a Canadian Murder.* Toronto: Canadian Scholars' Press, 2010. Print.

Bickel, Barbara, Stephanie Springgay, Ruth Beer, Ruth, Rita L. Irwin, Kit Grauer, and Gu Xiong. "A/r/tographic Collaboration as Radical Relatedness." *International Journal of Qualitative Methods* 10.1

(2011): 86-102. Print.

Blackman, Lisa. "Affect, Relationality and the 'Problem of Personality.'" *Theory, Culture & Society* 25.1 (2008): 23-47. Print.

Cader, Fathima. "Tamil, Tiger, Terrorist: Anti-Migrant Hysteria and the Criminalization of Asylum Seekers." *Briarpatch* (7 July 2011): n.p. Web. 14 Oct. 2014.

Cole, Desmond. "Human Art Installation Critiques Race and Immigration in Canada." 13 Aug. 2013. Web. 14 Oct. 2014.

Cooley, Alison. "Mass Arrival Art Action Challenges Racism & Refugee Laws." 17 Sept. 2013. Web. 14 Oct. 2014.

Cornish, Audrey. "Harvard Professor Makes Hip-Hop CD." *Washington Post* 6 Nov. 2001. Web. 15 Oct. 2014.

Debord, Guy. *The Society of the Spectacle*. Trans. Donald Nicholson-Smith. New York: Zone Books, 1994. Print.

Emberley, Julia. *Defamiliarizing the Aboriginal: Cultural Practices and Decolonization in Canada*. Toronto: University of Toronto Press, 2007. Print.

Fanon, Frantz. *The Fanon Reader: Frantz Fanon*. Ed. Azzedine Haddour. London: Pluto, 2006. Print.

Freud, Sigmund. *Jokes and Their Relation to the Unconscious*. Ed. James Strachey. London: W.W. Norton, 1960. Print.

Granados, Francisco-Fernando. "Confessions of an Ungrateful Refugee: Mass Arrivals." 2013. Web. 14 Oct. 2014.

"Hunger-Striking Asylum Seekers Sew Their Lips Together." *The Guardian* 2 June 2014. Web. 15 Oct. 2014.

Juris, Jeffrey S. "Performing Politics: Image, Embodiment, and Affective Solidarity During Anti-Corporate Globalization Protests." *Ethnography* 9.1 (2008): 61-97. Print.

Kempadoo, Kamala. "Public Forum: Can Human Smuggling be Defended?" Lillian H. Smith Library, Toronto. 11 Jan. 2010. Speech.

Kierulf, Arkaye. "Autobiography." *Philippine Studies* 53 (2005): 295–99. Print.

Memmi, Albert. *The Colonizer and the Colonized*. London: Routledge, 2013. Print.

Miranda, Farrah. "Disfiguring Canada." Disfiguring Identity: Art, Migration and Exile symposium, Surrey Art Gallery, On Main Gallery, and Kwantlen Polytechnic University's Fine Arts Department, 10 and 11 May 2014. Unpublished Artist's Talk.

Orpana, Simon and Evan Mauro. "First as Tragedy, then as Ford: Performing the Biopolitical Image in the Age of Austerity, from the G20 to Toronto City Hall." *TOPIA: Canadian Journal of Cultural Studies* 30-31 (2014): 271–89. Print.

Pellegrini, Ann. *Performance Anxieties: Staging Psychoanalysis, Staging Race.* New York: Routledge, 1997.

Phelan, Peggy. *Unmarked: The Politics of Performance.* New York: Routledge, 1993. Print.

Reder, Deanna. "What's Not in the Room? A Response to Julia Emberley's 'Defamiliarizing the Aboriginal.'" *TOPIA: Canadian Journal of Cultural Studies* 24 (2010): 406-415. Print.

Rogoff, Irit. "'Smuggling': An Embodied Criticality." 2006. Web. June 2010.

Žižek, Slavoj, ed. *The Plague of Fantasies.* London: Verso, 1997. Print.

Žižek, Slavoj. "The Prospects of Radical Politics Today." *International Journal of Baudrillard Studies* 5.1 (January 2008): n.p. Web. 14 Oct. 2014.

Žižek, Slavoj. *Violence: Six Sideways Reflections.* London: Profile Books, 2010. Print.

7.
Brown Skin, White Mirrors

Joshua Vettivelu's Enthralling Affect

WHITENESS: AN UNSPOKEN CURRENCY that flows across borders like money and the grammar of an Internet era. Whiteness: Nothing and everything all at once. A colourless parade of a culture born out of colonial exploitation, genocide, conquest, rape, and molestation that somehow quizzically masks itself in images of innocence, morality, and fairness. Joshua Vettivelu's artwork offers a deeply emotive and affective visualization and embodiment of the painful, confounding, and often comical moments in the lives and bodies of racialized diasporic subjects navigating a sea of whiteness. Vettivelu's artistic practice crosses the boundaries of canonical discipline and artistic medium, utilizing video, sculpture, and performance to offer texts that are rich in both aesthetic and philosophical value. Installations such as *Fort/Da!*, *Glory Hole*, *Washing Hands (Whiten Up)*, and *I've Done It/You've Done It/We've All Done It (Failed Survival Strategy # 1)* all gesture to the psychic life of desire that haunts migrant bodies across borders. These installations are painstakingly beautiful in their capacity to capture the frailty of bodies that are often multiply abjected from nationalist imaginaries owing to skin.

The dark skin of a Brown body is thrown against the chilling indifference of a white settler landscape. The skin of a desiring body is traitorous in expressing sensuality and sexuality that does not fulfill the idealized biopolitical wills of nationalism. The racialized diasporic body is restless, shaking loose their skin to be born again across borders. The skin of a transnational artist cannot ever be fully named or held in place. The ironies of a body that is always creating, labouring, moving, changing shape and form through new artistic visions lies in how it remains symbolically trapped in the trite and

banal imaginaries of those forever conjuring up Orientalist tropes of multicultural fetishism (Said). Joshua Vettivelu's work emerges in the often painful, paradoxical, and humorous excess that emerges between the lived realities of transnational artists of colour and colonial histories of succinct racial categorization. Against the imagined authenticity and cultural "purity" of organic yuppie curry and celebrity yoga, there is a meditative prose to Vettivelu's body of work that reincarnates those dead white men and mimicking postcolonials of psychoanalytic and philosophical theory, to pose haunting questions regarding the art of politics and the politics of art.

In *Washing Hands (Whiten Up)* and *I've Done It/ You've Done It/ We've All Done It (Failed Survival Strategy # 1)*, Vettivelu offers performance-based video installations that document the stark and often hidden truths regarding symbolic wills to whiten oneself on the part of racialized bodies. Both installations involve mixed forms of artistic media with the use of video and performance. In *Washing Hands (Whiten Up)*, we are left with moving images of hands being washed in white glitter. The hands begin by holding the glitter, with pieces of it falling from one hand to the other just as money changes hands within secular capitalist life worlds, where what passes between the skin of bodies is often mediated by capital. The gestures then change to those of washing, with the glitter being smothered over the hands. The video plays simultaneously alongside a performance of the artist using hot wax to cover their face and hands, that eventually hardened into a shocking white. While the glittery hands offer images of smoothness, with the shiny surfaces conjuring up archetypal allusions of decadence and beauty, the performance connotes pain, aggression, and anxiety. We hear the sounds of deep breathing, reflective of a captive body caught in the midst of struggle. We see the artist place the white wax across hands and face in a slow process of embodied labor, a ritual that is reminiscent of all the minute performative gestures that bodies enact daily in order to signify class status, gender, sexuality, and race. Vettivelu comments on the process and the significance of the use of materials. The artist states,

> The material being applied to my face is hot melted wax that starts off transparent and then cools to a translucent white that becomes more opaque as layers are applied. I chose wax

because, when applied in layers, it holds light in a similar way to skin. Also it has a history, within sculpture, as being the malleable medium that sculptures are cast in before they are turned into more permanent fixed materials like bronze. (Personal interview)

The video ends with a striking series of images of pain that are profound in their ability to generate affective feelings in a viewer made to consider the traumas that racism creates. We see the artist/performer struggle to free themselves from the white mask accompanied with the piercing sound of heavy breathing. The audible sound of strain and struggle works with the jolting and memorable visuals to create a deep discomfort in the viewer that moves them to consider the embodied suffering of those who experience racism. Vettivelu indicates that the making of this installation was indeed a "painful process" (Vettivelu, Personal interview). They discuss the meaning behind the trajectory of the installation stating, "[t]he video ends before the mask in fully removed, signifying that it is always a process to undo what we learn to do to ourselves."

Liberal left-leaning persons of colour are often encouraged to use terms such as "internalized racism" and espouse a pride in racial Otherness feigning shame and condemnation towards those who do not assert a love for their racial alterity; meanwhile, Vettivelu's works are honest reflections on the oppressive ethos of whiteness. As discussed previously in this book, creams such as "Fair and Lovely" that are used to lighten skin are sold throughout the world. Consumers throughout Asia, Africa, and multiple diasporas invest in skin bleach in an effort to appear both desirable and increasingly to be employable within what Badiou terms the "worldless space" of global capitalism (Badiou qtd. in Žižek, "On Alan Badiou"). The branding of racial capital also crosses the constructed binaries of gender with "Fair and Handsome" skin bleach being marketed to men. The advertising for this product often implicitly and explicitly associates whiteness in bodies marked as male with financial success and attractiveness. In the litany of images that normalize and valorize light skin and proliferate globally, the epistemic violence of white privilege is undeniable.

Vettivelu also states that the installation is one that is meant to evoke questions regarding agency and the possibilities of resistance: "It was

important for me to talk about the agency we have within/around white supremacy as well as flag for the audience that whiteness is malleable and not fixed (a rare optimism)" (Vettivelu, Personal interview). What is also optimistic lies in how the artist uses mediums of the artistic to disidentify with both the widespread worship of whiteness and the terms through which resistance is often imagined. By using art, the success of the installation also challenges the idea that "model minorities" overcome racism through attaining white settler wealth and aspiring to be part of the conservative mainstream. The very discourses of aspiration that often orient the racialized person towards mimicking white settler ideologies and apolitical capitalist ideals are troubled in this beautiful installation, exemplary of the ability for art to reimagine ideas of human worth (Halberstam).

In Vettivelu's installation *Washing Hands (Whiten Up)* and *I've Done It / You've Done It / We've All Done It (Failed Survival Strategy # 1)*, the artist offers a clever use of visual metaphors to connote the imbrications between monetary wealth and whiteness. As postcolonial theorist Frantz Fanon wrote, "[y]ou are rich because you are white; you are white because you are rich" (Fanon xx). As mentioned, Vettivelu's video shows the artist washing their hands in white glitter. Outside of individualistic economies of therapeutic diagnosis and sales, one can consider this installation as offering an eviscerating critique of the relationship between ongoing colonial history and the collective unconscious of postcolonial bodies, haunted by ghosts as white as bleach. The act of washing hands with glitter conjures up images and genealogies of cleanliness, moral sanitation, and puritanical ideologies of Europeans, which spread themselves across world maps and Brown bodies like a cancer devouring the earth. The missionary moralism of a rhetoric of cleanliness and godliness was used to script Brown and Black bodies as "dirty," with filth being used to signify a psychic and discursive chain of association between race, hygiene, and morality.

Ann McClintock discusses the relationship between soap advertising and colonialism, with soap being emblematic of the cult of domesticity and the rise of imperialism in the nineteenth century:

Both the cult of domesticity and the new imperialism found in soap an exemplary mediating form. The emergent middle-class values—monogamy ("clean" sex which has value), industrial

capital ("clean" money which has value), Christianity ("being washed in the blood of the lamb"), class control ("cleansing the great unwashed"), and the imperial civilizing mission ("washing and clothing the savage")—could all be marvelously embodied in a single household commodity. (208)

The nineteenth century ushered in an era of soap advertising espousing the ideologies of empire through images such as white children washing Black children, and the use of obscene metaphors that associated whiteness with moral hygiene, health, and racial superiority. Vettivelu's work offers a contemporary queer articulation of this tale (McClintock 207–31), and a commentary on a new form of force-fed "vanilla," as banal as white narratives of missionary moralism have always been.

Figure 7.1: Joshua Vettivelu, Washing Hands/Whiten Up and I've Done It/ You've Done it/We've All Done it (Failed Survival Strategy #1). *Video and Performance. Video Stills. Image: Joshua Vettivelu.*

The contemporary queer of colour is, as Jasbir Puar points out, one who becomes queer to the nation in racial and religious terms. Puar discusses homonationalism, a process through which, owing to the bombing of the world trade centre, there has been an ushering in of a security era of paranoia towards Muslims, Brown people, and migrants. Idealized white queer bodies are increasingly included within the nationalist imaginary to the extent that they assimilate to nationalist branding (Puar). While white, secular, affluent, gym-fit gay men are invited to play house, constructed "terrorists" become queer to the nation in border security cells and through covert forms of xenophobic and racist exclusion. The illusions made between whiteness and morality resonate with the

"vanilla" of the homonationalist body, one that is celebrated within dominant Western nationalist mythologies. Contemporary white middle-class bodies are counted as part of the biopolitical vitality of nation states by distancing themselves from the darkness and death once associated with queerness. The AIDS crises of the 1980s and 1990s in North America once scripted queer people as infecting the nation state with death. It is now the figure of a fetishized terror that comes to be associated with the murder of an already dying dream of Western nationalism, as haunting as the white ghosts of original colonial settlers raping and looting Indigenous lands.

Vettivelu's installation brilliantly captures all of the confounding psychosocial and political making and unmaking of Brown skin across time and space. One can consider that South Asian colonies such as India and Sri Lanka were the jewels in the crown of the British Raj. The use of these colonies to extract labour power, resources, and capital to support colonizing empires allowed colonial travelers and ideologues to construct images of a South Asia that was resplendent in wealth (Nayar). Similar images of diasporic Bollywood excess and princely states abound in the South Asian diaspora, just as the "model minority" myth is used to imagine all South Asians as middle-class diasporic professionals and Brown patriots in white settler nation states. The Brown body across temporal gaps and cartographical spaces as wide as a world of damned rivers and pillaged Indigenous lands is forever being invited to wash their hands in a glittery hue of white. The imagined culture of South Asian communities and the anxieties of class status, morality, hygiene, and sexual respectability cannot be divorced from colonial histories that live on the skin and in the psyche. The will to whiten oneself has always existed as a means of not only aesthetic performance but of postcolonial linguistic and nationalist mimicry. Homi Bhabha discusses the concept of mimicry as that which is "almost the same but not quite" (127). Bhabha makes reference to colonial India, stating that the process of mimicking colonial language and norms was also "almost the same but not white" (127), with the colonized Brown native being forced to mimic the mother country as a means of economic survival and linguistic intelligibility. And yet, for Bhabha the process of mimicry often revealed the inherent ambivalence of the colonial project as one that discursively and politically deemed the colonized to be less than human, while also attempting to reform

the wretched of the earth in the narcissistic mirror image of whiteness.

Brown hands can never be white, can never fully hold the riches of the world, as the riches of the world were and are pillaged by European colonizers. Nevertheless, in a cruel and yet comically useless quest, Brown hands are forever made to attempt to hold these white riches that slip like soap from open palms, left to fall into waterways haunted by dead migrants and dazed European explorers lost at sea. Laughable lies of a meritocracy beyond the skin are told again and again like the anxious repetitions of germophobes in cities of grime repeatedly scrubbing their hands. There is an obsessively compulsive need to soothe the dark truths of history with white lies. With one more generation of diasporic doctors, lawyers, engineers, and middle-class yuppie homosexuals, Brown hands will finally be free of darkness, finally grasping whiteness through wealth. But still, the glitter falls, and the hands remain stained with the marks of those categorized and named in words not of their own design, with power inevitably slipping from the grasp of colonized people. The ridiculous rhetoric of "fair is fair" Western secular democracy smothers the stench of racist murders with the pungent smell of lily-white soap. White settler colonies bury violent spectacles of colonial genocide and racism in multicultural pageants of glitter while justice and dignity are elusive, slipping from dark palms.

In their installation *I've Done It / You've Done It / We've All Done It (Survival Strategy #1)*, Vettivelu offers a contemporary artistic rendering of Fanon's canonical postcolonial text, *Black Skin, White Masks*. In Fanon's moving treatise regarding the formation of the racialized psyche within the context of colonization, the author surmises that the Black man raised in a French colony learns to whiten himself and to desire whiteness as a means of psychic survival. And yet, as a phenomenologist and psychiatrist, Fanon was also deeply interested in documenting the embodied and emotive costs of this whitening. In Vettivelu's installation we see the artist making a white hot wax mask, which they wrap across their Brown skin. The installation finishes with the performer removing the mask from their flesh in what they write of as a "painful process" (Vettivelu, Personal interview).

In discussing this installation in relation to embodied aesthetic approximations of white Western norms, one can reflect on the

Figure 7.2: *Joshua Vettivelu,* Washing Hands/Whiten Up and
I've Done It/ You've Done it/We've All Done it (Failed Survival Strategy #1).
Video and Performance. Video Stills. Image: Joshua Vettivelu.

actual pain involved in forms of body modification such as corrective
eye surgery, skin bleaching, and fitness regimes in which racialized
bodies within the West often "improve" by approximating images of
branded white wealth. However, one can also think of the painful
psychic and emotive costs associated with symbolically dawning and
then removing white masks. What is interesting in Vettivelu's work
is that they offer a fantastic performative reading of the excruciating
trauma that comes not from the act of wearing the white mask as
Fanon described, but rather from removing such a mask. For Fanon,
returning to an imagined authentic Negritude was a liberation of
body and soul. Vettivelu's installation however offers a remarkably
honest commentary on the pain that comes with refusing whiteness.
Within a time of what Slavoj Žižek terms multicultural multinational
capitalism, exoticized pageantries of Otherness are increasingly sold
to white Western consumers through processes of auto-colonization
(Žižek "Multiculturalism"). As discussed throughout *Uncommitted*
Crimes, auto-colonization refers to a form of consumerist colonialism
in which shoppers salivating for samosas and saris function as neo-
imperialists whose empty universalist position masks their whiteness
and dominant religious position (Žižek, "Multiculturalism"). To
refuse to play the part of exotic multicultural object to be consumed,
token Brown male, grateful immigrant, or diasporic patriot is to
leave ones skin exposed to the world. Without a white mask of
wealth, assimilation, and sickening platitudes and pleasantries of
white civility to bury ones head in, the racialized body confronts
their brown skin in the mirror, a phenomenological and historically

Figure 7.3: Joshua Vettivelu, I've Done it/ You've Done it/ We've All Done it (Failed Survival Strategy #1). *Video and Performance. Video Stills. Image: Joshua Vettivelu.*

marked skin that no "fair is fair" protestant work ethic can contain. The painful removal of the white bandages, however, can also connote the colonial wound as one that is forever damaging and yet can perhaps be healed, if only in the creative and momentary acknowledgement of the phantasm of white rage as a narcissistic mirror image that threatens to forever distort bodies and minds. If, as Žižek suggests, multiculturalism functions through a disavowed racism, expressive of anxieties towards the material jouissance of the other (Žižek, "Multiculturalism"), Vettivelu's unmasked Brown face and body in pain is the returned repression of the body nowhere to be found within the saleable goods consumed by the glittery hands of white neocolonial shoppers.

There is something horrific and fantastical regarding *I've Done It / You've Done It / We've All Done It (Failed Survival Strategy #1)"*that offers a deeply psychic, affective reaction in the viewer. The installation is both chilling and sentimental as it returns the jouissance of the Brown corporeal body to the frame of a white settler colony. Brown flesh is deferred through the fetishism of exotic spices, while the racialized body is often anxiously kept at bay through obscenely polite racism and the distantiation of difference that often defines white settler capitalist civilities.

The artist's masked body conjures up images of illness. The postcolonial body is deformed and reformed across world maps, carrying the scars of formerly colonized nations such as Sri Lanka and those created by white settler nations such as Canada. The wounds of the postcolonial body are symptomatic of enduring and often unremarked upon political violence. The artist's masked body is a casualty of all we do not say, of all we keep at bay in disavowed racist anger, aggressions, and libidinal desires bandaged by white papers of five-star words, colonial treaties, and money. In removing their white mask to reveal brown skin, Vettivelu unmasks us of our pretensions. The artist strikingly reveals all that cannot be contained in an elite bureaucratic language of anti-racist grammar that does not mask the skin.

VETTIVELU'S *FORT/DA!*

In Derek Walcott's poem "The Sea is History," Walcott writes lyrically of the relationship between colonization, nation, and history utilizing the metaphor of the sea. Walcott's lyrical poem bears witness to the haunted graveyards of oceans, rivers, and seas as those that carry the undocumented deaths of many slaves who died in the middle passage, carried as human cargo across borders by white slave masters. Walcott writes,

> Where are your monuments,
> your battles, martyrs?
> Where is your tribal memory? Sirs,
> in that grey vault. The sea. The sea
> has locked them up. The sea is History. (364)

The memory of an imagined authentic tribal past of African slaves dragged across the earth by European colonizers is lost to history. In *Fort/Da!*, a filmed performance by Vettivelu, the spectator watches the artist throwing stones into the sea. The tide is coming in, with waves lapping against the shores as we watch Vettivelu throwing rocks into the blue of the sea, again and again. The installation perhaps comments on the loss of history, memory, and fixed ideas of authentic culture and homeland for the queer racialized artist whose true home perhaps lies only in the artistic gesture. Walcott's poem captures how history is, as Walter Benjamin suggests, written in the language of victors of war. Walcott writes of a history written in the language of white Christian colonizers, who declared the beginning of the world as commencing when seen by the blue of their eyes. While Walcott's poem is perhaps meant to touch on the histories stolen from Afro-Caribbean people through slavery, one can ask how a similar erasure of precolonial history is reflective of Canada's ongoing colonial genocide.

Figure 7.4: Joshua Vettivelu, Fort/Da!, 2012-2017 (ongoing). Video. Video Stills. Image: Joshua Vettivelu.

As a racialized queer migrant within a white settler colony that prides itself on "multiculturalism" while ignoring histories of colonization through narratives of fairness, Vettivelu's body is positioned on stolen land, as one that is understood as not being truly at home owing

to skin and name. Brown bodies exiled in the trite mythologies of a purposeful form of colonial amnesia are used within a rhetoric of neo-liberal multiculturalism to celebrate supposed diversity while pillaging Indigenous lands. In *Fort/Da!* the artist's repeated throwing of rocks against the sea resonates with Walcott's description of the sea as a space beyond articulation, record, and colonial categorizations of national grammar. The rocks that Vettivelu throws into the ocean are not owned like the property entitled white settlers cling to as their nation, against the land claims of Indigenous peoples. The oceans are not owned by patriarchal homophobic national leaders of South Asian nations such as Sri Lanka, in which the queer body is also exiled from official historical archives.

As Walcott writes,

> Then came the white sisters clapping
> to the waves' progress,
> and that was Emancipation—
>
> jubilation, O jubilation—
> vanishing swiftly
> as the sea's lace dries in the sun,
>
> but that was not History,
> that was only faith,
> and then each rock broke into its own nation;
>
> then came the synod of flies,
> then came the secretarial heron,
> then came the bullfrog bellowing for a vote,
>
> fireflies with bright ideas
> and bats like jetting ambassadors
> and the mantis, like khaki police,
>
> and the furred caterpillars of judges
> examining each case closely,
> and then in the dark ears of ferns
> and in the salt chuckle of rocks

Figure 7.5: Joshua Vettivelu, Fort/Da!, 2012-2017 (ongoing). Video. Video Stills. Image: Joshua Vettivelu.

with their sea pools, there was the sound
like a rumour without any echo

of History, really beginning. (364–68)

Vettivelu's installation can be read as a queer disidentification with images of nature and the natural often found within European colonial and white settler Canadian artistic traditions. While ideas of the natural are often used to imagine a philosophy beyond the bondage of nations within the writings and artistic laments of the colonized, references to the natural world are often subsequently used by Black nationalists and Brown religious and community leaders to suggest that queerness is a form of Westernization. The queer body moves against the imagined biological destiny and biopolitical valorization of heteronormative lives that are imagined to reproduce ideal citizens and members of racialized communities. One can consider that queerness is criminalized in postcolonial South Asian nations such as India and Sri Lanka through colonial sodomy laws that declare non-reproductive queer sex acts to be "unnatural."

In *Fort/Da!* the queer Brown body throwing rocks echoes Walcott's writings of rocks breaking through their own nations and national mythologies. In throwing the rocks, Vettivelu throws out the expectations lauded onto bodies to belong as property to the nation. The act of

throwing the rocks can be read as a creative queer refusal to belong to any succinct "homeland." The racialized queer artist refuses to wave a flag for the stolen rocks of Canada or for South Asian nations imagined within official histories as heteronormative and sexist, as microcosms for an idealized, straight, upper-class family. It is also striking that the installation is titled *Fort/Da!*, making reference to Freud. Ricky Varghese discusses the installation in psychoanalytic terms:

> ...in an uncanny sense, Joshua Vettivelu's performance and video installation *Fort/Da! Fort/Da!* takes its name from the famous game that Freud is claimed to have played with his grandson, and that then would become foundationally significant to the former's theorizing of the psychical experiences of desire, loss, repetition, and pleasure. Vettivelu, a Canadian artist of Sri Lankan Tamil origin, performs a gesture, visually lyrical in appearance, which shows him playing the same game with a large body of water....

Varghese further discusses the Freudian references in Vettivelu's compelling artistic work:

> The Freudian allusions are immediately clear for the viewer as Vettivelu attempts to physically perform longing in the guise of child's play enacted by the artist's gesture. The viewer, much like the artist himself, is unsure of who the recipient of the gesture is; who is it that Vettivelu is playing with? Who is it that resides on the furthest reaches of the horizon, the tenuous line where sea and sky meet, that metaphorically appears to return the object being thrown out into the distance? (12-13)

Varghese reads the installation as one that connotes longing, using the psychoanalytic concepts of mourning and melancholia to comment on how Vettivelu's artistic work reflects an inherent sadness in the one who throws the rocks into an empty ocean, one whose gesture is not returned, and whose gaze is not returned. The throwing of the rocks—the throwing of the signifiers of a nation for a queer diasporic body who is never at home—signify the melancholic

longing for somewhere to call home, when the idea of "home" itself is already deeply imbricated into ideas of white colonial settlement and an idealized heteronormative family unit that is foundational to the modernist nation. The mother countries and fatherlands of idealized straight white colonial patriarchs and homophobic Brown religious nationalist leaders offer no returned affective feeling for the Brown queer body, forever at sea in the callous racism and homophobia of majoritarian fictions of belonging.

Varghese argues that the artist's gesture of throwing rocks into the sea—objects and gestures that are unreturned—straddles divides between mourning and melancholia. The fullness of the vast body of water commingles with the emptiness of loss, and the empty hands of the one whose act of play receives no return, and whose gaze receives no return (13). The lack of return of the stone to the thrower in Vettivelu's installation can be compared to the diasporic subject's lack of homeland, as they are not connected to the figure of the mother/father in the way that the European child is. For the diasporic subject who throws the stone, there is no guarantee, no strings of imagined bloodline that hold this body in place. The sea can also be seen as a metaphor for migration and all the deaths and potential deportations and exiles that racialized migrants face both symbolically and literally—the exclusion of the Brown body from the imagined space of Canada and from an imagined homeland. This is also magnified in the body of an artist whose work explores themes of sexual desire and racism. Vettivelu's artistic praxis often centres the lives of those who are racially maligned, made invisible, and hated within the space of the white settler colony, and homophobic "homeland" in South Asia, as objects out of place—loose stones lost at sea.

Sections 365 and 365A of the Sri Lankan Penal Code are laws that are supposedly designed to protect "public morality." Article 12 of the Sri Lankan constitution protects marginalized bodies from violence and discrimination, though sexuality is not explicitly mentioned. In 2014 the International Gay and Lesbian Human Rights Commission (IGLHRC) submitted a report to the United Nations Human Rights Committee regarding widespread transphobia and homophobia in Sri Lanka. As one journalist writes,

IGLHRC noted that the Sri Lankan Constitution's lack of

specific anti-discrimination language on sexual orientation and gender identity places LGBT people at a disadvantage in accessing rights, protections and legal guarantees. In addition to Section 365A, the Vagrancy Law and the Gender Impersonation Law (Section 399) were used to intimidate, arbitrarily question, arrest and detain individuals (such as butch lesbians, masculine-looking women, and transgender men and women) whose appearance did not conform to gender norms. (*OutRight International*)

Vettivelu's artistic praxis as a racialized queer Sri Lankan-Canadian is an act of political defiance against many regimes of governmentality around the globe. The artist's public performances and installations that comment on queer sex is a visual opposition to the homophobic and racist politics of citizenship. Sri Lankans who do not conform to gender norms are stripped of countenance as full citizens in Sri Lanka, while subtle racist hegemonies cause the queer person of colour to seem suspect in white settler nation states such as Canada. While the government of Sri Lanka argues that Sri Lankan queer rights are protected under Article 12, the experiences of embodying a subaltern sexual identity are deeply uncomfortable. Similarly, while Canada is officially decreed to be a multicultural utopia with a bevy of legal rights and freedoms for all, the passionate hatred that is attached to Black and Brown skin haunts the white settler imaginary. Refugee claims made by queers from Sri Lanka seeking asylum are often based on the fear of persecution, violence, and death. While such claims construct a "homeland" of legislated hatred, LGBTQ and human rights organizations run by upper-middle-class white homonationalist subjects often champion such causes in ways that construct Western nations as spaces of imagined liberation. There is little attention paid in this discursive formation to the racism, poverty, and exile that queer people of colour experience in the West.

There is a haunting resonance to Vettivelu's installation *Fort/Da!*, one that touches on the multiple losses that bodies of colour often carry across borders. One can contemplate this ghostly reckoning in relation to the artist's other installations such as *I've Done It / You've Done It / We've All Done It.* The coming into being of an understanding of one's body as being racialized through white supremacist discourse is,

as Vettivelu states, a painful process (Personal interview). To unmask normative cultures of white nationalism and homonationalism as inherently racist is to be left with the haunting loss of imagined belonging within white settler nations that this produces. To attempt to approximate whiteness and be left as a racialized body that will inevitably fail to reproduce an idealized nation or community conjures up ghosts of the colonized across time and space.

The endless performative gestures of Black skin wearing white masks, of Brown bodies wanting white men, and of Brown model minorities wearing white lab coats and business suits to serve the fantasies of docile, hard-working supermodel minorities, are positioned in opposition to the haunted histories of pathologized Black and Indigenous people. Varghese discusses the rather haunting ending of *Fort/Da!*:

> Vettivelu's body and its actions are multiplied across the space of the shoreline while the layering creates a faded effect, such that their body appears to perform the gesture in a series of ghost-like apparitions. The viewer is forced to strain to see the body as it disappears from sight. In straining to catch a glimpse of the disappearing body the viewer participates in the very experience of longing that the work stages, wherein longing, once again, becomes an experience without an object. (14-15)

The disappearance of a body that is lost to multiple nationalist fantasies constructs a ghost that comes to produce fear and anxiety in the imaginaries of other. The Brown Tamil Sri Lanka body, scripted as a "holy terror" to white nations in a time of deported Tamil refugees is a ghost in the machine of secular capitalist narratives of "fairness" and "right." Similarly, the body marked with the lingering colonial anxieties of sex within an imagined South Asian homeland is also a haunting presence. The dissident sexual body in postcolonial South Asia is one whose desire is as ancient as pre-colonial mythologies of divergent sexual desires etched onto temple walls, now white-washed in colonial sodomy laws and neo-liberal cities of call centres and shopping malls. Finally, the Brown body disappears from a pageantry of homonationalist "pink dollar" branding in which the saleable image

of gay identity offers no place for the racialized working class, left to crash against tides like rocks in the sea.

While Varghese's writing touches on the melancholia of the haunting, Avery Gordan also discusses the appearance of ghostly apparitions as political figures. Gordan suggests that haunting can appear as an affective state that expresses what is to be done, a lingering need for something that has not been resolved to be met with attention. Gordan uses the term "haunting" to describe "those singular and yet repetitive instances when home becomes unfamiliar, when your bearings on the world lose direction, when the over-and-done-with comes alive, when what's been in your blind-field comes into view" (*Ghostly Matters* 197). One can consider this loss of bearings in *Fort/Da!*, where the artist appears by the sea throwing rocks in a ritual that is reminiscent of those shipwrecked and left without a fixed address or homeland. This loss of bearing is metaphoric for the body who comes to develop an intelligibility and language of critique pertaining to white settler racism, diasporic Brown sexual moralism, and the inevitable exile of those who have no mythic imagined kingdom of religious and nationalist honour to return to. And yet, while this ghostly loss can be read as a traumatic affective state, Gordan suggests that haunting can be used to refer to a "socio-political-psychological state when something else, or something different from before, feels like it must be done, and prompts something to be done" ("Some Thoughts" 3). The "to be done" in Vettivelu's *Fort/Da!* does not lie in a trite platitude of happy endings or delusional ideas of stasis and communal forms of utopian amnesia, which would suggest that one can live without loss or can and should be held in place. Rather, it is in the repetitive artistic gesture that the "to be done" finds expression as the restless creative inspiration that is born out of a spirited refusal to rehearse banal scripts.

As discussed throughout *Uncommitted Crimes*, the marvel of a political event can be created through acts of original artistic intervention. The event of the artistic ritual is a prosaic testament to creative forms of labour not structured by meritocratic capital and heteronormative patriarchal authorities. Vettivelu does not plant a flag in the soil as "great" white settlers once did, nor do they play Freud's game of *Fort/Da*—one of sons and fathers that restages the paternal family as a space of innocent fun and pre-political humanity. Rather,

they construct an event of artistic ritual, a magical repetition born out of the transience of the restless energies of artistic labour.

Varghese writes of *Fort/Da!* as an installation in which the repeated gesture of throwing the rock is not a search for true origins, or a desire for the return to homeland, or the return of the artist's gesture, but rather a form of melancholic longing. The author states,

> This longing, a sadness in relation to an object of desire, does not need the object of that desire for itself to become manifest. It appears, invoking Stewart again, to stage a "desire for desire" and consequently "lack ... fixity and closure" (Stewart 2007: 23). In a way, it suggests a melancholic relationship to the object, precisely in the style and manner that Freud himself described it in his now-famous and canonical essay "Mourning and Melancholia." (8)

This "desire for desire" relates to Žižek's philosophical writings regarding "The Big Other" and "Objet A." Žižek suggests that within nations and times governed by "The Big Other" of an authoritarian state and/or religious power, one's desire is repressed and prefigured by forms of overarching authority that prevent desire. Within times of secular capitalism, Žižek proposes that one lives within an order of "Object A," which refers to the desire to desire itself: our contemporary consumer capitalist marketplace produces our desire to constantly consume. Global capitalism and the order of "Object A" constitutes bodies that are made to constantly desire, producing insatiable longings for fulfillment that can never be satisfied through acts of conspicuous consumption (Žižek, *The Sublime Object*).

Within Vettivelu's installation, one can see this melancholic desire for the desire of homeland itself through those who are made to want for a "home." The desire for desire is a repetitive gesture akin to the act of shopping or the mundane rituals of Western secular economies of work and leisure. With every work week there is a weekend of obscene surplus enjoyment. Unlike religious and nationalist authoritarian regimes, secular capitalist branding does not curb the desire to enjoy. Rather, there is an injunction to enjoy the melancholic symptoms of late capitalist excess where belonging becomes synonymous with capitalist consumption. Similarly, one can ask how the body of colour

within a white settler colony is impelled to desire the desire for fixity, settlement, and belonging.

Whether it is through the marketing of multicultural diasporic patriots who construct Canada as a model minority utopia, homonationalist soldiers who wish to "liberate" the queer Brown body into a racist and classist "queer community," or heteronormative Desi cultures constructing a desire to desire some imagined pastoral space of timeless "culture" and "tradition," the Brown queer figure is presented with implicit injunctions to enjoy the banal gestures of settlement. In mundane tales of white colonial settlers buying provincial homes on stolen land, nouveau missionary tales of legal settlements for those whose need refuge from hate crimes in the Global South are used to mask racist exclusion in mainstream LGBTQ communities. That is, in fantasies of an untranslatable "back home" that does not welcome public queer expressions, the impossibilities of home on colonized land are expressed. The rocks are not the bricks of proud white men building weekend cottages over the graves of tribal peoples, nor are they a "holy land" in which hate crimes are legislated. The rocks are also never returned to the thrower. An imagined utopia of a returned gaze and intelligibility of one who straddles many seas and borders is forever evaded. As Varghese writes in reference to the concept of futile belonging expressed in *Fort/Da!*,

> Belonging will only ever be experienced as a form of longing here. Similarly, Vettivelu's performance craves a return—a return to an unknown and imagined home across the body of water and a return of the object of play. The transitory nature of the subject in Vettivelu's work, which is their self, proclaims a desire for something that cannot be returned or easily accessed, resolved or satiated. The paradoxical stagnancy of the transitory subject is captured in the repetitive gesture that Vettivelu performs, as well as the layered fading exercise they put his video through until the final instance. Here, they ceases to exist in relation to the body of water which, in the course of their enacting child's play, comes to represent their own longing. (9)

The idea of that which cannot be returned can also be thought of in

relation to sexuality—the return of sexual desire from one's love object. One can also think of this in relation to the idea of return in the sexual act itself where sensual and emotive touch and gestures are exchanged and there is a return of physical and affective contact and connection. The back and forth, the endless unfulfilled impossible longing can be read as a masturbatory action, one of the lone artist positioned on-screen performing the same repetitive gesture—actions that the viewer is invited to watch and yet cannot return. This act of erudite artistic masturbation can be considered in relation to other installations such as Vettivelu's *Glory Hole*.

GLORY HOLE

Like much of Vettivelu's artwork, the artist's installation *Glory Hole* is a philosophically, emotionally, and politically rich piece of work. "Glory hole" is a colloquial street slang term that refers to a hole "[u]sed to either spy on one's neighbor in the adjacent [bathroom] stall, or to facilitate sexual contact" (Peckham 122). A glory hole, however, is also a mining term: "Originally conjured during the gold rush to describe the process employed by those miners who could not afford conventional and more sophisticated extraction methods, the glory hole was the single shaft dug straight down in hopes of happening upon a gold seam" (Nelson). Vettivelu's clever use of the trope of the glory hole can be read as offering a commentary regarding the relationship between sexual desire, capital, and the public spectacle of the queer artist of colour who is often made to perform on public stages.

The artist discusses the technical aspects of the sculptural installation, which was initially part of an art fair in Toronto: "It's an eight-and-a-half by four-foot mirror that has a hole cut out of it approximately where my navel is. It's backed by a wooden backing with kind of an A-frame setup and the wood is left exposed and unfinished" (Vettivelu). Vettivelu further discusses how *Glory Hole* is both a work of sculpture and performance piece, which also functions as a liminal sexual space. The artist describes impromptu performances that were staged when audiences used the *Glory Hole*:

> I was standing on the unfinished side of the glory hole, or the exposed wood side rather. And there were all these discarded

white synthetic Easter lilies around me and I would pick them up and start to weave them into a garland, which was then ejected out through the glory hole. So viewers on the other side would see the garland coming out of a mysterious hole in the air. (Vettivelu, Personal interview)

Vettivelu also describes the historical significance of the installation and its relationship to subaltern sexual politics:

The glory hole is where traditionally gay men or men who have sex with men would go to find a public bathroom and there would be a hole cut out in between the stalls or just a hole cut out anywhere and they would insert their penis into it and someone on the other end would fellate that penis. So I'm interested in the glory hole because it has this kind of historic cruising kind of element to it. Even though they are active today, I think they are sited very much as part of a nostalgic sexual era (as objects belonging to that era). (Personal interview)

The artist makes reference to the glory hole as part of an era in queer history that was marked by homophobic anxieties and paranoia concerning queer sex associated with death through AIDS. Vettivelu states that the installation,

...has this kind of sex/death connotation. The anonymous sex. The anonymous encounter with the viewer. And also the idea of this kind of sexual consumption that happens in glory holes where there is a division between the maker and the recipient of it. So the mirror is used as an ego surface to further implicate the viewer so they would see from their own stomach my beautifully constructed garland being ejected from them. (Personal interview)

In Vettivelu's installation one can find a deft philosophical and theoretical commentary regarding the relationship between narcissism, commodity consumption, and the will for Western secular publics to comment on images of the sacred, the cultural, and the deeply personal

through the body and through the body of work of a racialized queer artist. The artist discusses the relationship between the installation and the space of the art fair in which it was initially staged:

> I was thinking specifically about the art fair and what a mirror means in a room full of people like that. So a lot of the footage I have is just people checking their make-up and taking selfies in the mirror. Anytime there's a mirror that's also a consideration. I want people to treat it as frivolity and also this kind of gazing ritual and also as a metaphor for how they are situated in the space of the art fair. (Vettivelu, Personal interview)

Vettivelu further comments on the complexities of this multi-layered installation, which like much of their work crosses divides between sculpture and performance. He states,

> *Glory Hole* was a performance that hinted/longed towards the spiritual but was undercut by the context of the art fair. Six hundred synthetic white Easter lilies were bound together and pushed out from behind a mirrored glory hole. The mirror acted as an ego-surface, creating a separation between artist and product. As people took selfies in the mirror, a neatly produced art object was excreted slowly through the glory hole. From behind the mirror I stood facing a wall, binding disparate materials (deeply symbolic of my personal tension with religion, whiteness and death) into aesthetically pleasing form.… At the end of this process, the garland is undone and the process begins again. *Glory Hole* reflected a moment where the cultural, the sentimental and the spiritual became object/image commodity. (Vettivelu, *Notes from Artist Talk*)

Identity politics often purports itself as a form of inclusion in the nationalist imaginary for people of colour. However, one can question how such a branding of alterity cannot be separated from the distanciation that multiculturalism as a form of multinational capital produces. The body and emotions of the person of colour are separated from the commodity object, which exists to be bought, sold, and gazed

at. Vettivelu discusses their use of a mirror in the installation, where spectators could take "selfies" while they stood behind the mirror making a garland of flowers that resonates with uses of flowers in ceremonies of death, romantic unions, and birth in many religious traditions.

The use of the mirror offers a critique regarding how white, Western secular audiences fetishistically consume the art of so-called Others as a form of multinational capital that is used as an appendage to their egos, to brand the viewer as an "enlightened" and "progressive" thinker for having looked at the works of art made by racialized queer people in a white settler colony. As Vettivelu states,

> I thought about the mirror psychoanalytically a lot when I was making it but I haven't given it a lot of thought since. When I say mirror—in my brain I hear ego-surface. So a surface for projecting desires and you see yourself reflected. I think that's my interest in reflections in general even in my rubbing one out piece—it's kind of a similar idea. (Vettivelu, Personal interview)

And yet, the artist's position behind the mirror, at a distance, also removes the jouissance of the body from the scene. As Žižek argues, multiculturalism can function as an inverted form of consumptive racism where left-leaning liberals feel better about themselves for having consumed images and products associated with Brown bodies, while keeping the fears of racial and sexual contagion at bay. The will to voyeuristically and narcissistically consume the body of the Other is subverted as the audience is left only with their own mirror image and picture as an "exotic souvenir" of the often neocolonizing impetuous of white consumers and audiences.

The Easter lilies Vettivelu uses in *Glory Hole* make reference to the relationship between Christianity and whiteness, alluding to ideas of death and resurrection. When read in tandem with Vettivelu's other installations, it is significant to consider that Easter signifies a holiday commemorating the resurrection of Christ. The use of white lilies, much like the white wax in *I've Done It / You've Done It / We've All Done It (Failed Survival Strategy # 1)*, signifies a rebirth beyond efforts to whiten oneself to assimilate to a dominant colonial order. The

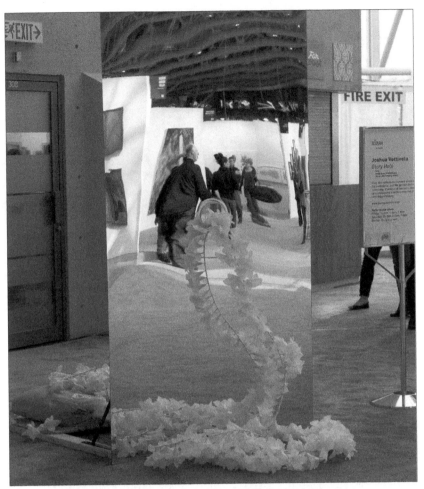

Figure 7.6: Joshua Vettivelu, Glory Hole, 2012. Installation/Performance.
Photo: Elise Victoria Louise Windsor.

artist suggests that these signifiers offer a subtle symbolism regarding tensions between whiteness, death, and the sacred. Allusions to the sacred and the deathly also resonate with the colonial history of white settler states such as Canada where whiteness was often embedded into the colonizing Christian ethose of missionary work. Whiteness also conveyed the the simultaneous attempt to obliterate Indigenous traditions and people. In interviews regarding *Glory Hole*, Vettivelu further discusses the allusions to sex and death that are made through their use of flowers. The artist makes reference to flower markets in India, where flowers are used in ceremonies to signify both fertility

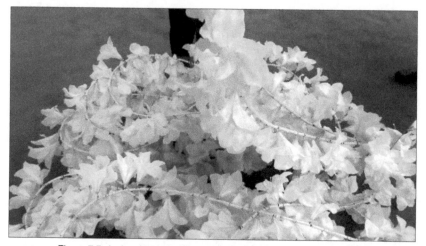

Figure 7.7: Joshua Vettivelu, Glory Hole, 2012. Installation/Performance.
Photo: Elise Victoria Louise Windsor.

and mourning. They subsequently discuss the commodification of flowers in the Indian subcontinent and the relationship between consumer capitalism and the will to purchase signifiers of the sacred and commemorative (**Vettivelu, Personal interview**). Vettivelu's artistic allusions to the commodification of, sex, death, and emotion are perhaps demonstrative of the experience of many queer artists of colour whose personal struggles are often turned into public spectacle for art viewers, staging intimacies that become open to scrutiny and critique.

Images of sexuality and death haunt the queer body of colour across borders. As discussed in previous chapters of *Uncommitted Crimes*, within a time of sexualized torture used in ongoing neo-colonial Orientalist wars, the Brown body is often constructed within mainstream North American public discourse as one that is marked by sexuality and death. The body of the sexually tortured and defamed Brown male is a recurring image that functions as sickeningly vulgar patriotist paranoia in North America and Europe, justifying the imperialist aims of war. The image of the Brown male body within the global phantasm of visual production is one whose figure and form can be used to allude to the disturbing relationship between sexuality, violence, and death that haunts white settler colonies and their newfangled colonial bids for power. The body of a Tamil Sri Lankan diasporic artist can also conjure up its own genealogies

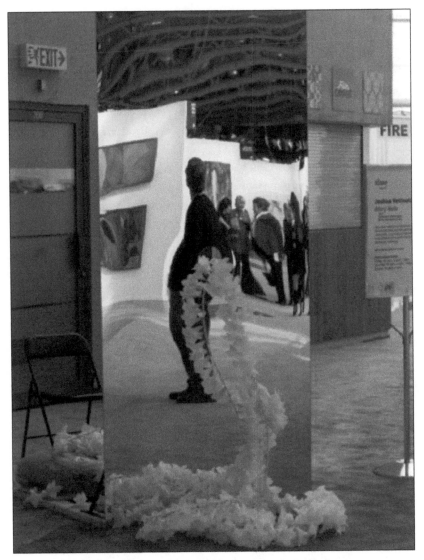

Figure 7.8: Joshua Vettivelu, Glory Hole, *2012. Installation/Performance.*
Photo: Elise Victoria Louise Windsor.

of sex and death. Tamil Sri Lankans are marked with both death and sexualization owing to laws that criminalize public discourses pertaining to sexuality in Sri Lanka, which trouble the ability of artists to freely create works pertaining to sex. In 2009, the government of Sri Lanka banned all websites deemed to be pornographic, as well as "adult only" films. The government has also given more power to the

Public Performance Board that can censor public art and performances considered to be threatening to national culture and public morality ("Adult Only Films Banned"). The deep irony with such justifications of epistemic violence in the name of protecting public consciousness lies in how such puritanical moralities owe themselves to European colonial ideology, rather than Indigenous precolonial cultures. Images of supposed sexual deviance and criminality are marked by a deathly sex that can be violently removed from the national imaginary through cases of street-based violence and legalized erasure. Vettivelu's *Glory Hole* would likely not be viewed in Sri Lanka without persecution from the state and threats of violence, marking the queer body in the post-colony as a deathly one, haunted by the ghosts of colonizers.

The Tamil Sri Lankan body within Canada also comes to be associated with psychic anxieties and aggressions that are both sexualized and deathly through cases such as the deportation of migrants seeking refuge from nations such as Sri Lanka. The refusal of the Canadian government to grant asylum to Tamil Sri Lankan migrants aboard vessels such as the *MV Sun Sea* signifies an overarching fear of racialized contagion, in which dominant white conservative publics fear being overtaken by swarms of Brown bodies. A racist rhetoric which imagines Brown migrants as having too many children heterosexualizes and pathologizes the Tamil Sri Lankan migrant as one's whose sexuality signifies the contagion and death of the white Western nation state. The discursive construction of the racialized migrant seeking refuge as one who will overrun the white settler state with Brown people has been a defining form of white hysteria within the history of Canadian immigration, and one that speaks to a fear of white extinction. Such a racist form of paranoia masks the actual extinction and death of those who are deported to war-torn countries and facing conditions of extreme poverty and civil wars that script their death through a global map haunted by the violent remains of colonialism. Finally, one can consider the relationship between sexualized exoticism and the deathly low-wage labour exploitation of racialized migrants. While the "sexy spice" of multicultural products and images often makes for salivating audiences, the poverty of Brown people is an unremarked upon street spectacle of the everyday that is not part of the branding of "world class" cities. The "world class" city can sell saris and samosas to a certain class of bored shoppers, while

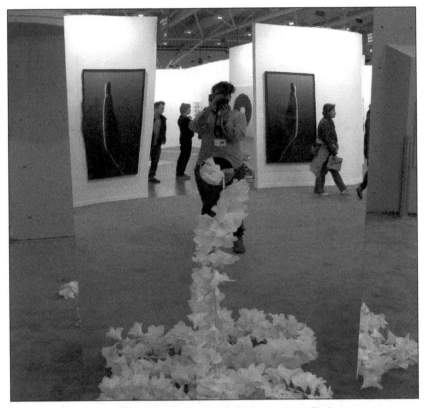

Figure 7.9: Joshua Vettivelu, Glory Hole, 2012. Installation/Performance.
Photo: Joshua Vettivelu.

the rest of the world struggles to live above the poverty line.

With the disillusion of "the Big Other" of religious and nationalist authoritarian regimes of power where desire and drive is curbed by the states and the institution of the order of "Objet A" where everything is permitted by consumer capitalism, images of the sacred and the sexual are often sold en mass. The voyeurism of *Glory Hole* is similar to the "gold mines" of queer artists of colour's lives, which become public spectacles and saleable commodities for those touring the lives of Others, like dazed white tourists vacationing in impoverished places in the Global South. However, in offering an interesting parody that points to the impossibility of authenticity within what Badiou terms the worldless nature of global capitalism (Badiou qtd. in Žižek, "On Alan Badiou"), Vettivelu's installation does not provide one with a self-righteous moralism that derides the viewer. Rather, the

installation seems to comment on how both artist and viewer, both spectacle and spectator, participate in a world where one is either labouring or gaining something from the labour of others. The artist is behind the mirror labouring to create an installation that offers an interpassive form of pleasure to the viewer who can gain a psychic, emotive, and spiritualized affect from the artistic ritual, at a time when religious rituals are not part of the every day. While the viewer could take pleasure in such a ritual to the benefit of their own narcissism, the artist is not positioned as judge and jury, but rather one whose body and body of work produce the mirror images of audiences. What is refreshing about *Glory Hole* lies in the artist's use of comic elements to move away from positions of vilification in which minoritarian bodies often deny their implication in the oppressive workings of global capitalism to play positions of martyrs or consummate victims of the white gaze.

Vettivelu's brilliance lies in their ability to diffuse the phobic sentiments lauded onto Brown and queer bodies with humour. As with many of the artists discussed in *Uncommitted Crimes*, Vettivelu generates a comic reaction from the average spectator in ways that make it palatable to a mainstream audience. And yet, the comic moment does not compromise the artistic integrity and philosophical depth of the work. As the artist states in reference to *Glory Hole*,

> The joke I constantly love to make is that I am an artist because I love to masturbate; so much of how I arrive at artworks comes from a really vigorous kind of navel gazing. Seemingly disparate things like sexual encounters, sprouting new body hair, familial trauma or remembering the knee pain I would get while kneeling in church become subject to compulsive magnification. (Vettivelu, *Notes from Artist Talk*)

Far from being trivial, the joke is a psychosocial tool that allows for repressed anxieties, aggressions, and libidinal desires to be momentarily released in the event of laughter (Freud). While Vettivelu states that there is a comic element to *Glory Hole* in its overt references to sex, the underlying references to narcissism, sexuality, and the death drive are not lost. The tensions in the installation between whiteness, sex, and death are all those that are deeply serious in relation to colonial

history as much as they are sites of anxiety that often generate laughter. The fear of death within contemporary cultures of secularism is one that reveals a discomfort with corporeality that also resonates with embodied sexual repressions and puritanical ideology. In playing with these tropes, the artist uses certain recognized symbols and tropes to provoke a psychic reaction in the spectator. In constructing an installation of public voyeurism, the artist also taps into the inherent paradox of cultures of identity politics and political art by those deemed to be marginalized. Those constituted as phobic objects due to racism, classism, heteronormativity, and homophobia are often held at a distance from the nationalist imaginary, constructed as strangers in a sea of images of normative idealized whiteness. However, they are simultaneously often asked to perform alterity for the voyeuristic gaze of white audiences.

The performances that racialized queer artists are asked to enact for major galleries, art institutions, and art fairs can function as a form of public masturbation used to appease salivating white consumers. The Brown body becomes a repository for the repressed colonial fantasies, sexual desires, and rage of white publics. Vettivelu comments on the complexities of creating artwork within Western secular spaces and cultures in which creative works made by those whose bodies are marked as Other are often understood and made intelligible through discourses of identity politics. The artist discusses the structures of white narcissistic power that often include racialized bodies into mainstream art spaces as a self-congratulatory and guilty gesture.

> I am interested in "identity politics" as a sort of phenomenon within contemporary art. I'm hesitant to call it a trend, because that would imply a sort of passing interest, and it runs the risk of brushing off a lot of really intense and engaged work that many artists have made. A lot of the work that gets curated or categorized as "identity politics" is made from an earnest exploration of a specific subject position. But if we are departing from the understanding that a lot of the art world is structured around an economy of white supremacy, then for artists of colour to break into that, there needs to be a tangible dialectic that legitimizes the issues that POC artists are bringing to the table, and so what results is an inclusion

into spaces like museums, galleries etc. that is based off a logic of white guilt. (Vettivelu, *Notes from Artist Talk*)

In utilizing the techniques of the comedic, the melancholic, and the pointedly personal and political, Vettivelu constructs artwork that is deeply courageous. The artist's work is brave in its willingness to move away from essentialist sentimentalist uses of tradition and culture. Joshua Vettivelu's artistic praxis is also an inspiring feat that moves outside of the often sullen and rage-filled discourses of the political. What is also deeply refreshing is their refusal to play the role of the perpetually innocent and victimized, and to further discuss the corporate structures that implicate the artist's work within a wider system of global capitalism. In discussing the art world as that which is not beyond critique and informs both the praxis and production of artists, Vettivelu discusses the potentials and limitations of art as a political act. They state that interrogating the fetishistic role that Brown bodies are often invited to play in a mainstream white art world has lead them to question the political and liberatory power of art:

> …it leads me to this question of whether or not art can be emancipatory in a political/ systemic kind of sense. I absolutely believe that art has the power to be emancipatory/liberating in a personal sense. I think especially those of us who occupy this kind of marginalized space, this exploration of self through material aesthetic can be linked to a very real kind of survival. However, I'd like to complicate the idea that art has this kind of innate political power. (Vettivelu, *Notes from Artist Talk*)

One can return to the psychic value of the joke as similar to the political value of melancholia that is produced by other works by Vettivelu. Colonial repressions can be momentarily released when faced with the "glory holes" of racialized queer artists, thereby providing a brief outburst of white colonial rage, anxiety, desire, and fear that might otherwise erupt in violence. Sexual imagery used by Brown queer artists on white settler landscapes can lead to a comical reaction in which humour functions as a psychic release for the rage of dominant whiteness. The punchlines of the racialized queer comic

moment might otherwise find expression by using the bodies of Brown queers as punching bags. However, the joke fades, while the repressed libidinal desires, anxieties, and rage of whiteness remains. And yet, the political value of Vettivelu's artistic events lies in how such stagings also allow for moments of grace on the part of creative visionaries whose work offers a stark commentary and questioning of a white secular capitalist order of "Objet A," in which the desire to desire itself inevitably constructs spaces and times of common-sense narcissism. Vettivelu's references to masturbation both in discussing the artistic act and in staging installations that utilize comedic tropes express a touching and self-reflexive humility.

Joshua Vettivelu offers inside jokes to those who are often asked to perform masturbatory gestures before white audiences in order to survive as artists in a competitive capitalist economy. The ironies of fetishizing staged performances of alterity are acute in times in which many Brown bodies cannot cross the real borders of nations, or the implicit borders of symbolic racial capital that structure belonging in a white settler colony. Vettivelu's remarkable talent lies in a willingness to turn the real traumas of exclusion into a resilient laughter and charming form of critique. It is perhaps those who have had to bear the brunt of so much of the melancholia of exclusion who are left to tell the most poignant inside jokes.

WORKS CITED

"Adult Only Films Banned in Sri Lanka." *Lanka Newspapers Online.* 30 July 2009. Web.

Benjamin, Walter. *On the Concept of History.* New York: Classic Books America, 2009. Print.

Bhabha, Homi. *Location of Culture.* London: Routledge, 1991. Print.

Fanon, Frantz. The Wretched of the Earth. Trans. Richard Philcox. New York: Grove Press, 2004. Print.

Freud, Sigmund. *Jokes and Their Relation to the Unconscious.* 1926. Ed. James Strachey. London: W.W. Norton, 1960. Print.

Gordan, Avery. *Ghostly Matters: Haunting and the Sociological Imagination.* Minnesota: University of Minnesota Press, 2008. Print.

Gordan, Avery. "Some Thoughts on Haunting and Futurity." *Borderlands* 10.2 (2011): 1-21 Print.

Halberstam, Jack. *The Queer Art of Failure*. Durham: Duke University Press, 2011. Print.

McClintock, Ann. *Imperial Leather: Race, Gender and Sexuality in the Colonial Contest*. New York: Routledge, 1995. Print.

Muñoz, José. *Disidentifications: Queers of Color and the Performance of Politics*. Minnesota: University of Minnesota Press, 1999. Print.

Nayar, Pramod K. *English Writing and India, 1600–1920: Colonizing Aesthetics*. New York: Routledge, 2008. Print.

Nelson, Antonya. "Definition of Glory Hole." *Language for an American Landscape* Web. 24 July 2015.

Peckham, Aaron. *Mo' Urban Dictionary: Ridonkulous Street Slang Defined*. Kansas City: Andrew McNeel Publishing, 2007. Print.

Puar, Jasbir K. *Terrorist Assemblages: Homonationalism in Queer Times*. Durham: Duke University Press, 2007. Print.

Puar, Jasbir K., and Amit Rai. "The Remaking of a Model Minority: Perverse Projectiles Under the Specter of (Counter)Terrorism." *Social Text* 22.3 (2004): 75-104. Print.

Said, Edward. *Orientalism*. London: Vintage Books, 1978. Print.

"Sri Lankan Government Says LGBT Rights are Constitutionally Protected." *OutRight Action International*. 20 Oct. 2014. Web. 7 Oct. 2016.

Varghese, Ricky. "The Sadness of Doors and Mirrors: Longing in the Work of Abdi Osman and Joshua Vettivelu." *Kapsula* 2.3 (February 2015): 7-17. Print.

Vettivelu, Joshua. joshuavettivelu.com. Web. 26 July 2015.

Vettivelu, Joshua. *Notes from Artist Talk*. G.A.G. VI., Glasgow Artist Guild, The Pipe Factory. Glasgow, 23 March 2015.

Vettivelu, Joshua. Personal interview. 21 September 2015 and 1 August 2016.

Walcott, Derek. *Collected Poems, 1948-1984*. New York: Farrar, Strauss, and Giroux, 1986. Print.

Žižek, Slavoj. "Multiculturalism, or, the Cultural Logic of Multinational Capital." *New Left Review* I/225 (1997): 34-57. Web. 24 July 2015.

Žižek, Slavoj. "On Alan Badiou and *Logiques des Monde*." 1997/2007. Web. 24 Oct. 2016.

Žižek, Slavoj. *The Sublime Object of Ideology*. London: Verso, 1989. Print.

8.
Unsettled

Transitory Lovers and the Boundless Art of Brendan Fernandes

T O FAIL. TO FAIL TO BE LOVED. To fail to return the gaze. To fail to exist in the mirrored reflection of another. Brendan Fernandes's performance *Encomium* was staged in the Onsite Gallery at the Ontario College of Art and Design, University in Toronto, Canada, as part of The Multiple Lives of Artists Conference. As discussed by Jack Halberstam in their work regarding the beauty of queer failure, I consider *Encomium* to be a queer art of refusal. Fernandes's performance offered time in which to consider the wonderful failures of passions that do not approximate heteronormative, secular capitalist ideals of love as never-ending devotion. Fernandes's installation troubled the idea of love as the mirroring of matching bodies, offered a queering of ideas of success, and explored the relationship between white secular capitalism and normative understandings of romantic love. The installation *Encomium* was inspired by Plato's *Symposium*, a classic within Western philosophical traditions. In Plato's iconic text, love is ruminated on through speeches of praise and devotion. In Fernandes's embodied rendition of Plato's writing, the language of love is explored through the bodily gestures and techniques of dance. The body is a work of translation, where words perhaps fail to capture the affective feelings of unrequited love and temporalities of desire, both fleeting and impermanent. Instead, it is through the bodily gestures of dance and movement that the failure to approximate platitudes of heteronormative romantic scripts is expressed when the lovers in *Encomium* walk away.

I had the pleasure of being captured by the artistic vision, creative restlessness, and passion of Fernandes when we met months before

the opening of *Encomium* in Toronto, where I interviewed the artist about his remarkable body of work and artistic vision. I write now of *Encomium* and other installations that are among Fernandes's incredibly diverse and rich creative oeuvre. In the embodied grammar of dancers, the temporalities of artistic movements that defy succinct nationalisms, the impossible translations of emotion, and the lexicons of multiple subaltern genealogies, Fernandes's visual spectacles rewrite history, sometimes without so much as a word. There is violence done to a body that is beyond translation. There are lusts and desires that carry no words. There is the momentary work of an artist's installation that much like love, ends, hanging like smoke in the air before falling into memory.

"PERFECT LOVERS" AND THOSE WHO WALK AWAY: DISIDENTIFICATIONS OF LOVE

Writing of a 2013 staging of *Encomium* at the Rodman Hall Art Centre at Brock University, Canada, Patrick Mahon states, Fernandes presented his *Encomium* (speech in praise of love), which resonates with the knowledge that Plato theorized the "ideal" form of love to be between males. So, in the piece, Fernandes made a robust declaration about love and queerness. Among this work's other functions is the assertion that the art gallery can be used for presenting queerness in ways not often included among the many expressions of mourning and rage necessitated by the AIDS crisis (Mahon).

While Mahon writes of the optimism presented in the idealized "healthy" queer male lovers who perform in *Encomium*, one should be aware of how biopolitical notions of health are grafted onto homonationalist images of queer bodies to align them with state interests against queer "terrors" to the nation.

Rather than seeing *Encomium* as a celebration of the success of queers in a post-AIDS crises moment of "pink dollar" branding, I read this installation as a celebration of queerness that is reminiscent of the inspirational work of queer artists of colour such as Felix Gonzales-Torres. Gonzales-Torres's disidentifies with timely narratives of eternal love that follow straight temporal narratives in which one is born to be educated, work, fall in love with one partner of the opposite sex, reproduce ideal citizens who succeed lineages of racial, religious,

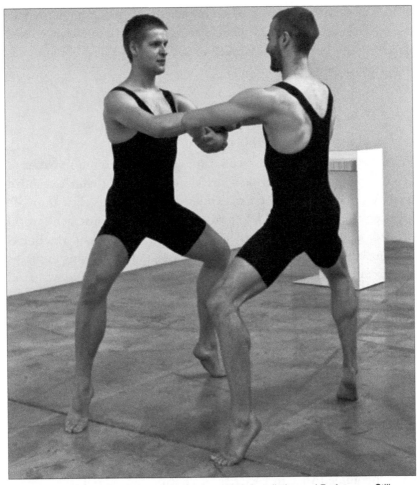

Figure 8.1: Brendan Fernandes, Encomium, 2013. Installation and Perfomance Stills. Photo: Brendan Fernandes. Courtesy of the artist and Monique Meloche Gallery, Chicago.

and class-based norms, and die. Similarly, Fernandes works on and against Plato's narrative of heteronormative romantic temporalities. Rather than wholly divorcing himself from dominant canons of straight Western art history, Fernandes enters into an embodied queering of Plato's romantic scripts. His work disidentifies with art histories and heteronormative temporalities of romantic love. As a disidentificatory act, Fernandes's work also refuses to wholly identify with trite narratives of mainstream heteronormative capitalist love found in mainstream film and television. However, the artist's work does not turn away from the idea love completely. Rather, *Encomium*

disidentifies with romantic Western canons of poetic renderings of desire. This also mirrors Muñoz's discussion regarding racialized and queer youth's breathtaking ability to survive racist and homophobic majoritarian public spheres.

IT ONLY GETS "BETTER" ONLINE:
ART AS PUBLIC INTELLECTUAL CULTURE

Within spaces of Western secularism, queerness is often a matter of privatized legal right and personal choice regarding which branded queer product to consume or Grinder dating sight to click through. Discourses of teleological Western "progress" often construct a world of legal, affluent gay subjects clicking through windows of MacBooks as being better off in privatized capitalist isolation than living in spaces where nosey neighbors would peer through bedroom windows. And yet, one can ask how privatized rights to be left alone to labour and consume remove any discourse of desire from the public sphere. One can further question how the imagined progress of secular capitalism might in fact produce new forms of violence.

Violence also enters the intimate spaces of lives and minds through the ever-present Internet. Jamie Rodemeyer was an American boy of fourteen who killed himself after being bullied online by high school classmates. On the Internet, he read the words: "JAMIE IS STUPID, GAY FAT AND UGLY … HE MUST DIE!" (Atluri, "Is Torture" 246). The Internet is perhaps exemplary of what Gilles Deleuze meant when he argued that in societies of control, the school, the prison, the hospital, and the market exist in a mutual system of never-ending deformation (3-7). Within worlds where lives are increasingly lived online, the Jamies of the world carry the hate speech of the school with them. The online worker or student is everywhere and nowhere, out of the bounds of clocked hours, and yet is consistently surveyed and controlled by the powers of state and market.

As Michael Hardt and Antonio Negri state, "Since value is outside of every measure (outside of both the 'natural' measure of use-value and monetary measure), the political economy of postmodernity looks for it in other terrains: the terrain of the conventions of mercantile exchange and the terrain of communicative relations" (87). Hardt and Negri go on to discuss the relationship between the contemporary

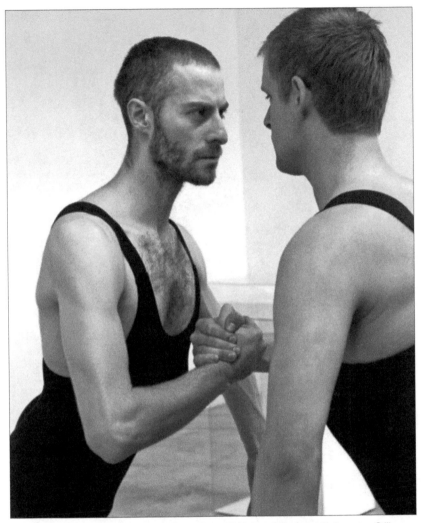

Figure 8.2: Brendan Fernandes, Encomium, 2013. Installation and Perfomance Stills.
Photo: Brendan Fernandes. Courtesy of the artist and Monique Meloche Gallery, Chicago.

market and contemporary biopolitical control: "Conventions of the market and communicative exchanges would thus be the places where the productive nexuses (and thus the affective flows) are established—outside of measure, certainly, but susceptible to biopolitical control" (87). When does one's ability to be regulated end in a time in which employers can survey them online, and one's classmates can harass them online? The tragic death of Rodemeyer demonstrates the ironies of the proliferation of text within cyberspace that produces the disturbing

Figure 8.3: Brendan Fernandes, Encomium, 2013. Installation and Perfomance.
Photo Stills. Photo: Brendan Fernandes. Courtesy of the artist and
Monique Meloche Gallery, Chicago.

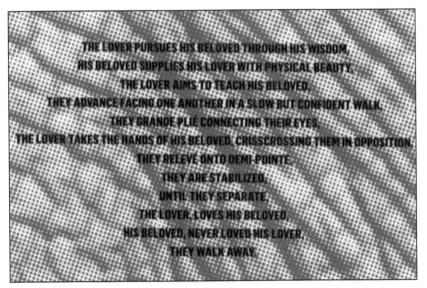

THE LOVER PURSUES HIS BELOVED THROUGH HIS WISDOM,
HIS BELOVED SUPPLIES HIS LOVER WITH PHYSICAL BEAUTY,
THE LOVER AIMS TO TEACH HIS BELOVED,
THEY ADVANCE FACING ONE ANOTHER IN A SLOW BUT CONFIDENT WALK,
THEY GRANDE PLIÉ CONNECTING THEIR EYES,
THE LOVER TAKES THE HANDS OF HIS BELOVED, CRISSCROSSING THEM IN OPPOSITION,
THEY RELEVÉ ONTO DEMI-POINTE,
THEY ARE STABILIZED,
UNTIL THEY SEPARATE,
THE LOVER, LOVES HIS BELOVED,
HIS BELOVED, NEVER LOVED HIS LOVER,
THEY WALK AWAY.

Figure 8.4: Brendan Fernandes, Encomium, *2013. Installation.*
Photo: Brendan Fernandes. Courtesy of the artist and Monique Meloche Gallery, Chicago.

paradoxes of isolation and a lack of ethical responsibility toward others. Before killing himself, Rodemeyer posted this message online: "I always say how bullied I am, but no one listens to me.... What do I have to do so people will listen to me?" (Edwards, Edwards, Wahl, and Myers 55). Despite access to an infinite array of communication methods, Rodemeyer felt censored and unheard. Slavoj Žižek argues that we are living in a post-political, biopolitical moment. The author defines "'post-political' [as] a politics which claims to leave behind old ideological struggles and instead focuses on expert management and administration, while "bio-politics' designates the regulation of the security and welfare of human lives as its primary goal" (*Violence: Six Sideways Reflections* 40). Foucauldian biopower and biopolitics bind the everyday performative gestures, health, and aesthetics of bodies to state power through injunctions, orders, and routines. Biopolitics also involve subtle regulations of populations whose lives are supported to produce idealized gendered, racial, and religious subjects. Žižek goes on to argue, "It is clear how these two dimensions overlap: once one renounces big ideological causes, what remains is only the efficient administration of life" (*Violence* 40). He argues that within our post-political, biopolitical present, the only way to mobilize people is

through fear (*Violence* 40): "Today's liberal tolerance towards others, the respect of otherness and openness towards it, is counterpointed by an obsessive fear of harassment. In short, the Other is just fine, but only insofar as his presence is not intrusive, insofar as this Other is not really other" (*Violence* 41). While the corporate branding of social media sites extend themselves to people as entertainment and fun, we bear witness to the use of these sites to enact biopower against the weak and the oppressed. What is also interesting is that the response to cases like Rodemeyer's has also erupted through social media sites such as YouTube, Facebook, and Twitter.

The "It Gets Better" campaign was launched by gay sex columnist Dan Savage after an outbreak of queer suicides erupted in the West. Technology was used to disseminate messages regarding the success of queer subjects. In regards to contemporary capitalism, Žižek uses an example of a chocolate laxative to discuss how capitalism ventures to sell us solutions to the problems it causes (*Violence*). Could the use of an online media campaign used to offer quick snippets of speech and narratives of neo-liberal capitalist success be seen as a chocolate laxative of sorts? It seems ironic that much of the violence that young people experience happens through online media, and instead of the response being a political campaign or ongoing protests in public space; it was more internet activity. Deleuze argues that the most mindless reality television shows are successful because they mimic the corporate situation with precision. One can ask how the "It Gets Better" campaign acts as a form of reality television, with acceptable queer subjects narrating their achievement of North American dreams, often through their ability to attain capital and normative familial structures.

It is also interesting to consider how "It Gets Better" turns on ideas of teleological progress. Judith Butler states, "Politically, the questions—'What time are we in?' 'Are all of us in the same time?' and specifically, 'Who has arrived in modernity and who has not?'— are all raised in the midst of very serious political contestations" (1). Butler argues that the idea of warring civilizations or cultures within the "war on terror" would "miss an important point, namely, that hegemonic conceptions of progress define themselves over and against a pre-modern temporality that they produce for the purposes of their own self-legitimation" (1).

We live in increasingly high-speed anti-intellectual times in which "progress" is associated with capitalist accumulation and privatized legalized right. It purports to "get better" online and through corporatized branding and mainstream television coverage. Art might function as one of the remaining forms of thoughtful public culture within late secular capitalist life worlds. Rather than seeing secular Western capitalist time and space as "better," one can consider canons and traditions of art in which love and desire are made into public acts of witnessing. Fernandes's art resonates with that of Gonzales-Torres who politicized queer desire, love, and intimacy through art installations that unsettle heteronormative illusions.

Within the time of Plato, love was lyrically and publically evoked through songs of praise that offered a public staging of love and desire. It is through the disidentificatory artistic praxis of artists like Gonzales-Torres and Fernandes that we are left with opportunities to publically see queerness and to consider love collectively. Muñoz states that within the work of Gonzales-Torres "[p]rivate loss is restructured as public art" (170). Gonzales-Torres constructed billboard installations in New York that commented upon the loss

Figure 8.5: Brendan Fernandes, Encomium, *2013. Installation and Perfomance Stills. Photo: Brendan Fernandes. Courtesy of the artist and Monique Meloche Gallery, Chicago.*

of his lover and other queer people to AIDS. A billboard depicting an empty bed with indented pillows where lovers once slept offers a public visual to all of the private trauma of queer lives. Muñoz writes, "The billboards powerfully challenge notions of publicity and privacy. The image, repeated throughout the city, is one that represents not a presence, an identity, but instead an absence, a lacuna, a void gesturing to something valuable, loved, and missing" (170). Within cultures of Western secular capitalist privatization of desire and sex, the general public is free to avoid any images of queerness or Otherness that trouble them. While one is legally free to desire and express love in multiple ways, there is little space where the public is challenged to question subtly and violently enforced heteronormative ideals of intimacy, love, beauty, and desire. Like Gonzales-Torres's, Fernandes's artwork turns very private questions of love and desire into public events. Muñoz states, "The performances and installations of Gonzales-Torres achieve a tactical misrecognition of dominant publicity's public/private binary" (169). Similarly, in disidentifying with Plato's writings regarding love, Fernandes also turns questions of love and desire into a form of public culture. Plato's writings were public texts that offered philosophical commentary regarding love, and would often be read aloud and debated publically. Fernandes queers Plato in ways that challenge homonationalist images of queerness as branded, privatized, "legalized gay" imagery. Queer love and its failure to visually and temporally approximate heteronormative white settler ideologies become a public disruption of racist homophobic public culture. Gonzales-Torres's *Perfect Lovers* was an art installation that commented on the artist and his lover who died of AIDS. His piece included two battery-powered clocks that fail to keep the same time. As Lisa Le Feuvre writes, "The 'perfection' lies in the failure of accuracy; anything else would be romantic fiction. Like these out-of-sync clocks, human beings are all fallible; perhaps this is most explicitly revealed to us in how we understand the past—that is, through memory and imagination. Here failure abounds" (2010). Titled *Perfect Lovers*, the installation offered a wry ironic commentary on the imperfection of bodies, time, and desire, none of which can be measured by clocks or scales. The bodies of lovers and the affective resonance of desire cannot be timed or measured. Similarly, within Fernandes's remarkable *Encomium*, the dancers do not remain within

each other's mirror image. The lover and the beloved walk toward each other, mirroring each other's gestures and movements. They are frozen in each other's image, moving in time to each other's breath and step and yet they can never be perfectly synchronized. The beloved does not love his mentor, he fails to remain perfectly timed and in synchronicity with his suitor. Breaking with the narcissistic will to mirror his lover and with heteronormative capitalist scripts of love as a form of eternal property ownership over another, the beloved turns and walks away.

Like a student who fails to repeat after a teacher, a pupil who fails to need their mentor, or a queer child who does not grown up to succeed the heteronormative image of their parents, optimism does not lie in perfect bodies, scales, or ledgers, but in the radical possibilities of uncertainty. Gonzales-Torres's *Perfect Lovers* commented on the failures of love and desire to be fully structured by the clocks of secular capitalist temporalities, and the scales of idealized images of health that support the vitality of bodies that are economically viable to nationalist aims. Such valorizations of biopolitical strength happen through the simultaneous denigration and devaluation of other lives, namely those whose futures are not imagined to support the production of idealized citizens, seen as incidental to fantasies of white, heteronormative nation-building. Similarly, the beauty of *Encomium* lies not in the optimism of perfectly timed love and desire, but in the uncertainty of queerness and the freedom of the one who breaks from the mirror image of the mentor's gaze and walks away. The installation is an optimistic queering of ideas of time that challenges the increased branding of happy gay families as those that approximate the trite romantic fictions of heteronormative, white settlers.

There was a simplicity to the staging of *Encomium* that involved the repetitive movement of two bodies walking toward each other in synchronicity, breaking with each other's mirror image and walking away. Far from the frenzied pace of endless Internet activity, the simple gestures of two male bodies walking toward each other and the text affixed to the gallery wall that made reference to queer sex, desire, and love was a remnant of queer protest and philosophical canons of public overtures of the intimate, predating Google. Fernandes included posters with a script that guided the installation for audience members to take with them, before they too walked away. The gallery space was

barren, with white walls forming the backdrop of the staging. Muñoz writes of similar minimalist techniques utilized by Gonzales-Torres: "Gonzales-Torres's minimalism evoked meaning and employed connotation, using the minimalist style to speak to a larger social order and to expanded issues of identity. His refunctioning of minimalism enabled him to rethink identity and instead opt for disidentity" (170). *Perfect Lovers* utilized two simple clocks to offer a rich philosophical text that opens up questions regarding the nature of love, capitalist secular temporalities, death, and desire. So too does *Encomium* offer a seemingly simple visual image that explores complex questions regarding failure, the mirroring of romantic partners, and a queering of ideas of eternal love. The rescripting of Plato's writings, which often artistically ruminate on a love between mentor and student, also opens up ethical questions regarding age, patriarchal modes of desire, and agency.

While the mentor loves the student, does the student express free will or are they made to romanticize the gaze of the teacher as a father figure owing to paternalistic power relations? The love between a young man and an older man, while romanticized in many great canons of art and literature, can be troubled within heteronormative masculinist power relations where "father figures" are often desired through the idealization of older, affluent white male bodies that signify recognizable faces of authority in white settler colonies. Fernandes's *Encomium* does not wholly identify with this patriarchal romance script, but rather disidentifies with this unproblematic equation of power and desire, as the one who is mentored refuses to be fully captured by the gaze of authority. There is a resonance in Fernandes's work with that of Gonzales-Torres whose work exists on the margins of multiple essentialisms, those of idealized affluent white queer culture, heteronormative representations of racialized masculinities, and multinational, multicultural branding of sanitized saleable difference.

Within discourses of secular capitalism, one could also argue that the body of the older man once celebrated in the times of Plato often becomes an undesirable object of desire owing to the ageism of branded images of beauty in which unattainable images of youth become "sexy." Ideas of romantic love and sexual desire within normative capitalist discourse are increasingly inseparable from

oppressive forms of advertising and media that create an unattainable bodily ideal. Wealth, beauty, youth, and power are disturbingly conflated in ways that idealize billboard images as love objects. Rather than subverting paternal authority, the market economy becomes the ultimate figure of authority, dictating which bodies are desirable. By using the bodies of live dancers, Fernandes's *Enconium* troubles the fetishization of a disembodied fantasy of branded sex appeal. The live performance recuperates the corporeality of queerness, with the bodies of queer men dancing far from the pages of magazines and Internet screens, moving in the real time of the gallery space. The two lovers stand face to face, confronting the body of (an) Other not as a recognized LGBTQ category or a celebrity icon but as one whose jouissance cannot be kept at a distance. The presence of an embodied and emotive lover interferes with the ostensible individualism and interiority of the self. The audience who bears witness to *Enconium* is also challenged to see queer sex and desire not as a celluloid and screen fantasy, but in the flesh.

SKINNED ALIVE: ART AS ACTION

In disidentifying with dominant stagings of bodies within the dance world, Fernandes transforms the cultural logic of the dance world and the art world by making work that crosses disciplinary boundaries. Furthermore, in queering ballet and art Fernandes's work also challenges succinct ideas of politics and the political. This public staging of queer bodies is in itself a political event that turns the motions of queer lovers into a social movement of artistic sensuality. Fernandes's body and body of artwork are also in constant movement as he crosses borders to stage installations and hold artist residencies in New York City, Toronto, India, Africa, the Caribbean, and throughout Europe. Failing to be held in place by the hierarchal ordering of bodies within the mainstream dance world and biopolitical categorizations of bodies that attempt to name and hold ideal citizens in place, the artist and his work are in constant flux. As Fernandes states,

> I always say that identity is something that is in line with cultural histories. This is positing Stuart Hall that identity is in a constant flux. I'm not just Indian or Canadian or Kenyan. I

am these things. I'm also queer, I'm also a dancer, subculturally I still reference punk rock from youth so those things also make identity. Identity is something that is always changing, in flux. (Fernandez)

Encomium offered a visually striking image of bodies: two men dressed in matching wrestling costumes striking the postures of ballerinas. Like Fernandes's own body as one that archives a disidentification with dominant cultures of ballet and dance in which the imagined ballet dancer is often an archetypal white feminine body, *Encomium*—like much of Fernandes's art—is a poignant disruption of aesthetic norms.

In speaking with Fernandes regarding the politicization of bodies, we discuss his own trajectory, as someone who trained to be a ballet dancer and whose body is also an archive of movements across multiple borders. Multiple ideas of movement frame Fernandes's identity and artistry: "[A]s a dancer movement is something that is generalized through spectacle. But as a dancer, the reason I stopped dancing was that I got injured and I wasn't allowed to dance anymore. So it all kind of frames the idea of identity and the kind of makeup of who I am." Fernandes further comments on the relationship between hierarchical orders of bodies and ballet, stating,

I look at ballet as a kind of hierarchical order. And that's the reason I stopped dancing because ballet was promoting a kind of rigorous idealized body that I wasn't able to have so I was kind of filtered out of the system. So I'm looking at the idea of making gestures, gestures of the body but also kind of political gestures so what does the movement mean through the racialized body, the queer body, that I make it through this space with my body being transformative.

There is a historical and ongoing relationship between the making of bodies through the cultures of "high art" and racist biopolitical hierarchies of recognized and valorized citizens. The "body beautiful" image of the ballerina within the Western bourgeois imagery of the mainstream dance world is often represented as a hyper-feminine, white, thin, heteronormative, youthful, cis-gender woman. This trope

of the imagined ballerina gains its visual resonance from images of "innocent," white femininity found in Eurocentric fairy-tale representations of certain women. Within the mainstream world of ballet, it is often difficult to find images of subaltern bodies, just as these bodies are often not represented within dominant romantic narratives. Fernandes's installation restages bodies of dance and canonical bodies of romantic poetry as a political movement, recharting bodies and the body politic.

Žižek writes of responses to trauma, discussing two ways in which violence is often responded to; through the superego and the through the act. Žižek writes,

> So, rather than remain stuck in debilitating awe in front of the Absolute Evil, the awe which stops us to THINK what is going on, one should recall that there are two fundamental ways to react to such traumatic events which cause unbearable anxiety: the way of superego and the way of the act. The way of the superego is precisely that of the sacrifice to the obscure gods of which Lacan speaks: the reassertion of the barbaric violence of the savage obscene law in order to fill in the gap of the failing symbolic law. (*Welcome* 143)

Žižek further discusses the possibility of responding to trauma in ways that challenge the obscene order of power. He discusses an unlikely heroine of the Holocaust, a ballet dancer who took action, and in doing so, offered an act of resistance:

> One of the heroes of the Shoah for me is a famous Jewish ballerina who, as a gesture of special humiliation, was asked by the camp officers to dance for them. Instead of refusing, she did it, and while she held their attention, she quickly grabbed the machine-gun from one of the distracted guards and, before being shot down herself, succeeded in killing more than a dozen officers. (*Welcome* 143)

Fernandes's artistic installations do not reassert the violence of "high cultures" of dance often born out of existing disciplinary structures of white supremacy, patriarchy, and capital in which the

vitality of the white feminine ballerina supports the death of queer bodies like Rodemeyer, and the invisibility of racialized bodies. Rather, there is a disidentification with dance that works on and against dominant visualizations of bodies to produce public bodies of art as embodied politics. The figure of the ballet dancer who does not approximate ideal whiteness, who is categorized as being at best invisible to and at worst disposable to national narratives, haunts Fernandes's artistic defiance. Like many racialized, queer, feminist, and political artists he uses the tools and techniques of the dominant biopolitical order to challenge normative ideas of art, culture, and the body itself. The queer dancers within *Encomium* are not straight-shooting cowboys, firing colonial guns on a white settler landscape. Rather, in their failure to remain in place, they unsettle dominant ideals of love, embodiment, and desire. Ideas of normative straight love and racist hierarchies of bodies are tied to vulgar Nazi genealogies that marked queers with pink triangles as constructed objects of extinction, just as bodies marked as racial and religious Others were scripted for death.

Fernandes subverts the violent obscenities of heteronormative romantic scripts in the gallery space, an unlikely battlefield of combative dance. The Jewish ballerina that Žižek writes of turns the guards' gun on them in ways that minoritarian artists disidentifiy with mainstream "high culture," staging their own nationalist narratives in a different shade, pitch, and key. The Jewish ballerina and the racialized queer artist are often not found in official histories and aesthetic representations of nationalism. They are those whose bodies archive violence, trauma, and hatred, and yet who despite all odds, continue to shoot from the hip.

THE JOYS OF FAILURE:
QUEER ICONS NEED NOT SUCCEED FOREFATHERS

The body is a never-ending archive of admirable failings. Within the secular capitalist world, one is often raised from cradle to grave to endlessly attempt to live up to an idealized body connoting heteronormative white wealth. Along the way, every inevitable failure to approximate an unattainable and rather banal image of success is often met with narratives of individual blame for ostensible failures.

Halberstam discusses failure, both as a constructed concept that pathologizes the oppressed and in relation to a queering of success that troubles universal notions of error. The queer body, as one that does not follow the successive line of patriarchal forefathers within Halberstam's text, is not one to be grieved, but rather one that troubles the very terms "success" and "failure." Queer failure asks one to consider the relationship between aspirational cultures and violent structures of biopolitical governance. Halberstam writes, "Perhaps most obviously failure allows us to escape the punishing norms that discipline behavior and manage human development with the goal of delivering us from unruly childhoods to orderly and predictable adulthoods" (3).

Within Fernandes's *Encomium*, the beloved walks toward his mentor in the gallery space, and they are frozen for a fleeting moment within each other's gaze. However, the beloved does not fully return the gaze of the one who loves them. They break from the synchronized routine, shattering the mimesis of successive heteronormative patriarchal succession, in which sons follow in the footsteps of fathers, the governed followed in the footsteps of those who govern, and romantic love is bound to patriarchal lineages and heteronormative families. The mirror image is broken as is the narcissistic fantasy that holds hegemonic fantasies of "true love" in place. The lovers turn and walk in opposite directions. As Fernandes states,

> I look at love as a space of failure. So I look at in relation to the body and how the body reaches a point when it can't do something. How does the body relate to ideas of love and failure. So I have this piece and I've created pieces with dancers. So I have this piece that's called *Encomium* based on Plato's the symposium where Plato speaks about an asymmetrical love between a younger male and his companion. And he speaks of how this love will dissipate because the mentored with grow up and not need his mentor anymore. There are a lot of those questions of love and failure.

Halberstam draws on Foucault's writings regarding disciplinary power to discuss queerness and loss. The author suggests that disciplinarity is a tool of modern power that judges success based on the molding of bodies and minds to approximate normative ideas that are

tied to modernist state structures and capital. Disciplinarity "depends upon and deploys normalization, routines, conventions, tradition, and regularity, and it produces experts" (Halberstam 7). The tutelage of the student who must follow the orders of the mentor is akin to the lover who is bound to patriarchal models of desire. The authorial body that commands the law of the father can capture the partner in a gaze imbued with disciplinary power. And yet, in Fernandes's embodied staging of *Encomium* there is a queering of romantic love that also troubles the heteronormative, patriarchal disciplinarity of both family and education. The mentored no longer needs the mentor, just as the child no longer needs the parent, just as love fails to last.

THE KISS OF DEATH:
KILLING WHITE SETTLER MYTHOLOGIES

Within Fernandes's deft artistic world, there is also a connection between the body as an archive of failing and the troubling of normative ideas of gender, race, and the nation state that trouble the biopolitical aims of nation building. As an Indo-Kenyan-Canadian artist who resides in New York City, Fernandes's body crosses borders both literally and metaphorically, as neither the artist's body nor their body of artistic work approximates mainstream normative images of "India," "Africa," "Canada," or "America." Throughout the remarkably diverse range of Fernandes's artistic praxis, there are constant allusions to the primitive that both deride racist and colonial notions of Africa and Africans. Simultaneously, Fernandes disidentifies with the supposed primitive, subverting colonial notions of progress that construct the secular West as being advanced and bodies in the Global South as failing to live up to secular capitalist modernity's narcissistic image. Drawing on animalistic metaphors in their work, Fernandes's art ruminates on ideas of love that are bound to the death drive. He states, "I also look at love through the dynamics of power, of predator and prey. So the kind of cycle of life that needs to be happening. I've done a number of drawings of Lions taking down buffalos so it looks like they're embracing but they are actually engaged in this kiss of death" (Fernandez).

Fernandes also uses the primitive to explore the inevitable failures of succinct ideas of nationalism that bind people to notions of authenticity.

His artistic work gestures to the beautiful failings of queer, racialized diasporic artists. Halberstam writes of the relationship between capitalism and universalist ideas of success in which one is taught to see their inability to succeed in capitalist structures as their own fault. This apolitical and ahistorical amnesia is used to produce harmful platitudes of North American positivity. As Halberstam states, "While capitalism produces some people's success through other people's failures, the ideology of positive thinking insists that success depends only upon working hard and failure is always of your own doing" (3). As discussed throughout *Uncommitted Crimes*, the South Asian and Asian body within North America is often used to promote and enforce this ideology through the myth of the "model minority." Asians are imagined to be successful based on hard work in comparison with the vilified Black body, the racialized poor, undocumented migrants, and the Indigenous. At the same time, ideas of "cultural authenticity" that fossilize racialized communities in images of the primitive are used to sell "multicultural" products to affluent yuppies in search of Orientalist exoticism.

LIGHTEN UP? THE QUEER PARODIES OF MULTICULTURALISM

There is a space of irony, humor, and dialogue that is opened up in Fernandes's artistic work. One in which the failure to construct Africa through colonial metaphor gives way to the mockery of trite images of the Global South and the racialized migrants associated with antiquated ideas of culture and community. Fernandes mocks the "African Lion Safaris" of North American multicultural, multinational capitalism through an artistic labour praxis that defies the clocks and ledgers of normative apolitical cultures of consumerist exoticism. Fernandes's art of failure reveals the ironies of multiculturalism as a discourse that constitutes Asian bodies as thankless workers, while fetishizing the branded ironies of over-the-counter forms of "cultural authenticity" marketed to white Western consumers.

As discussed throughout *Uncommitted Crimes*, there is a comedic and ironic space that is opened up within the multicultural pageantry of late capitalist secular worlds. Racialized migrants are often deeply exploited, working in the lowest tiers of the capitalist system, while "authentic" multicultural products are often expensive forms of cultural

capital gesturing to what Badiou calls the worldless" space of global capitalism (Badiou qtd. in Žižek, "On Alan Badiou and Logiques des Monde"). The racialized migrant is a depersonalized worker behind the counter at 7/11, while Asian food, yoga, and ayurvedic healing are

Figure 8.6: Brendan Fernandes, Neo-Primitivism II, 2007. Sculpture and Installation Stills. Photo: Brendan Fernandes. Courtesy of the artist and Monique Meloche Gallery, Chicago.

expensive industries used to sell products. There is a deep and dark irony regarding forms of branded multiculturalism that market third world poverty to rich white Westerners as exciting, decadent, and exotic. Writing in regards to the ironies found in Fernandes's artistic oeuvre, Mahon discusses the artist's queering of multiculturalism. Fernandes uses his personal experiences as an Indo-Kenyan who grew up in suburban Ontario, a world away from colonial images that produce essentialist and ridiculous fantasies of Africa and Africans to trouble racist ideologies. As Mahon suggests, Fernandes's comedic brilliance lies in using his own experience as a Kenyan-born Indian who immigrated to Canada as a youth to humorously problematize the nature of authenticity. A particularly memorable performance video, *Foe* (2008), shows Fernandes training with a voice coach to learn (and often fail to learn) how to mimic the accented English

spoken by an ostensible "real" Kenyan-born Indian, not one raised in the oral flatlands of suburban Toronto, as Fernandes was. Pandora Syperek describes Fernandes's *Neo Primitivism II*, which was staged as part of the Sobey Exhibition in Montreal in 2010. Fernandes was the youngest artist to ever be shortlisted for the prestigious Sobey Art Award. Syperek comments on the ironic and playful images of Africa in Fernandes's art:

> Upon entering Fernandes's section of the Sobey exhibition in Montreal, one was confronted by a herd of life-sized plastic deer wearing African masks made of white resin. Though potentially menacing, the fake creatures were all braced in the same startled position, as if prepared to flee. A forest of vinyl spears that wrapped the gallery wall—at once violent and decorative—further confounded the juxtaposition between the deer's jeering false faces and their timid disposition. Entitled *Neo-Primitivism II* (2007), this plastic-fantastic *mise en scène* playfully invokes postcolonial critiques of the gaze that emerges in encounters with the unknown.

In failing to be known through romantic saleable images of Africa and India that gain their currency from colonialism, and in failing to entertain quaint provincial narratives glorifying white settler Canada, Fernandes's work queers racial authenticity. There is an intermixture in their work between images of queer desire that trouble dominant white settler narratives of happy straight white settler families, and also disrupt racist constructions of culture that imagine racialized migrants to be representatives of timeless traditions and other places, far from here. Mahon writes of the humour that Fernandes applies to queer discourses of race and multiculturalism, and the colonial ideology that often underpins both:

> Wry humour is part of Fernandes's artistic toolkit, and it was not left idle here. Alongside all the thoughtful exuberance in *Encomium I, II, III*, the artist presented a video entitled *seeing i* (2014). This animation shows line drawings and rolling dialogue that reads like excerpts from a social media exchange between two elephants, one Asian and the other African. The

work suggests the breakup of a gay relationship while also alluding to post-colonial power struggles.

Discussing the role of the comedic in this artistic praxis, Fernandes states,

> Humour is definitely something that I use and that I am kind of playing with through stereotypes like African Lion Safari. Those are the kinds of things that mediate "Africa." And I still say "Africa" because African kind of gets visualized as this land of the primitive, the exotic. So those are the kinds of things that I faced when I moved here. I was asked, do you have elephants in your backyard? Did you have a school or cars? So I'm trying to parody this. I think that it's there. It's a way to open up the dialogue. So I'm kind of freaking out in the video. So humor is a tool, a way of getting people to engage with the work but underneath it there is always a kind of political, poignant message underlying it.

As a racialized, queer, migrant artist whose body straddles the divides of many fictionalized communities and whose artistic work crosses disciplinary boundaries, Fernandes's brilliance lies in confounding succinct categories. Rather than producing art that can be easily labeled as the property of one group or nation, Fernandes's artistic work is in constant movement, dancing across borders of time, space, and fixed notions of identity. It is through the artist's restless and transitory migrations and the multiple artistic mediums they utilize that the shape-shifting iconoclast and their work are united, in unsettling and liberatory ways. If "great white men" succeeded within Canadian, American, and European histories of colonialism by "settling"—both in implicitly violent structures of white heteronormative love and explicitly murderous settlements on the land of colonized people—Fernandes refusals to settle in profoundly political ways.

HEAR NO EVIL, SEE NO EVIL:
SILENCE, THE ACT, AND DEVIL'S NOISE

Halberstam draws on a diverse archive of supposed failing that crosses

historical, racial, and national boundaries to collect an arsenal of what the author terms "weapons of the weak" (88). Halberstam discusses the revolts of landless peasants in Southeast Asia and slave rebellions in which different strategies ranging from working slowly to making

Figure 8.7: Brendan Fernandes, Neo-Primitivism II, 2007. Sculpture and Installation Stills. Photo: Brendan Fernandes. Courtesy of the artist and Monique Meloche Gallery, Chicago.

errors in labour production were used to dissent against colonial and capitalist hierarchies. Drawing on Scott, Halberstam writes, "Describing peasant resistance in Southeast Asia, Scott identified certain activities that looked like indifference or acquiescence as 'hidden transcripts' of resistance to the dominant order. Many theorists have used Scott's reading of resistance to describe different political projects and to rethink the dynamics of power" (88). One of Fernandes's most striking installations, *Devil's Noise*, makes reference to the protests of South African students who revolted against the imposition of Afrikaner language in schools during the reign of Apartheid. As Fernandes states in describing the installation,

> *Devil's Noise* was conceived and produced during a residency at the prestigious German new media academy ZKM. This

work investigates the student protests of 1976 in South Africa in which silence was used as a means of protest by student groups opposing the imposition of the Afrikaans language within the school system, effectively barring much of the population from participation. The title references a protest sign carried by a young boy stating We Will Not Speak Your Devil Tongue. The work questions how language can act as a way to oppress and control people.

In refusing to speak the language of colonizers, in failing to approximate the linguistic injunctions of disciplinary power, these students were part of a "hidden transcript" of insurrectionary silence. While speech and the ability to articulate oneself and to name ones oppression is often seen as a part of progressive politics, it was in failing to speak that these students both literally disrupted the authorial voice of education bound to racist state structures, and metaphorically troubled the association between the passive voice and defeatism. This triumph of silence can also be thought of in relation to loud, aggressive, warring masculinities that often define images of supposed victors throughout official historical discourses.

One can return to Žižek's discussion regarding the two reactions that emerge in response to traumatic events, "the way of the superego and the way of the act" (*Welcome* 143). While students could have responded to the violence of apartheid through an assertion of the obscene violence of the symbolic law, asserting an authorial voice of masculinist power that mirrored that of state authority, they opted instead to act in silence. It was through the body in silence that they staged a protest. These 1976 student protests in South Africa are connected to other political movements that arose during this time period. As one author states,

The political context of the 1976 uprisings also take into account the effects of workers' strikes in Durban in 1973; the liberation of neighbouring Angola and Mozambique in 1975; and increases in student enrolment in black schools, which led to the emergence of a new collective youth identity forged by common experiences and grievances. ("Soweto Student Uprising")

Figure 8.9: Brendan Fernandes, Devil's Noise, 2011. Installation and Video Stills.
Photo: Brendan Fernandes. Courtesy of the artist and Monique Meloche Gallery, Chicago.

Figure 8.9: Brendan Fernandes, Devil's Noise, 2011. Installation and Video Stills.
Photo: Brendan Fernandes. Courtesy of the artist and Monique Meloche Gallery, Chicago.

While, as Butler notes, secular Western capitalist narratives of progress are often used to imagine that things have "gotten better" over time and that North American and European nations are more

progressive than countries in the Global South, the embodied defiance of revolutionary protest movements prove otherwise.

The "wordless" space of global capitalism offers an endless stream of written English language words, with hate speech popping up on computer screens alongside diatribes on feminist listserves and advertisements for happy meals, and yuppie yoga studios. An infinite array of text and speech regarding otherness might correspond to a fear of the embodied Other, one whose bodily difference cannot be contained or quantified. Racialized queer artists who visualize and politicize embodied alterity demonstrate a courage beyond mere words.

Fernandes's *Encomium* involved the silent march of two queer dancers whose fleshy sensuality creates artistic spaces of queer politics as public culture. The words that sit dormant on screens, with teenagers typing "It gets better" before pulling the triggers of guns to commit suicide conceals the material and psychological realities of subaltern lives and deaths. In the space of the art gallery, watching and bearing witness to the artistic prowess of Brendan Fernandes, *Encomium* was for me an erudite form of protest. The remarkable artistic event gave vitality to the timeless spirit of rebellion. Brendan Fernandes disidentifies with Plato in profound ways, through public occupations of space.

The queer love that cannot be named, spoken, or ever held in place. The body that walks away.

WORKS CITED

Atluri, Tara. "Is Torture Part of Your Social Network?" *The Žižek Media Studies Reader.* Ed. Matthew Flisfeder and Louis Paul Willis. 241–57. Print.

Bulcha, Mukuria. "From a Student Movement to a National Revolution." *Ayyanntuu News.* 8 May 2016. Web. 18 Sept. 2016.

Butler, Judith. "Sexual Politics, Torture, and Secular Time." *The British Journal of Sociology* 59.1 (2008): 1-26. Print.

Deleuze, Gilles. "Postscript on the Societies of Control." *October* 59 (Winter 1992): 3-7. Print.

Edwards, Autumn, Chad Edwards, Shawn T. Wahl, and Scott Myers. *The Communication Age: Connecting and Engaging.* London: Sage, 2013. Print.

Fernandez, Brendan. Personal interview 23 December 2014.

Halberstam, Jack. *The Queer Art of Failure*. Durham: Duke University Press, 2011. Print.

Hardt, Michael and Antonio Negri. "Value and Affect." *boundary* 26.2 (Summer 1999): 77-88. Print.

Le Feuvre, Lisa. "If at First You Don't Succeed, Celebrate." *Failure* 1 January 2010. Tate Etc. Issue 18: Spring 2010. Web. 18 Sept. 2016.

Mahon, Patrick. "Brendan Fernandes Balances Politics and Optimism." *Canadian Art* 12 Feb. 2015. Web. 18 Sept. 2016.

Muñoz, José Esteban. *Disidentifications: Queers of Colour and the Politics of Resistance*. Minnesota: University of Minnesota Press, 1994. Print.

Plato. *The Symposium*. Indianapolis, IN: Hackett Publishing Company, 1989. Print.

"Soweto Student Uprising." *South Africa: Overcoming Apartheid*. Web. Accessed: 6 June 2016.

Syperek, Pandora. "Brendan Fernandes: The Nature of Culture." *Canadian Art*. 7 April 2011. Web. 18 Sept. 2016. Print.

Žižek, Slavoj. *Welcome to the Desert of the Real*. London: Verso, 2002. Print.

Žižek, Slavoj *Violence: Six Sideways Reflections*. London: Picador, 2006. Print.

Žižek, Slavoj "On Alan Badiou and Logiques des Monde." 1997/2007. Web. 24 Oct. 2016.

9.
Seeing Red in the Streets

Taking Shelter in the Imagi/nation of
Kerry Potts and Rebecca Belmore

Figure 9.1: Love on the Streets, *2009. Film stills. Director: Kerry Potts, Cinematographer: Andrew McAllister. Photo: Kerry Potts and Andrew McAllister.*

FROM THE 6 (NATIONS)?
QUESTIONING IDEAS OF "HOME" IN A
WHITE SETTLER COLONY

IDEAS OF HOME ARE COLOURED IN DIFFERENT HUES against the bloodstained white landscape of a colonial country. Chirpy radio hosts pronounce Canada to be multicultural utopia. The multitalented musician Drake uses his lyrical skills to construct sonic homages about Toronto and receives the key to the city from political leaders who do little to protect Black people who are routinely carded and killed by racist police. Drake emotively comments on anti-Black racism and the Black Lives Matter

Figure 9.2: Love on the Streets, *Director: Kerry Potts, Cinematographer: Andrew McAllister*
Source: Andrew McAllister (Cinematographer)

movement in the track "Current Events (BLM)," with frank lyrics such as, "I'm just so fed up with the feds/I swear they want to see my people dead." Drake provides a stirring rhythm to drown out the shots of gunfire, while remarkable activist groups such as Black Lives Matter Toronto protest anti-Black racism transnationally. And yet, subaltern identity as celebrity is used by white elites to brand cities as diverse while they often remain indifferent to racism. White settler cities pose questions regarding racialized people's belonging, celebrated through rare forms of economic power that do not stop the violent markings of racialized skin, often marked for death. The "current events" of contemporary racism are haunted by ongoing colonial histories of white supremacy.

Drake has been credited with naming Toronto in iconic ways, such as when the artist refers to the city as "the 6" in certain memorable tracks. Journalist Josh McConnell writes,

> The most seminal Toronto reference comes in the crowd-pleasing track *Know Yourself*, where the chorus has become an outright singalong on Drake's world tour, with everyone repeating: "Runnin' through The 6 with my woes/You know how that should go." ("Woes" itself, supposedly an acronym for "working on excellence," is a Drakeism that has reached meme levels of pop-culture saturation.)

It is suggested by some that "the 6" is an affectionate nickname that refers to the area codes 416 and 647 that are found in the city. Others make reference to the amalgamation of six boroughs in Toronto into one city. (McConnell n.p) And yet, including the Six Nations of Indigenous peoples whose ongoing colonization defines contemporary Canada as part of "the 6" would perhaps cause all non-Indigenous people in Turtle Island to question ideas of "home."

Metaphors of "home" as the settlement of Indigenous land are repetitive tropes in Canadian media, finding renewed expression in celebratory representations of new waves of diasporic settlers. Television shows like *Little Mosque on the Prairie* are cartoonish examples of the hyperbolic ways that racialized migrants function as diasporic patriots within Western nations. Turbans are matched to hockey jerseys, and the lilt of accents from around the world are accentuated with an "eh." And yet, to be at home in a white settler colony of ongoing attempts to materially and symbolically destory Indigenous people is to cast oneself in history as a victor, one who has conquered the land and is entitled to occupied colonized territories. The relationship between racialized migrants, non-Indigenous feminists, and queers is a fraught and fractured one in which metaphors of place, belonging, and this strangely unsettling idea of "home" trouble easy wills toward solidarity.

Diasporic patriots and happy homonationalist settlers create imagined communities in gentrified enclaves within cities, turning colonial ideas of heteronormative familial bliss into an emblem of "culture" and "survival." To grow up to approximate the idealized middle-class white family is a testament to the arduous hard work of immigrants and the "it gets better" rhetoric of class mobility as an expression of achievement. However, what disturbs the metaphoric equation between imagined peace and settled lives is the ghostly haunting of Indigenous bodies. Many of the histories and bodies of colonized people lie in sacred graves far beneath the concrete and steel of the city. And yet, far from delusional fantasies of the "vanishing Indian," Indigenous people continue to resiliently occupy the everyday of urban spaces. In Canadian cities such as Toronto, one often encounters urban Indigenous people who occupy the lowest economic strata of Canadian society.

As discussed throughout *Uncommitted Crimes*, Julia Emberley argues that technologies of representational violence exist alongside processes

of material and political violence that inform Canada's ongoing colonial genocide (Emberley 12). Emberley further argues that the complexity of Indigenous lives were reduced to a set of static and essentialist images that came to haunt idealized constructions of biopolitical citizenship in Canada (12). The author offers a fascinating discussion regarding the disappearance of Indigenous lives through processes of representation that erased the diversity of Indigenous people, while also causing the figure of the uniform "Aboriginal" to appear as a trope, repeated throughout North American literature, film, and media. Emberley explores how technologies of film, photography, and other artistic and representational mediums were central to staging the lives of Indigenous peoples in racist ways to support the colonial fantasies of white European superiority.

DON'T SHOOT AN INDIAN:
FILM AND THE POLITICS OF DECOLONIZATION

Films made by European explorers such as *Nanook of the North* offer an example of uses of film to support constructions of the European, patriarchal bourgeois family as a normative ideal. Emberley states,

> *Nanook of the North* is an early filmic text that demonstrates how "the family" became a visual screen for colonial power to re-signify Inuit kinship relations within the ideological representation of the English and Euro-American bourgeois family. Such filmic sources were part of the vast network of colonial knowledges, practices, and representations circulating at the time that sought to "pre-figure" the Aboriginal as an already existing entity in the history of European civilization. (73)

Emberley makes references to uses of supposed documentaries to stage fictionalized representations of colonized peoples that confirmed European superiority. The author draws connections between colonial film in Canada, Orientalist depictions of Arabs, and racist constructions of Latin America. Emberley argues that,

> The truth claims assembled by the ethnographic film

documentary were not only designed to introduce the Western Spectator to the differential value posed by colonial subjects—and there is a great deal about the film to indicate who it thinks it is positioning as its spectator—but to deploy that differential value in order to affirm the superiority of bourgeois colonial bodily culture, its codes of conduct, its homemaking and child-rearing practices, its hygiene, not to mention its sex, its labour, and its "race." (80)

In the artistic works of Kerry Potts, techniques of documentary film are utilized to return the colonial gaze that often captured Indigenous people in epistemically violent ways. Similarly, artist Rebecca Belmore employs visual strategies of decolonization to address the gendered and sexual discourses of colonial Canada that mark the bodies of Indigenous women in ways that justify rape, murder, and invisibility. What is of interest in relation to Emberley's discussion lies in how Potts and Belmore employ artistic tools to counter dominant colonial representations of idealized families, sexual moralities, and normative images of whiteness. Obscene uses of filmic technique present staged narratives of racialized familial, gendered, and sexual failing that solidified the ostensible sanctity of the affluent European family, through images that masked the rape script of white settler colonial histories. Delusional narratives of the "good families" of colonizers served as domestic microcosms for racist nationalist discourses.

Potts's artistic praxis subverts the colonial gaze of the camera's lens through empathetic and political uses of documentary film. In her film *Love on the Streets*, the shadows that haunt the homeless people interviewed regarding ideas of love, relationships, and intimacy are not the dark shadows of Indigenous people that inform normative white Canadian identity. Rather, the absent figures that shadow the narratives are those of wealthy, white, provincial, colonial families, romantic love stories of suburban homes, spacious cottage country, and endless land over which "happy" families traipse. This illusion of colonizing Canadian wealth conceals the obscenities of racist and classist outgrowths of colonial rule, which leave many Indigenous people both literally and metaphorically homeless. Similarly, the ghosts that haunt Belmore's installation *Vigil* are not mythic,

noble, savage figures or Indigenous people who are constructed as part of Canada's past, having died out with the onset of European settlers. Rather, *Vigil* is inspired by the spirits of murdered and missing women who are abducted from Canada's streets in acts of colonizing, racist, gendered, and sexual violence. The imagined sexual morality of Canada is not informed by the constructed licentiousness and depravity of Indigenous people, as was the case in early colonial film and continues in mainstream racist depictions of wild women and dysfunctional Indigenous families. In the deft creative praxis of Indigenous artists such as Belmore and Potts, the inherent dysfunction of Canada's imagined polite culture is revealed in the eerie silence that surrounds missing and murdered Indigenous women who disappear from Turtle Island. One is left to question how the historical memory of colonial violence is subsumed under a rhetoric of multiculturalism and the everyday cruelty of a Canada hiding behind the "fair is fair" rhetoric of meritocracy, concealing the injustice found on the streets of "the 6."

"HOME IS STILL A FIGURE OF SPEECH": THE ART OF INDIGENOUS WOMEN

In her remarkable and touching short film *Love on the Streets*, Potts interviews homeless people in Toronto regarding the idea of love. In one poignant sequence, one of the respondents states that "home is a figure of speech." The idea of home, of stasis, of being held in place spatially and temporally, is one that cannot be materially actualized by many in Turtle Island: those whose lives involve continuous movement from shelter to shelter, from street corner to street corner, from love on the streets to the cold and chilling indifference that much of the general population expresses toward the homeless, many of whom are urban Indigenous people. If "home is a figure of speech," one can also question the limits of language in expressing the ghastly obscenities that undercut discourses of politeness, fairness, and niceness that often structure narratives of Canadian national identity.

Rebecca Belmore's installation, "Vigil" offers a performance art installation in which the artist uses embodied action and gesture to comment on the shocking number of missing and murdered Indigenous women in Canada, many of whom are subject to sexual

Figure 9.3: Love on the Streets, *2009. Film stills. Director: Kerry Potts, Cinematographer: Andrew McAllister. Photo: Kerry Potts and Andrew McAllister.*

violence on city streets. In Potts's film, the director interviews six people, all of whom are or have been homeless and some of whom are visibly racialized Indigenous people:

> The short introduces the audience to Mo, Sylvia, Lisa, Michael, Matt, and Kyle—individuals who have lived on Toronto's streets and who share their various perspectives about love. Images from across the city are interwoven with tightly shot interviews in order to convey an intimacy with the subjects and an intimacy that people develop with the city while living on the streets. Viewers are challenged to refocus their gaze in order to see these individuals as partners, friends, parents or lovers. (hotdocslibrary, online)

The film is divided into a series of subsections, some of which take their titles from the words of those interviewed: The road home is right in front of you; Home is still a figure of speech; A great healing place; My child's sweet embrace; The nature of the spirit. The film is an uplifting overture to the power of love against material and systemic violence. And yet, it also offers a raw and truthful representation of life on the streets and the impossibility of easy, trite platitudes of love beyond the political.

Belmore's *Vigil* is an affective performance art installation in which the artist utilizes her own body to comment on the abhorrent forms of gender-based, sexual, and physical violence enacted against Indigenous women as part of Canada's ongoing colonial project. In the installation, staged in Vancouver, the artist pays tribute to the many missing and murdered women from Vancouver's lower east side, some of whom are sex workers and some of whom are Indigenous women. As the artist's website states,

> Performing on a street corner in the Downtown East Side, Belmore commemorates the lives of missing and murdered Indigenous women who have disappeared from the streets of Vancouver. She scrubs the street on hands and knees, lights votive candles, and nails the long red dress is wearing to a telephone pole. As she struggles to free herself, the dress is torn from her body and hangs in tatters from the nails, reminiscent of the tattered lives of women forced onto the streets for their survival in an alien urban environment. Once freed, Belmore, vulnerable and exposed in her underwear, silently reads the names of the missing women that she has written on her arms and then yells them out one by one. After each name is called, she draws a flower between her teeth, stripping it of blossom and leaf, just as the lives of these forgotten and dispossessed women were shredded in the teeth of indifference. Belmore lets each woman know that she is not forgotten: her spirit is evoked and she is given life by the power of naming. (Belmore, rebeccabelmore.com)

Belmore pulls a thorny flower through her teeth fearlessly and screams out of the names of each woman lost to the violence of the everyday cruelty of Canada. The names echo in city streets much like the voices of homeless people in Turtle Island, begging for mercy. The red dress signifies female sexuality, and in her wearing of this symbol Belmore draws attention to the violent sexualization of Indigenous female bodies. She struggles to free her body from the poles, held prisoner in colonial Canada, and in the racist and sexist imaginaries that cast Indigenous women as vixens and victims. Pieces of a torn red dress remain on the streets, remnants of histories of the blood

of Indigenous women spilled in "good" "clean" countries. Indigenous blood is bleached out of nationalist narratives shrouded in denial by colonizing settlers who feel entitled to call Indigenous land "home."

Figure 9.4: Rebecca Belmore, Vigil, *2002. Performance stills.*
Talking Stick Festival, Full Circle First Nations Performance. Firehall Theatre.
Vancouver, British Columbia. Photo: Rebecca Belmore.

WHAT'S LOVE GOT TO DO WITH IT?
CHALLENGING ROMANTIC LOVE AS PROPERTY

Ideas of love are increasingly used in the branding of transnational corporations in ways that resonate with secular English language grammars of love that are haunted by colonial history. In a time of technologically powered globalization, metaphors of love are increasingly used to sell products. iPhones are sold through branding campaigns that declare that ninety-nine percent of iPhone users truly love their phones (Matyszczyk). The ninety-nine percent that took to the streets in global Occupy protests and the Chinese workers committing suicide in Apple factories are beyond this market-based "love." In the act of nailing her body to telephone poles and leaving remnants of a red dress behind, to litter the lily white streets of a colonizing country, Belmore troubles the ethics of love as property. The relationship between love and the ownership of women's bodies is imbricated in heteronormative patriarchal colonial ideologies. Entitled white settler's love for Indigenous land constructs bodies of

Indigenous women as those who can be metaphorically conquered as part of ongoing colonial violence.

The universal concept of English secular love as pre-discursive and innate can be critiqued when considering the English language use of the word "love," the relationship between ideas of romantic love and colonial history, and how the concept of love is manipulated within global capitalist branding. Betsy Bolton discusses the relationship between ideas of love and colonialism. Bolton cites the writings of Frederic Jameson who discusses uses of love within nineteenth-century Europe as a means of masking class antagonism: "Frederic Jameson suggests that romance originates with a class conflict not yet articulated in terms of class or conflict" (3). Sara Suleri further suggests that the romantic genre within eighteenth- and nineteenth-century Europe emerged at a time of nationalist conflict, in which romantic love became a metaphor for the love of the nation. The love of one's mother country corresponds with idealized forms of heteronormative, monogamous, familial love.

The popularization of romantic Anglo-Indian fiction within empire reflects the use of romantic narratives to evade material questions of capitalist and colonial power. Relationships laden with oppressive hierarchies of power came to be celebrated through metaphors of love, romance, and benevolent scripts of salvation. Suleri discusses how the conventions of the romance genre were used to stage scenes of imperial domination as love stories. The affective sentiments of desire and longing scripted the relationship between colonizers and the colonized as a tender affair. The obvious capitalist exploitation, racism, and violence of colonizers was masked in a trite narrative of love. As Suleri states, "In negotiating between the idioms of empire and of nation, the fiction of nineteenth-century Anglo-India seeks to decode the colonized territory through the conventions of romance, reorganizing the materiality of colonialism into a narrative of perpetual longing and perpetual loss" (11). Suleri discusses how within the mirage of romantic longing produced through imperialist genres of romance, colonized countries such as India become the absent Other that is longed for. The colonizing power loves the colony in the way that an abusive patriarch turns power into romance. Suleri continues, "India becomes the absent point toward which nineteenth century Anglo-Indian narratives may lean but which is may never possess, causing

both national and cultural identities to disappear in the emptiness of a representational mirage" (11).

Homi Bhabha's writing regarding the psychoanalytic dimensions of colonization makes reference to the deeply seethed narcissism of empire. As the "jewel in the crown" of the British Empire, the Indian subcontinent is desired for and "loved" much like capitalism turns the ownership of women's bodies within heteronormative patriarchal narratives of conquest into something called "love" (Bhabha 126–31). The projections of the patriarchal male gaze onto the body of women resonate with the libidinal fantasies projected onto the colonized by the colonizer. Victorian moralism and tales of missionary salvation in which the colonies are represented as savage and in need of the maternal love of mother countries distort the brute aggression of colonization as a relationship of care. As Bolton states, "the sentimental mode of late or imperial romance attempts to resolve this tension by translating the materiality of colonialism into an appeal to sensibility and moral right" (4). Bolton further draws on Rudyard Kipling's canonical colonial writings of the "white man's burden" to discuss how the material exploitation of colonialism is rewritten as romance. As the author suggests, making reference to the farcical nature of colonial romance scripts, "Taking power in the name of history coincides with a turn from farce toward sentiment and romance: the white man's burden is yet another variant on the knight's quest to save the forms of civilization for humanity" (5).

As discussed in relation to Ann McClintock's writings regarding soap, cleanliness, and imperialism, domestic advertising was a means through which racist imageries entered the intimate spheres of social lives (McClintock 207-231). Domestic products such as soap advertised using images of celebrated pristine whiteness, which provided a means for turning the romance of the home into one that taught illiterate masses of Europe that racism was a matter of moral virtue. Love became associated with forms of domestic, heteronormative, familial bliss that turned the wretched project of racial and capitalist domination into one of care and salvation. Bolton discusses how the domestic scene within European colonial fiction masked oppressive and gendered power dynamics in the home, and the violence of imperial conquest that put tea into the cups of happy colonial families. As Bolton writes, the "longed-for domestic space cramped and invaded by labour; poverty,

tears, illness and physical abuse represent the ideal family intimacy" (6). Nineteenth-century fiction and advertising turned colonialism into a narrative of romance in which the "fair and lovely" colonial mother country imagined itself as performing a benevolent gesture of salvation by attempting to domesticate the imagined savage in the colonies. The capitalist power dynamics of colonial pillage, slavery, and the use of the colonies to produce the wealth of empire were both naturalized and made sentimental in these romantic narratives. Similarly, contemporary globalized branding also tells a love story that masks its inherent violence.

In contemporary white settler Canada, ideas of love cannot be separated from ongoing colonial genocide. The love of nation, static ideas of "home," and trite familial scripts of provincial family values are deeply imbricated in the ongoing exile of Indigenous people. In *Love on the Streets*, feminist filmmaker Potts interviews homeless people regarding this often profanely overused and intangible idea of love. While the "fair and lovely" mythologies of happy colonizing settlers often revolve around scenes of idealized domesticity, middle-class familial bliss, and sanitized desires, Potts's film speaks to a love beyond property. And yet, it is an outgrowth of the ongoing valuing of human love as connected to wealth, ownership, and the ghostly presence of those made homeless to serve the comfort of others both materially and psychosocially through an ethos of colonial denial that structures normative truth claims within contemporary Turtle Island. The lovely romances of wealthy settler couples and families continue unscathed despite the piercing wails of the homeless crying out for recognition on city streets.

HOUSEWIVES AND HOMELESS WARRIORS: THE POLITICS OF THE FAMILY

Emberley discusses the relationship between visual depictions of "the family" within colonial Canada, biopolitical constructions of race, and the genocide of Indigenous peoples. Emberley writes of the family portrait as a photographic tool that became popular during the height of colonialism in Canada, one that was used not to mimetically document a family, but to discursively and psychosocially create an idealized heteronormative, middle-class

alliance to serve the biopolitical aims of a white settler society as one that would reproduce good, white Canadians. Images of happy, white bourgeoisie families were juxtaposed to the simultaneous use of photography to visually pathologize and denigrate structures of Indigenous kinship. The image of the "wild woman," the ostensible paternal failings of the Indigenous man as "father," and the visual depiction of Indigenous children as those who were uncared for by parents justified the missionary abduction and abuse of Indigenous children who were imprisoned in the residential schooling system. Furthermore, just as the phantasm of the good, white, Christian and Catholic colonial family became a microcosm for the political governance of the nation, the depiction of Indigenous people as those who could not govern their families was metaphoric for the racist invocation of a people not fit for political rule.

Emberley also notes that the spectral violence of visual and verbal categorizations of "Aboriginal" and "Native" peoples did not simply misrepresent the Indigenous, but constructed them as a uniform group of people, obliterating traces of specificity between band, tribe, and nation. Within the lingering colonial discourse of white settler Canada, Cree, Ojibway, Anashinabe, and several other Indigenous tribes and nations are known as "Aboriginal" or "Native." These essentialist terms collapses differences in language, religion, territory, and history between bodies. Similarly, terms such as "Black," "Brown," "Arab," "Muslim," and "African" are used to submerge history in the apparent similitude between racialized bodies that are constructed as uniformly Other. The essentialist trope of racial Otherness functions in relation to the corresponding scripting of dominant whiteness as a visual truth that materializes white bodies who ironically appear as idealized citizens on stolen Indigenous land. Bodies marked by colonial histories are a ghostly apparition haunted by all of the violence that lies beneath the surface of the skin.

In contemporary Canada, one can question how Indigenous people are united not necessarily through shared language, cultural, or tribal origins, but through the shared survival and trauma brought about by white settler violence. It is interesting that both Potts's and Belmore's artistic installations unify the struggles of those on the streets, sex workers, the homeless, and others who occupy the nightmarish truths of North American dreams with those of anti-colonial resistance.

The figure of the homeless person and sex worker are not necessarily Indigenous, just as Indigenous persons occupy a range of diverse positions within the class strata of urban Canada. And yet, the relationship between urban poverty, sex work, sexual violence, and Indigeneity is one that is deeply imbricated in colonial history as that which unfolds in minute theatres of injustice across city streets. Belanger, Awosoga, and Weasel Head discuss the relationship between homelessness in contemporary Canada and Indigenous people. The authors state,

> The issues confronting all homeless populations are dire, but those facing the urban Aboriginal homeless population in particular are of mounting concern: growing numbers of urban émigrés lead to new residents integrating themselves into populations experiencing high birth and fertility rates. This quickly escalating population now represents more than 60 percent of the country's Aboriginal population, and 73.4 percent of the national Aboriginal households. (5)

The authors argue that national statistics are needed regarding homelessness and Indigenous people in contemporary Canada.

"A WANDERING SPIRIT":
THE FEARLESS ETHOS OF THE ARTISTIC

Potts's *Love on the Streets* offers a lyrical, poetic, and poignant commentary on that which cannot be counted as property, a love beyond trophy wives and Barbie and Ken dream homes. The narrative voice that frames Potts's film in its introductory segments discusses a "wandering spirit," one that counters the apparent civilizational progress and normalcy of stasis with an intellectual, creative, and sacred restlessness. These metaphors of movement and travel both physically and metaphorically constitute a self that is never held in place but is infinitely in transition, refusing the comfortable apathies that often define North American dreams of betterment as wealth. Beyond the ostensible morality associated with white picket fences, wealthy settler families conceal their profit from the poverty of others. The homeless people in Potts's film evokes a fearless spirit and belief

in the intangible that is often absent in secular capitalist culture. Mo, who is interviewed in the documentary, reads a touching poem that he has written. He writes and speaks of a faith in that which cannot be seen in biopolitical whiteness or counted in images of numerical wealth. As his poem lyrically states,

> A wandering spirit, like smoke passing through the air. Some see it, smell it, but cannot feel it. The road home is right in front of you. Only you'll never see it with your eyes, you'll never touch it with your hands or feet. But one can only feel it. So take heart my dearest, it will be the longest road you'll ever know. That road home ... is from your head to your heart. Sounds easy but it is not. Fear stands at the door.

The mention of fear speaks to an overarching sentiment and political position discussed previously regarding *Mass Arrival* and xenophobia. Within a time of gated communities and cultures of supposed left-wing language-policing based on the cultural capital of certain terminologies, the ultimate freedom often lies in the freedom to not be harassed (Žižek, "Against Human Rights") Nowhere is this truer than on the streets of the white settler metropolis in which interactions with the homeless are often met with fear. Potts challenges this rhetoric of harassment by speaking with and documenting the homeless of the city and their relationship to universal ideals of love. The fear of strangers is also a deep irony within a white settler nation in which those estranged from the aesthetics and class-based appearances of supposed normalcy are often urban Indigenous people—those who are Indigenous to the land. Potts and Belmore also offer pedagogies of Indigenous feminist artistic production that counter the trepidation of classist and racist white feminist discourse, which often construct those on the streets as objects of fear, sexism, and threats to women's safety. By centering the lives of those on the streets who are often feared by many, these artists reconfigure the idea of the assumed aggressor and perpetrator of violence to be a person on the street. The resilient spirit of the homeless that counters fear with faith is used to reimagine the implicit violence of dominant constructions of home as private, securitized property. White settler constructions of happy homes on

stolen lands are revealed in these artistic acts as spaces designed to further exile urban Indigenous people whose homelessness is part of Canada's ongoing genocidal genealogy.

In Belmore's *Vigil*, the missing and murdered Indigenous women in cities where celebrated racialized migrants are famed for property ownership are those whose very right to life is threatened through a spatialization of fear. The downtown lower east side is marked as a bad neighbourhood in ways that are deeply imbricated with the racist construction of Indigenous women who live, work, and occupy the space of city streets as ostensibly bad, and therefore as deserving of violence. Belmore's installation offers a gripping and poignant challenge to the rhetoric of neo-liberal fear, as she occupies the street defiantly, refusing the easy silence of Canada's unremarked upon colonial genocide. As discussed throughout *Uncommitted Crimes*, "multiculturalism" as segregation and marketing is used to keep distinct ethnic Others in their place. Otherness is contained and quarantined to certain "multicultural" neighborhoods in which diversity is sold in food and other products, while Asian, South Asian, Arab, and other racialized bodies are constructed as part of distinct racialized communities, held at a distance from the white mainstream. The management of fears of "racial contamination" reflecting Canada's underlying ethos of white supremacy is expressed subtly and spatially. Belmore defies the quietude of a Canada that sells saris and samosas as an appendage to anti-racism, while racism continues to structure policing, economics, the reproduction of the white middle class, and the rape and murder of Indigenous peoples.

There is a fearless spirit to Belmore's willingness and ability to cause a scene. An inspiring courageous spirit also exists in the narratives of the homeless people that are interviewed in *Love on the Streets* who learn to boldly traverse the city streets, risking violence every day in their efforts to survive. And yet, the inability to calculate the ongoing economic and political violence that makes "world class" cities of "diverse" indifference to Indigenous homeless people is an epistemic act of colonial denial. One can visibly see the violence of white settler colonialism in the faces of those who sleep in bank shelters and freeze to death on the streets of a cunningly racist place, while the nation state keeps few accurate records of the traumas of nationalism. In both Potts's and Belmore's works, Canada's spatial crimes are recorded

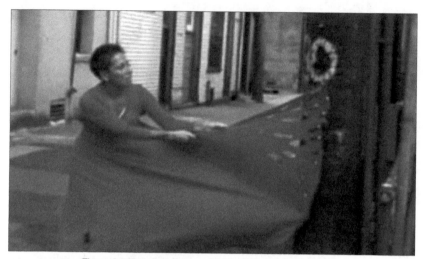

Figure 9.5: Rebecca Belmore, Vigil, *2002. Performance stills.*
Talking Stick Festival, Full Circle First Nations Performance. Firehall Theatre.
Vancouver, British Columbia. Photo: Rebecca Belmore.

artistically in narratives that document the lack of space afforded to homeless people who attempt to recuperate a sense of humanity and humane love in an often inhospitable urban sphere. Those whom Potts interviews discuss the difficulty of finding space to love within the shelter system. Mike and Lisa, a couple who are interviewed in the film, discuss their experiences of being a couple in the shelter system. Mike begins by stating, "Shelters aren't the greatest place to start a relationship in the first place, but I guess everybody's got to feel that love somewhere." Lisa continues, reflecting upon the inability for the shelter system to recognize the homeless as those with desire, as those with a capacity to love. Her comments are perhaps reflective of a bureaucratized system of capitalist biopolitics in which those without property are often stripped of humanity. Lisa states,

There's also just that privacy that's involved with being in the shelter. Well, the lack of privacy especially with the couple being in the shelter because they don't look at us as a couple, they look at us like your this bed number. Right, so it's a little difficult because you're in a room with a whole bunch of girls and he's in a room with a whole bunch of guys. And there's not really that in between space where everyone can kind of connect. So in that way it was difficult.

The dehumanizing bureaucracy of antisocial cultures of social work within a country where the professional occupations of white settlers become those of managing bodies in shelters is troubled by the emotive stories of the streets. Similarly, the countless murdered and missing Indigenous women lost to colonial violence are named in Belmore's performance installation *Vigil* when the artist screams out the names of murdered Indigenous women into the empty streets of colonial Canada.

STOLEN LAND AND COTTAGE COUNTRIES: SPACE, SEXUAL VIOLENCE, AND PUBLIC ART

Michel Foucault defined the time of capitalist modernity as one of spatial anxiety. Foucault suggests that "the anxiety of our era has to do fundamentally with space, no doubt a great deal more than with time. Time probably appears to us only as one of the various distributive operations that are possible for the elements that are spread out in space" (23).

Daily street theatres of cruelty often define the movements of female, transgender, and queer bodies in public spaces. The commonplace nature of gender-based violence is definitive of what Kalpana Kannabiran terms "the violence of normal times" (3). Certain bodies appear in public space as punch lines and punching bags, across borders. In 2010, SlutWalk emerged as a protest movement after a Toronto police officer gave a talk to a group of York University law students regarding 'personal safety' and offered a vulgar treatise of heternormative misogyny. The police officer stated: "You know, I think we're beating around the bush here.... I've been told I'm not supposed to say this—however, women should avoid dressing like sluts in order not to be victimized" (Pilkington 2011). SlutWalk involved bodies occupying and refashioning the commons. While the word "slut" caused a great deal of fervor in the mainstream media, the officer's statement that he had been "...told I'm not supposed to say this" demonstrates how policing and state power are steeped in rape culture. Rape culture in contemporary Canada cannot be divorced from white colonial sensibilities that racialize Brown women's bodies in sexually violent ways.

In *Vigil*, Belmore, an Indigenous female artist in white settler

Canada, uses her body to pay tribute to murdered and missing Indigenous women, some of whom are sex workers who disappear from Vancouver's lower east side. Belmore struggles to free her body from the telephone poles in a red-light district where totem poles are lost to colonial history and public feminisms are as scarce as a city street where billboard models are not worshipped as goddesses. The ongoing history of colonialism within white settler Canada is at once a discursive and ideological project and a form of capitalist violence, one that turns once sacred spaces into those of commerce and capitalist consumption. Cities of towering banks and shopping malls are built over sacred burial grounds, and the myths that define place are submerged within colourless parades of commodities, making contemporary Canadian cities indistinguishable from other Western secular marketplaces where the grids of city maps and the routes of those who appear in public spaces are often governed solely by productive labour and consumer excess.

The ironies of Turtle Island are felt in the exile of those who are Indigenous to the nation. Increasingly, urban displacement produces class-stratified urban spaces in which the colonizing ethos of affluent white settlers entitled to plant flags across world maps is expressed in the subtle racism that defines urban gentrification. While Potts and Belmore document the violence of homelessness, murder, and rape that haunts Indigenous bodies and the bodies of impoverished people in urban Canada, once working-class neighborhoods also become ghost towns where all traces of the working poor are often removed. Condominiums, hipster bars, and other branded appendages of "cool" use working-class histories to simultaneously market neighborhoods as edgy and avant garde while driving out residents who cannot afford store-bought deviance.

HIPSTER HEADDRESSES AND "WILD" WOMEN: THE GENTRIFICATION OF THE SACRED

It is interesting to consider the politics of urban gentrification, displacement, and spatial violence in relation to the histories of forcibly removing Indigenous peoples from land. The sublimation of colonial anxieties and aggressions is expressed in the commodity fetish of hipster kitsch bearing traces of colonial racism. The marketing

of certain products conceals the violence of ongoing colonization through a celebratory rhetoric of global capitalist branding. One can consider companies such as Urban Outfitters, a banal example of how contemporary corporate culture attempts to profit from ongoing histories of colonial violence. The company garnered attention and outrage from Indigenous leaders in the Americas through its attempts to appropriate sacred symbols of Indigeneity. Danielle Paradis writes of the "Smudge Kit" through which the spiritual traditions of Indigenous people were turned into hipster branding. As the author states, "Urban Outfitters came under scrutiny for its sale of a 'Local Branch Smudge Kit' ($39.99 on sale from $52.00), a sort of pseudo-ceremonial kit marketed toward hipsters as 'energy balancing' that contains a wild turkey smudging feather, stoneware smudging dish, candle and instructions" (n.p). Paradis discusses the reactions from Indigenous peoples in the Americas who saw the appropriation of these signifiers as disrespectful of Indigenous traditions. The author states,

> Many indigenous people feel this is cultural appropriation. What is the big deal? To start with, there is not just one Native American culture; there are hundreds across the U.S. and Canada. Secondly, repeated missteps by retailers and non-indigenous fashion designers could be avoided if they took the opportunity to engage with Indigenous communities in an authentic way, instead of commodifying and misappropriating sacred symbols. Simply put: If Urban Outfitters loves the aboriginal aesthetic, maybe they should hire some aboriginal fashion designers and artists.

While "hip" neighbourhoods are branded as being artistic, Indigenous female artists such as Potts and Belmore use creative mediums to offer a political commentary regarding how sacred traditions still linger as a means of survival, rather than sales. In the introduction of *Love on the Streets*, Sylvia is interviewed and offers a poetic treatise regarding the use of spirituality in the lives of homeless people who lyrically comment on the sacred and love beyond materialism. As she states,

> I love what you can't see. The protection that's around me. It's not a person. It's something that keeps me through the hard

times like homelessness. Some energy. I don't know what it is. Some people call it a guardian spirit. Some people call it Totems. And I know there is one for me. Not necessarily love but I hang on to that belief. And as a result, I love the other side of life too.

As with many places, the symbolic capital of gendered and racialized embodiment and the systemic oppression of global capitalism often define love, life, and death in Turtle Island. Sylvia's narrative gestures to ideas of the sacred outside of a belief in the materiality of skin and wealth. Similarly, Mo states, "There are so many people trying to find something to believe in. Only some are looking the wrong way. They tell me to believe in this, believe in that, but most don't even know for sure what they're doing or where they're going. We have a goal. A reason to try. Knowledge is all we need. And we cannot see the nature of the spirit."

While Urban Outfitters sells stolen Indigenous traditions to bored gentrifying yuppies, the homeless people Potts interviews discuss the importance of what some term the spirit, as a means of surviving homelessness, and retaining a belief in love against all odds. The melancholia of the white middle class, often found among affluent white consumers and hipsters drowning themselves in trends and hedonistic middle-class lifestyles, may seem privileged in comparison to the urban poor. And yet, what is striking in Potts's film lies in how it is those who are often systemically, politically, and psychosocially stripped of love who espouse its importance. While Internet dating can lead to cultures of shopping for love the way one shops for furniture, those who live and love on the streets carve out spaces of meeting in unlikely places. Many homeless people occupy spaces in ways that gesture to the survival of human sentiment, affect, and embodied desire. Love on the streets survives against the glare of mall lighting, the clicks of computer keys, and the banal cash register hymns of a day.

One can also consider the kinds of hipster appendages that major multinational companies often sell, which are associated aesthetically with Indigenous people. Urban Outfitters for example, sells "Native print" flasks, panties, and headdresses that are marketed toward supposedly edgy female consumers. The products are marked with

feminine excess that connotes store-bought sexuality, a wild life for the affluent hipster in a white settler colony. While such marketing schemes are seemingly harmless and banal, the signification of the "wild woman" now sold en masse in "Native print" panties and flasks for drunken collegiate crowds exist in an ongoing panorama of colonial violence. The "wild" is intelligible through long-standing racist depictions of Indigenous women that justify rape, sexual violence, and abuse. As discussed in previous chapters of *Uncommitted Crimes*, the image of the Indigenous "wild woman" was emblematic of the "wild" land that needed to be tamed by colonizing patriarchs (Emberley 8). Emberley further states that representing the Indigenous and specifically Indigenous women as "wild" simultaneously constructed idealized images of domestic, white, bourgeois femininity. The irony of such representations lies in how it was through making Indigenous people both literally and metaphorically homeless that images of those who were figured as "at home," and as maternal and paternal authorities, were constructed as the norm. As Emberley states, "The duality of savagery and civilization shaped English ideas about indigenous cultures as essentially ones that existed in a savage infantile state in need of the governing rationality or a more advanced and enlightened bourgeois society" (8).

The association made between Indigenous people and "nature" is a subtle example of how colonialism masks its violence through romantic scripts. Indigenous people are figured as being "at one with nature" and "wild" in ways that somehow celebrate their symbolic and literal homelessness in the nation. Depicted as forever living in tents or as nonexistent, the seizure of land and the placing of Indigenous people on the outskirts of both national geographies and imaginaries are naturalized. As Emberley further writes, "In contradictory fashion, science and aesthetics created representations of colonized Others that served as the basis for a progressive narrative of nature's terror and beauty, her unruliness and innocence" (8).

The "taming" of the wild continues to be used to conflate Indigenous women's bodies with the colonized landscape, as an imagined barren surface on which ostensibly great white men can violently plant their flags. As Emberley writes of the relationship between Canadian colonialism and representations of the "wild" Indigenous woman, "Like an overly aggressive child, she must be physically tamed, taught proper

social values of work and family, theistic values of love, compassion, and forgiveness, and the meaning of applied intellectual and technological European superiority" (8). The reference to "childhood" and the association between immaturity, adolescence, and Indigenous people resonates with the marketing of "wild child" products to urban hipsters in North America. The affluent consumer of "Native inspired" products is invited to tour exotic images of sexually risqué Otherness in their youth. The exoticism of Indigenous lives is countered with the material poverty of homelessness that defines the experience of many urban Indigenous and other homeless people of all ages. The sale of fashionable products and appendages of consumerist excess to young consumers that are marked with references to an essentialist figure of the "Aboriginal" construct Indigenous culture and tradition as a fun, frivolous vacation from adult responsibilities that the consumer can partake in, the way a rich white tourist can vacation in a poor country in the Global South. And yet as Sylvia in *Love on the Streets* writes in a poem regarding the homeless (much like the Indigenous women whom Belmore pays tribute to in *Vigil*), there is no fashionable exoticism found in grinding poverty: "Watch Joes doing blow, a shelter hot holiday," her poem wryly describes.

Once the "wild years" for urban-outfitted fashion tourists have passed, party-going adolescents can grow up, moving beyond the unruly images of childhood that script Indigenous people as being morally, psychologically, and culturally caught in an infantile state. The downtown hipster can trade her "hipster headdress," "Native panties," and "Navajo inspired flask" filled with girly drinks for the colonial sensibilities of the white bourgeois mothers who came before her. In Belmore's and Potts's use of the artistic, such trite forms of commodity fetishism and subtle racism are challenged. Rather than depicting Indigenous peoples as childlike or scripting adulthood through the heteronormative capitalist temporalities that inform one's ability to obtain wealth and property, the artists represent a sense of survival and political integrity that reveals cultures of white, European colonial civility as spiritually and politically immature. The polite racist denial of white Canada is figured as an expression of irresponsibility that defines colonial ideology as one that is—much like a love not found in the streets but in racist commodity fetishism and the worship of whiteness—lacking in wisdom and empathy.

SEEING RED IN THE STREETS
EMPATHY, RACISM, AND INVISIBLE PAIN

To empathize often involves being able to place oneself in the position of another, to imagine the circumstances that beset their lives or have brought them to a certain place. While empathy with others may seem to be an inevitable part of humanity, it is perhaps always informed by politics and an unwillingness to conceive of those whose pain is justified by racist discourse. Authors write of the "racial empathy gap" to discuss how skin colour can effect one's ability to empathize with others. Writing in regards to the shooting of Trayvon Martin, an African American shot by a white police officer, Jason Silverstein argues that race and racism inform different perceptions of the pain of others. As Silverstein writes,

> researchers at the University of Milano-Bicocca showed participants (all of whom were white) video clips of a needle or an eraser touching someone's skin. They measured participants' reactions through skin conductance tests—basically whether their hands got sweaty—which reflect activity in the pain matrix of the brain. If we see someone in pain, it triggers the same network in our brains that's activated when we are hurt. But people do not respond to the pain of others equally. In this experiment, when viewers saw white people receiving a painful stimulus, they responded more dramatically than they did for black people.

Silverstein states that the "racial empathy gap" can be used to explain both institutional and every day racism. As the author states, "The racial empathy gap helps explain disparities in everything from pain management to the criminal justice system. But the problem isn't just that people disregard the pain of black people. It's somehow even worse. The problem is that the pain isn't even felt" (n.p).

Silverstein further comments on the relationship between empathy and privilege. In several studies regarding race, racism, and empathy, researchers found that if someone appeared to be more privileged they garnered more empathy regarding their perceived pain. Conversely, those who appeared to be less privileged were assumed to have the

capacity to withstand pain. Constructions of racialized people as those who are strong and have undergone hardship throughout their lives in fact causes them to be perceived as being able to withstand pain, and therefore not as deserving of empathy or compassion. Silverstein makes reference to several research studies that attempted to gauge the empathy of a cross section of the North American public in regards to racism and empathy: "The more privilege assumed of the target, the more pain the participants perceived. Conversely, the more hardship assumed, the less pain perceived. The researchers concluded that 'the present work finds that people assume that, relative to whites, blacks feel less pain because they have faced more hardship'" (n.p). In white settler Canadian spaces known as financial centers, and beautiful pastoral places, one would assume that the pain of the homeless would cause those who purport to be nice, polite Canadians speaking proudly of multiculturalism to be empathetic. However, the assumed hardship of the homeless and specifically many urban Indigenous people often remains invisible, justifiable, and beyond empathy. For those living on the streets, homelessness can also produce a fear of expressing emotion, as evinced in *Love on the Streets*. In the film Matt states,

> I think homelessness has impacted my experience of love or definition of love very negatively. Like I mentioned before any expression of love or empathy or any of those soft emotions are considered weaknesses. But that's not just it. When I was on the street—First I ended up homeless—I was so hurt, so emotionally battered, so betrayed that my heart was the only thing left and I'd be damned if I was going to let anybody have it. And I didn't want there's either. Because of those events that led up to me being homeless I had this belief that everything came with a string attached. Including, especially love.

Matt further discusses how histories of abuse throughout childhood also impact his understandings of love. He states, "And a lot of people who said they loved me throughout childhood who abused me helped to form that tainted vision of what I considered to be true love." Potts uses the space of film and the techniques of documentary filmmaking

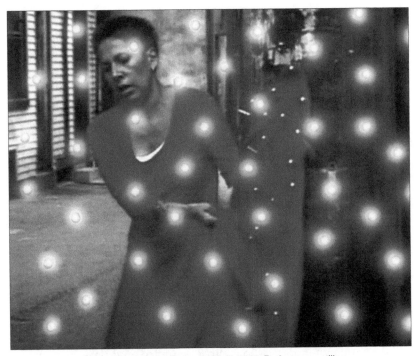

Figure 9.6: Rebecca Belmore, Vigil, 2002. Performance stills.
Talking Stick Festival, Full Circle First Nations Performance. Firehall Theatre.
Vancouver, British Columbia. Photo: Rebecca Belmore.

to offer those who are often stripped of the capacity to express affect and emotion a chance to publicly espouse cathartic personal stories.

MISSIONARY POSITIONS:
ART THAT DOES NOT BEG FOR REDEMPTION

Academic and historical information, as well as statistics and narratives regarding the brutal violence that Indigenous people experience can be used to construct certain people as being able to withstand all circumstances, and therefore as unworthy of empathy. Furthermore, discourses of missionary moralism in white settler Canada can be used to justify the erasure of the humanity of homeless people. Racist images of alcoholism, drug addiction, and bad families demonstrate how mainstream Canada continues to rely on biopolitical constructions of deviance to justify systemic oppression. Both Potts and Belmore utilize a language beyond bureaucratic rationality to offer striking, emotive

artistic work that asks audiences and publics to empathize beyond the wealth and skin of those who experience unspeakable violence. These artistic gestures are those that defy the static ways that mainstream news media often construct the homeless, Indigenous peoples, sex workers, and the poor as undeserving of compassion.

In *Vigil*, Belmore reads the names of missing and murdered women written on her arm. The use of the names of women who often appear only as numbers in statistics or in racist caricatures within mainstream media personalizes those who are offered a genocidal lack of empathy. David Sanlal discusses how contemporary representations of violence against Indigenous women in Canada justify sexual violence. Sanlal states,

> [S]exual violence against Aboriginal women is legitimized by colonial attitudes that have created systematic racialized hatred and systemic discrimination … the colonial manipulation of public perceptions of Aboriginal women rationalize their subjugation by constructing the idea of Indigenous women as the "Squaw Drudge" who is dirty, degraded, and slave to men.

Drawing on research regarding mainstream representations of Indigenous women in Canadian media, Sanlal concludes that "the discursive construction of Aboriginal women as social waste simultaneously organizes the narratives of Canadian media" (n.p). Sanlal compares the treatment of cases of sexual violence against Indigenous women and non-Indigenous women in the Canadian press. The author states,

> The Aboriginal women received six times less coverage; their articles were shorter and less likely to appear on the front page. Media constructs the image of Aboriginal women as "bad" or "beyond redemption," which render the invisibility of the violence perpetrated against them. The media treatment of Aboriginal women victimizes the women again as they perpetuate the colonial views that Aboriginal women are inferior and insignificant.

Both Belmore and Potts challenge this rhetoric of Indigenous

inferiority. Bearing witness to their remarkable artistic works, one is also left to question the poverty of the supposedly civilized love of wealthy colonizers. The ostensibly bad Indigenous woman and morally deviant homeless person are rescripted as those who are heroic in their belief in love, and whose names haunt the "fair is fair" rhetoric of white settler Canada.

TEXT MESSAGES AND TOTEM POLES:
DESIRE AND DISAPPEARANCE IN TURTLE ISLAND

While rich colonial settlers can decide who and how to love through Tinder apps, Facebook quizzes, and other games that turn love into a contest of wealth, beauty, and attempts to approximate normative aesthetics found in racist mainstream media, love on the streets abounds for homeless people who express a courageous and resilient ability to retain faith in humanity, beyond capital. Cynical publics espouse values of love through friendships and romances that are often structured by class status, racism, and implicit attempts to approximate the narrative frames of white colonial bourgeois family romances. The constructed inferior Others of the streets emerge in Potts's film as those who can teach one about the miraculous ability for love to withstand chilling forms of oppression. Mainstream North American publics use money to signify supposed love, often through wedding rings, posh martial homes, honeymoon vacations, and endless photos posted on online media. What can emerge is a narcissistic pageantry in which shopping, beauty, envy, and egoism are conflated with human love. The irony and poignant wisdom of Potts's film lies in depicting those who are stripped of self-centred capitalist appendages as being able to espouse a love beyond vanity. Those whom the filmmaker interviews gesture to the sacred nature of love itself, to a love beyond the superficial use of other people as accessories to class-based identities. Without property or the cultural capital of affluent whiteness, those featured in the film express an intangible faith in the profound nature of love that is perhaps beyond literal translation. As Kyle remarks in the film, love for those who are stripped of property often challenges the relationship between love and ownership. He states that love "is a two way street, you loving them and them loving you but when I love someone, it's freedom."

Belmore also challenges the racist erasure of Indigenous women's lives creatively in *Vigil*. The remnants of the red dress nailed to the telephone poles of Vancouver's lower east side gesture not to the missing and murdered sex worker's body as "beyond redemption," as is so often depicted in sickening forms of racist moralism found in mainstream Canadian media. Rather, it is perhaps a white settler colony that remains beyond redemption in its ongoing rape script, which is not "settled" in speeches given by politicians or tax exemption cards. Colonial violence lingers in the ghostly apparitions of women left for dead, the tattered remnants of their forsaken love haunting the streets. It is through the artistic voice that both artists challenge the cash-based mantras of North America. Within contemporary Turtle Island, the ideology of a North American dream often connected to multicultural capitalism supports delusional ideologies regarding the power of legality and meritocracy to effect systemic change. An imaginary steeped in the denial of colonial history and its coveting of whiteness as an ideal suggests that meritocracy can stop history and erase the violent markings that colonization leaves on the skin.

The "fair and square" mythologies of work, "settling" one's bills, and paying one's taxes to demonstrate morality conceal the obvious sickness of colonial histories of land theft, impoverishment of Indigenous peoples, residential schools, and abhorrent forms of sexual assault and murder of Indigenous women. Northrup Frye once commented that "Americans love to make money, Canadians love to audit it" (Frye, O'Grady, and Staines 468). There is a ridiculous and disturbing hypocrisy to white settler Canada's obsession with bureaucratic order and fairness, given that the entire fabric of the nation state is informed by theft, violence, and ongoing attempts to destroy Indigenous people. In offering artistic insight into the lives and struggles of homeless people in Toronto, some of whom are visibly marked as "Aboriginal," Potts challenges the tired rhetoric of equality and industrious success that are used to support willful historical amnesia. Similarly, Belmore uses an emotive, raw, and gripping artistic performance on the streets of Vancouver to gesture to the obscene underbelly of Canadian nationalism. Finally, what is interesting and instructive regarding postcolonial futures and artistic production lies in the use of art to articulate traumas that cannot

perhaps be expressed, understood, or empathized with through linear language or cold, hard, numbers.

BODY LANGUAGE:
CREATIVE GRAMMARS TO EXPRESS THE UNTRANSLATABLE

As discussed, Slavoj Žižek suggests that the trauma of extreme violence cannot often be fully expressed in rational, factual discourse (*Violence*, 63). It is arguably only through nontraditional mediums in which truth is not authorized like bank statements that traumatic events can be expressed in meaningful ways. Belmore's *Vigil* offers a stark, gripping, and moving performance in which "home" as a figure of speech is forever interrupted by the stutter of repeating refrains of colonial history—tongues forever caught on English lies of civility. Polite rhetoric and mythologies of a clean, nice, and innocent Canada are revealed to be disgusting in their denial. The great white settler fairy tale is an obscene delusion, tainted by the bloody corpses of colonized women that all of Canada's pleases and thank yous cannot undo. The silence and invisibility of the missing, murdered, and sexually brutalized Indigenous woman's body within mainstream Canadian discourse and everyday dialogue is symbolic of the perverse quietude that surrounds Canada's ongoing colonial project. The lives of Indigenous peoples are often pushed further to the margins of history through the tactical use of racialized migrants as evidence of an anti-racism that smothers the violence of colonizers in apolitical hip-hop anthems and Bollywood festivals.

If "home is a figure of speech" then who is "at home" in Turtle Island and how are they at home? If "home" is metaphoric of belonging, acceptance, inclusion, and even love, then whose bodies are used to mark the exterior zones of both the family and the nation? Beyond a self-righteous moralistic position or a final statement of certainty regarding the biopolitics of the Canadian nation state, Potts and Belmore offer impassioned artistic works that reflect upon the powers of transitory emotions. These remarkable creative thinkers produce affective sentiments that are not fenced in. Their artistic works evoke feelings that are not domesticated through the love stories of gentrifying "fair is fair" yuppies, sneering at homeless Indigenous women. In the art of these inspirational Indigenous women, the

impossible and intangible idea of "home" is not captured in "precious moments" photo albums or through social media sites documenting rich frenemies and branded desires. Rather, the emotive, political, and embodied histories that haunt a colonizing nation colour the streets, leaving evocative archives of casual genocide.

In Belmore's *Vigil*, the trauma experienced by the people whom the artist names in screams in the streets much like the red dress nailed to telephone poles offer no legalistic or scientific proof of violence. And yet, in the embodied artistic gesture, there is an emotive rage and sadness that captures the lived pain, justified abuse, and disappearance of Indigenous women. Belmore's artistic work poses ethical questions regarding the capacity of grief to ever be fully addressed through legal and bureaucratic grievance alone.

Potts's *Love on the Streets* also captures the intangibility of the idea of human love. Relationships are formed beyond white colonial bourgeois romance and normative secular capitalist scripts where finding love is akin to shopping. The love on the streets that Potts's film depicts is not a love of shiny diamond wedding rings, Yummy Mummies gentrifying poor neighborhoods, or weekend partygoers sporting Urban Outfitters headdresses to turn heads at posh parties. The love that articulates itself through the interviews of those who experience homelessness in contemporary Turtle Island is one that defies market rationalities. The love expressed is not bought like property, or the love of rich men buying women with material things, or parents buying their children's love and affection with products. Those interviewed discuss the feeling of love that one might experience by giving homeless people money on the street. As Lisa states, "I think everyone has been loved at some point and has loved. Whether it's just helping someone out, giving change to someone on the street or just doing that good deed for the day. That caring. So I think love exists in different forms and I don't think we should be questioning who deserves it or not." Those who have experienced homelessness discuss love as empathy and intersubjectivity beyond ownership, capital, and skin. Ideas of unconditional love are expressed by those whose invisibility is pathologized in the mainstream white settler imaginary. As Matt states in the film, despite hardship and homelessness he still believes in the timeless nature of something call love: "Unconditional love. Absolutely. Love with strings attached. I don't think so. I think we were put on earth to love."

Figure 9.7: Rebecca Belmore, Vigil, 2002. Performance stills.
Talking Stick Festival, Full Circle First Nations Performance. Firehall Theatre.
Vancouver, British Columbia. Photo: Rebecca Belmore.

UNSETTLING SOLIDARITIES:
SPARE CHANGE AND LINGERING QUESTIONS

Love on the Streets much like *Vigil* ends with a love that is not divided through colonial categorizations of race, nor through linear grammars dividing the worthy from the unworthy, the "hot" from the "not," nor the successors of colonial patriarchal lineages from those who fail to reproduce racism. As Kyle states at the end of the film, "If everyone was loving then so many problems would be fixed. The world would be a better place if everyone would just let that be." The rhetoric of the undeserving poor of a laughably "fair is fair" meritocratic country is not bitterly lamented, but countered with a universalism that is often espoused and yet rarely practiced. It is ironically those who are often afforded no measure of love who appear as its greatest proponents.

The artistic medium allows for a gesture of solidarity often not found in mainstream discourses and statist agencies that apprehend the homeless as those to be vilified, medicated, feared, or constructed as objects of pity. Hannah Arendt writes that pity is an enemy of

politics, as it often amounts to the glorification of the suffering of others. She explains, "Parasitic on the existence of misfortune, 'pity can be enjoyed for its own sake, and this will almost automatically lead to a glorification of its cause, which is the suffering of others'" (qtd. in Bowring 68). Arendt counters the idea of pity with that of solidarity. She writes that solidarity "can, by means of worldly principles and ideals (such as respect, honor and human dignity), unite the strong and the weak in a dispassionate 'community of interest'" (qtd in Bowring 68).

Both Rebecca Belmore's *Vigil* and Kerry Potts's *Love on the Streets* offer lingering questions regarding the possibilities of universal principles of justice and love within the context of ongoing white settler colonialism and white supremacy. In *Vigil*, pieces of a red dress are left on the streets of Vancouver, traces of the obscene entitlements of settlers to the land of Indigenous people who are often not entitled to the right to life itself. Similarly, *Love on the Streets* finishes with a statement made by Sylvia, one that could be posed as a question that lingers in the streets. Sylvia's unwavering belief in love beyond the crass lies of the "fair is fair" meritocratic rhetoric of a white man's country leave one to consider the possibility of love beyond the language of capital. As Sylvia states at the end of the film, "It's self explanatory. Everyone deserves to be loved."

WORKS CITED

Arendt, Hannah. *On Revolution.* New York: Penguin, 1965. Print.

Balenger, Yale, Olu Awosoga, and Gabrielle Weasel Head. "Homelessness, Urban Aboriginal People, and the Need for a National Enumeration." *Aboriginal Policy Studies* 2.2 (2013): 4-33. Print.

Belmore, Rebecca. *Vigil.* By Rebecca Belmore. Talking Stick Festival, Full Circle First Nations Performance. Firehall Theatre, Vancouver, British Columbia. 2002. Performance.

Belmore, Rebecca. rebeccabelmore.com. Web. 25 August 2015.

Bhabha, Homi. *Location of Culture.* New York: Routledge, 1994. Print.

Bolton, Betsy. "Farce, Romance, Empire: Elizabeth Inchbald and Colonial Discourse." *Eighteenth Century Theory and Interpretation* 39.1 (1998): 3-24. Print.

Bowring, Finn. *Hannah Arendt: A Critical Introduction*. London: Pluto Press, 2011.

Drake. "Current Events (BLM)." *Views*. Young Money Entertainment, Cash Money Records, and Republic Records, 2016. CD.

Emberley, Julia. *Defamiliarizing the Aboriginal: Cultural Practices and Decolonization in Canada*. Toronto: University of Toronto Press, 2007. Print.

Foucault, Michel. "Of Other Spaces: Utopias and Heterotopias." *Diacritics*. 1986. 22-27

Frye, Northrup, Jean O'Grady, and David Staines. *Northrup Frye on Canada*, vol. 12. Toronto: University of Toronto Press, 2003. Print.

Kannabiran, Kalpana. *The Violence of Normal Times: Essays on Women's Lives and Realities*. Delhi: Women Unlimited Press, 2006. Print.

Matyszczyk, Chris. "Apple Claims that 99% of iPhone Users Love their iPhone." *Cnet.com*. 10 July 2015. Web. 10 Aug. 2015.

McClintock, Anne. *Imperial Leather: Race, Gender, and Sexuality, and the Colonial Contest*. Routledge: New York, 1995. Print.

McConnell, Josh. "We The 6: Why the Name Drake Gave Us is Here to Stay." *The Globe and Mail* 10 July 2015. Web. 20 Oct. 2016. Print.

Paradis, Danielle. "Urban Outfitters' Smudge Kit is Insensitive Cultural Appropriation for theLow Price of $39.99." *Toronto Metro News* 8 April 2015. Web. 25 Aug. 2015.

Pilkington, Ed. "SlutWalking Gets Rolling after Cop's Loose Talk about Provocative Clothing." *The Guardian*. 6 May 2011. Web. 20 October 2016.

Potts, Kerry, dir. and prod. *Love on the Streets*. Cinematography Andrew McAllister. Hot Doc's Library. 2009. Film.

Sanlal, David. "Stolen Sisters: Colonial Roots of Sexual Violence Against Aboriginal Women and Unsympathetic Media Representations Toward their Stories in Contemporary Canada." *Capstone Seminar Series* 5.1 (Spring 2015): n.p. Web. 25 Aug. 2015.

Silverstein, Jason. "I Don't Feel Your Pain: A Failure of Empathy Perpetuates Racial Disparities." *Slate Magazine* 27 June 2013. Web. 25 Aug. 2015.

Suleri, Sara. *The Rhetoric of English India* Chicago: University of Chicago Press, 1992. Print.

Slavoj Žižek, "Against Human Rights." *New Left Review*, July – August 2005. Web.

10.
Should You Stay or Should You Go?

Beyond a Blur of White Picket Fences

"SHOULD I STAY OR SHOULD I GO?" sang The Clash, along with other timeless transnational anthems such as "Rock the Casbah." Art offers no conclusions or conclusive proof to be counted by calculator and graph, well-timed and recorded in the grammars of secular capitalism. And yet artistic and lyrical texts clash with the banalities of everyday cash register hymns, to put viewers and the public in tune with the personal and political sensibilities of those whose politics, genealogies, and bodies are often made invisible to the mainstream. Sylvia's statement in Kerry Potts's film *Love on the Streets*, "everyone deserves to be loved," can be read as a question asking us to consider the possibility of universal sentiments such as love. This declaration of the word "love" uttered by a homeless woman in a film regarding homelessness, exile, and poverty in a white settler colony is remarkably powerful. Sylvia's poignant resilience in a place that has dispossessed colonized people both literally and symbolically is a poetic rumination on all that is possible beyond the red letter economies that define everyday oppression.

Slavoj Žižek suggests that philosophy does not provide the right answers to questions, but rather critiques the questions themselves. When we are presented with problems, the very way we perceive these dilemmas is part of the enigmatic ethos of unresolved struggle (Žižek, "The Purpose of Philosophy"). The artistic works considered in this text can be conceived of as forms of public intellectual culture in a time of mass branding, common sense consumerism, and rapid-speed Internet temporalities. In times when the largest moral and philosophical questions that one is often made to consider lie in whether to drink organic coffee and give spare coins to homeless Indigenous people,

298

transnational artistic praxis creates a liminal space of feeling, politics, and creative invocations of hybridity. Art, much like philosophy, is often not a means of solving problems or offering succinct and easy political solutions or mantras. Rather, the spectator is left to think. The artist does not force an opinion on the viewer in the way that one is often forced within contemporary cultures of capitalist branding to imbibe advertising images that tell one to enjoy ad nauseam. Žižek discusses this "injunction to enjoy" that besets contemporary secular capitalist worlds in which one is perhaps free from everything but the limitless injunction to consume (Žižek, "'You May!'"). Rather than asking how more oppressed people can be included into mainstream white settler cultures of anti-intellectual capital, the artists in this work reframe the problem of exclusion in times when one is often taught to enjoy apolitical conformity.

An artistic installation, performance, film, or painting can be read as an affront to the creation of an object that's use and exchange value is solely determined by Western secular capitalist ethics of production and consumption. Undoubtedly, one's relationship to art, their ability to attend artistic events, and to apprehend and discuss art are bound to Bourdieu's understanding of cultural capital as a form of non-financial capital. However, art still broaches a space for thought and politics that cannot be easily dismissed as pretension. When one considers how the artists discussed throughout this text create artistic work that occupies public space, crossing boundaries of class and culture to offer entry into the lives of those that are often made invisible, their art becomes a meaningful and poignant utterance of politics.

DESIGNING DIAGNOSIS:
ARTISTIC ELUCIDATIONS OF SYMPTOMS

Similar to the discussion of *Mass Arrival* in chapter 6, the symptom Žižek identifies is that which draws attention to cracks in mythologies of a social order ("You May!"). The universally excluded figure of the non-status migrant points to the inherent inequalities of cultures of Western secular capitalist democracy. While narratives and doctrines of Canadian multiculturalism are used to imagine white setter nation states in North America to be open to supposed diversity, the deportation, racism, and xenophobia lauded onto the bodies of Tamil

migrants has material consequences. Cities and nations that celebrate saris and samosas to garner tourism simultaneously deport migrants from Sri Lanka who are forced to return to war and genocide, threatening their right to life itself.

The apparent hospitality of a multicultural multinationalist form of capitalist branding in which everyone is invited to partake in Otherness through the sale of exotic items meets the abhorrent disdain for the jouissance of the "real" of Otherness. Tamil migrants are referred to as "diseased terrorists" by the same Western secular publics that celebrate a sanitized store-bought Orientalist invocation of South Asian culture (Žižek, "Multiculturalism or the Logic of Multinational Capitalism").

ILLUSORY IDENTITIES IN A WHITE IMAGINARY
PSYCHOANALYSIS AND CONTEMPORARY ART

Within times of polite over-the-counter racisms and the bureaucratization of lives and deaths, art serves as a means of exposing the realities of oppression. The courageous work of an artist reveals the glaring hypocrisies of universal ideals of love and justice in the context of a white settler capitalist society. Through the critically creative lens of the artists discussed in *Uncommitted Crimes*, meritocratic appeals to betterment and branded emotions appear as false platitudes in the context of global capitalism. Similarly, while "race" and racism are often managed through a language of legality in which racism is thought to have disappeared with the passage of affirmative action policies and laws, the artists discussed in this book offer creative meditations on the continued epistemic, psychological, and material violence that lingers on the skin. Joshua Vettivelu's installation *Washing Hands* is, for example, an artistic work that draws attention to the phenomenological experience of racism that Frantz Fanon discussed in his postcolonial treatise *Black Skin, White Masks*. The pain of racism continues, structuring the subconscious and libidinal desires for whiteness that seamlessly inform normative images of morality, truth, beauty, and success.

Bryce Lease discusses the relationship between psychoanalysis and art, drawing on scholarly insights from Slavoj Žižek and Jacques Lacan. While Lease focuses solely on the medium of theatre and theatrical representation, the insights offered regarding art and psychoanalysis are

relevant to the creative works discussed in this book. Lease states that "it is a common misperception of psychoanalysis these days to expect a theorist to unearth the personal idiosyncracies of an artist in order to reveal the 'truth' behind a particular work of art" (33). The author states however, that Žižek proposes the opposite task. For Žižek and in Lease's reading of art through a psychoanalytic lens, "our identity in the symbolic order cannot be reduced to our individual psyches: it is in fact the process of signification that forms our `intimate, psychic idiosyncrasies'" (Lease 33). In the work of the artists discussed in this text, identity is not reduced to individual narratives of personal trauma, joy, or familial background. Rather, it is through the artist's work and its relationship to processes of political and socio-symbolic signification within nationalist fantasies that scenes and spaces of intimacy are constructed between artist and spectator.

Shirin Fathi's portraits are not a reflection of the imagined authenticity of Iranian female identity. Rather, it is through the signification of the signs and signifiers of gender, genealogies of Iranian representation, and Orientalism that the apparent intimacies of the aesthetics of the female form and personal nature of the photographic portrait are called into question. Identity is staged through processes of signification that can be manipulated to challenge how aesthetics come to generate affect in viewers (Hall). The medium of photography as one that tells an apparent truth—much like personal narratives of experience that often inform narratives of the self—is troubled through the artist's use of photography to conjure up theatrical texts that bely succinct categories of occident and Orient, feminine and masculine, beautiful and grotesque, sexualized and repressed. Much like the work of iconic feminist artists such as Cindy Sherman, the sexist renderings of women's lives found in popular culture, are troubled by the hyperbolic construction of portraits that resignify gender as an infinite play of appearances. Cindy Sherman's tragic damsels in distress are not consummate victims traumatized by individual narratives of suffering, which signify within a sexist imaginary as those in need of patriarchal heroism. Rather, Sherman's figures only come into being as recognizable tropes within an entire system of gendered, heteronormative histories of artistic signification. Similarly, Fathi's portraits are deeply meaningful in the context of a global "war

on terror" and the construction of Iranian women through a neo-Orientalist gaze supported by the derisive images of Arab, Middle Eastern, Brown, and Muslim women's bodies in mainstream popular culture. Fathi destabilizes Orientalism and disidentifies with white Western feminist art histories by drawing on an alternative artistic genealogy of Iranian visual culture and global sartorial expression. Fathi, like many of the artists discussed in this text, enters into a dialogue with mainstream histories of representation as a means of subverting a dominant, masculinist, and colonial gaze.

CRACKS IN A MULTICULTURAL MOSAIC: ART AS POLITICS

This book does not use the work of the artists discussed to dissect and critique their positions as "authentic" native informants or read their work as reflections of personal biography. It is perhaps more interesting to consider what their artistic praxis and reactions to it reveal regarding the anxieties, desires, and aggressions that haunt white settler colonies and transnational viewing publics. If as Žižek discusses, the symptom is represented as the undesirable, unassimilable Other in nationalist fantasies, one that's exclusion sustains dominant ideologies, the artists discussed in this text can be read as producing artwork that is political. (*The Plague of Fantasies*) Lease discusses the role that art plays as an institution of social change, one that "exposes social symptoms rather than sustaining culturally embedded nationalist fantasies" (*The Plague* 4). Drawing on Žižek's discussion of anti-Semitic discourse, the author states that within discourses of German fascism, "the whole notion of social harmony can only be sustained if it appears to be threatened by the presence of an alien intruder" (*The Plague* 34). One can read the xenophobic and racist hysteria that surrounded the arrival of the *MV Sun Sea*, which inspired the installation *Mass Arrival* in similar ways. The racialized refugee was read as an intruder in ways that sustain Turtle Island's delusional multicultural fantasy. While diasporic patriots of colour with recognized Canadian citizenship documents are invited to sell forms of cultural exoticism to brand Canada as anti-racist, such a fantasy happens alongside stringent forms of border security, deportation, and brutal indifference to human life

dividing the hated foreigner from the familiar and trusted figure of the citizen. Similarly, in Kerry Potts's and Rebecca Belmore's creative works, the assumed social harmony of Turtle Island as a meritocratic and democratic nation of ostensible fairness only comes into being by pathologizing the homeless, the Indigenous, and particularly working-class Indigenous women who experience brutal sexual violence, invisibility, kidnapping, disappearance, and murder.

The construction of Turtle Island as a nation in which divergent groups of racialized people, cultures, languages, sexualities, and religious faiths coexist peacefully is a fantasy that is only sustained by ironically constructing those who are Indigenous to the land as perpetual foreigners. Indigenous people are both literally and symbolically made homeless to the nation. Within the rhetoric that defines the contemporary global "war on terror" and in mainstream discourses where white settler Canada is presented as a supposed peacekeeper, ongoing efforts to erase Indigenous people from the nation state remain invisible. Images of successful "model minority" immigrants fuel the North American dream of social mobility. Discourses of law and human rights are used to construct North America as a safe haven for women against nations in the Global South that are associated with misogyny, terror, and poverty. In *Love on the Streets* and *Vigil*, Potts and Belmore elucidate the symptoms of this national fantasy, creatively labouring to reveal the phantasm of colonial violence that haunts the provincial moralities and mythologies of the nation. Lease states that "an ideological fantasy will present the symptom as 'an alien disturbing intrusion' because it reveals an ideology's inconsistency, its inability to totalise (or harmonise) human experience. For this reason, the symptom itself is stigmatized" (33).

The returned repressions that appear as unsettled ghosts in a white settler colony are found in homeless people begging for change, intruding on quaint colonial narratives of North American dreams. Similarly, Belmore's screaming of the names of missing and murdered women through the streets of Vancouver are intrusions on the silent complacencies that sanction the deaths of Indigenous people in a white settler colony rife with racist denial. The imagined harmony of human experience is also troubled in Amita Zamaan's *Disconsolatus*, which gestures to those exiles who remain haunted within Western nations by forms of occupation, apartheid, and war that are supported

by Western governments and conservative racist publics. Helen Lee's *Prey* also visualizes and narrativizes the inconsistencies that lie in celebrated multiculturalism and meritocratic ideologies of hard work by creating films that focus on stories of colonialism and immigrant labour exploitation.

Finally, many of the artists whose work I address in this text also reveal the lack of harmony within creative industries and canons of art history that celebrate cis gender white male artists, while tokenizing or excluding racialized artists, feminists, and transgender people. Kara Springer's *Ana & Andrea* offers both a literal and symbolic rendering of how histories of minimalism often celebrate white male artists as ahistorical, disembodied iconoclasts whose work bears no reference to their bodies or genealogical locations. Springer's installation gestures to the embodied nature of art, in which the unmarked and often unremarked upon body of the white, Western man is constructed as an individual genius, while the art and humanity of Black women is reduced to skin and hair. In titling her installation *Ana & Andrea*, after the famed white minimalist artist Carl Andre and the racialized Cuban artist Ana Mendieta, whom he was accused of murdering, Springer's provocative designs make reference to the haunting ways that white masculinist violence is concealed, falling between the cracks of canonical art histories. Springer's body language asks one to consider how artistic disciplines themselves are discursively imbricated in the political construction of both the artist's body and their body of artistic work.

ART STARS AND PRECARIOUS WORKERS: CREATIVE LABOUR IN NEOLIBERAL TIMES

To live and work in creative industries as a minoritarian artist is increasingly a precarious venture. With the dissolution of the social welfare state transnationally, fewer and fewer state-funded artist's grants, a competitive capitalist economy in which artists are encouraged to sell their labour to major multinationals, and the lingering forms of oppression that colour the lives of those on the margins, the will of the artists discussed in *Uncommitted Crimes* to create artistic work is remarkable. Many of the artists discussed in this text straddle multiple positions within the art world, in terms of work

and politics. The artists discussed in this book also straddle borders through actual transnational movement between nations and through a socio-symbolic and psychic negotiation between borders of religious, nationalist, gendered, and political divides.

Artists such as Brendan Fernandes are at once Canadian while also living and working in New York. Fernandes is a former dancer, and constructs art in multiple mediums. Similarly, Syrus Marcus Ware's installation is at once art and activism, just as Ware is a dedicated and inspiring thinker, artist, and activist. Andil Gosine's *Khush* installation is a wonderful example of a creative installation that is at once an archive of political history and a visually interesting exhibition, just as his life and work are informed by interdisciplinary forms of academic labour, artistic prowess, and transnational movement. Finally, Elisha Lim's calendars and graphic novels are both finely crafted art objects and texts that document histories of queer and transgender people of colour in Turtle Island and transnationally.

The capacity of the artists discussed in this text to work in multiple domains, on multiple continents, and to tirelessly labour to create meaningful interdisciplinary artwork is striking. In discussing the construction of the artist-worker within the context of contemporary neo-liberalism Angela McRobbie states,

> There is as yet no category for the curated/project manager/ artist/website designer who is transparently multi-skilled and ever willing to pick up new forms of expertise who must constantly find new jobs for him/herself (e.g. incubator/ creative agent) who is highly mobile, moving from one job or project to the next and in the process also moving from one geographical site to the next. (518)

This figure of the multi-tasking artist is also one that must survive a conservative political climate in which economic stability is not guaranteed, particularly for artists on the margins whose work carries integrity, ingenuity, and wit. Rajni Perera's *Broke Lakshmi* is at once a humorous commentary regarding the economic realities that beset women of colour in the creative industry, and an artistic means through which Orientalist fetishism for expensive store-bought Eastern spiritualities are countered with the realities of racism and

class politics. As discussed, Perera strives to create interesting and meaningful art that refuses self-exoticism. At a time when borders are policed to exclude Sri Lankan migrants, while transnational corporations sell Barbies with bindis to capitalize on an empty rhetoric of diversity, Perera refuses to create art that profits from an Orientalist gaze. Perera, like the other artists discussed in *Uncommitted Crimes*, labours to create visually challenging and clever works of art that bely a search for authentic origins, taking influence and inspiration from multiples cartographical and temporal worlds.

DANCING CHEEK TO CHEEK: A CONSORT OF ARTISTS

The artists discussed in this book offer creative renderings of affect in times of numb technologically powered e-motion. While whole lives are lived through screens and "like" buttons are used to replace affective opinion, these remarkable transnational artists create emotionally charged creative interventions that allow one to affectively experience profound forms of intersubjectivity. Spaces where political art is free from censorship and artists of colour are taken seriously as creative visionaries are precious and rare. The artistic texts discussed in *Uncommitted Crimes* occupy spaces of galleries, archives, darkened halls of theatres where films of loss and love flicker on screens, and city streets where performance artists remap a landscape soaked in the blood of denial. If art is a rupture in thought and feeling, one that is smuggled across the borders of imagi/nation, these artists intrude into the lives of spectators and viewers in celebratory ways. The work of each of the artists whose relentless creative praxis I attempt to comment on in this book is in many ways an uncommitted crime. Art becomes a defiant way of deviating from the mainstream, critiquing and rupturing the social order and intruding on the privatized fears that govern neo-liberal cultures of individualism.

The uncommitted crimes of these artists lie in the courage of their unapologetic delinquent desires, striking political convictions, and scandalous talent. The artists who coalesce in the space of this book terrorize the banalities of mainstream political and popular culture, offering fresh and fierce aesthetics that counter mundane conformities with passion. Each artist discussed in *Uncommitted Crimes* constructs